The Business of Being an Artist

Third Edition

THE BUSINESS
OF BEING
AN ARTIST

Third Edition

DANIEL GRANT

ALLWORTH PRESS
NEW YORK

09 08 07 06 05 8 7 6 5 4

Published by Allworth Press
An imprint of Allworth Communications
10 East 23rd Street, New York, NY 10010

Cover design by Douglas Design Associates, New York, NY

Page composition/typography by SR Desktop Services, Ridge, NY

ISBN: 1-58115-056-3

Library of Congress Cataloging-in-Publication Data
Grant, Daniel.
 The business of being an artist / by Daniel Grant.—3rd ed.
 p. cm.
 Includes bibliographical references and index.
 ISBN 1-58115-056-3 (pbk.)
 1. Art—United States—Marketing. I. Title.
N8600.G7 2000
706'.8—dc21 00-024455

Printed in Canada

Contents

INTRODUCTION

These are days in which abysmal pessimism exists side by side with glassy-eyed hope among young and starting-out artists. Many artists look ahead to see only poverty in their lives, underappreciation and distrust by the rest of the world; yet, they also read about the hottest young sensation, whose face fills the cover of major art magazines (publications forever ready to promote the latest thing) and whose work is avidly sought after by both private and institutional collectors. Success in the art world looks particularly capricious, and those who achieve that success seem more akin to rock superstars—capitalizing hard, *now* on their fame, because they know the spotlight will soon pass to others and they will be forgotten—than to the celebrated artists of old.

How does one achieve success or make plans in such a seemingly chaotic environment? Plans themselves—sending out letters, résumés, clippings, and slides of their work to critics, dealers, curators, and other possible exhibitors; following up with telephone calls and visits; arranging for the framing, crating, and shipping of their work; negotiating with their dealers and galleries; responding to inquiries; and whatever else the advancement of their careers require—appear to defy the reasons why most people choose to become artists in the first place. Artists, think of yourselves as businesspeople and make an appointment with the Muse as your schedules permit.

Small wonder, then, that so many artists find themselves needing help understanding how the art world works and how to find their place in it. Some pick up information in the few "survival" courses offered at various art schools; others hire publicists and advisers to help promote, or give direction to, their work; most others glean what they can from the growing number of business and legal guides for artists available these days or just improvise.

A strong case can be made for just improvising, as there is little rhyme or reason in the way that certain artists become successful while most others do not. All the hard work of researching galleries, making telephone calls, sending out slides, developing a

portfolio and a long résumé of exhibitions may amount to nothing, while someone right out of art school who happens to know the right person or to be at the right place at the right time is lionized. Luck really cannot be talked about, and talent is not a subject for advice.

Still, throwing up one's hands or waiting for lightning to strike is no answer either. The business side of being an artist means knowing what the options are and making informed choices. Too many artists are unaware that they have choices or that there is more than one way for them to achieve success—defined here as the ability to make a living as an artist.

Every known method of attaining career goals has worked for certain artists, failed for others. Therefore, to prescribe a path for success—advising artists to write this sort of letter to a print publisher, sign this type of contract with an art dealer, dress in this manner for a potential corporate buyer—is doomed to fail most artists. It makes the most sense for artists to know what the possibilities are for helping themselves, allowing them to improvise but with informed choices.

Each artist has his or her own measure of achievement. To some, that might mean being written up in a textbook or getting work into a major museum collection; perhaps, it is being represented by a prominent art gallery or any gallery, or just having one's works displayed somewhere for the public to see. Artists who are starting out are likely to have career objectives different from those of artists who have been working for a number of years.

"Poverty," Anais Nin wrote, "is the great reality. That is why the artist seeks it." Perhaps, poor and undiscovered is another way to define the artist; an artist with a romantic view of the opposition of art and commerce will find little sustenance in this book. Artists need to understand how the art world operates and develop strategies for carving out a market for themselves—a type of knowledge that is never in fashion. Artists whose aim is to sell their work are still accused of "selling out" or, to use a more recent term, "careerism" (only in the art world would the idea of establishing a career be viewed with embarrassment and guilt). From art school into the larger society, the myth of the artist as alienated, poor, marginalized, and secretly superior to everyone else is maintained steadfastly. Sadly, other artists are the most fervent in protecting and enforcing this myth.

This book aims to describe the art market and the possible approaches that artists may take for success. This is not a how-to book. It is unrealistic to claim that a certain set of steps—or any one method, for that matter—will work for everyone. A good marketing plan will not compel people to purchase art objects they don't like, that they cannot afford, or that strikes them as inferior to the work of other artists. And, of course, a marketing plan that proves successful for one artist may be inappropriate for another, based on differences in personality, temperament, medium, and the specific type of work. Instead, this book examines different ways that artists have used to bring their work before potential buyers. The experiences of a wide variety of artists are described by artists themselves, and individual readers may pick the methods that make sense for them.

Fortunately, the art world is not monolithic. There are niches for every type of artist and specific markets for all varieties of art. Picasso may be better known and more widely acclaimed than other artists in this century, but only a small fraction of art collectors ever show interest in owning something the Spanish artist created, let alone are able to afford it. Other fractions of the market exist for miniatures, performance art, cowboy art, abstraction, portraits, illustration art, installations, landscape painting, mixed media and collages, still-lifes, videos, art copies, and the list goes on. Buyers of one type may or may not collect in any other category. Some buyers focus exclusively on a particular medium, such as sculpture or works on paper, while others concentrate their collecting on a certain style or movement (minimalism or Pop Art, for example). An artist must first find his or her artistic voice and then locate his or her market. Both surely exist.

A great deal of cultural baggage associated with the word "artist," and overcoming psychological barriers to success necessarily becomes a major component in becoming a professional artist, successful or otherwise. Many artists experience a variety of stresses as a result of the expectations they have for themselves and the assumptions that others in the larger society have about them. Chapters 9 and 10 are devoted specifically to the emotional side of developing a career as a professional artist.

A final point: The art world isn't fair, in the sense that strengths that generally pay off in other professions, such as hard work and good skills, may go unrewarded for artists. The student who is number one in his or her class at some prestigious law school can rightfully expect lucrative job offers from top law firms around the country. Major—or minor, for that matter—art dealers, curators, and collectors, on the other hand, are unlikely to know or care about an artist's grades, and they don't recruit students. What would it even mean to be the best student one year at, say, the Rhode Island School of Design?

Artists may also discover that recognition is unequal, as certain dealers and collectors are more prized than others, regardless of who sells more (isn't everyone's dollar the same?). A doctor isn't esteemed on the basis of who his or her patients are, but the opposite is true with artists.

After leaving school, one may endeavor to work one's way up the ladder—exhibiting first on the local level, winning acceptance to a regional or national juried art show, moving on to a larger urban gallery—and still find that sales and name recognition never materialize. Breaking into the part of the commercial gallery world where real money is involved, many artists learn, has a lot to do with whom they know and who is interested in them. For many young artists, the question seems to be, How do I get a show of my work? Presumably, a show leads to sales and more shows. Finding somewhere to exhibit one's work, however, is not all that difficult. Every bank lobby, restaurant and cafe, community center and school seems to have art for exhibition and sale. I once saw an artist's résumé that listed, under the heading "one-person shows," an exhibition at Cheesecake Charlie's in Lenox, Massachusetts. The issue isn't whether an artist can get work on display somewhere but how to make sales. For young artists, the question must be, How do I work my way into the art world of collectors and dealers?

Artists cannot wait, hoping to be discovered. They cannot assume that artwork as good as someone else's will be rewarded equally. Rather, artists must aggressively pursue the marketing of their work, and part of that process is meeting the people who may be of assistance to their careers as well as associating with other artists.

In most biographies, major artists are described as loner geniuses, coming to their ideas through reflection and personal experimentation, later discovered by dealers and collectors who only vaguely sense their importance. Art history is the last refuge of Romanticism. In real life, however, artists develop their ideas in association with like-minded artists, and these artists make referrals (to collectors, critics, curators, and dealers) for each other. One sees too many capable artists who will not take a personal involvement in the marketing of their work. They want that Romantic myth to work for them, allowing them to just pursue their art and be discovered by someone who makes their career. A current example of this tendency is the burgeoning number of artists' Web sites, hastily created and left unpromoted, which only lessens an artist's chances of being discovered in the realm of cyberspace. This book presumes the willingness of artists to take a hands-on approach to their careers. Following a list of recommendations will not ensure anyone success, and for that reason I have not written this as a how-to guide. However, understanding the options for starting and promoting a career will enable artists to make clear-eyed choices and increase their chances for success.

1

How to Get an Exhibition and Sell Art

Artists aren't people who simply create art and then drift off into oblivion; they want their work to be seen and to receive some sort of reaction from those who see it. Putting art in front of the public establishes an artist as a professional and, for many, the quest for a show is the primary goal. Fortunately, there are many venues available for exhibitions.

For the past 150 years, art dealers and galleries have been the principal route to success in the art world. One thinks of contemporary artists in terms of the galleries in which they show their work, and some artists are very closely identified with their dealers. Dealers frequently have a select clientele of one or more principal backers who do the bulk of the buying, and the ability to steer these important collectors to certain artists' work establishes a dealer's prestige. Few long-term successful dealers survive without this clientele, and gallery owners who rely on walk-in traffic for their sales tend to go in and out of business in a hurry. There are, however, far more galleries where sales are too modest to support any one artist than ones that have a robust record of sales.

Finding the right dealer who will lead the artist's work to major collections is a challenge, and few generalizations can be made. Dealers become interested in potentially representing artists largely through two means: The first is when dealers personally know the artist (meeting him or her at an art opening or on a studio visit) as well as hear about the artist from people they trust, such as other artists they represent, curators, critics, and collectors.

The second way is through the strength of an artist's work and market. Artists usually send dealers slides of their work and some indication that there is a market for it. To that end, artists who are starting out need to build a track record of group and one-person exhibitions and, along with that, develop a group of consistent buyers. Dealers don't like to try to build a market for an artist but, instead, look for artists who already have a market that can be expanded. Art galleries and dealers are but one, if a highly publicized, means for artists to exhibit and sell their work. Success in the art world may

lead to critical acclaim and financial rewards, but many artists find the process of cur-
rying favor with dealers, and even spending so much of their time in the large cities
where the major art dealers are located, both grating on their nerves and contrary to
why they sought to be artists in the first place.

There are alternatives, opportunities for artists to sell their work outside the
gallery structure, and many artists have been able to gain exposure or make a living this
way. The French Impressionist exhibitions in Paris of the 1870s and 1880s were all orga-
nized by the artists involved (one of Mary Cassatt's main values to this group was in
convincing wealthy American collectors to take a look). The German Expressionists of
the 1910s published the *Blaue Reiter* ("Blue Rider") almanac to promote their work;
Dadaist artists in the 1920s created "manifestations," and Pop Artists of the early 1960s
put on "Happenings." Eventually, many of those artists found their way into main-
stream galleries, but they made their start outside of them, and they did it by uniting for
a common effort. Artists need to think of themselves as small businesses and act entre-
preneurially, generating attention to both themselves and their work and pursuing sales
in a variety of areas. Certainly, before they consider the question of which gallery or
dealer should represent their work, artists must develop an exhibition record and a his-
tory of sales. Gallery representation should come after an artist has gained experience
in showing work and receiving some response. The first step on this path starts with
putting work before the public.

So, Where Can I Show My Work?

A wide variety of exhibition spaces are available for the starting-out artist. Banks,
libraries, corporate headquarters, community centers, hospitals, real estate offices, and
restaurants, for example, are frequently willing to allow artists to hang their works on
the walls where the public may see them. The likelihood of sales is often low and the pos-
sibility of damage to the work (fingerprints, coffee splashes, cigarette smoke) is consid-
erable, but this type of show is a chance for feedback and for the artist to circulate press
releases, announcements, and exhibition cards, and be remembered the next time his or
her work is on display.

Many towns and smaller cities have arts centers where exhibits can be seen in an
actual gallery setting. A notch above the art show in the bank or library, the arts center
is likely to have its own means of promoting activities, increasing the number of people
who may come to view the artwork. Here may be a first opportunity for a write-up in a
local newspaper, again increasing the number of people who know about the exhibit and
the artist.

Juried Art Competitions

Juried art competitions are another means by which the public may come to see an
artist's work. Some are very specific as to medium (watercolors, for instance), style (real-
ism), type (miniatures), or content (Christian themes, maritime, equine), while others
are more general; and the better-established shows draw specific collectors who may buy

only at these exhibits and not at galleries. Some competitions clearly have more prestige than others, based on the renown of the juror(s), whether or not prizes are offered (for instance, by paint manufacturers), whether or not any sort of catalog is published, and where the exhibit is held (a museum has greater prestige than a sidewalk). Shows that take place in more august settings, juried by a person of some importance in the art world and leaving some sort of memento behind after the event is over, such as a catalog, are most likely to increase the artist's visibility and chances for later success.

Between 10,000 and 15,000 art competitions are held in the United States and Canada every year, many of them listed on the Web sites of state arts agencies (look for "State and Regional Partners" on the home page of the National Endowment for the Arts, *www.arts.endow.gov/*), Art Deadline *(www.artdeadline.com)*, Art Job *(www.artjob.org/)*, WorldWide Art Resources *(http://wwar.com/employment/)*, artists' membership organizations, and in a variety of art journals *(American Artist, Art Calendar, The Artist's Magazine, Southwest Art,* and *Sunshine Artist,* among others—see the Bibliography in the back of this book for addresses and subscription information). The most complete evaluation of juried shows is *Sunshine Artist's The Audit Book* ($30), which is published every September and contains information about the number of participants, the number of visitors and the volume of sales for 5,000 shows.

Just as most galleries reflect a certain stylistic preference or subject matter, many juried art shows focus on particular media (for instance, watercolors or prints) or type of imagery (such as equine, landscape, maritime, miniatures, or wildlife). And, like galleries, they attract collectors who are interested in these media or images. However, many artists and collectors focus on these shows and have little if anything to do with commercial galleries; these shows represent an entire art world (and art market) in themselves. When there is a crossover from one to the other, it usually begins with an artist who has been successful in selling work at shows who is later invited to join one or more galleries.

For Houston, Texas, painter William Kalwick, invitations from dealers, as well as from a host of other juried shows, came from being included in the annual Prix de West exhibition at the National Cowboy Hall of Fame in Oklahoma City, Oklahoma. Knowing the prestige of the Prix de West, he had submitted slides for that show for four years before finally being accepted. "There is a lot of politics in the art world, and the directors of the Prix de West all have their favorite artists," Kalwick said. "They want to know something about the artists who submit; they want to be sure that an artist is going to be around for the long-term and not just do a few paintings and then on to something else. One of the requirements of being a successful artist is to hang in there while people get to know you. After I submitted one year, one of the directors called me and told me that 'We like your work, but we want to see more of your work next year, so please submit again.'"

Resubmitting slides year after year was one way to show the directors his work. Kalwick also began submitting slides to other, although similar, juried shows that the

Prix de West directors would likely see, such as miniature exhibitions at the Gilcrease Museum in Tulsa and the Pioneer Museum in Fredericksburg, Texas, as well as the annual "Settlers West" show at the Tucson (Arizona) Museum of Art and a "Masters of the West" competition in Los Angeles. "After four years, they had seen enough of my work, realized that I was consistent and found a place for me in the Prix de West show," he said.

His work has been included in that show every year since 1996, which is common: Once an artist is admitted into a prestigious show, he or she is generally invited back year after year, unless there is a noticeable drop-off in the quality of the work. Kalwick has never won any prizes in the Prix de West show, but that has not affected his career for two reasons: first, inclusion in the show is a significant honor in itself for artists pursuing Western subject matter, and collectors of this genre recognize that these are the top painters in the field; second, Kalwick's work has sold well at the Prix de West shows. Both collectors and dealers circulate the exhibition area with note pads, writing down the names of artists whose work is in demand, and this generates interest on their part in either buying or representing the paintings of these artists.

Sidewalk Art Shows

One of the most prevalent alternatives to the commercial gallery world is the sidewalk art show. Artists who follow the outdoor show circuit paint for part of the year and travel their works to art shows around the country for the rest. It is a hard life, but a different sort of hard life than one generally associated with being an artist. One thinks of artists alone in their studios, attempting to express some idea or feeling in a two- or three-dimensional work. Keeping their works dry from the rain, steady in the wind, and not scraping against each other in the back of a station wagon are quite different worries.

Sidewalk artists generally don't feel themselves to be in competition with the commercial art galleries but, rather, to exist in a different dimension. Their market is the people who may feel nervous about going into art galleries, who like to collect and are happy to bypass the middlemen in order to meet the artists and (quite likely) pay less money for works.

"Galleries are a dead-end," said Lafayette Ragsdale, a Memphis, Tennessee, painter. "The overhead is fantastic, and the dealers have to take a large commission to pay for it. This means that the price of each picture has to go way up, and that means you don't sell your works very often. You can make a living at outdoor shows where you can't at galleries."

Art Fairs

Art fairs are a related, somewhat more high-toned version of the sidewalk art show, which tend to take place on a state or regional level and which are usually juried (many sidewalk shows are not). The jurying increases the prestige of these events, drawing collectors from a wide area. Some art fairs are also thematic, devoted to western (cowboy) art, miniatures or something else, and as such draw a very specific group of potential buyers.

Some artists are able to support themselves through these direct sales and by getting commissions from the people visiting these fairs. In all cases, artists should establish a file of names and addresses of those visitors who have expressed interest in their art in order to inform them of new work and upcoming shows (or exhibitions) where they will be on display.

"I have a list of 600–700 people on my Rolodex," Peyton Higgison, a Brunswick, Maine, artist, said, "and when I am going to be doing a show in, say, Buffalo, I get out my Buffalo file and send out cards to people there, telling them when I'll be there. I've thought about getting a computer to print out cards to people, but most people seem to prefer a personal note."

Different artists send out different types of mailers to potential buyers. Some use postcards, with a reproduction of a new work on one side and information about a show or the work on the other. Others include more narrative, discussing the work or a new direction that the artist is taking. Still others send out whole brochures, some the size of a small L.L. Bean catalog, filled with reproductions of available pieces.

Selling one's art directly to buyers, without the intercession of a dealer, has some clear advantages and some clear drawbacks. Selling directly to buyers may help artists stay more attuned to what collectors prefer and look for, which is both advantageous in terms of meeting a market and potentially compromising. Without a "third person," such as a dealer, to locate buyers, the artist must devote more time than the gallery-represented artist to strictly marketing concerns. Unlike the German Expressionists, Dada, and Pop artists, there is less likelihood for later fame because sidewalk and art fair painters, as well as those who offer artwork through mailers, never get reviewed in magazines, included in museum exhibitions, or mentioned in art books. And, because fame quickly translates in the gallery world to ever-increasing prices, the sidewalk artist is unlikely to get rich. Direct sales, however, gives back to the artist control over his or her market. For some artists, that's reward enough.

Alternative Spaces

Alternative spaces (nonprofit organizations dedicated to arts activities that may be outside the mainstream) and cooperative galleries (in which a group of artists band together to share the work and expenses of running a gallery that features their own artwork) are questionable in terms of leading to actual sales, but they are places where artwork may be seen, written about, and discussed.

Arnaldo Roche Rabell, a Puerto Rican–born painter, came to live and study in Chicago and eventually exhibited his work at university galleries and alternative art spaces throughout the city. In time, that paid off. "There are a lot of alternative spaces in Chicago, which are set up to show new stuff, fresh work that maybe the other galleries haven't caught on to yet," Roche said. "Over the course of six, seven, or eight years, people got to see my work at various places, saw the quality and consistency, and after a while my paintings got mentioned in the newspaper reviews of these shows."

Two of the most important of those exhibitions were one at the School of the Art Institute of Chicago (which Roche entered as an undergraduate and walked away with the top prize of $5,000, enabling him to pay his Masters of Fine Arts tuition at the same school) and another called "Emerging" that took place at the University of Chicago, which brought him telephone calls from art dealers wishing to represent his work. "A show here, a show there, and your name starts to travel around as more people have seen your work," he stated. "I've never knocked on doors, trying to get big galleries to show my work. I've never written letters to big galleries asking them to look at my work. The big galleries called me because I've shown elsewhere."

University Galleries and Museums

Shows at university galleries are in a class by themselves, not as potentially lucrative as commercial gallery exhibits but of a higher prestige than the town arts center or cooperative space. University galleries expose work to the public, although it is not often a buying public. However, some of the renown of the college or university itself rubs off on the exhibitor to a degree, because these shows reflect some degree of curatorial selection.

A notch above college or university galleries are exhibitions at local museums. A number of museums in cities around the country have established "emerging artist" or "matrix" series, featuring short-term shows of local, regional, and (sometimes) mid-career artists. This has been a burgeoning area of programming for museums, as these shows cost far less than major scholarly exhibits (the National Endowment for the Arts has provided much of the financial impetus for "matrix" shows), require months instead of years to plan, spotlight the work of local artists where there is no significant market for art, and enable essentially historical institutions to have a relevance to the art of the present day. Frequently, although not always, museums buy work from these shows as a way to develop or improve their contemporary art collections. The museums' publicity departments can also generate considerable enthusiasm within the community for at least seeing the work.

A growing number of museums also specialize in contemporary art, which is less expensive to collect than works by more established artists, and some focus exclusively on regional artists. The DeCordova Museum and Sculpture Park in Lincoln, Massachusetts, for instance, is devoted exclusively to showing and collecting contemporary New England art. It is the plan of the DeCordova to become "the largest collector of New England artists in the region," according to the museum's director, Paul Master-Karnik, and through its exhibition and acquisitions programs to spur sales of this art among private collectors. He noted that, traditionally, museums have been the passive recipient of donations from collectors for the bulk of their holdings and have conservatively relied on "accepted wisdom and what the critical mass of art historians have decided" about these works in the institutions' presentation to the public. "The contemporary art museum has to be much more dynamic than the traditional museum. We hope to form tastes and judgments, and part of the way we can do that is by buying work and presenting that work in a way that interests the public."

There are other museums of regional art in the United States—the Morris Museum of Art in Augusta, Georgia, for instance, holds an extensive collection of Southern fine and decorative arts, and the Anchorage Museum of History and Art in Alaska contains indigenous art and artifacts from over a period of centuries in Alaskan history. The Morris Museum's concept of Southern art is an expansive one, including artists who were born or who worked in the South, such as Georgia O'Keeffe and Cy Twombly, who painted in South Carolina and Georgia, respectively, for small periods of time, and Jasper Johns, who was born in Georgia and grew up in South Carolina. Many other museums, whose charters are not as specific, focus on regional art if only by default; that is, because they receive insufficient donations of, and cannot afford to buy, the art of anything else.

Exhibitions at university galleries and museums are also valuable for artists, because catalogs are usually created for the events. Most shows are short-term, as are most visitors' memories of what they saw (including the name of the artist), but a catalog extends the exhibit indefinitely, allowing potential buyers to revisit the work and read about the artist time and again. Dealers also are likely to give extra consideration to artists whose work has received more weighted notice.

You can learn about arts competitions, private dealers, galleries, fairs, museums, and nonprofit exhibition spaces by contacting regional, state, and local arts agencies, some of which publish booklets with this information. For instance, the New England Foundation for the Arts publishes a two-volume *Guide to New England's Art Facilities*, and many state arts agencies produce free directories of art festivals taking place within their borders or include listings of exhibition spaces on their Web sites. In addition, various nonprofit arts organizations, such as Chicago Artists' Coalition and the Art Resource and Information Center of the Minnesota Institute of Arts, and for-profit companies, including *Art Calendar* magazine and Renee Phillips Associates in New York City, publish regional directories of galleries and upcoming shows.

All of these exhibition spaces afford opportunities for artists and potential collectors to meet. Opening receptions provide a means for artists to talk about their work and take down names and addresses of visitors who might be contacted about future shows. A sign-in book near the door of the exhibition space not only is useful as a marketing tool but as a feel-good measure, because artists appreciate knowing that many people (especially other artists) have come to look at their work. That feel-good element should not be underestimated, as many well-established artists who have long ago built up a sizeable audience of collectors still want to know who has seen their exhibitions. Landscape painter John Heliker, for example, said that it is "very reassuring to me to see how many people have come to my shows," and Karl Schrag noted that "I see people who wrote their names in the book a year ago, and I thank them for coming to my show. I always look to see who has come to my shows."

ROUNDING UP VISITORS
Who will come to an artist's early shows? The answer is, any number of people, but first artists must start out with their own network of friends, families, and associates, all of

whom are predisposed to think well of the work. Artists have friends who might come; those friends have friends and business associates, some of whom may be persuaded to come. An artist who works in an office has coworkers, supervisors, a boss, clients, and suppliers who may be willing to come to a show. Family members may also have friends, business colleagues, clients, and suppliers who would be interested in attending shows. Out of all these people, there may be some who buy a piece because they like it or just as a show of support. A more informal style of exhibiting work that frequently results in sales is for friends or relatives to host a private showing in their homes, inviting ten people they know to meet the artist and examine the work close-up.

An exhibition forms part of an artist's marketing plan. An artist discovers, through comments in a guest book or (preferably) by physically standing in the space where the work is displayed and watching the viewers, who appreciates the work: Are these people old or young, men or women, black or white? By mingling with viewers (or having a spouse, relative, or friend make conversation with them), an artist may also learn if these people are homeowners or renters, city dwellers or suburbanites. If there are any sales, it is advisable for the artist to personally deliver the piece to the collectors' homes in order to learn more about them: What is the color scheme? What rooms in the home might be suitable for art?

An exhibition creates the opportunity to develop a mailing list of people who have shown interest in an artist's work (and who may be regularly informed through postcards, letters, or brochures of upcoming shows, demonstrations, open studio day, talks, and new works), but ferreting out information about their lives increases the opportunities for sales to take place. The closer that a collector feels to an artist, the greater the investment of time and attention and the more likely that this sense of personal warmth will be rewarded by purchases. A collector's (or a collector's spouse's) birthday or anniversary may be an opportunity to purchase something from the artist. If the collector is Jewish, an artist may send a note suggesting a Hanukkah present. Christmas, a graduation, a family reunion, Mother's or Father's Day, Valentine's Day, and other, perhaps more personal events are also occasions to contact prospective buyers about making purchases, but this requires a knowledge of the collectors and the development of a personal relationship.

Art is a long-term career, and the relationships with buyers should be maintained on an ongoing basis, meeting collectors at a museum, inviting them to one's studio or out to lunch or to a Christmas party. No one wants to feel wooed and then dropped after the check clears, as that will diminish the likelihood of further sales.

GETTING THE MEDIA'S ATTENTION

In addition to creating the opportunity for public comment and developing a mailing list, exhibitions allow the media to become aware of your work. Artists should think about writing a press release (what to say about their work) and to whom it might be sent well in advance. A press release reads almost exactly like a regular newspaper article, with the most important information at the top ("An exhibition of photographs from

the Civil Rights movement of the 1960s will be held . . ."), followed by a statement or two about what makes this event newsworthy ("first time shown," "using a new technique," "marking the anniversary of"). From there, the press release should note where and when the exhibit will take place (address, dates, and time) and mention the artist. The artist may be discussed higher up in the release if the artist figures into the news event of the story ("was chased up a tree and needed to be rescued while sketching a leopard") or if the artist is local to the area or received training there.

The press release is often part of a press package, which consists of the news release, one or more photographs or slides of the work, information about the artist and perhaps an artist's statement. To whom this package should be sent is not clear, so artists should be familiar with the media to which they are submitting material and also have a number of copies to send to any one place: At a newspaper, it might be the arts editor, art critic, features editor, calendar editor, magazine editor, Sunday editor, weekend editor, or managing editor—a telephone call in advance might whittle down the list somewhat. Artists should also think not only about obvious places where a notice might be placed but elsewhere. A women's editor or a reporter may write largely about women who are doing something noteworthy in one field or another. There may be a news angle for the business, sports, or travel editor.

If submitting a press package to magazines, it need not only be an art journal but a travel publication or one devoted to retirees, collectibles, and other luxury items. If the target readership has money, that group is likely to be interested in buying artwork. Press releases and other material should be sent to newspapers between two and six weeks before the event is scheduled to take place, and telephone calls should follow the expected receipt of the notice to make sure that it arrived and went to the appropriate person. It is very possible that the same release may need to be sent again (followed again by a phone call), because reporters and editors are flooded with announcements. Magazines have a much longer lead time, and press material should be submitted at least six months in advance.

As important as developing personal relationships with potential and current collectors is creating a rapport with editors and reporters. A critic might be invited to one's studio, or an editor asked out to lunch or to a gallery opening, in order to build an investment of time and interest in an artist's work and career. This relationship should be ongoing, so that the editor doesn't feel used and the artist's name isn't forgotten if a year or two has passed between exhibitions or other events. Also note that journalism is a nomadic profession, in which critics, reporters and editors change their jobs frequently and regularly: Artists should be flexible and tolerant enough to like the new editor or critic as much as the old one.

SELLING DIRECTLY TO THE PUBLIC

"Everyone is a potential client," said Walter Wickiser, an artists' advisor. "The important thing is to let people know that you are an artist, because you never know who might become a collector." For that reason, artists need to develop a client list, one that

changes and (it is hoped) grows over the years, that will be used to contact people about art exhibitions or an open studio event. The list can grow with the help of some of those friends and family members who suggest other people to contact (their friends and business acquaintances, for instance), and those friends and family members may be persuaded to write or call on the artist's behalf. Using people the artist knows to locate new prospects is a pyramid approach that ensures that more than the same group of potential collectors show up at each exhibit.

Barbara Ernst Prey, a watercolor artist in Long Island, New York, began selling work by finding buyers through people she knew. Her mother's friends were some of the first collectors, quickly followed by the friends and associates of her husband's parents, and later friends from college became buyers.

Her brother, who lives in Manhattan, also set up a show of her work in his apartment, and other friends in Massachusetts and Pennsylvania did the same—all of which resulted in sales. Word-of-mouth advertisement and people she met at art openings and other social get-togethers further increased her client base. Eventually, an artists' representative in Washington, D.C., took her on, as did five galleries. "Between them all," Prey said, "I'm selling everything."

It is advisable for artists always to be on the lookout for potential buyers, attending the kinds of social events and activities where they would likely be found, such as art exhibition openings and parties. Artists should keep a pen and paper on them at all times in order to write down these people's names for the client list.

According to Nina Pratt, a New Yorker who has taught sales techniques to artists, "the artist should then send a letter to these new prospects, following up with a telephone call within ten days in which the artist says something along the line of 'Hi. My name is Nina Pratt and I am a painter. So-and-So suggested that you might like to come to my studio—or come to such-and-such gallery where an exhibit of my art is taking place—to see the work I am doing now.'"

It may be advisable for artists to set a goal of contacting so many prospective buyers, or arranging a certain number of studio visits, per week or month. Getting someone into the studio is a large first step, and the artist will have already passed through a major stage of awkwardness. Talking about your work or listening gracefully to others make comments about it, however, may be no less difficult. Pratt stated that artists "need to know how to shut up. You want to draw out the client, because most people like to talk while they look at something new, by asking leading questions, such as 'How do you feel about this? What's your reaction to that?' You want to get the buyer to thaw out. If the artists do all the talking, it feels like they are imposing their own views, and potential buyers don't want to commit themselves to anything."

She added that "comments may frequently be inane, such as 'Well, it certainly is a large painting,' and the artist should respond with something like, 'I'm glad you noticed that. What else do you see in my work?' You have to decide which is more important, a wounded pride or one's pocketbook. Most artists prefer their pocketbook."

The last major area of awkwardness is the actual sale, as the subject of money often makes everyone a bit squeamish. Again, the artist needs to take the initiative in closing the deal, although it may be easier to soften the sell by focusing attention on which piece(s) the collector seemed to prefer as well as how, when and where the art should be delivered. The payment question can be brought up in the form of "Do you want to pay me now or upon delivery?" Other possibilities include being paid half now, half later or some form of barter.

When artists sell their work directly, rather than through an intermediary, they need to utilize many of the same sales techniques as gallery owners. For example, artists should have brochures, postcard images, and other written materials (such as a bio and a price list) readily at hand. Fumbling in a desk or file cabinet for an exhibition history takes away from the impression of the artist as a professional prepared to sell work, and prices that are not committed to paper may suggest to potential buyers that they are made up on the spot with the amounts dependent upon the artist sizing up the collector's financial resources and whether the artist likes the buyer or not. Gallery owners talk about the artists they represent with collectors, and artists must be prepared to talk about themselves and their work, offering explanatory, biographical, and technical information as fits the art or the interests of the potential buyers. In general, artists should arm themselves with three "talking points" for their work; for instance, how it was created, what other artists or artworks or events in the news inspired the piece, how long one has been working in a particular series. Artists shouldn't feel a need to chatter the entire time that a collector is looking at their work, but artwork can often leave people tongue-tied or lead them to say things that are awkward or inappropriate. Directing the way in which a potential buyer might come to understand a work of art is both appreciated by the collector and helpful in making a sale. Art is a form of communication: The better the level of understanding is between artists and collectors and the more interaction there is between them, the greater the investment that the would-be buyers make in the artists. There is no rule of thumb concerning how much conversation results in sales, but purchases and commissions become more likely when there has been ample communication.

If would-be collectors are expected to purchase works from the artist's studio, there should be some area within the studio set up for displaying art. Artists should follow a collector's interests, determining an individual's preferences in media, size, colors, and subject matter and showing additional works that correspond with those tastes, rather than attempt to direct a potential buyer to particular works they would like to sell. Artists may offer to bring a selection of works to the collector's home or office so that the buyer can choose the piece(s) that works best in the environment. In most cases, the delivery of the sold work of art should be at no additional charge to the collector.

Those pieces that one does not want to sell should be clearly marked (i.e. "NFS"—not for sale) to eliminate the potential for misunderstanding between artist and buyer (if the object isn't marked in advance, a collector might wonder, Why won't the artist sell that work to me?). Collectors may ask for discounts (5 to 10 percent is not

uncommon in the gallery world), although allowing price breaks may lead to irritation with one's dealer if the artist's work is also represented by a gallery (see the section "Coming to Terms" in chapter 2). Delicately, artists should try to discern the buyer's budget, leading the person to pieces priced in that category, rather than attempting to urge the collector to spend more than he or she feels comfortable with. Artists may also offer a return policy, allow a buyer to change his or her mind about the piece within a week or two, or permit collectors to take the object home on a trial basis (again, a week or two) before paying. Collectors may want to pay over time or pay through trade (other artwork or goods and services), which is taxable income but not the hard cash with which to pay the tax (see "Bartering and Leasing Art" in chapter 3). A measure of flexibility in price and the manner of payment entails increased risk for the artist, but it may also inspire greater confidence on the part of the collector.

Some written document should accompany the transaction, either a straight bill of sale or a sales agreement. The bill of sale will indicate all relevant facts about the transaction, such as the artist's name, the name of the artwork, the work's medium and size, the year the work was created and if it is signed (and where), the price of the piece, and the date of sale. A sales agreement will include all those facts as well as add some points that are advantageous to the artist, such as reminding the buyer of the artist's rights under the copyright law as well as allowing the artist to borrow the work (at his or her own expense) for up to sixty days once every five years in the event of a gallery or museum exhibition and permitting the artist access to the work in order to photograph it for his or her portfolio.

Artists who sell directly to customers should obtain a sales tax number through the state department of taxation (the number usually is one's social security number and there rarely is any charge for receiving this number) and add a sales tax to the price of the artwork they are selling. Every state has its own percentage tax for sales. An added benefit of having a sales tax number is being able to either deduct the sales tax one pays for art materials or not pay sales tax at all if the materials are incorporated into a work for resale. The artist should contact the sales tax bureau in his or her own state concerning the sales tax laws (see "A Word about Taxes" below).

Selling directly to the public, bypassing commercial galleries, does not eliminate the need for artists to rub elbows and socialize with critics and customers. In fact, the successful ones usually find themselves doing more of it. Dealers and their commissions are truly the only things sure to be avoided. Selling directly involves a greater interaction with one's audience and, for some artists, that is beneficial both for the art and the sales.

Accepting Credit Cards for Sales

In days past, one measure of someone's wealth was the thickness of his or her wallet. Nowadays, the richest among us carry hardly any cash at all, relying instead on the gold and platinum cards issued to them by major credit card companies. Most artists and craftspeople recognize that an increasing percentage of the people who buy from them

directly at juried arts and crafts shows, expositions, and fairs—the wealthy and the middle class alike—are more likely to pay with a credit card than with either cash or a check.

An added benefit of being paid by credit card is that, first, carrying large amounts of cash or checks make an artist more vulnerable to robbery and, second, financial institutions credit one's bank account faster with a credit card payment than for a check. As a result, more and more artists and craftspeople who make their living selling work at crafts shows have sought to receive authorization from banks and other financial institutions to accept payment by credit card.

Banks, which issue Diners, MasterCard, and Visa cards, however, have become increasingly wary of extending this authorization to individual entrepreneurs. "Citibank is no longer accepting applications for credit card processing for home-based operations," company representatives in the bank's Merchant Services section are instructed to say. Other banks less formally make the same statement, citing a recurring problem of mismanagement and fraud on the part of these entrepreneurs (refusing to resolve complaints from customers, going in and out of business, running into debt and declaring bankruptcy, relocating elsewhere without revealing their new addresses).

Some artists will try one bank after another until some institution finally provides them with authorization, and/or apply to American Express (800-445-2639, ask for Establishment Services) or Discover (800-347-6673), which offer their cards and permission to accept payment by these cards directly without the intercession of a bank.

Also, sellers of all kinds, including those who work out of their homes, may apply to a number of bank brokerage firms for permission to accept credit card payment. The largest are the Seattle, Washington-based Card Services International (206-608-1364) and Financial Alliance (800-928-2273 or 502-339-0595) in Louisville, Kentucky, as well as Litle & Co. (603-896-6000) and DMGT (603-882-9500), both in New Hampshire. These companies arrange approval for merchants (artists and craftspeople included) through banks that are willing to take on the risk, accepting some or all of the major credit cards.

Whether it be a bank or bank brokerage company or either American Express or Discover Card, all applicants are asked basically the same information, frequently over the telephone and sometimes in the form of a written application: the name, address, social security number, and telephone number of the artist or craftsperson (also, the home address and telephone number if the artist's place of business is elsewhere); the bank he or she uses; how long in business; what products are being sold; the average price for pieces that are sold; how the pieces are marketed to the public; the volume of sales (monthly or annually); the state sales tax number or federal tax identification number; business references (suppliers, patrons, craft shops, or art galleries). Additionally, the artist may be asked to submit federal tax statements for the preceding two years and bank statements for the preceding three months.

Applicants are asked how they plan to process credit payments. There are two main methods of processing credit card receipts: The first is manually, using an imprint-

er and later that day processing the charges into an IBM-compatible computer and transmitting them via modem to the bank or bank brokerage company; the second is electronically, through a point-of-sale terminal, which one often sees used in restaurants and department stores. The benefit of the point-of-sale terminal is that approval of the credit card takes less than a minute, lessening the risk factor of fraud. These terminals, however, generally cost far more than the softwear required for the modem method, and they also require separate telephone lines, which may not be available at many shows. The applicants are also asked how they wish to be paid, by check sent to the artist's address or wired directly to his or her personal bank account.

For their part, the credit companies check business and credit references (through the same sources as a mortgage broker), the applicant's financial history, and other relevant information. For instances, Card Services International will hire a local appraiser to examine where the applicant works, taking photographs of that person's house, sales booth, and studio in an attempt to determine the viability of this business. The approval process takes between one and three weeks, generally.

As much as artists may be anxious for some credit company to approve them, they should shop around for the best rates, of which there are a wide variety. American Express, for example, has no application or set-up fees, and it charges merchants an average of 3½ percent (if the sale is processed electronically) and 4½ percent (if the sale is processed manually) for each sale. (Working with American Express is complicated by the fact that one does not submit charges directly to the company and, instead, must use a third-party processor, which involves an extra charge.) Financial Alliance, for its part, takes only between 2 and 3 percent of the sales price (depending upon the volume, lowering the percentage for higher sales), but it charges a $125 application fee, a $7.50 monthly "statement" fee, transaction fees of between 20 and 30 cents per sale and adds a $695 cost for the purchase of the imprinter, computer terminal and modem (through which to transmit charges back to the company), and credit card decals.

Litle's sales percentage ranges from 2 to 5 percent (depending upon the average price of the pieces sold, with higher rates for less expensive items), and the company's application and monthly maintenance fees are $100 and $25, respectively. Litle also sells point-of-sale terminals to customers for $330, less than half the price that Card Services International charges, although CSI's percentage rate for sales is under 2 percent. Clearly, there are a number of factors that must be weighed in selecting one company over another.

Different companies also have their own prejudices. American Express does not allow its cards to be used when selling as a wholesaler to retail outlets, for instance, and Financial Alliance is unwilling to authorize credit card activity for all but the smallest amount of mail order sales. "Mail order is a high risk business," Dave Lutrell, sales manager at Financial Alliance, said. "You don't know who's calling in. They can have fraudulent cards. It's better when you can see the customer and see the card at an arts and crafts show."

A Word About Taxes

Artists and craftspeople may receive money in a variety of ways, including awards and prizes at shows, project grants, scholarships, and fellowships. The prize money or the monetary value of an award (the cash value of a gift certificate, for instance) that an artist receives at a show is taxable at normal state and federal rates. The same taxability is true for money received through project grants from a private or government agency. On the other hand, no tax is paid on fellowships and scholarships if the craftsperson is studying for a degree at an educational institution (including tuition, lodging, equipment, and travel expenses), nor is an award taxable if it comes from a government agency or school. If the award is contingent on the recipient teaching or offering demonstrations or some other part-time service, however, a portion of the fellowship or scholarship will be taxed.

The sale of one's work, of course, also occasions the payment of taxes to state and federal agencies on either a monthly, quarterly, or annual basis. Those artists and craftspeople who sell their work at retail or wholesale shows in the state where they live or out of state are required to apply for a resale tax number both in their home state and where the shows will be held. Usually, one applies with a state's department of revenue, and the cost of registering to sell work is in the area of $10, although some states have no charge. In some cases, registration is for one year, although some states permit applicants to receive a two-day or weekend resale tax number. Most show promoters require a state resale tax number as a condition of taking part in the event. The artist or craftsperson will receive from the state information about how much sales tax to collect (generally, between 3 and 8 percent) and how to pay it—often, a coupon book is enclosed (the coupons are to be mailed back with sales tax receipts). Usually, applicants receive their number and paperwork from the state in a couple of days.

When selling out of state, one must pay that state's sales tax (and not one's home state sales tax), an amount which, in most cases, may be deducted on one's federal income tax form. If the state one is selling in has no sales tax, no sales tax need be paid to one's home state either. Around the United States, artists and craftspeople may apply for resale tax numbers to their state departments of revenue. (*See* Appendix for list of state offices.)

MAKE SURE YOU HAVE GOOD SLIDES

Unfortunately, there are only a handful of cities around the country where an artist can make a living selling work through a dealer. Sooner or later, most serious artists decide to pursue dealers and galleries in those few cities. This pursuit can be conducted through the mail or in person. All the material that would be brought to a gallery—a telephone call in advance to line up a few minutes with the dealer (or his or her assistants) is advisable—should be included in any package mailed to the gallery or dealer.

The postal route requires mailing slides of one's work (a sheet of slides holding as many as 20) along with a cover letter, résumé and any other biographical or artistic information, published write-ups of one's work, and a self-addressed stamped envelope. Since being in the right place at the right time is important, these packages should be

sent out periodically, as it is never clear when a dealer will be looking for new talent. Some dealers handle only twenty artists while others represent as many as two hundred.

If asked, galleries may return slides to the artist, sometimes months after they were originally sent in and looked over. Slides can be expensive, but they only do the artist some good if they are in the hands of the dealers or gallery owners who may at some point be in the market for new talent. Many artists choose not to ask that slides be returned.

While slide sheets are still the preferred method of presenting one's art, albums of photographs are becoming increasingly common. While juried art competitions specifically ask for slides, art dealers generally don't object to receiving albums, which shows the art larger and without the glare of a light source on the other side. Most reputable dealers own light tables, which they use when showing work to potential buyers. However, when faced with a new artist's work, many of them simply hold the slide up to an overhead light source for a second or two and move on quickly—obviously, craning one's neck and looking into a light fixture are not conducive to careful and long-term examination. Photographs, especially those in an album, are more apt to be looked at longer, and the album may be left open on the gallery owner's desk, enabling that person to take a second look. On an individual basis, photographs are less expensive to produce than slides, although the savings may be offset by the increased cost of mailing a bulky album to a dealer.

A larger question than whether to send slides or a photograph album is what the recipient wants. Artists should call or write the dealer (or gallery, corporation, art school, juried competition, or magazine) to find out what is wanted and when. Some dealers, for instance, only look at slides once a year—in the summer, for instance. Artists who send a packet of slides or an album of photographs to such a dealer in January and ask that they be returned within a month or two will miss the viewing opportunity.

Whether one uses slides or photographs to represent one's work and career, they should be made with care. A high-quality 35mm camera with a 50mm or longer lens (a wide-angle lens may cause distortion) should be used, set on a tripod (especially when shutter speed is below one-sixtieth of a second) to prevent accidental movement. Using a grey card when shooting slides of white-ground work is important, as is employing a black fabric backdrop, clean white wall, or white paper background to hang the work being photographed. The camera should be placed parallel to the work (to reduce distortion and blurring), and the alignment should be checked with a level on both the camera and the artwork. The photograph should be taken indoors to control the direction and distance of the light source. All natural light should be eliminated from the room so that the setup is the only light source. Tungsten light bulbs should be used for correct color temperature, set at 45° angles on either side of the flat artwork. The type of film should be matched to the light source, such as tungsten slide film (Ektachrome 64t). Of course, any protective glass should be removed from the framed artwork. If the work reflects light, one might use polarizing filters on the lights and camera, increasing the

exposure by 1½ stops to compensate for the camera filter. One also might experiment with the light source (diffused or aimed directly on the object, perhaps bounced off a white wall) to determine how the work being photographed looks best. It is a good idea to have copies of your slides and photographs on hand at all times, and usually it is less expensive and less time consuming to take the same picture more than once than to make duplicates. Of course, if it all seems overly complicated, you can hire a professional photographer (particularly one who specializes in this kind of work). That may be expensive, but it's worth it.

In addition, whether one submits a slide or a photograph, the artist should write on it his or her name, the title of the artwork, its medium and size. In general, 15–20 slides or photographs are the upper limit for dealers, corporations, or schools unless they specifically request more—juried art competitions specify how many slides they will look at. Dealers and corporations prefer to see an artist's current body of work and subject matter, with an emphasis on consistency, rather than a retrospective of your entire career. However, art schools are more likely to be interested in a more retrospective approach, as that indicates an artist's versatility and capability of teaching a wide mix of students.

Artists should prepare a package of information for the recipient that includes the slides or photographs, résumé (or list of exhibitions and critical notices), a "cover letter" that introduces the artist and mentions what he or she is looking for (gallery representation, a job, a commission), and a self-addressed stamped envelope. The return postage envelope is very important, as galleries are unwilling to spend money to return something that was generally unsolicited to begin with, and they also resent the artist's failure to include it. Unless a dealer agrees to hold the material for the artist, it is best not to drop off the packet and say, "I'll be by Wednesday to pick it up." That creates a storage problem for the dealer and increases the possibility of the packet being lost.

The more contained this packet is, the better, as a cumbersome package of loose clippings and other bits of information that are difficult to contain or to put into the return postage envelope makes a poor first impression. Many art dealers receive between ten and thirty of these packages a day; by necessity, they approach them hurriedly, and a messy, unorganized presentation engenders an irritation with the artist, which is a poor way to begin a relationship.

In addition to slides and albums of color photographs, other ways of presenting one's work may be considered. Color xerographic copies are often less expensive to make than additional copies from the photographic negatives, and the quality may be good enough—once again, find out what the recipient wants. Caroll Michels, an artists' advisor in Long Island, New York, recommends creating a brochure, with pictures of one's work and information about the artist, that may be sent along with a "cover letter that says, 'If you're interested, I will be happy to send slides.' You have to look at the initial outlay. The cost for each packet of slides and postage on the self-addressed stamped envelope is likely to be $15–25, while a brochure may cost 85 cents a copy. With a brochure, you save money on those who aren't interested in your work."

THE NEED TO SPECIALIZE

Artists not only make images but project to the world an image they create of themselves through their artwork. That is to say, we know artists by what they do. We say, she is a landscape painter, he is a minimalist sculptor, and we know that through seeing a body of work that allows us to identify their respective subject matter, style, and media. The more coherent the artist's work, the more easily we may recognize the creator.

To achieve that recognition, therefore, enabling a viability in the marketplace, artists must become specialists. The landscape painter must forego photography and performance art, the minimalist sculptor needs to spend less time with the rock-and-roll band and the theater company. Unfortunately, what makes sense in the market defies a basic element of creativity: Most creative people are interested in a variety of artistic doings, and choosing one that is more likely to earn them money and recognition may be a wrenching decision.

This is not to say that artists must be confined to just one type or style of work for their entire careers. Robert Rauschenberg's body of art, for instance, has included painting, sculpture, installations, and graphic prints; to say "I bought a Rauschenberg" necessarily requires some clarification. Of course, as an artist, Robert Rauschenberg has pursued a series of recognizable ideas through a variety of media, and those who collect the artist's work know him for his ideas—the stamp of personality he places on everything he creates.

The same cannot be said for Edward Betts, a painter who works in two completely different styles, large abstract acrylics and smaller, traditional landscape watercolors. "If I'm known for anything, it's for the abstractions," he said. The owner of Contemporary Arts, a New York City gallery with which he had a relationship, told him that "I could continue to do the watercolors if I liked, but it would be best if I used another name, Edward Howards or something like that." Another Manhattan gallery that handled his paintings, Midtown-Payson Galleries, "told me simply that they weren't interested in representing those works." In both cases, dealers were concerned that the watercolors might confuse buyers as to exactly what type of artist Betts is. As a result, he exhibits and sells the watercolors in galleries in his home state of Maine—"where there still is a strong demand for realism," he stated—and the abstractions in New York and other larger cities.

In a similar vein, more than one West Coast gallery owner has told Santa Monica, California, artist John White, "Don't let anyone know you do performance art." Distinguishing his art between "static work" (paintings, drawings, sculpture) and "nonstatic work" (performance art, video), he stated that, "to the gallery owner's mind, the fact that this isn't the only kind of art I do takes away some of the punch from the paintings, and the public thinks of performance art as suspect anyway."

At times, there is a direct connection between White's static and nonstatic art, as the paintings, drawings, and sculpture have served as stage sets for performances. Still, performance art traditionally has been antiobject, and pairing the two sometimes makes for an uneasy mix.

There are only so many hours in the day, and White had to give up the performances for a number of years in the late 1980s and early 1990s in order to make time for his studio work. Working in a number of different styles and media concurrently may reflect an active, creative mind at work, but real life often intrudes. Artists find that it is difficult to have more than one focus of their attention. They may become frustrated as they are pulled in different directions, and ideas, works in progress, and deadlines begin to pile up at the same time. Many artists find that, if they don't necessarily have to give up a certain portion of their artistic work, they may need to place it on a back burner for extended periods of time in order to produce the work that sells better.

Take, for example, Elizabeth Busch, whose first love is what she calls her "quilt painting," in which she paints a picture, cuts it up, and sews it back together in a different configuration, adding a variety of fabrics and other elements. These pieces have been exhibited in galleries in New York and California, with somewhat limited sales. Since 1990, the vast majority of her income has come from public commissions, in which she uses colored plastics that are cut into strips and hung from atrium ceilings. As with White, there are connections between the quilt paintings and the public artworks, "but the quilts are more personal, they come from a different part of me than the public art, which I think of more like an assignment," she said.

Busch called the success she has earned with public art pieces "a mixed blessing: It's how I make a living, and I have to live, but it doesn't allow me a lot of time to do the other work, which I really want to do."

Bonnie Bishop, an artist in Athens, Maine, faces an even harder choice in her career. Balancing graphic design, children's book illustration, and teaching with her primary art interest, book art, Bishop stated that "I struggle with the questions of, Am I doing too many things? When is the right time to do what?" She had worked full-time in graphic design at various companies, quitting that life to work at home and take graphic work and illustration on a freelance basis in 1992 in order to free up time for her book art, which has only had moderate success in finding buyers.

Making time for nonpaying work, however, has not been easy because she has to work harder to obtain freelance assignments, and "I have to do any graphic design that I get, because I have to make money." She fears that, within the next year, "I will probably have to give up the book art, because I need more than just the amount of graphic design work I am currently getting to help pay for it."

In most cases, the reason for choosing one style, medium, or subject matter is money. One thinks of artists doing what they do out of love and zeal; having to give up that work and devoting themselves to a type of art that may not interest them as much, as a result of market considerations, seems to defy why they became artists in the first place. Art skills are put to use, although they may be tangential to their main interest in art. On the other hand, artists who find something within their creative realm that earns them money may feel quite fortunate.

Over time, many artists learn these hard truths, or they may be told the same by artists' advisors. "You have to decide," Sue Viders, an advisor to artists, said, "are you

looking to please yourself or the marketplace? If your goal is to make money in the marketplace, eliminate the work that makes the least money." She noted that some artists may work in three different media, "but that requires you to have three different marketing plans, because painting galleries usually won't take your sculpture, and most painting and sculpture galleries don't handle photography. Also, do you have time to do all three media well? A problem I see is that artists get pulled in too many directions, and everything they do looks mediocre."

Another advisor, Susan Joy Sager, stated that "artists are not seen as serious by collectors and dealers if they do a lot of different things." She also pointed out that, when dealers or show sponsors are aware that an artist works in a number of different styles and media, they may be concerned that the artist will not have enough of one kind of work to fill the gallery (for a one-person show) or exhibition booth.

Artists, by nature, like to experiment throughout their careers, but collectors and dealers frequently view an artist working in more than one style at the same time as a sign that he or she hasn't yet matured artistically. Establishing a market for an artist's work is a matter of developing acceptance among would-be buyers. Art dealers spend a considerable amount of time educating their collectors about artists they represent and are loath to discover that one of their artists has suddenly changed styles, as that involves rebuilding acceptance.

"What I tell artists," Sylvia White, founder and director of Contemporary Artists' Services and the wife of John White, "is that they have to put all their eggs in one basket. In the same way that you don't send the same résumé out for five different job openings, but tailor the résumé for each particular job, artists have to decide, 'How am I going to present myself to this particular dealer?' Once the artists get someone interested in their work, once that relationship is secure, then they may be able to say to the dealer, 'Would you like to see some of the other artwork that I do?'"

THE VALUE OF A MARKETING PLAN

What if Jackson Pollock had developed and followed a "marketing plan," a step-by-step program for projecting income and expenses, finding exhibition spaces and buyers? Would he still have taken that stick, dunked it into the can of paint, and waved it at the canvas?

In Pollock's day, there were so few galleries and buyers of contemporary American art as well as fellow artists supporting themselves from their work that he may be forgiven his lack of planning. An artist's marketing plan—a term and a concept borrowed from the business world—depends on a certain degree of predictability: that there are collectors who will buy, that there are various options available for showing work and earning money, and that one's personal and professional life are under control. Today's artists see many of their kind earning a living, perhaps a substantial living, as stiff competition. Finding one's place in this new world, the art business, requires an understanding of the entire market, a sense of how to achieve one's goals and, perhaps, a marketing plan.

Marketing plans may be quite grand, encompassing a number of years, or relatively small, focusing on a particular event, such as a single exhibition. These plans are promoted by artists' advisors, career counselors to artists, who give the term their own individual meanings, but in all cases "the point of a marketing plan is to commit to paper a plan of action for an artist," according to Sue Viders. "You develop a plan—'I am going to get gallery representation for my work'—and then break that down into subgoals: get a portfolio together; get names and addresses of galleries showing the kind of work I do; budget money for postage and printing. From there, you assign yourself small tasks, so that the whole thing doesn't become overwhelming, such as spending an hour in the library looking at art magazines and finding a photographer to take slides of your work."

Even small marketing tasks may seem overwhelming to artists who prefer to be discovered than to assert themselves and face the possibility of rejection. Making art is more pleasurable than locating the names and addresses of galleries and, if the studio work makes one lonely, there are exhibition openings and other social activities for compensation. "There are a million other things you can do to avoid developing a marketing plan," said Calvin Goodman, an artists' advisor whose book, *Art Marketing Handbook*, contains nineteen separate marketing plans, "but, eventually, artists get tired of filling up storage space with artwork that isn't sold. The artists who moan and groan the loudest about how no one wants to buy their art tend to put the least amount of energy and discipline into marketing their work. I tell artists all the time, there is no fairy godmother who will magically do it all for you."

There are marketing plans for all stages in an artist's career. For the emerging artist, the plan is likely to focus on how to get started, finding a gallery or being accepted into juried shows. Morris Meyer, for example, a painter who works full-time as a mechanical engineer in Columbus, Ohio, noted that "part of my marketing plan—if you want to call it that—is building a name for myself as an artist and getting exposure."

Working with Calvin Goodman for the past few years, he has developed a strategy of entering, and perhaps winning awards at, regional and national art competitions (such as Audubon Artists, Midwest Watercolor Society, Rocky Mountain Water Media, and Watercolor USA, among others) as well as selling work at outdoor art shows and through art galleries. Claiming that he paints slowly, Meyer stated that he earns between $2,000 and $3,000 per year for his art from sales at outdoor shows and at the competitions. Over time, he hopes to sell more artwork and, when he retires, open his own art gallery.

"Calvin tries to channel my efforts into areas that sell," he said. "I'll send him a photograph of my work and he'll tell me, 'You should have added this' or 'You should have done that.' There was one painting, a picture of a building in the Universal Studios lot in Orlando, Florida, that he told me to muddy up the foreground and tone down the colors, in order to make it look older. With other paintings, he has told me to add a person here, eliminate the telephone pole there, change this or that. Calvin's not an artist, but he knows what sells."

Not all artists' advisors take such an editorial role in their clients' artwork, although they all stress finding the most appropriate buyers or how to make the art more marketable. For Sue Viders, the key ingredient is determining what the market wants to see and paint accordingly. "It comes down to the question of why are you creating art?" she said. "Are you only trying to please yourself because, if you do, you have to find people like yourself in order to sell your work. Or, if your aim is to sell your work, you have to find out what the buying public wants, likes, and needs."

If emerging artists need a marketing plan in order to get a foothold in the art world, more successful artists are likely to use a plan for expanding their markets, budgeting, and time management.

"I lay out my plans in November and December for the following year," said Karen Vernon, a painter in Houston, Texas. "I ask myself, how much money do I want to make for the year, then divide that into the months, the weeks, and days. I see what I have to produce every day. Say, I have to produce $3,000 per day. Then I ask myself, how do I get there." Her computerized marketing plan is filled with projections of revenues and expenses, based on comparisons with the year, quarter, or month before.

Vernon has four different ways of marketing her work—at street shows and malls, through gallery sales, at trade shows, and through a print publisher—and produces approximately seventy-five original paintings annually. In years past, her output was closer to 150 paintings per year, attending as many as forty-two street and trade shows annually. However, following her plan, she has cut back the number of shows to between twelve and fifteen per year while increasing her income.

Vernon keeps a red folder in her desk for all the show application forms she receives. On the first of every month, she looks at the folder to see which applications are due that month and which shows (based on sales figures stored in the computer) are worth entering again.

"I look closely at each of my four avenues and try to expand it," she stated. "For instance, I want to go from having six galleries showing my work to eight, and I make sure that all my galleries are selling enough of my work. If they aren't, I'll take my work to a better gallery. Also, I have to figure out how many gallery shows I want for the year, and I'll send a letter to my galleries saying, 'These are the dates I will be in the area and can appear for openings in the coming year.' I let them scramble to schedule my shows."

Most artists create alone, sending their work out into a void: Does anyone care for my work? Is it art? These questions are rhetorical and, anyway, not for the artist to answer. It is buyers who determine what is or isn't art, fixing the issue of quality with the amount they pay. Artists have no control over what collectors, critics, curators, dealers, and publishers may decide. Marketing plans, however, are a form of empowerment for many artists, enabling them to not only control the product but the way the product is presented to the world. Psychologically and literally, it also allows them to look ahead, past the vicissitudes of individual tastes, periodic (or frequent) rejections, and often tedious chores, to a time of greater achievement and recognition.

Few artists go hungry and unrecognized by choice, although the romanticized image of the pure, starving, bohemian artist lingers on. According to Calvin Goodman, "every successful artist I've ever met or read about had some plan for achieving that success. Even with someone like Jackson Pollock, you find that everything he did in life was unconsciously well-planned. He moved from Wyoming and Los Angeles to New York, where he could learn to paint the way he needed to, studying with Thomas Hart Benton. I don't think that was accidental. He found the best way to market his work was to socialize with people who would buy his work and represent him to the public. That wasn't accidental either."

GETTING READY TO EXHIBIT

What art should cost and how it should be presented are matters that only its creator can decide, sometimes in consultation with a dealer, but these decisions affect others as well. Sculptor David Smith defied his dealer by keeping prices out of reach of all but his most ardent and well-heeled admirers—a scornful attitude to a world that he believed had ignored and disdained him for too long—and it resulted in very few sales during his lifetime and great misery for his heirs and the executors of his estate immediately after his death. Joseph Cornell bought dime-store frames for some of his works, giving them a sort of mock-elaborate quality, and it turned off some potential buyers.

Artists can clearly be quirky, which may or may not work to their benefit, but most prefer not to do anything that will harm the possibility of sales. There are no hard and fast rules to pricing and framing, but there are ways of playing it safe.

Pricing Artwork

Deciding what price to put on artwork is one of the most difficult problems for lesser-known or "emerging" artists, since there is no obvious point of reference. (Artists who have had a history of sales, on the other hand, will have a better idea of prices that are more suitable for particular buyers.) The best way to establish one's market value—the price a collector is likely to pay—is by going to art fairs, art galleries, and other places where artworks of comparable size, imagery and quality by artists of similar standing in the art world are sold. Those prices should offer some guidelines to what an artist may charge for his or her works. One should never ask prospective buyers what they would pay for art; that is the artist's decision. One may have some flexibility in this, perhaps offering a discount of, say, 10 percent for collectors who like to negotiate, but the pricing decision should never be taken out of the artists' hands.

Discounts can be tricky, since there is great potential for situations to get out of hand: If an artist offers a discount to one collector, word may get around and every potential buyer may not only ask for but demand the same or better discount; if an artist negotiates a discount with a collector in front of other people but the sale never takes place, the artist may look a little foolish and even desperate. Artists should prepare themselves for these conversations with would-be buyers, steeling themselves to say (for example) that the stated price is the actual price. If a collector says that So-and-So

Artist, whose work is similar to yours, lowered her price so why won't you, artists will need to remember that not all art is interchangeable and that those buyers who want a work badly enough will pay the asking price. An artist might say to a discount-seeking collector, "I'm not going to lower the price, but I will throw in a brochure and a personal invitation to my next exhibit." (One may be tempted to say something catty, such as "If saving money is your goal, she probably is your kind of artist," but that could embarrass and offend the would-be buyer and poison relations with another artist.)

It is often the case that an artist looks to price items in such a way as to achieve a certain per hour wage, and some attempt to develop a complicated equation that includes cost of materials, rent, utilities and labor. Such an equation, and a final price for a given object, may exist somewhere, but it does not (and cannot) reflect the market, especially for someone who is new to the field. One artist's painting should not be priced twice as high as everyone else's, simply because either that artist's rent is high or he or she doesn't want to feel like a slave. The reasonable price needs to be established first, and all other related expenses need to be adjusted accordingly—if one's rent is too high, find a less expensive studio, for instance. If an artist cannot bear to part with a particular work for a low price, he or she shouldn't sell it.

Of course, prices for works will vary greatly from a small town to a major city. An artist whose market is (or is more likely to be) smaller town collectors would want to set prices at the level of those buyers. Similarly, for those artists whose goal is to be represented in the larger urban center, those city's prices should determine value. However, the prices an artist sets should be uniform, as dealers in cities won't want "regional pricing," that is, having the same works sold more cheaply somewhere else. Artists should feel confident that collectors everywhere will pay what something is worth, if they want it enough.

When a work is sold directly by the artist to a collector, the artist should create two copies of a bill of sale, each listing the buyer's name, address, and telephone number; the title of the artwork; and its dimensions, media, and sale price. One copy of the bill of sale should go to the buyer; the other to stay with the artist. The artist's sales record is important for tax preparation, and information about the collector will be useful to have when sending out announcements of upcoming exhibitions.

Raising prices becomes justified as one's market grows and a heightened demand for a fixed supply itself gives the sought-after works increased value. Consider the case of Scott Fraser, for example, a painter in Longmont, Colorado. His paintings were first shown in an art gallery in Denver and sold for $300 in the early 1980s. Some sales took place and, the following year, his prices went up to $900. The value of his work continued to rise, to $1,500 and beyond; at present, an average oil painting sells for $7,000, with some works fetching as much as $20,000.

"Each time you make a jump in pricing, you have to get a new set of buyers," he said. "I've lost some of the people who bought my work in the early years, because they can no longer afford me. Every time you break the couple of thousand dollar barriers with your prices, you have to look to get new collectors."

For Fraser, the plan for attracting new buyers involves keeping in touch with current collectors by letter ("I write to them, telling them what I'm working on, when and where I'm having a show") and also writing to potential buyers when "a lead" is mentioned to him, either by a friend, associate, or dealer at one of his galleries. That letter usually includes a biography, slides of his paintings, and a statement about his artistic purpose, as well as some mention of the person known in common (who gave Fraser the "lead" in the first place).

For other artists, raising prices may require finding another gallery or dealer, where opportunities for having works purchased by collectors who will pay more or lend enhanced prestige to the work are greater. Some dealers may be able to work only with emerging artists and not have the contacts to help an artist who is selling work steadily. Changing galleries may be a difficult decision for an artist who got his or her first big break with a particular dealer, and it can be doubly hard in the art world because the relationships between artists and dealers often are on a personal, friendship level.

The issue can be discussed with other artists, some of whom may have experienced the same situation or might facilitate an introduction to their own dealers, or by directly making contact in one form or another with a dealer whose gallery and contacts better reflect the artist's current situation. Networking, passing on information, and using the "favor pool" are the most common ways for artists to advance their careers.

"You have to be discreet when you're looking for a new dealer," painter Nancy Hagin said. "Dealers certainly don't like it if you bad mouth them but, of course, why are you shifting and looking around if you aren't unhappy?"

Hagin noted that she "sniffed around . . . put out the word that I was looking for other representation . . . talked to people who knew me and knew which dealers were looking for what" and, finally, found the right match. She had been represented since 1973 by New York City art dealer Terry Dintenfass and found, "I got a fair number of sales, but I didn't get a lot of shows and the prices were low."

She began sending out announcements for her shows at Dintenfass to the director of New York City's Fischbach Gallery in the late 1970s, later adding a note "that said, in essence, I was restless and had a body of work ready to go. Would he be interested in talking?" The Fischbach Gallery, as it turned out, was happy to represent her work. At the outset, she requested a show every two years, higher prices for her work, and faster payment, all of which she obtained.

"Fischbach doubled my prices immediately"—from $2,400 for a $4' \times 5'$ picture to $5,000 and up—"and began paying me monthly installments instead of in one lump sum, which is a lot better for me," Hagin stated.

To Frame or Not to Frame

It would be easy to say that most contemporary painting seems to call for relatively simple, unadorned frames—New York City's Museum of Modern Art thinks this way, having reframed a large portion of the works on display in solid metal frames—but many works look even better in a fancier casing and sometimes the frame becomes an integral

part of the artwork. Picasso sometimes placed his own paintings in seventeenth-century Dutch frames, which not only worked aesthetically but also fit his overall concept of viewing each piece as within an artistic tradition.

Inappropriate frames—those that seem to clash inadvertently with the picture—may turn off the person looking at the art, who, at best, will try to edit out the frame mentally. Many dealers report that badly stretched and poorly framed paintings work against the artists seeking sales and representation.

Not all pictures need frames all the time; frames usually are required when the works are being moved around (corners and edges may otherwise get banged up) and when they are being displayed. Diane Burko, a Philadelphia painter, said that she some-times exhibits her work unframed—to emphasize the edges in her all-over style of work—and other times framed. "It depends on whether the work is going to be travel-ing," she noted. "If the pieces are just going to stay in the gallery, I may leave them unframed. If they are going to travel to other galleries or to another city, as some shows of mine have done, I generally put frames on them for protection."

Another reason to keep works unframed or not to spend much money on the mat-ting and framing is that a potential buyer may like the picture but not the frame, finding that the frame doesn't go with the decor in his or her house. "Some people like to do the framing themselves and they may not like the mat and frame that the artist put on it," said Carol Becraft, customer service manager at Westfall Framing in Tallahassee, Florida, a mail-order frame company. "It's better for artists to keep it simple and inexpensive."

Others note that many pictures don't look complete without a frame and find that an attractive frame can help sell the work. The prices of frames vary widely, based on whether the artist plans to fit a picture into an existing frame, whether the frame has to be built to a special size and whether the artist does the work him- or herself or uses a frame shop (these range widely in services and quality), which will do the entire job of matting, framing, and setting behind a protective glass (possibly costing hundreds of dollars).

"It depends on where you're showing the work," Ronald Cohen, manager at MADD Frames in Philadelphia, which provides frames for a number of galleries in that city and Manhattan, stated. "The air of certain better galleries just seems to demand a high-quality frame while, probably, a nice frame doesn't matter so much at an outdoor art show."

Artists who are unsure how best to frame a particular work may want to ask their dealers or show organizers for some advice, if their good favor is important to the artist, or check with a museum curator. In the past, dealers automatically took charge of fram-ing the pictures that were going on display; now, fewer gallery owners are willing to pick up that tab. Dealers nowadays, however, still want some say over what kind of frame is used even when they don't (or only partially) reimburse the artist for the expense.

In many cases, the gallery look in frames is stark and clean, made of thin pieces of hardwood (stained or varnished) or metal (black, silver or, rarely, with a gold color), and many artists lean in that direction. One of the simpler types of framing that is increasingly being recommended is a casing of four thin strips of lattice wood (one-

eighth to one-quarter inch thick). Frequently, artists will also place another (although thinner) four strips of lattice wood between the outer perimeter of the picture and the strip frame. Those thinner strips are recessed (and sometimes painted black or some other dark color) in order that the paintings seem to "float" within the frame, and the distance between the picture and the strip frame keeps the artwork from looking visually compressed.

More expensive frames may or may not also have some sort of protective glass in front—that decision is usually based on how sensitive the artwork is to light and dust. Plexiglas or ultraviolet Plexiglas, which filters out the most harmful of the sun's rays, is frequently used, although it is considerably more expensive than regular clear glass. Ultraviolet Plexiglas may be as much as ten times more costly than regular glass and it scratches easily. The major benefits of Plexiglas (either regular or ultraviolet) over glass is that it is more shatter resistant and doesn't carry the slightly green tinge.

Some artists use different types of frames for different kinds of artwork. Larger paintings may be given strip frames, partly because this is less expensive than buying big frames and, partly, because the paintings get pushed around and bashed a lot in galleries. An important consideration is that an artist may spend $200 or $300 for a nice frame and find that it gets damaged by the gallery, forcing the artist to pay to reframe it when a buyer decides to purchase the work.

Smaller pieces, on the other hand, may seem to call out for a real frame of some sort. Works on paper are almost always framed for their protection, with a protective glass (Plexiglas) in front, although the work should never touch the glass itself but be separated from it by an acid-free mat. The backing for a work must also be acid-free, not cheap cardboard and not wood. Paper can easily absorb resins, pollutants, and acids from its backing and mat. The only time never to use Plexiglas is for a pastel drawing. Plexiglas has a static charge that acts like a magnet to draw dirt and dust to it. Pastels, which have a chalky consistency, can be problematic as the glass would tend to pull the medium off the paper.

With works on canvas or panels, the fragility of the surface of a painting may become a consideration in the decision of whether or not to frame. Of course, the framing question may be less pressing for artists whose work is generally the same size from one picture to the next, since if one buyer wants the art but not the frame, the frame can be reused for another painting.

ARTISTS WHO WORK AT HOME

If Barre Pinske, an artist in West Barnstable, Massachusetts, decided to paint a picture in his own garden, would it be in violation of the town's zoning restrictions? West Barnstable's home occupation ordinance permits artists and other entrepreneurs to operate a business out of their own homes in a residential neighborhood "if the business has no employees, if there is no sign, if it doesn't create traffic problems, if you can't tell it's a business from the outside, and if it doesn't produce a lot of noise and bother people," said Ralph Crossen, the town's building commissioner.

Pinske's work, painting but predominantly sculpture, bothers a neighbor who has repeatedly contacted local, state, and federal authorities about the noise and visibility of the art. As a result, the artist has been cited by the town's zoning board "and told to cease all artwork production outside" one of the buildings on his property, Pinske said. "Any one of my neighbors, who aren't artists, would be allowed to paint outside because they are hobbyists. But, because I am a professional artist, if I did it I would be in violation of the zoning board."

Most artists are probably more discreet than Pinske, who once put an eight-foot sign with the word "Aaaaaahhh!" out a window of his house as an artistic protest against domestic violence (resulting in his first citation), but many more are likely to face questions from town and city officials about their ability or right to work in their homes. Home occupation ordinances exist in the majority of towns and cities of the United States, but there is a greater effort at present to require home-based entrepreneurs to take out a license and pay business taxes. "Cities are looking for additional revenue sources, and permits, licenses, and business taxes for home businesses may be for cities the growth area of the future," said Fay Dolnick, a researcher at the Chicago-based American Planning Association.

Anyone with a home-based business should assume that he or she may need to get a permit from the town or county, according to Raymond L. Boggs, director of home office research for IDC/Link, a private research firm in New York City. The zoning board for the jurisdiction will state the requirements for operating a home business, and the fees and requirements vary wide from one municipality to another. Those who earn under a certain amount of income (under $5,000) or whose work is not likely to create traffic or noise in the neighborhood (such as a writer or painter) may not need to obtain a license in some towns but are required to in others. "Some cities don't care if you make or lose money," Boggs said. "They just want their license fee." Yearly permits and licenses to operate a home-based business cost between $25 and $200, and taxes range from $1 to $6 per $1,000 in gross income. A certificate of occupancy may also be required for those taking a deduction for a home office (for instance, a studio) on their income taxes.

There are believed to be far more people who earn their livelihood from a home-based business than pay the necessary permit fees and taxes or follow zoning regulations required by the jurisdiction. According to the U.S. Bureau of Labor Statistics, more than 21 million people in nonagricultural industries are doing work at home for which they are being paid, although perhaps half of them are simply taking work home from the office. Between 11 and 12 million households rely on a home-based business as a primary source of income. This total number has grown steadily during the 1980s and 1990s, "brought about by economic downturns that eliminated jobs for white-collar positions in companies and aided by the use of computers, which has enabled people to do all the same types of work they did at an office but now at home," Dolnick said.

Home occupation ordinances are used to control the negative impact on residential neighborhoods. Numerous deliveries (especially those involving large trucks) and vehicular traffic (employee parking or clients coming throughout the day to a psycholo-

gist or accountant, for instance), as well as the use of loud machinery or toxic substances (such as those used in automobile servicing) create a burden on neighbors whose quality of life is adversely affected. These ordinances often stipulate that the home-based businesses have no employees (or, perhaps, just one or two employees) outside the family, that the activity poses no danger to the community (such as animal training or gun sales), that clients are permitted only by appointment rather than as walk-ins, and that the work involved takes up no more than between 25 and 50 percent of the space in the home.

Another stipulation is that signs not be placed in sight of neighbors, which proved a stumbling block for Upper St. Clair, Pennsylvania artist Nancy Bellamy, whose 4' × 8' painting of butterflies placed on her lawn was cited by the town for being a commercial sign in a residential neighborhood. She was told to remove the painting within five days or face fines up to $300 per day. The Pittsburgh chapter of the American Civil Liberties Union represented Bellamy in her dispute with the town, claiming the work is a work of artistic rather than commercial expression.

"If I had a sculpture on my lawn, there wouldn't be any problem," Bellamy said. "But, because it is a painting and I happen to have painted it, it is being treated as though it were a billboard."

Pinske's fiberglass sculpture, carved by a gas-powered chain saw and a sandblaster, created noise and dust that irritated neighbors. In most instances, however, "problems occur when there is an unrelated problem with a neighbor about the dog that got loose or the window that your child's baseball broke and the neighbor decides to also inform on you about operating an unlicensed business in your home," said Joshua Kaufman, a lawyer in Washington, D.C., who represents both visual and performing artists. One of his clients, a puppeteer in Maryland who worked out of her home, was sued by a neighbor for a matter unrelated to her puppeteering. Kaufman advised her to get a permit for her work shortly after the suit was filed, "because we didn't want opposing counsel to hassle her, report her to the county or to the IRS."

Some activities are more likely to reveal that a business is being operated than others. "Building a kiln in your backyard is different than painting in your den," Kaufman said. Knowing when to contact local authorities is not always clear to many artists and entrepreneurs, who often start out casually as hobbyists rather than with the expectation of earning all or part their income from their work. "At what point do you cross over?" Boggs said, adding that if their earnings are small or they use a residential telephone for business or they do not deduct business expenses, artists may or may not need to obtain a permit, depending upon the jurisdiction.

"It's advisable to know what the local law is," said New York City attorney Barbara Hoffman, who represents a number of fine artists, "but compliance is another issue. Do you really need to comply with a law that no one remembers enacting and that no one bothers to enforce?" Artists may see themselves as having a choice whether or not to obey an ordinance, or obey it while seeking to overturn it—after a period of advocacy and lobbying, artists in Chicago, Illinois won the right to be exempt from the city's home office ordinance.

Compliance may have its drawbacks for artists, because they are entering an indeterminate relationship with a government agency. Mark Ryavec, a lobbyist for the Writers Guild of America, which successfully brought a lawsuit in 1997 to force the Los Angeles City Council to rescind a requirement that artists and writers pay a $25 city permit before working out of their homes, noted that licensing creates privacy concerns. "Their names and addresses, which wouldn't otherwise be public, end up being on a city register," to which many people have access, Ryavec said. This was of particular concern to many Hollywood screenwriter members of the Writers Guild, "who were concerned that stalkers and other criminals could get their addresses," he added.

As in any other business, artists might be required to post their business licenses prominently where they work, and they are potentially subject to unannounced inspections of the workplace in order to ensure compliance, reviewing one's documents and records at the same time. Artwork that is deemed pornographic by a city inspector might be subject to a municipality's adult entertainment laws, "which gives cities a say in what artists do, making this a first amendment issue," said Brian Zick, a graphic artist in Los Angeles who was involved in the effort to eliminate the permit requirement. "Just giving an official the right to deny a license to someone is an unconstitutional bar on free expression in your own home."

The penalties for noncompliance are perhaps as varied as the home office ordinances in existence around the country. According to Kaufman, a fine may be as low as $25, "or it can be a misdemeanor—a thousand dollars and a year in jail, although I doubt there are any cases in which an artist has been thrown in jail for not having a license to paint in his home." He added that the costs of noncompliance may add up "if an artist builds a studio and then gets told that the studio is illegal and can't be used. Town officials may fine an artist again and again or get an injunction against the artist." A legal problem may also arise if an artist deducts home office expenses for the IRS while claiming to the town that the art is only a hobby to avoid obtaining a license or certificate of occupancy.

PURSUING A CAREER IN THE STICKS

It's not easy for artists anywhere to develop their art and promote their careers but, at least in larger cities, the recommended road to success is better marked. There often are a variety of art spaces in these cities where artists may show their work, hoping to attract buyers and opportunities to exhibit in more prestigious commercial galleries.

Again, that's not easy but it can be done. The problems of exhibiting and marketing artwork, however, are magnified with artists in rural areas. Often, the community has a dearth of interest and art galleries, few places to find certain art supplies as well as basic information about opportunities for artists, a lack of peer feedback or support, and discrimination against artists both within the rural setting (where they may be viewed as oddballs) and in the larger cities (simply because the artists live in the boondocks).

These artists have chosen where to live—because they like the location or the people—over where best to advance their careers, but that choice makes other decisions for

them. It may be less possible for those with no established clientele to avoid being a major participant in the marketing of their work, such as taking part in outdoor art shows, sending out brochures with photographs of new work, organizing local exhibitions, and otherwise being active and visible in the community.

Sculptor Larry Ahvakana and his wife, for instance, live in a Native American settlement in Suquamish, Washington, because "I believe in being close to my roots," he said. The price of that belief is having to travel between 6,000 and 7,000 miles every year to show or bring his work down to the art galleries in Arizona and California that represent him. (When he brings work to his gallery in Alaska, add another 3,000 miles to the total.)

"I certainly couldn't sell any here, even to the people who come during the tourist season, and support myself," he stated.

Covering vast expanses in the American West is not the only concession he makes to living away from cities and his markets. Buying the materials in Seattle for his wood and stone sculptures and transporting it back by ferry across the Puget Sound is an all-day affair, and the problems of shipping work from Suquamish in general have led him to downsize his pieces and concentrate on smaller wooden carvings.

Living in Redway, California, 250 miles north of San Francisco, affected the artwork of painter Peter Holbrook. "It is so much trouble to mail canvases out of here and so much easier and cheaper to send out a watercolor, that I largely gave up on oils and stayed with watercolors," he said. "The companies that are able to transport art are not convenient, and it was just a nightmare experience the time I tried to get a van to move a big canvas. They didn't send, or they didn't have, a big enough truck and, if you want to ship a big painting, you have to build a big crate. You can end up spending half your life building crates."

Another watercolorist, Larry Kent Stephenson in Ponca City, Oklahoma, also chose his medium based on living where he does. Stephenson doesn't ship his work far—most of his sales are to collectors in Oklahoma or Wichita, Kansas (90 miles to the north)—but, "for buyers in Oklahoma and Kansas, you have to sell your work for less than you might get in, say, New York or Chicago. You have to think about a painting's marketability. Watercolors are spontaneous and don't take a lot of time and, because of that, they can be priced for the buying public here. An oil painting or an egg tempera is more time consuming and, for the money, I can't afford to do them like I can the watercolors. That's really how I decided to concentrate on watercolors."

Few artists living in outlying areas find that they can simply retire to their studios in order to create without a thought of where to show and sell their art. Some discover that teaching art itself brings them local attention, which may eventually be translated into a sale at some point in the future. Lillian Montoya of Rocky Ford, Colorado, for example, holds demonstrations of oil and watercolor painting techniques at area libraries and local clubs, which helps make her own work better known and occasionally leads to a sale. "What you're doing is advertising yourself," she said. "You can't be a hermit out here."

Others become aware that the solitude of an area where neighbors may be miles away and don't just drop in requires greater discipline and stick-to-itiveness on their part. Many join clubs and artist membership organizations as well as get on the mailing list of the state arts agency, which sends useful information about art competitions and news in the field.

Through participating in juried art shows sponsored by the New York City–based American Watercolor Society, the Los Angeles–based National Watercolor Society, and the National Academy of Western Art in Oklahoma City, Oklahoma, Gerald Fritzler of Mesa, Colorado, was able to find a gallery to represent his paintings. Mesa, whose population, Fritzler said, "takes up a page-and-a-half in the phone book," wouldn't be able "to support me for a week."

Juried competitions are coveted events among rural-based artists, exposing their work to a wider audience and allowing them to both examine the current work of their peers and learn from friends and other contacts at these shows where opportunities exist. Networking and meeting prospective buyers and art dealers wherever possible becomes an important part of their lives.

It is especially important because there may be few peers from whom to receive comments and advice about one's artwork. Noting that "people look at me strangely here when I mention that I'm an artist," Richard Copland, a painter and sculptor who lives outside the small town of Billings, Oklahoma, stated that "I've never had a discussion with anyone around here about what I do."

Stephanie Grubbs, a fiber artist in Purcell, Oklahoma, also said that "there are no other fiber artists in Purcell, and I guess there aren't any artists of any other sort here, either." She belongs to a fiber artist group in Oklahoma City, however, and travels there once a week for meetings.

Artists residing in rural areas and conscientiously seeking to promote their work live where they do by choice. Their need to travel often great distances (frequently measured less in miles than by the number of hours in the car) certainly makes them aware of the career opportunities and benefits of living in the larger cities where there is more of a market for art, more and better feedback on their work, and fewer difficulties in purchasing supplies or shipping art.

"As long as I can make a living selling work in places where tourists and collectors go to buy art," Gerald Fritzler said, "it doesn't matter where you live, and I love living here."

2

DEVELOPING RELATIONSHIPS WITH ART DEALERS

Success for an artist is measured over a long period of time, while a big career break is an event. Without some type of break—an important exhibition, a major write-up, a sale to a renowned collector, a grant from a foundation, low rent on a studio, a word of encouragement from a well-placed source, among other possibilities—success is less likely to occur. This big break increases the name recognition for an artist among potential buyers and makes his or her art seem especially current ("He's hot!").

To the minds of many, the most important breaks are those that give artists and their work wide and (we hope) positive exposure. In a world where there appears to be an oversupply of artists, you need to stand out from the crowd and receive recognition. Will artwork that shocks the public or blocks traffic do the trick?

It is not always clear at the time, however, which events are the big breaks and which perhaps will be interesting footnotes to a career. An innocuous-seeming encounter may later result in great things, while a presumably significant honor—say, a major museum acquiring your artwork—could have no discernible career benefit. And, when it is a big break, how does one take fullest advantage of it?

FINDING REPRESENTATION

For many artists, having a third party (someone other than themselves, such as an agent or dealer) speak on behalf of their work is a major stepping stone in their careers. Someone not only says that he or she appreciates the artwork but will make an investment of time, space, and money to promote and sell it. The artist's time is freed to create more work, which now merits the attention of the mainstream art world (artists who sell work on their own are rarely reviewed in art periodicals). For others, a middleman lessens the relationship between artist and buyer, resulting in an increase in prices and fewer sales.

Art Consultants

That middleman can be an agent or representative (see "Artist Representatives" in chapter 5), an art consultant, or a dealer (or gallery). At times, art consultants are gallery owners and even museum curators who advise individuals and companies in the area of decorating or building a collection on the side. Those who are free agents, serving only the interests of their clients, generally don't have galleries and don't represent particular artworks or artists; rather, they tend to work from their offices or homes, maintaining information (bios, slides, press clippings) on a variety of different artists whose work may be of interest to particular clients. Some focus exclusively on contemporary art—works created by living artists—while others will hunt through all styles and periods, depending upon the interests and budgets of their clients. "Our criteria for selection revolves around our clients' tastes," said Josetta Sbeglia, a consultant in St. Louis, Missouri. "We hope we like it, too."

Consultants learn of artists in a variety of ways: They attend exhibitions at galleries, as well as at art fairs and juried competitions; they receive recommendations from other artists; they go to "open studio" events; and they are contacted directly by the artists, through the postal service, telephone, or e-mail. Some consultants encourage artists sending them material, while others do not—it makes sense to inquire by telephone or letter what, if anything, a particular consultant is interested in seeing before mailing a portfolio. Lorinda Ash, a New York City art dealer and consultant, said that "I get phone calls, FAXes and slides from artists all the time, but that's not how I ever become interested in an artist. I find artists through going to galleries." On the other hand, Jennifer Wood-Patrick, an art consultant at the firm of Art Advisory Boston, welcomes receiving material from artists but notes that "we have a limited amount of time for telephone conversations and sorting through packages sent by artists. I much prefer when artists e-mail us about themselves and include images. It's a lot faster and a lot easier for storage." Lester Libo, an art consultant in New Mexico, solved the storage problem by scanning the artists' images that he is sent into a computer, which is then recorded on a compact disc. Since he works from an office in his home, Libo makes presentations at the home or office of a client using the CD with a Kodak player hooked up to a television.

The relationship that artists develop with art consultants can be long term and lucrative. During the 1980s, New York City painter Joseph DeGiorgio was contacted by various consultants who had seen his work in New York gallery exhibitions ("I never called any consultants. They called me," he said). Many consultants from around the United States come to Manhattan to look at galleries and make notes on artwork that may be suitable to client interests and needs. For DiGiorgio, these consultants arranged both purchases from his studio and commissions for new pieces. "I was getting these gallery shows, but not making much money from them," DiGiorgio said. "Three quarters of my income came through consultants. The same people who might have seen my work in a gallery now became quite interested in buying it when a consultant pointed it out to them."

Another painter, William Barron of Falmouth, Massachusetts, specifically chose to market his work through consultants, having been represented by galleries here and there. "I've done all right with galleries, but not as well as with consultants," he said. "Consultants bring stuff to clients—clients don't have to go anywhere—and these are people who have money and are ready to buy something. My galleries couldn't get these people to look at my work, but consultants have. Consultants work harder for their money and take a smaller commission, too." To satisfy the "ego thing of having a show," Barron created his own gallery in Falmouth in which to maintain an ongoing one-person display of his work.

There is no association of art consultants, but many of them advertise in *ARTnews* and *Art in America*, and the galleries identified in *Art in America's Sourcebook to the U.S. Art World* are coded to indicate those in which the dealers also offer private consulting. *ARTnews's International Directory of Corporate Art Collections* ($109.95, which can be ordered from *ARTnews*, 48 West 38 Street, New York, NY 10018, 212-398-1690) is another useful source of information, as it notes who is the art consultant for each collection. James Cavello, a consultant with Corporate Art Associates in New York City, noted that "some of my clients and some of my artists have found me through the Yellow Pages." Obviously, some people who call themselves art consultants are going to be more effective in garnering wealthy clients and placing expensive art than others. In the who-you-know and who-knows-you art world, it is important to determine a consultant's reputation through word of mouth, such as from artists whose works have sold, experienced collectors and dealers.

Art consultants who are also gallery owners may primarily look to sell artworks that they own or have on consignment; in that case, the consultant or dealer will receive the customary commission. Consultants who are not otherwise dealers do not purchase artworks or take pieces on consignment. Instead, they make a search of appropriate art determined by the client's needs and interests (size, subject matter, colors, price, medium, style) and make a presentation to that person of eligible pieces. In some cases, the client will be brought by the consultant to a gallery or to the artist's studio to make a selection firsthand, and usually the client will pay for the work, not the consultant. The client may also choose to commission a new work from an artist, which increases the contact between the two even more.

The studio visit will be directed by the consultant, but the underlying purpose is for the artist and client to meet, requiring the artist to be tolerant, friendly, nonjudgmental and responsive to questions. DiGiorgio noted that visits to his studio by corporation executives "can be very comical in a weird way. The big honcho would say, 'I like it,' and everyone around him would agree emphatically. If he says, 'I don't like it,' everyone would shake their heads. These guys can be so full of themselves, and they're supported by those around them. Should I nod and shake my head, too?"

The consultant's commission may range widely, from 10 to 50 percent. The commission tends to be smaller if the consultant has found work represented by a gallery, because the gallery and the consultant will be splitting the regular commission (the

artist doesn't earn any more money, but the gallery keeps less). The consultant's percentage is likely to be higher when a new work is commissioned, although the exact amount is often negotiable with the artist. In general, an art consultant should not take as large a commission as a dealer or gallery, because the consultant has not made the substantial investment in the artist's marketing (putting on exhibitions, promoting the artist) that the dealer has.

Art consultants are frequently associated with corporate collecting, since many companies spending sizeable amounts of money look for help in making decisions, and they either hire staff or (more often) retain the services of an outside art advisor or art consultant. These advisors assist the company executives on which works to buy, how many, where they should be purchased and how they ought to be displayed in the corporate offices.

How serious the company is about its collection is often reflected in the person who is in charge of buying works or maintaining them in good condition. It is clear that the First National Bank of Chicago was committed to high standards because it chose Katharine Kuh (for many years the paintings curator at the Art Institute of Chicago) to buy its 3,000-piece, $5 million collection, and Dr. John Neff, former director of the Chicago Museum of Contemporary Art, to be its on-staff art advisor. Similarly, Sohio of Cleveland reflected its high-mindedness by asking Evan Turner, director of the Cleveland Art Museum, to be on its art advisory committee when that oil company created an 800-piece contemporary art collection for its corporate headquarters built in the mid-1980s.

Galleries

There are three ways by which artists tend to look for galleries to represent their work. The first is by purchasing a mailing list of galleries, listing names and addresses of hundreds or thousands of shops to which artists might send material (slides or photographs, bio, statement). For businesses in the direct mail field, it is believed that a response rate of 2 or 3 percent makes a mailing profitable. However, these lists are not vetted for the type of gallery (art, antiques, furniture—many shops call themselves galleries), the type of artwork represented, or even if they wish to be contacted by artists at all. A lot of money simply may be thrown away. Additionally, even if 2 or 3 percent of the contacted galleries express interest in an artist's work, they are not buying—as they would from a company's direct mailer—but consigning pieces. More time and money would have to be spent for any sales to take place, and as a matter of fact, the type of gallery that would take on an artist in this manner is unlikely to have regular buyers and generate sizeable sales.

Artists should research the galleries that they hope will represent them to determine, not only whether or not they show work that is similar thematically to their own, but if the galleries will look at new, unsolicited art (that can be discovered through a telephone call). A second (and more time- and cost-efficient) way in which artists search for galleries is through various publications, such as the national magazines *Art in*

America, Art & Antiques, Art & Auction, Art Forum, and *ARTnews. Art in America's Sourcebook to the U.S. Art World,* listing art dealers around the United States, as well as the type of art that the gallery represents. *Art Now* gallery guides, which are published regionally around the country—New York greater metropolitan area, Boston and New England, Philadelphia, Southeast, Southwest, West Coast, Chicago-Midwest as well as one for Europe and an international edition—are another source of information. A growing number of galleries also have Web sites, which can be explored to ascertain the preferred style of art. The Internet addresses of these galleries are often listed in art magazine gallery advertisements and in gallery association Web sites, as well as in the *Sourcebook to the U.S. Art World.* You can also conduct a Web search for galleries, which may be time consuming and offer largely irrelevant information but may also help find an appropriate site if the keyword is precise.

The third, and best, method is for artists to actually visit the galleries that are of interest to them. Not only do artists want to see that their artwork would fit stylistically with the other pieces on display, they would be interested in knowing whether or not the space is suitable for their work (tall and spacious enough for sculpture or large-scale paintings), how the other artists' work is displayed (attractively, good lighting, information available about the artist or the pieces on view), and the general price level of the works in the gallery. Dealers and gallery owners look for art that has a specific price range by artists of a certain renown, because that is what their regular buyers seek or can afford. Dealers are very reluctant to represent $2,000 paintings in a gallery where the average is $20,000; they also are not likely to raise a lesser-known artist's work ten times to bring it up to the gallery level of pricing.

Personal contact usually makes a substantial, if not crucial, difference. Knowing the dealer or knowing (or favorably impressing) someone who has the ear of the dealer is likely to turn the tide for a dealer who is unsure about the salability of an artist's work. That is why artists cannot hide away from the world, maintaining some romantic myth of the artist who must be alone, but need to associate with other artists.

Both painter John Hull and sculptor Donna Dennis, for instance, were "discovered" through the intercession of friends who prodded their dealers. Hull worked as a machine operator in a cardboard box–producing factory on the 3:00 p.m. to midnight shift for two years, and he also ran an alternative space gallery in Baltimore, Maryland, for five years. Dennis lived in New York City for seven years before she began to exhibit her art (starting as a painter and gravitating toward sculpture). She worked as a secretary at the Whitney Museum of American Art in New York City for one year ("I was fired because I couldn't type") and as a picture researcher for various publishing houses. Eventually, the two artists found time to make and exhibit their art—she at the cooperative West Broadway Gallery in lower Manhattan, where she was spotted by the collector Holly Solomon, who had just opened her own commercial gallery and invited her to show work there; he at alternative spaces such as W.P.A. in Washington, D.C., and at P.S. 1 in Long Island City as well as at New York's New Museum, where he caught the eye of Manhattan art dealer Grace Borgenicht. In both cases, friendships paid off. Hull

knew one of the artists in Borgenicht's gallery, David Saunders, who spoke on his behalf. "Grace liked my work and she had read reviews of my shows," Hull said. "No one talked her into liking it. But Grace had some questions about me that David could answer: Is Hull a serious artist? Does he do a lot of work? Is he a reasonable person?"

Holly Solomon was led to one of Dennis's shows by Denise Greene, whom she had known from a consciousness-raising group and who was already represented by the collector-turned-dealer. Personal connections served her again when artist Harriet Shorr, whom she had known "from the group of poets I hung around with when I first lived in New York," gave Dennis her first show outside of New York, at Swarthmore College, where Shorr was then teaching. Later, in 1990, Shorr was teaching at the State University of New York at Purchase and suggested to Dennis that she apply for a faculty position.

Meeting people who can be of help to one's career—call it "making connections" or "networking"—is vital to artists, although this may be a difficult course to plot: Those who obviously are looking to make headway with the "right people" are apt to be seen as opportunists. Sharing ideas and information, attempting to interest others in one's work, and showing enthusiasm for theirs, on the other hand, are essential to advancement, as the art world picks winners and losers primarily on the basis of what people say. "I've never lived in New York City," Hull said, "but I go there regularly to meet people and see art. It's as important for me to talk to other artists as it is to see a Goya."

"I didn't think of meeting various women artists as a business thing," Dennis stated. "It was the early years of the women's movement, and we all knew the statistics of how few women were in galleries or in the Whitney Biennial. It just felt good to find people who appreciated my work and what I was trying to do, who understood and faced the same problems I faced."

Connections can be made throughout the art world. For Claire Romano, a printmaker who teaches at Pratt Institute in Brooklyn, societies and artist associations were a source of important contacts. Romano was one of the jurors for a show sponsored by the American Society of Graphic Artists in the early 1960s; another juror was Jacob Landau, who was then a teacher at Pratt Institute. "He liked my way of looking at art, the way I articulated my ideas, and he also liked my art," Romano said. "Not long after, he was named chairman of the Fine Arts department at Pratt and asked me to take over his classes." That Romano was selected to be a juror for this show and there met her future employer was serendipitous. "I never looked for a job," she said. "I was just offered it."

In addition to personally knowing people, artists need to have their work shown as widely as possible—a critic, collector, curator, or dealer may spot it (for instance, as a juror in a competition) and pass the word on about an interesting find—and to make themselves available to potential buyers and gallery owners. Showing art involves more than simply hanging up a picture in front of someone who agrees to look at it. It requires an affirmative effort on the part of artists, first, to place their work in front of people who can be helpful in their careers and, second, to be part of the process of marketing their work.

COMING TO TERMS

Landing a dealer, whether or not that person is a major figure in the art world, is not the end of an artist's art business concerns. If art dealers were as trustworthy as so many artists are trusting of them, there would not be a growing body of art law, nor would there be a growing number of lawyers specializing in artist-dealer conflicts. As much as artists want to be "just" artists when they finally find a dealer who will represent them, devoting their attentions solely to creating works of art and leaving the legal and business considerations of their careers entirely to people in other, less ethereal professions, artists must proceed with caution and a down-to-earth sense of their own rights.

Dealers come in a wide assortment. Some have strong contacts with established collectors and are able to sell most everything by artists in whom they believe; others may not sell very much, earning most of their money through framing pictures or consulting with private individuals and corporations on what art to buy and where to hang it; yet others are artists themselves who have set up a gallery for the primary purpose of creating a fixed venue for their own art, exhibiting other artists' work at the same time. Some dealers are personally and professionally supportive of the artists they represent, while others believe in letting artists find their own creative paths. Not all dealers are right for all artists.

Artists and their dealers may not be of the same mind on a variety of practical matters as well. Disagreements may arise over pricing, proper accounting, discounts, assigning of copyright, the frequency of exhibitions and a host of other legal and business issues. These differences are not necessarily the result of ill intentions on the part of a gallery owner; rather, the power imbalance between artists (especially the younger emerging artists) and their dealers often forces artists to accept otherwise unacceptable arrangements. To a degree, artists can only hope that success in selling their work will provide them greater leverage for negotiating better deals later on. However, it is useful to have a firm idea from the start of what one's arrangement with a dealer is and to get that in writing if at all possible.

Written agreements can be broken as easily as verbal ones. Verbal agreements are legally enforceable, although disputes may be settled much more quickly when there is a clear agreement in writing signed by both parties. Certainly, the legal costs would be less, if the dispute reaches that stage, because it takes less time to enter a legal document into evidence in court than gathering hours and hours of conflicting depositions by both sides, disputing what was said when by whom.

A number of artist advocates recommend that artists and their dealers sign explicit consignment contracts as a means of fully clarifying their relationship and avoiding conflict. Written contracts make sense and solve a lot of problems, but dealers frequently make sour faces whenever an artist offers one. In many instances, the modern business world and the tradition-bound gallery system are found to work at cross-purposes. Artists tend to be more eager to win the endorsement of a gallery that will represent them than assert their legal rights, and it is difficult to fault them. Dealers who profess to scorn contracts are disingenuous—they certainly sign contracts with banks, landlords, and collectors—but the old rhetoric dies hard.

"A lot of the relationship between the artist and the dealer is based on trust, and you can't pin that down in a written contract," one prominent New York City dealer said. "In fact, the written contract may imply a lack of trust."

The threat of "turning off" a dealer may well make an artist reluctant to present any written agreement to his or her potential agent. However, artists and their dealers should speak with some specificity about how they will work together, and this should be written up by the artist in the form of a letter that the artist asks the gallery owner to approve and sign. Frequently, artists and dealers have a short-term agreement—a sort of trial marriage—to determine whether or not they work well together, and this may be renewed or expanded later on.

According to Caryn Leland, an attorney who frequently represents artists, "It could be a straightforward letter that starts out with, 'This letter will confirm our understanding of your representation of me,' and ends with 'If this is acceptable to you, please sign below and send it back to me.'"

The letter should address the most pertinent issues, such as:

- The term of the agreement (how long will we be bound by this contractual relationship). Initially, the term should be two or three years, which allows the dealer a reasonable amount of time to promote the artist and to see that investment pay off. An agreement of only six months may make the dealer reluctant to develop the market for an artist's work and lead to the dealer dropping the artist if works don't sell immediately. A much longer agreement may keep an artist whose work begins to sell well in a disadvantageous position if the contract is weighted toward the dealer.
- The nature of the relationship (exclusive or nonexclusive representation, for instance). The dealer may have the exclusive rights to sell all of the artist's work, or exclusive rights to sell only prints (another dealer has exclusive rights to the sculpture, yet another has the rights to the canvas paintings); perhaps, the dealer has the exclusive rights to market the artist's work in North America or just New York City. The dealer may simply handle an artist's work with no claims to exclusivity. These situations should be discussed directly with the art dealers involved since, in the very thin-skinned art world, hurt feelings and unhappy artist-dealer relationships may result from surprises. Possibly, dealers for the same artist will work together by coordinating exhibitions (when in the same city) or rotating an artist's works from one gallery to another, which makes it possible to keep artworks from sitting in the same gallery in perpetuity.
- An exact accounting of what is being consigned to the dealer. A paper trail should accompany every work that the dealer or gallery is sent, listing the title of the piece, the medium and size, and a signed receipt should be in the artist's possession. Galleries often maintain a large inventory, and works may be misplaced; if the gallery owner cannot locate something that he or she acknowl-

edged having received, it becomes that person's responsibility to find the work or pay the artist. Little is to be gained from an I-gave-you-that-work, no-you-didn't disagreement.

- Price arrangements (minimum amounts per work or prices for each work, as well as what sorts of discounts may be allowed). It is up to the artist, in consultation with the dealer, to determine the price of artworks. The dealer may have good reason to ask for flexibility in pricing by the artist—certain prestigious museums expect a 50 percent discount, and other prominent collectors may also seek more than the customary 5–10 percent discount—since placing a work well has long-term benefits for an artist. Still, an artist cannot abdicate the responsibility of setting prices.

- The percentage of the dealer's commission (30, 40, 50, 60, 70 percent—the median is 50 percent, but artists and their dealers work out their particular financial arrangements, depending upon the prominence of the artists and the services rendered by the dealers; whatever the percentage, it should not come as a surprise to the artist).

- The responsibilities of both dealer and artist (how promotional efforts for a show will be handled, where advertisements will be placed, who will pay for framing and insurance, whether or not the artist will be compensated for the loss in the event of damage or theft).

- The frequency and nature of the exhibits (one-person exhibits, group shows, once a year or less often, when in the year, how the work will be shown). In some galleries, it is very easy for an artist to get lost, shown only in group exhibitions at nonpeak times of the year. Scheduling shows should be discussed at the outset of the relationship.

- A requirement for periodic accounting (who purchased the works, how much was paid for them, where and when have works been loaned or sent out on approval). Artists have reason to know who their collectors are, not only to include on their curriculum vitae but in the event that a retrospective of their artwork is planned and pieces need to be tracked down. For artists in California, where a state resale royalty law is in effect, subsequent sales of their work would likely result in a royalty payment based on the presumed increased value of the resold pieces.

- Prompt payment by the dealer (sixty to ninety days should be the absolute limit, thirty days is preferable). Some dealers will pay their artists as soon as the check clears, while others may receive payment from collectors on layaway and not send money to the artist until the last payment is received. (That latter method is patently unfair to the artist; the dealer receives a 50 percent down payment for the work, representing the gallery's commission, leaving little incentive to hurry the buyer toward paying the remainder.) Some dealers wait for the buyers to "live with" the work for a period of time to ensure that the collectors are satisfied with it before requiring payment (some time after that, the artist will be

paid). The owners of some marginally profitable galleries flat out tell their artists that they need to pay their rent, utility and telephone bills first—the artists will be paid when money becomes less tight. In general, artists should not subsidize their dealers, allowing them to use the proceeds of sales for other purposes. However, artists should never be in the dark about where their money is and when they will receive it.

While the artist automatically retains copyright (that is, reproduction rights) for his or her work even after a sale, some artists may want written contracts for the sale of each piece, including, for example, a provision for resale royalties (requiring the buyer of the artwork to pay back some percentage of the profit when that person later sells the work).

Other provisions that might be discussed and formalized in a letter of agreement between artist and dealer include a mechanism for resolving disputes (such as presenting a disagreement before an arbitrator), protection of the artist in the event that the gallery goes bankrupt in those states where artist-consignment laws do not exist. If the agreement requires that all attorneys' fees be paid by the person who is in breach of the contract, this will encourage the dealer to act ethically.

The issues of bookkeeping and prompt payment are frequently the most troubling in the artist-dealer relationship. If the artist is selling throughout the year, the accounting should probably be monthly; at the very least, it should be quarterly. Artists should also carefully maintain their own records, knowing where their works are consigned or loaned as well as which pieces have sold and to whom.

It is wise to see the sales receipt for any consigned work after it is sold in order to ensure that the dealer has not taken too high a commission or paid the consignor too little. The practice of keeping two sets of books is not unknown, and artists are wise to check every step of the way. Many art galleries are notoriously poorly financed operations that often use today's sale to pay yesterday's debt, and many artists have had to find recourse in the courts when a dealer withheld money owed to them. Twenty-one states around the country—Arizona, Arkansas, California, Colorado, Connecticut, Florida, Georgia, Illinois, Iowa, Kentucky, Maryland, Massachusetts, Michigan, Minnesota, New Mexico, New York, Oregon, Pennsylvania, Texas, Washington, and Wisconsin—have enacted laws that protect an artist-consignor's works from being seized by creditors if the gallery should go bankrupt.

Even artists whose dealers are in other states than these have some protection from creditors seizing art on consignment in galleries. One recourse for artists is to file a UCC-1 form for works on consignment (available in the County Clerk's office, requiring a nominal filing cost), which stipulates that the artist has a prior lien on his or her own works in the event that the gallery has to declare bankruptcy. In the event that one's dealer disappears in the face of numerous creditors and leaves a warehouse full of art, the law permits artists who have filed the UCC-1 form to retrieve their work.

Another unfortunate possibility is that the artist's works may have been sold, leaving the artist owed money by a dealer who has disappeared. However, the dealer may still have assets in the state, such as jewelry in a safe deposit box or a house, which can be attached by the artist.

"If there are assets, the artist may have a preferred right to them," Martin Bressler, counsel to the Visual Artists and Galleries Association, said. "You would show your consignment form, listing the works you've sent to the dealer, the works you've received back or have received payment for and the prices for all those pieces. You add up what you're owed and present that number."

In those instances where dealers have closed shop without returning consigned works to the artist or paying money that is owed and the dealer is still in the same state, the artist has some recourse to the law—contacting the city district attorney's office or the office of the state attorney general, or hiring a lawyer to recapture any works on con-signment to the dealer or money owed through past sales. If the dealer has left the state, the legal possibilities become less clear and more difficult for the artist.

Sometimes, however, the reason that an artist has not been paid, is quite innocent. Perhaps the artist has moved but neglected to provide a forwarding address to the gallery owner. The dealer, planning to retire and pay all outstanding debts, cannot locate the artist. Artists should always give notice in writing of any moves, even if only for six months.

Inquiring about the integrity of a particular dealer—finding out how long this person has been in business and whether or not the Better Business Bureau or state attorney general has received any reports about the dealer's business practices—helps artists make a critical decision. One way to check out the dealer is to find out how long the gallery has been in existence; another is to call a local museum curator for any infor-mation about the dealer; a third approach is to ask the dealer for a bank reference. Nothing is foolproof but, without some sense that the dealer is legitimate and in for the long term, the artist runs a potentially sizeable risk.

Knowing what to beware of in dealers is important, but it is equally valuable for artists to develop strong personal and professional relationships with their dealers. The dealer should be aware of which ideas the artist is pursuing, any changes in the work and other events in the artist's life (such as winning an award or receiving an honorary degree) that may help promote the artist's work. It is often the case that artists who don't communicate with their dealers are the ones who complain that their dealers do nothing for them.

To Consign or Sell?
The consignment arrangement between artists and their galleries is a periodic cause of contention: Artists complain that not owning the work lessens both the commitment of the dealer to the art and the risks of not selling it; dealers respond that they couldn't afford to stay in business if they had to purchase everything they wanted to sell. Gallery owners frequently do better when they own the works outright. In a consignment rela-

tionship, the dealer typically keeps half of the sale price; when the gallery owns the work, the artist is paid a net price, and the dealer may sell the artwork for far more than double the artist's take. "Dealers certainly make more money on artworks they own than on those they consign," said Gilbert Edelson, administrative vice-president of the Art Dealers Association of America, said. "The problem is tying up capital."

The association has never tracked what percentage of the works sold by its members involved in the primary art market were owned by the dealers rather than consigned to them. Ideally, the numbers should correspond to the percentage owned and consigned by the dealers, which would indicate that the galleries worked as hard to sell pieces they did not own as for works they did. Common sense suggests that the percentage is higher for works the dealers owned. Perhaps for that reason, almost all print publishers require the galleries that represent their work to purchase them outright. Greenwich Workshop, for instance, has minimum ordering requirements for the galleries authorized to sell its prints (purchase works by at least ten of its artists) and minimum sales (no less than $5,000 per year) to spur the galleries to aggressively pursue buyers. Other publishers have different agreements with galleries, but consigning is never a part of them. "We only sell work, we don't consign," said Kristin Heming, director of Pace Prints in New York City. "We have, on occasion, lent a few works out when a gallery is having a special exhibition, but that's only with galleries we've worked with and only after they've shown a real commitment to the work by buying it."

For both artist and dealer, consigning artwork entails more paperwork. Emerging artists are more likely to face a consignment situation than for those creators who are better known—the dealers of well-established artists are more apt to buy at least some of the works they show or provide a stipend (a monthly payment, which is deducted from later sales) or guarantee minimum sales to the artists, realizing that if they don't they may lose the artists to other dealers who will—and this reflects the power differential of the art world. "The question for most artists is not if they are going to consign their works but how they will do it," said Todd Bingham, a Vista, California, career advisor to artists. "Artists may consign work to a gallery they want to get into on a ninety-day basis. After ninety days, the gallery either returns the works or pays the invoice." After that trial period, the artist and gallery may regularly decide to exchange new pieces for old on a three- or six-month basis. He noted that, simply as a means of protection, artists should not allow their artwork to languish at a gallery indefinitely, increasing the possibility of it being lost, damaged, stolen, or just forgotten about.

Spreading Yourself Too Thin

The problems for artists in maintaining more than one gallery relationship, of course, are significant: The artists must produce enough pieces to keep each dealer satisfied; the works cannot be better for one dealer than for another; the bookkeeping, insurance, and specific consignment agreements with each dealer or gallery require considerable organization on the artist's part; and it may be much more difficult to arrange major shows in one specific location when pieces are spread around the country.

In addition, the artist may be able to sell his or her works privately, and this should also be discussed with the dealer. Some dealers don't mind, while others do. Dealers who allow their artists to sell privately demand that those prices not fall below what is charged in the gallery. Underpricing your dealer will sour that relationship as well as diminish the overall value of your work in collectors' minds.

SEVERING THE ARTIST-DEALER RELATIONSHIP

Severing the artist-dealer relationship is often the result of hard feelings on at least one side—the dealer isn't promoting or selling work, the dealer does not pay promptly after sales take place, the dealer isn't showing interest in the artist, the artist made private sales, the artist isn't producing high-quality work—and produces hurt feelings on the part of whomever has been left behind. Often, a complicated mix of reasons lies behind an artist and dealer split-up.

Sculptor William King left the Zabriskie Gallery in New York in part because "the gallery had a low ceiling, and I expected higher prices and more sales," but the precipitating event was the dealer's "refusal to give my girlfriend a show." He went to dealer Terry Dintenfass, who agreed to exhibit the work of his girlfriend. On the other hand, painter Jacob Lawrence ended his relationship with Terry Dintenfass because "I wasn't getting paid the money I was owed, I didn't get quarterly statements from her, and she was generally hard to work with."

One way in which artists often judge the solidity of their relationship with their dealers is the number of telephone calls from their galleries. "Artists want to hear regularly from their dealers," Curt Marcus, a New York art dealer, said. "It's important that they know they are being thought about." Both Gregory Gillespie, a painter, and Faith Ringgold, a painter and sculptor, said that they are called by their respective dealers at least once a week, relaying information on prospective buyers, past collectors, a new show, asking how the work is coming along, how's the family—the specific content may not be as important as the ongoing connection.

Painter Richard Haas noted that a sign of how his relationship with a dealer "is fizzling out" is that "the dealer is calling you most of the time when you're in the middle of it; when you find yourself calling the dealer most of the time, you're not in the middle of it anymore. There are not enough phone calls, not enough visits to your studio; you don't get invited to dinner. You know you're at an end."

Many artists approach their relationship with dealers cynically. "You get priority treatment from dealers when your work is selling," said painter and collage artist Nancy Spero, "and dealers have no time for you when sales are slow. In other galleries, the attention you get is based on where you are in the pecking order of artists that the dealer represents."

Haas said that the relationship between artists and dealers is based "on mutual needs, but those needs keep changing, and one is seldom in sync with the other." For Haas, who is best known for his murals, dealers lose interest because they are "object oriented," whereas his living is based on commissions, which are more difficult to

arrange than private sales. Painter and photographer William Christenberry left the Zabriskie Gallery "as a matter of conscience" after he had been awarded a commission from the federal government's General Services Administration in 1979, "and the gallery wanted a substantial part of the fee as their commission. They hadn't help me get the commission, as a lot of other galleries do, and I didn't think they deserved any of it." Painter Peter Halley left dealer Larry Gagosian in New York because of the requirement that Gagosian be his exclusive agent. Dealers elsewhere in the United States and in Europe did not want to share sales commissions with the New York gallery, resulting in lost sales. "Seventy-five percent of my market is in Europe," Halley said. "My collectors are not likely to come to New York to buy. Dealers in Europe chafe under the requirement that they pay half of the commission they earn to my New York dealer." To his mind, Gagosian would prefer to forego sales than to lose his commission.

At times, the point of contention is whether or not the artist feels free to develop artistically under the existing relationship. Jacob Lawrence noted that he ended his association with Elan Gallery because the dealer, Charles Allen, "wanted to buy all the work he showed, which put me in the position of creating for him. He didn't come out and say, 'I want you to paint in such-and-such a way,' but it still felt that way to me and I wasn't comfortable with that."

Similarly, Faith Ringgold, who was represented by New York art dealer Bernice Steinbaum from 1985 to 1993 before joining ACA Galleries, said that she "wanted a gallery that was more high powered, that could get better prices and place my work in better collections. But it wasn't just the money; I wanted my entire career to move forward, and I sensed a tendency on Bernice's part for me to stay where I was."

Ringgold noted a mounting number of suggestions for, and outright criticisms of, her work by Steinbaum. "We weren't agreeing on anything anymore," she said. "It was just a constant aggravation that kept me from concentrating on my work. The only thing I could do was leave her gallery." When she decided to leave, Ringgold had her lawyer contact the dealer and arrange the split-up.

Most artists announce their decision to leave in person, sometimes in a letter, and hope that the break-up with the dealer will be painless and amicable. "I tell my artist clients, 'Don't go away mad. Just go away,'" Jerry Ordover, a lawyer who often represents artists, said. "When you start thinking about leaving a gallery, do it in steps: Start by reducing the size of the inventory; take back works that have been there two or more years to start with, then take more recent pieces. You don't want to leave hostages with a dealer whom you've just told you're leaving. You might find the works get kicked around, or you're told they are lost. Next, you want to get all the money owed to you, little by little if not in a lump sum. You want to settle the money part while the two of you are still on good terms."

Complicating the break-up may be the question of money owed to the dealer for advances against sales (sometimes called "stipends") or the costs of advertising, framing, restoration, the purchase of materials, or the publication of a catalog. An artist may not have the cash to immediately cover the debt and attempt to repay the dealer through

works of art. When Jacob Lawrence left Terry Dintenfass, she had some graphic prints of his and he owed her some money; they agreed to let her keep the prints in exchange for wiping out the debt.

The problem isn't always resolved as easily. "If there is an agreement that money owed should be recompensed in art, you want to know how that art is selected," Martin Bressler, a lawyer and vice-president of the Visual Artists and Galleries Association, said. "Does the artist pick? Does the dealer? Do they pick together?" When Hirschl & Adler Galleries in New York decided to end its relationship with painter Joe Zucker in 1993, following a private studio sale that the artist had made to a collector, the gallery refused to return twenty-six of his works until $36,000 in advances plus interest had been repaid. Zucker filed a lawsuit and, in 1996, the New York Supreme Court ruled against Hirschl & Adler. The artist and gallery eventually settled the debt by selecting four works (the gallery chose from a sample of works that Zucker selected).

Ending a relationship amicably is important not only since the dealer may be in possession of an artist's work but because "the art world is small," said painter Nancy Hagin, who left Terry Dintenfass in 1980. "It's not like I'm never going to see her again. I see her again and again and again." Within a small art world, an incensed dealer may begin denigrating the reputation of an artist both to other dealers and collectors, adversely affecting the artist's career. Even though their formal relationship has ended, the dealer may remain a source of future sales and commissions, and some artists may return to a former dealer. William King returned to Terry Dintenfass after his experiment with Virginia Zabriskie, and Gregory Gillespie was invited back by dealer Nina Nielsen in Boston a couple of years after she had "asked me to leave following a big blow-up we had."

The experience of ending a relationship is almost always unpleasant, artists and their dealers report, but it is an unpleasantness that everyone tries to get over quickly. Over the course of a career, an artist may change dealers any number of times, and knowing how to make a satisfactory exit must become one more skill to acquire. The dealer Betty Parsons "wouldn't talk to me for a few years when I told her I was going to show my work at the Janis Gallery," said painter Ellsworth Kelly, "but we patched it up and even took a vacation together." When Kelly left dealer Sidney Janis for the Leo Castelli Gallery, "there was some initial bitterness there, too, but that didn't last long and we remained good friends."

The agreements that artists and dealers make when they start a relationship should contain some strong sense of how it might end, according to Joshua Kaufman, a lawyer in Washington, D.C., who noted that when he drafts a consignment agreement between an artist and a dealer, "I spend more time on the termination clause than on anything else. You don't want to leave this stuff up to when everyone's feelings are hurt."

The overall contract will indicate how long the agreement is in effect. Bressler said that the contract term should be a minimum of three years, if the gallery is the artist's exclusive agent, "anything less than three years doesn't give the gallery enough time to really promote the work." Far longer terms, however, may bind an artist to an arrangement that he or she has outgrown.

Some artist-dealer consignment agreements allow either party to terminate the contract at will if there has been a clear breach (for instance, the artist isn't paid, shows don't take place, the artist violates the exclusivity) or if either side is simply unhappy with the arrangement. Even if there is no specific termination clause, one cannot be bound by a contract indefinitely. According to Barbara Zucker, Faith Ringgold's attorney, "the contract may be terminable at-will" or, at worst, the statute of limitations will not permit the agreement to be enforced past one year.

Of course, when there is no written agreement between artist and dealer, either side may end their relationship at any time. However, the lack of some formal or informal (an exchange of letters) document may lead to other misunderstandings or even a drawn-out legal action that promises to be expensive and not necessarily conclusive.

BAD DEBTS AND OTHER RECOVERIES

Don't pay the utility company, and your electricity will be cut off. Miss some auto loan payments, and your car will be repossessed. Forget about the credit card charges, and a collection agency will be in touch and your credit rating affected. Don't pay the artist for his or her painting, and you can keep the artwork and your money. What's wrong with this picture?

When artists go unpaid, they usually have two options: Hire a lawyer whose legal work is likely to cost far more than the value of the artwork itself (lawyers' fees and court costs are rarely included in a settlement) or vent and fume.

In general, artists go unpaid in two different ways: Their dealers sell works but continually find excuses for not turning over the cash (minus sales commission) to the artists; collectors who buy directly from artists, taking possession of the works with an agreement to pay for them over time, simply stop sending the artists money. To determine what to do after artists find themselves owed money, it is useful to examine what they might do before a sale is made.

"You need a clear understanding with the dealer or collector of the terms and conditions of payment," said John Henry Merryman, a professor at Stanford University Law School and coauthor of Law, Ethics and the Visual Arts. "How much are you going to be paid? When are you supposed to be paid? What is the price of the artwork? Are there any discounts? What is the dealer's commission? If the dealer or buyer has a clear understanding with the artist about payment, that person is more likely to pay the full amount and on time."

Some lawyers recommend including legal language on consignment agreements between artists and their dealers, such as an indemnification clause or an arbitration clause. An indemnification clause, according to Patricia A. Felch, a lawyer in Chicago who has represented artists, strengthens an artist's ability to protect his or her rights by ensuring that the cost of legal assistance does not stand in the way. Such a clause would say, in effect: "If full payment following the sale of a work is not received by the artist within x-number of weeks, artist will be entitled to all expenses including attorneys' fees incurred by artist as a result of dealer's failure to pay." This language requires only modest alteration to apply to a collector in a private sale.

DEVELOPING RELATIONSHIPS WITH ART DEALERS

An arbitration clause requires both the artist and dealer (or artist and private collector) to submit their dispute to a neutral arbitrator, whose decision is binding and not subject to appeal. Arbitration is not free—the filing fee is usually $200 or $300 (sometimes more, depending upon the amount of money in dispute), and the arbitrator is paid another $200 or $300 (sometimes more) per day—but it is generally less expensive than hiring a lawyer and bringing a lawsuit. The New York City–based Visual Artists and Gallery Association drafted a form consignment agreement with an arbitration clause, and California Lawyers for the Arts developed an arbitration and mediation service to help artists, collectors, and dealers resolve disputes.

Among themselves, lawyers involved in the arts argue whether or not dealers and galleries are likely to sign contracts with arbitration or indemnification clauses. "No dealer in his right mind will accept an attorneys' fees clause," John Henry Merryman stated. "They're not going to do something that would increase their exposure."

Gilbert Edelson of the New York City–based Art Dealers Association of America, claimed that dealers don't want to sign contracts with their artists that are full of legalese. "They don't want to pay for a lawyer to negotiate the contract with the artist as a practical matter," he said. "They may represent twenty artists—do they want to pay the lawyer twenty times to work out all the agreements?"

Felch, however, said that indemnification clauses she has drafted for artists have been signed by their dealers and galleries. "Calling it an indemnification clause frightens people," she stated. "It's a big word, and some people freak out. So don't label it an indemnification clause."

Arbitration, even if it is accepted by the collector or dealer, is itself not quite the bargain alternative to the legal system that many hope. "This is a legal process," Laurie Moss, director of marketing for the American Arbitration Association, said. "We inform people that to pursue arbitration without legal counsel is not wise." Artists may find themselves once again hiring a lawyer, first to advise them on whether or not arbitration will achieve what they are looking for, and second to accompany them to the hearing before the arbitrator. For a smaller fee of between $100 and $200, the Visual Artists and Galleries Association instructs an artist how to go into arbitration without a lawyer, but that may not be suitable for every artist.

"Arbitration is not circumventing the court system," Moss noted. "The reality is that, even if you win at arbitration but the dealer says that he refuses the pay the artist, the artist still has to go to court to affirm the judgment. That's expensive."

Artists are in the best position to protect their rights and receive what is owed to them when they have maintained good records of what has been consigned to their dealers and both sides have unambiguously agreed to certain conditions, such as the price, commission, discounts, and method and promptness of payment. The law may add some muscle to the artist's position. The same laws in the twenty-one states around the country that protect an artists' works on consignment if the gallery declares bankruptcy (see above) also classify the dealer as a trustee for the proceeds of a sale; that is, dealers may not use those proceeds even to pay themselves until the artist is paid in full.

An artist's position is weakened when he or she has not maintained good records and if no clear understanding was set out with the dealer or private collector for the financial dealings. The issue of how much money is owed by a dealer to the artist may also be muddied if advances were made against royalties, framing or publicity charges, crating, insurance and shipping expenses, as well as personal loans (with or without interest) and other fees.

"Sometimes, artists think they are owed money when they are not," Merryman said. "In some cases, the artists haven't been paid yet, because the dealer hasn't been paid by the collector. Artists need to communicate more with their dealers. Artists come out of a culture—I think they learn it in art school—that assumes that dealers are an enemy, a necessary enemy but an enemy all the same. They are prepared to think the worst about their dealers, which often becomes a self-fulfilling prophesy."

An artist may receive satisfaction in a variety of ways that do not necessarily involve the high-priced legal system. Mediation may work in cases where the parties are willing to discuss compromises in the presence of a third party who directs the discussion. A growing number of volunteer lawyers for the arts organizations are offering mediation as a low-cost service, and others may direct artists to mediators elsewhere.

Many dealers and galleries belong to associations, which will set up arbitration (at no cost to the artist or gallery) when complaints are lodged against a member. "We take a very dim view of dealers not paying their artists," Gilbert Edelson said. "It is grounds for expulsion with us."

Another possible approach to getting payment in full or in part is contacting a collection agency. "Debtors know that eventually the creditors are going to get tired of calling and asking for their money, that they will get on with other things in their life, and that's just what they want," said Mike Shoop, president of the Denver-based Professional Finance Company, Inc. "But for us, collecting bad debt is all we do, and we will write to the debtor and telephone the debtor and visit the debtor, in order to convince that person of the benefits of paying the debt and the consequences of not paying the debt, until the debt is paid."

One of the consequences of being pursued by a collection agency is that a negative report is usually placed on one's credit report, which may prove troublesome for the dealer or private collector when that person tries to obtain a loan. Most galleries, like most businesses in general, survive on borrowed money.

There are thousands of collection agencies in the United States, but not all of them take on individual clients. More frequently, agencies serve the big company—such as a department store, with hundreds of potentially lucrative accounts—in their struggle to obtain payment from individuals. Most agencies work on a contingency fee basis, receiving as much as 50 percent of the money received from the debtor. (A source of information and prospective agencies is the American Collection Association, 4040 West 70th Street, Minneapolis, MN 55435, tel. 612-925-0760.)

As with everyone else, when artists are wronged, they want justice but may receive only small consolation. The legal system is not predictable in its results, for those willing to invest money and often years in resolving a dispute. Even those who win a lawsuit may still not be able to collect, for people who owe artists money are likely to owe money to landlords, utility companies, credit firms, and others—there may be no money to collect. In that case, artists would have to write off the loss as a bad debt on their taxes and hope to approach their next dealers or buyers with more knowledge about what could go wrong.

3

EXPANDING SALES
WITHIN AND BEYOND THE
GALLERY MARKET

The traditional view of what artists do to earn money is to create a work, sell it, then create another, and on and on. In this entrepreneurial age, artists have a variety of ways to generate income from their work.

LICENSING
Licensing art images has become the fastest growing segment in the entire licensing industry, according to Charles Riotto, executive director of the Licensing Industry Merchandisers' Association (350 Fifth Avenue, New York, NY 10118, 212-244-1944, *www.lima.org*), generating $130 million in royalty revenues (the amount the property-holder actually receives) in 1998. The association holds an annual trade show in June at the Jacob Javits Center in New York City, and one section of it is reserved for artists and art licensing agents. Other than attending the annual show, one may purchase the association's *Directory* ($250), which lists names, addresses, telephone numbers, e-mail addresses and Web sites, and the type of goods licensed.

Some artists handle their own licensing arrangements with corporations, but most use an agent. An agent will pursue manufacturers and other prospective licensees—looking widely (at games, publishing, furniture makers, or apparel, for instance) or at a niche market (such as baby products) depending upon the type of artwork. They also will ensure that a contract is advantageous to the artist. Among the key elements of a licensing contract are these:

- *Rights.* What is granted to the licensee. The art, referred to as "property," will be defined as a particular image or a collection (for instance, twelve images for a calendar). The specific products (such as a calendar, poster, jigsaw puzzle, T-shirt) on which the images will be used should also be specifically identified. An artist's work should not be used on a variety of products if only T-shirts were

agreed upon. The term of the license should also be indicated, limiting the licensee's use of the imagery for a specified period of time, after which the art may be licensed to other manufacturers and other products.

- *Territory.* Where the products with the licensed imagery will be sold. An artist may license the use of imagery for one or more products to be sold in the United States but license the same imagery for other products elsewhere in the world.
- *Distribution channels.* In what market will the products be sold? Products may be sold through mail order, at department or discount stores, at gift shops and high-end stores. The artist may or may not want his or her name associated with a particular marketplace. For example, artists with a prestigious gallery may not want their work sold at K-Mart. Artists also may license images for products sold through one distribution channel, while another licensee sells products through a different channel.
- *Royalties, payment.* Licensing royalties are customarily between 5 and 10 percent of the "net sales" or wholesale selling price of the item, which is evenly split between the artist and agent (the division may be 60–40 in favor of the artist when the artist is well-known). The contract should not only indicate the percentage but define the term "net sales" in order that the licensee cannot take numerous deductions that lessen the actual royalty. Usually an advance against royalties is paid to the artist by the licensee, which ensures that an artist needn't wait until the items sell before receiving any remuneration. There also may be a guaranteed royalty, stipulating that, over a specified period of time, the artist will receive a specified amount of money. The artist may be paid monthly, quarterly, semiannually, or annually—it needs to be written out, and agreed to, in a contract. Further, a royalty audit clause would permit the artist or someone assigned by the artist to audit the manufacturer to ensure that the artist was properly remunerated. Some contracts even describe penalties if the correct royalties are not paid.
- *Approval.* The artist is allowed to approve or disapprove the final product. The artist may request layouts, preproduct samples, or a copy of the actual object to evaluate.
- *Marketing date.* This specifies when the product is introduced into the market (for instance, at a trade show) and when it will be shipped to retailers.

For Julia Cairns, a painter in Davenport, California, whose work has been licensed to book publishers and the manufacturers of thermal beverage holders and refrigerator magnets, "almost all of the money I make from licensing comes from advances, not the royalties themselves. The license may be only for two years, so the license expires before additional royalties kick in."

"I'm looking for artists who have a specific style or subject matter that people can grasp easily," said Shirley Henschel, owner of the New York City–based art licensing agency Alaska Momma. "When I look at art, I think, 'Can it provide a direction for the market or does it reflect an existing direction in the market?'"

Unlike the relationship of artists and their dealers, there is rarely a strong personal bond between artists and licensing agents. Helen Lee, a painter of impressionistic landscapes in Kansas City, Missouri, has had her work licensed to the makers of over 200 products (including journals, note pads, paper plates and napkins, books, coffee mugs, shower curtains, shopping bags, photograph albums, and jigsaw puzzles) for ten years by Shirley Henschel without ever meeting her. "I read something about Shirley in a magazine article somewhere, and I sent her some examples of my work," Lee said. "Within a few days, she called me up to get more samples. She started selling my work right away."

A variety of factors determine how much an artist will earn. The state of the economy, the market for particular items (what else is competing on store shelves), how effectively the manufacturer sells the product line, and where retailers place items on their shelves all factor into the success and failure of a product. It can be quite difficult to determine, when an object does not sell well, the degree to which the artist's image is or is not the problem.

The world of art licensing, even more than the art world, is also limited by fads and changing tastes: What looks fresh and interesting for a certain period of time becomes stale after a period of time. A gallery artist may receive a considerable amount of acclaim for his or her work at one point, which eventually and inevitably recedes as new artists and styles come to the fore, but a group of collectors are likely to continue buying the artist's work over the years. Manufacturers, on the other hand, make rapid and abrupt shifts. As the market for products with impressionist garden scenes became saturated in the 1990s, there was less interest on the part of manufacturers in licensing Helen Lee's images. She continues to earn some royalties for her images, but she needed to pursue gallery sales of her originals in order to make up the lost income. "Those sales have actually become easier because of how many people had become familiar with my work through licensing," she said. "That familiarity has also made them willing to pay more for my work."

ARTISTS' PRINTS

Print publishers offer different kinds of potential rewards to artists. Prints allow artists to get paid for the same image again and again. Art prints clearly sell for less than original works but, because of their greater numbers, are disseminated more widely. The lower prices of prints may also bring artists an entirely new clientele, some of whom may later purchase the more expensive original pieces, as well as provide money to tide them over until the larger works begin to sell.

There are different ways in which a line of prints may come into being. A wide range of agreements may be made between artists and print publishers, and the differences reflect the broad range of publishers around. Some publishers, such as Tyler Graphics or Gemini, which publish limited editions by some of the most renowned contemporary artists, allow artists maximum artistic control and guarantee income. Others, such as Franklin Mint, are mail order houses and offer artists what are actually work-for-hire agreements that take away copyright in exchange for a flat, up-front fee.

Self-Publishing

The most common approach is that artists themselves locate a fine art printer in order to self-publish an edition (limited or not) of an image from an original painting, produced through photo-offset or by computer ink-jet printer. Self-publishing is customary for artists who sell their work directly to buyers at art fairs, shows, and expos or through subscription; and it requires an extensive knowledge of their collectors. Artists who have a limited track record in terms of showing and selling their work would be unlikely to want to print 3,000 copies of a particular image, because they might never recover their initial costs. Some fine art printers, however, encourage artists to print in large quantities, offering price breaks for each thousand.

It is rare that an artist starts a career selling prints; instead, the market for original pieces should be tested, with prints following as the number of potential buyers grows. Early in their career, artists should forego the price breaks, creating smaller editions that are in keeping with the expected size of the actual number of people likely to purchase a print.

Fine art printers can be located in a number of ways. Many of them advertise in art periodicals, and the magazine *Decor: The Magazine of Fine Interior Accessories* (Commerce Publishing Company, 330 North Fourth Street, St. Louis, MO 63102-2036, $20 per year for 12 monthly issues), which sponsors the Art Buyers Caravan shows around the United States, has an annual "Sources" issue every July that lists many of the fine art print publishers and distributors in the country. Of course, one may also inquire of other artists, who could report their own experiences and levels of satisfaction. Certainly, artists would want their work printed on archival acid-free, pH-neutral paper with tested inks (not soy-based, for instance) that will not fade in normal light. Printers that do not specialize in fine art prints are likely to use inks and papers that are not sufficiently durable. Some printers have consultants on staff, who will help artists plan for the appropriate publication size and marketing plan (do you have a mailing list? do you want a postcard version of the image to send to potential buyers?).

Print Publishers

Many galleries that sell prints obtain these works directly from publishers who have established a distribution network. Mill Pond Press, Greenwich Workshop, Wild Wings, Applejack, and other publishers are regularly contacted by artists who would like photo-offset prints of their work sold in galleries; and these companies are also regularly on the lookout for artists whose works would both reproduce well and appeal to their clientele. These companies produce catalogs of the prints they sell, and artists should examine them to see if their work would fit in. The size of these editions is generally under 1,000, and artists receive a royalty of between 10 and 20 percent (the amount determined by the prestige of the artist and how well their work has sold in the past). The company doesn't print the editions itself but contracts out to other printers.

A number of points should be kept in mind when negotiating a contract with a print publisher: The artist should retain copyright and demand that the seller always plainly state the name of the artist and that the artist holds the copyright; second, the contract must state the number of copies that the company is permitted to sell.

Another point to be considered in a contract with a publisher is the time period during which the distributor may advertise and sell the works, since the artist may choose to make his or her own edition to sell at some future date—of course, that is possible only if the artist holds copyright and the contract allows it. Another way in which artists may maintain their control is by selling only a certain number of prints to a distributor. For example, L.L. Bean catalogs contain descriptions of "limited quantities" for certain prints, which refers to the number of prints in stock and not the entire edition. In such cases, the artist has sold L.L. Bean a stack of prints but remains free to print up more to sell.

The percentage of the earnings from the sale of prints (or royalties) payable to the artist should be covered by the contract. It is important to stipulate that any advance paid to the artist is not refundable if the works do not sell, known as an "advance against royalties." In addition, some artists may be reluctant to proceed on an all-royalty basis. Certainly, none of the publisher's costs of printing, advertising, framing, taxes, or distributing these works should be borne by the artist. If the publisher wishes to purchase not only limited reproduction rights but also the original work itself, artists may try to divide this sale, offering the original for one price and the reproductions on a percentage basis. That may not always be possible.

A final point involves maintaining some artistic control over the reproductions whenever possible in order to ensure that the copies best represent the artist's intentions. Poor quality reproductions or any malfeasance, such as prints that have duplicate numbering or are misrepresented as being approved by the artist when they weren't, may reflect badly on the artist's reputation and diminish the value of the artist's other work.

Dealers and Galleries

At times, the process of selecting, creating, and paying for an edition will be taken over by an artist's gallery or dealer, who may sponsor the artist in creating an original work at a print studio or photo-offset an existing piece. When commissioning an original work, the artists are more likely to work with high-end printers, such as Gemini or Tyler Graphics. The sizes of these editions are often smaller than the runs in self-publishing— galleries are marketing pieces to their select clientele rather than to the thousands of people attending an art fair, and the number is often under 100 and sometimes closer to 10 or 20—and the dealer will receive the same commission as for original works.

"Signed by the Artist"

The art print market is one where signatures count for a lot. An artist's name on a print can bring up the price by two or three times, and artists generally view signing and numbering works as a valuable source of income for themselves.

That is not to suggest that signed prints have intrinsic value only to the autograph hound; many artists and their dealers contend that by signing a print the artist approves and endorses it and, implicitly, claims it as his or her own work. In some cases, however, the entire economic value of a print is in the signature. Salvador Dali and Marc Chagall, for instance, signed blank pieces of paper on which reproductions of their works were to be made. Picasso's granddaughter, Marina, also published a posthumous series of the artist's prints. In none of these instances did the artists ever see the finished works. Nonetheless, those prints were marketed at prices that would lead collectors to assume they were original works of art in some way.

The tradition of artists signing their prints is about 100 years old—before that, they frequently used monograms. Artists such as Henri de Toulouse-Lautrec and Pierre Bonnard signed some and not others depending upon the wishes and ego of the buyer. They signed works as they sold them, and those for which there was no demand in the artists' lifetimes went unsigned. The value of their signed and unsigned prints is the same, as there is no question of the artists not authorizing or approving them for sale. The more recent convention of artists signing all the prints in an edition at one time is said to date from the 1930s when a Parisian dealer, Leo Spitzer, convinced a few of the major artists of the day, including Henri Matisse and Pablo Picasso, to produce elegant reproductions of their work that they would sign and he would sell.

Most artists are now well aware that their signatures mean more money for their works. Picasso did one series of etchings in the 1930s called "The Vollard Suite," which he began signing in the 1950s and 1960s as a way of increasing contributions to political causes he championed. Norman Rockwell signed a series of prints to help support the Cornerhouse Museum in Stockbridge, Massachusetts, which featured his paintings; and Andrew Wyeth did the same on behalf of the Brandywine River Museum in Pennsylvania, where his paintings are on display. Other artists have less philanthropic uses for the money that they make from their signatures.

The high prices that these signatures mean have led to fake signatures, signatures that are printed on the paper along with the image, and false or misleading statements about these works by their sellers. While artists may be altogether innocent of false claims made about their work, prosecution of their dealers or complaints by collectors may adversely affect the market for a significant degree. Such has been the case with Salvador Dali for a number of years, a result of the large number of prints on the market that may or may not be "original."

Artists should carefully review any promotional material associated with their work as well as make certain that their copyright is noted (on the same or an adjoining page where artwork is reproduced) and, if this is a limited edition, that there is no duplicate numbering. Publishers sometimes print more than the stated number in an edition, in case there is a smudge or damage to the paper or something else. Extras may be sold accidentally or intentionally as part of the edition unless the artist sees that they are destroyed.

BARTERING AND LEASING ART

More than anything else, artists prefer straight sales of their work and prompt cash payment, but this doesn't always happen. At times, agreements can be made to barter artworks for something else; at other times, works may be leased. Potential problems abound with these situations but so do great benefits for artists.

Bartering

Bartering is probably the oldest form of economics—money, on an historical scale, is the new kid on the block—and artists who are rich in canvases if short on cash have kept barter alive. A lot of people have benefited from bartering with artists. Jack Klein was Larry Rivers's landlord for a number of years and was able to retire and move to Paris on the paintings his tenant gave him in lieu of rent. Sidney Lewis, president of Best & Company, built up a collection of paintings by major and lesser-known artists swapped for washers, driers, and other appliances.

Dr. Frank Safford is another. He tended to the health of Willem de Kooning during the 1930s and 1940s, in the years before the artist's works began selling. He was paid in half a dozen paintings, one of which the doctor later gave to the poet and dance critic Edwin Denby, who sold it to buy a house.

In general, doctors and lawyers do the biggest bartering business, because, not surprisingly, their fees are often beyond the reach of most artists. Of course, many professionals will not accept artwork in exchange for their goods and services, and it is best to discuss methods of payment and how bartered objects will be valued in advance. Bartered property is taxable income and must be declared as such. For various reasons, the artist may give his or her work a high value while the recipient, wishing to keep taxes low, might pick a low value. Most artists who exchange their work for goods or services have not sold before, and there are few objective criteria available for valuation. An agreement must be made between the two parties, as discrepancies may pique IRS interest. This can be a testy area for negotiations.

Some people will accept art in total or partial payment from some clients but not all the time. They, too, have to pay rent and employees' salaries, and the partners of a law firm cannot share art as they would a cash payment for services. Not being able to accept art as payment does not imply that the professional thinks less of the artist and will not do his or her best work, but artists are free to shop around for people who will accept artwork as payment.

Dealers, from time to time, also accept something other than money for consigned works in their galleries, such as jewelry or other pieces of art. The artist, of course, should be paid only in cash and at the price level established between artist and dealer—not at whatever the appraised value of the jewelry or artwork is found to be.

Leasing

Renting or leasing works of art also provides the opportunity of greater exposure for artists' work and, more often than not, results in sales to private individuals and corpo-

rations. There are benefits for both artists and dealers, because they are able to generate some income from works that haven't yet sold.

Artwork rentals can be arranged through a variety of sources, starting with artists themselves. One New York City real estate developer, for example, leased a wall sculpture from Jeffrey Brosk for the lobby of the Fifth Avenue apartment building he had erected "in order to give the place cachet for prospective tenants," according to the artist. It seemed to work, as the building filled up and the developer decided to purchase the sculpture.

Art dealers and corporate art advisors also arrange rentals and leases for clients who want to "try works out" for an extended period of time. Dealers often allow prospective buyers to take art home for up to ten days with no charge to see if it "works" and may devise rental agreements for collectors who take longer to decide or whom they would like to cultivate as long-term clients.

"Some people need a breathing space of time in order to consider the purchase, and renting can allow that," said Christopher Addison, owner of the Addison-Ripley Gallery in Washington, D.C. "More than half of the people who rent end up buying the work, partly because of laziness—they've grown accustomed to the work."

A number of art museums around the country, too, have established sales and rental galleries that permit collectors to buy or lease works in a variety of media. With certain institutions, such as the Wadsworth Atheneum in Hartford, Connecticut, or the Whitney Museum of American Art in New York City, works of art from the institution's own collection have been loaned to certain corporate museum members, but the objects in most sales and rental galleries are separate and distinct from the museums' collections.

Both the sales and rental galleries at the Baltimore and Philadelphia museums of art have paintings and works on paper on consignment from local galleries and those in New York City, affording a mix of lesser-known and well-known artists (such as Jennifer Bartlett, Jim Dine, Jenny Holzer, Sol Lewitt, Robert Motherwell, and Louise Nevelson). Other sales and rental galleries, such as those at the San Francisco Museum of Art and the Springfield (Massachusetts) Museum of Fine Arts, consign pieces directly from artists, most of whom are likely to be of the lesser-known variety.

The art rental field is generally one for younger, lesser-known or "emerging" artists, since the more famous artists are likely to have waiting lists for their work and would have less incentive to let pieces go out on rental. Being associated with a museum, even though it is with the sales and rental gallery of the institution, does attach to the artist a museum imprimatur that adds stature to the artist's work.

Renting a work is usually a short-term event, lasting from one to four months, while leasing may range up to two years with payments applied to the sales price should the customer decide to buy. Fees for renting or leasing are usually based on the market value of the art, ranging between 2 and 5 percent a month, although it can go as high as 15 percent. Discounts for leasing more than one piece at a time can be negotiated with dealers, and sales and rental galleries frequently have discounts for museum members.

Some rental agreements stipulate that the renter provide insurance for the work for the entire term of the lease as well as pay for crating and shipping. In addition, the schedule of payment, perhaps monthly or in total at the outset, may be negotiated or specified in a contract.

Leasing has generally become more attractive to businesses since the enactment of the 1986 Tax Reform Act, which lengthened the period of depreciation for office equipment that a company buys. Art has usually been lumped in with "property, plant and equipment" for business accounting purposes, viewed as office decoration rather than a separate category of investment. The Internal Revenue Service has increasingly disallowed deductions based on a depreciation of corporate art (because, the IRS claims, art actually increases in value over time and isn't subject to wear and tear). Furthermore, the new, slower payback resulting from the 1986 law's extension of the period of depreciation has led companies to look more favorably on leasing telephones, automobiles, and a host of office-related equipment.

"With leasing, a company can deduct all of the expenses now instead of waiting for years," Janice M. Johnson, partner at the accounting firm of BDO Seidman, stated. "Leasing lets you get around the depreciation problem. Leasing works of art instead of buying them also solves other problems: How long will the company managers have the same tastes? Some people just like change. How permanent are the company's facilities? Maybe the company will move in a few years and will want different art. There's also the issue of the quality of the art—you may rent cheap stuff now while saving up to buy something more substantial later."

Not all art dealers and advisors are pleased to let work out on a rental basis, however. It can be a bookkeeping, insurance, and inventory headache for dealers who must keep track of lease payments, establish rental agreements, protect these pieces from damage, arrange insurance coverage, and arrange for the work to be returned at the end of the rental period.

"Facilities people" at many companies have no idea of how to care for artwork and may place pieces where they will fade from exposure to direct light or where employees smoke or there is inadequate ventilation. Vandalism and theft are also concerns. In addition, because they are not buying it, the corporation is more apt to view the art as mere decoration and not shield it from damage in the same way as it would protect something the company owned. Other dealers and art advisors have mentioned that artists aren't as likely to lease their best work.

"There are questions you have to ask," Jeffrey Brosk said. "Who is renting it? Where is it going to go? How will it be protected? You have to be more selective when you're renting a piece but, if you are more selective, you can give better-quality work."

Artists derive a number of very clear benefits and practical concerns with renting and leasing their work. Their pieces may be seen by a wider range of people than the limited group of art gallery "regulars," stimulating interest in the work by those who may become future collectors.

Stephen Rosenberg, a New York City art dealer who has consigned work to the Philadelphia and Delaware museums of art, noted that "people have come in here when they're in New York to see the work of some artist they saw through a rental arrangement somewhere else. I've had quite a few sales that way."

The potential for positive exposure may convince artists to loan works to banks or restaurants or charge only minimal fees, stipulating that the work must be returned in good condition. If there is any damage, all restoration costs should be paid by the institution, not the artist.

Any contract between an artist (or an artist's dealer) and a renter should include specifics about the following:

- The length of the rental arrangement
- The rental price (which the artist is likely to decide with his or her dealer, who may know a lot more about going rates)
- How the artist or artist's dealer is to be paid; documentation that the art is insured for the entire period of the lease (by the renter or artist's dealer but not by the artist)
- That the artwork is credited to the artist (it also doesn't hurt to have information on the artist noted somewhere)
- That the art not be harmed; but, if it is, that the renter must pay for all repairs (the artist should be given first refusal on making any repairs) or cleaning (if a lot of cigarette smoke or coffee splashes have discolored it)
- That the renter (or the artist's dealer but not the artist) should bear all expenses of packing and shipping the work.

Artists may also wish to have some say over where and how their work is displayed and may want some veto power over certain companies with which they do not wish to be associated. In addition, the work should be available for the artist (or dealer) in the event of an exhibition.

"There should also be an affirmative obligation on the part of the renter to return the work after the lease has expired," said Kate Rowe, a New York City lawyer who frequently works with artists. "It must be stipulated on the rental agreement that the renter is obligated to return the work at the end of the rental period. It's not uncommon that no one takes responsibility, and the work just sits there indefinitely. If a long time passes or someone dies or the paperwork is lost, no one quite remembers who owns the work. This problem happens a lot with museums in their long-term loans."

When the work is rented through the artist's dealer or gallery (or consigned to a sales and rental gallery by the dealer), the contractual agreement between the artist and his or her dealer should resolve some of the same points. Specifically, it should indicate that the artist not bear any expenses and that any rental payments to the dealer will be split between the artist and the dealer on the same percentage basis as when a work is sold.

Some dealers consign works they represent to the sales and rental galleries of museums as a way to help out the institutions, which use the sales and rental galleries as fund-raising tools. A painting consigned by the dealer may be sold at the sales and rental gallery; the artist receives the same percentage (for instance, 60 percent) as if the picture had been sold regularly by the dealer, with the dealer and sales and rental gallery splitting the amount of the customary dealer commission (40 percent)—usually, that gets divided in half.

Also remember that an artist receives no tax deduction for renting a work of art to or through a museum. Tax deductions, for artists and everyone else, are available only for outright gifts to nonprofit institutions.

DEVELOPING YOUR OWN SALES NETWORK

To many artists, art galleries and dealers are the gatekeepers of the art world, leading to exposure, sales, a place at the table. That gate also strikes some as a barrier, lessening their chances to show and sell work and keeping away would-be buyers who are not part of the art market. These buyers may not be thought of as true collectors, as they look for artwork that is pretty or decorative or sentimental—terms that are not art criteria. From time to time, artists look to create a system for showing and selling their artwork outside "the system," perhaps putting their work in malls or on sidewalks or on the World Wide Web.

After beating their heads against the wall, trying to get into the traditional art market, husband and wife Bob and Michelle Kennedy of Key West, Florida, decided to open their own galleries—Kennedy Galleries (for paintings) and Kennedy Studios (for prints and photographic reproductions of the paintings). The works have sold well ("Just in Key West, we do $2 million a year," Bob Kennedy noted) to the point that, beginning in the 1980s, the two started to franchise their names. Around the United States, there are forty-two Kennedy Studios and five Kennedy Galleries, all displaying the work of the two artists.

"I didn't want to have to tiptoe around dealers," said Michelle Kennedy. "I didn't want to convince a gallery owner that my painting works." She also didn't want to wait a long time to have her work displayed and an even longer time to see any sales. Her experience of other galleries and dealers left her frustrated for other reasons as well.

"I had been in other galleries, but they all tended to pigeon-hole artists," she said. "When something works, they're afraid of anything different. Some artists find their bliss and keep repeating it, but I don't want to rely on a style." Her work covers a wide territory in terms of subject matter and style, from academic realist still-lifes to abstract landscapes and satiric German Expressionistic images. For reasons of marketing, dealers generally want the artists they represent to have a defined look, which further turned off the Kennedys to the traditional gallery world. "If I work in one style one day and in another style the next day, it never seems to have bothered the people who buy my work," she said.

Because of the popularity of their work, especially Michelle's, would-be gallery owners have proven willing to pay between $25,000 and $100,000 to franchise the name. Most of the gallery owners exhibit the work of other artists as well and are not required to purchase either Bob or Michelle Kennedy's work, although they all do, paying 35 percent of the suggested retail price; contractually, they must also pay an annual royalty fee to the Kennedys of 3 percent of gross sales.

Some artists wait for the "big break" to come in their careers—their work is selected to be in a prestigious exhibition or gallery, their work wins an award, a major private or public collector purchases their work—while others try to create their own breaks. Monterey, California, sculptor Richard MacDonald's complaint with galleries was simply that they didn't work hard enough at actually selling the pieces on display and, he believes, the dealers were content to consign rather than buy outright the artworks they represented, which limits both their risk and their incentive to make sales. "What kind of business relationship is this, where the artist puts out all the effort and money, and the gallery does nothing?" he said. "A car dealer buys a certain number of cars and has a certain amount of time in which to sell them. That drives the market. Why shouldn't art dealers meet the same kinds of performance requirements?"

Unlike the Kennedys, MacDonald did not start his own gallery but fashioned a relationship with the seventy-plus galleries representing his work that largely takes over their operations. The galleries handling MacDonald's work are referred to as "subscribing galleries," as they sign on to purchase—rather than take on consignment—a minimum of ten sculptures. ("I need to show enough of my work to have free expression," MacDonald said. "If someone has only three of my works on the floor, you're not representing me.") When a gallery expresses interest in representing MacDonald's work, "someone from our staff flies out to visit the gallery, in order to make sure it is compatible with the work," said the artist's son and business manager, Richard MacDonald Jr. "Is the gallery large enough for sculpture? Will the work be given its own space? We don't want my father's work mixed in with other sculpture." Both MacDonalds ascertain that the prospective gallery is well capitalized by running credit checks and demanding to see financial records.

The demand that MacDonald be the principal sculptor in whatever gallery he is represented, that his work be shown in depth and without the distraction of various other artists, upends the traditional artist-dealer relationship, but his subscribing galleries play ball. "When you're doing $1.2 million in sales, which is what my galleries average for my work annually, you can get what you want," he said. "Success leads to different assumptions."

Marvin Carson, director of New York City's Gallery Revel, which represents MacDonald, noted that "every dealer asks himself two questions about the art in his gallery: Does it have integrity?—and, certainly, Richard's work has the quality—and can you make money from it? Richard's work does sell. There are so few saleable sculptures in the world, and his work captures peoples' hearts. It's so pretty."

Contracts between MacDonald and the subscribing galleries not only include provisions for their purchasing outright ten pieces but also that they sell a certain number annually. They also must reorder whenever a sale is made ("Nothing leaves the floor until a replacement arrives," MacDonald said) and regularly place local advertisements ("They can't run an ad without our shooting the image and OK'ing the text"). For his part of the deal, MacDonald not only provides the artwork but runs national ads in magazines. "The yearly advertising budget is in the six-figure range," MacDonald Jr. said. It includes marketing brochures for all galleries handling the artist's work, photographs of each piece, cards with a history on the back for each piece, letters for galleries to send to prospective buyers (the artist employs an in-house writer) and videos on the artist and his manner of working to show to collectors. When an agreement to sell to the gallery is made, a sales training seminar is conducted for gallery staff, describing how to present and light the work, how orders should be filled, and what should be said about each piece (a mock sales presentation takes place).

MacDonald runs a medium-sized corporation, with 45 employees that include a sales force of twenty-eight, six account representatives, several supervisors, and support staff. His rent for studio and office space amounts to $70,000 per month. A somewhat larger operation is run by Monterey, California, painter Thomas Kinkade, whose Media Arts Group has approximately four hundred twenty employees (in separate departments for accounting, customer services, legal affairs, marketing, public relations, sales, and warehousing) and is listed on the New York Stock Exchange. These employees work with the investors in Media Arts Group, with the almost 30,000 members of the Thomas Kinkade Collectors Society (costing $50 per year, making them eligible to purchase Kinkade print editions available only to society members), with the thousands of people seeking tickets ($75 per person) for the artist's appearances at the galleries showing his work, the dozens of licensees who create products (coffee mugs, greeting cards, jigsaw puzzles, mantel clocks, night lights, plates, and stationery, among others) based on Kinkade's imagery and with the hundreds of galleries that represent the artist's work.

Approximately 200 of these galleries are referred to as "signature galleries," a generic term for spaces that exclusively represent one artist, and they only handle prints—photographic reproductions of the Kinkade's paintings on paper or transferred onto canvas. Many of these galleries, however, also carry the licensed merchandise. Those looking to sell the work of Thomas Kinkade are required to undergo a weeklong training program in Monterey (known as the "Thomas Kinkade University") run by the Retail Development Group of Media Arts, in which one learns about inventory control, marketing, and sales. The layout, lighting (dimmer switches mandatory), wall paint (teal), and carpet color of the gallery is also decided by Media Arts, and the physical space must be approved by a district sales manager before it is allowed to open.

Just as with Richard MacDonald, Media Arts does not consign work to galleries but sells it outright; and a gallery's initial purchase must be at least $40,000 wholesale (with 60 days to pay) with a performance agreement to buy between $50,000 and $100,000 annually after that. Media Arts stipulates that galleries must

mark-up their prints 100 percent for retail sales. "You cannot discount. If you do that, they'll cut you right off," said Stan Brown, owner of three East Coast Thomas Kinkade signature galleries.

With so many galleries relying specifically on them, the Kennedys, MacDonald, and Kinkade all need to be highly productive. In the mid-1990s, the limited edition size of Kinkade's prints was approximately 3,000. More recently, as the number of signature galleries has expanded, the number has topped 10,000, divided between canvas and paper prints, and they are limited in terms of being "signed and numbered," "galley proofs," "publisher's proofs," or "artist's proofs." While large editions mean that more people are able to purchase an artist's work, there is also a downside in terms of the artist's lowered reputation in the mainstream art world. "Serious collectors are serious snobs," Marvin Carson said. "They want to buy works where the edition is eight or fewer. They see someone like Richard MacDonald putting out works in editions of ninety or so, and they say, 'That's not a real artist.'" Recognizing this as a problem, MacDonald has reduced the size of some of his editions, from 175 to 90 and a few editions have gone as low as 9 or 10 pieces.

The need to keep putting out "product" can also be quite wearing on an artist. According to Bob Kennedy, who tends more to the business aspects of the franchises, Michelle produces "around one hundred paintings a year, maybe two or three a week," and the majority of them are turned into limited print editions (980 photographic reproductions and 200 giclees). "Sometimes, I feel it's a curse to have to keep the studios well-stocked, but it's also very motivating," she said. "I produce a lot because I know I have to." Her one lament is that "I've never been able to build a body of work. As soon as I've finished something, it's out of here."

SELLING TO CORPORATIONS

Just as artists need to research potential galleries that might show their art, those looking to sell work to, or have it commissioned by, corporations must find out which companies are buying and what kinds of artwork they purchase.

One of the ways to discover this is through some of the publications in this field. Americans for the Arts (One East 53 Street, New York, NY 10022, tel. 212-223-2787) publishes *Corporate Giving to the Arts* ($30, plus $4 for shipping and handling), which is available at many libraries around the country. The most often used book for corporate collectors, however, is ARTnews' *International Directory of Corporate Art Collections*, which is revised biannually on even numbered years and contains names, addresses, telephone numbers, contact persons, and both general and specific information on the collecting practices of almost 1,200 companies around the United States and Europe. This book is a favorite among artists' representatives, who use it as a way to place the work of artists they represent in these collections, and it can be found in many libraries around the country.

Since corporations do not list separately on their ledger books how much money they spend acquiring works of art, it is impossible to get a complete picture of the total

aggregate value of corporate art buying. However, the New York City–based Business Committee for the Arts, a nonprofit group that keeps tabs on corporate financial involvement in all areas of the arts, estimates that companies annually bought in excess of $1 billion in art during the 1980s. During the 1990s, there was less buying, and some long-time corporate buyers have even been selling off part or all of their collections, perhaps because they need the money or find the attention on art to be a distraction or have concluded that buying art is less appropriate for leaner-meaner companies. This market has become smaller and more competitive as a result; artists may want to concentrate their efforts more on companies in their own towns or neighborhoods, where a company's good neighbor policy encourages the acquisition of artwork by local artists.

As noted above, many companies rely on the help of art consultants to select appropriate two- and three-dimensional artwork. With other companies, however, the people in charge of the collections may have few art qualifications—some are interior decorators who have upgraded their titles—and have little to do with the works under their care, save for maintaining an occasional inventory or arranging where pictures hang in a company's cafeteria. At yet other corporations, the individuals in charge of the art collections are found in the public relations, advertising, or marketing departments. Still, some corporate heads—for instance, the president or chief executive officer—prefer their own opinions to those of outside art advisors or others on their payroll. It is wise for artists to find out who in a company is in charge of purchasing art and make contact with that person, if possible.

Most art consultants who work for corporations prefer to deal with just one top person rather than a committee, because groups are less clear about what they want, and artists may take the same point of view. "I tried to do some work for a five-person committee at a law firm in Boston once," said Bruce St. John, former director of the Delaware Art Museum and an art consultant for many years. "They all had different ideas about what they wanted, and they kept throwing out suggestions but wanted to change them right away. 'Oh, no, that's too expensive,' someone would say when I'd recommend something. But I'd say to them, 'I thought you had a budget of so-and-so to buy this sort of work.' 'Yes,' they'd say, 'but we've decided we don't want to spend all that.' What in hell do I want that sort of nonsense for?"

However, when there is only one person in charge of the collection, what happens when that person steps down? Union Carbide sold off a large portion of its collection at Sotheby's in 1982 after the top man resigned and the company moved its headquarters to Danbury, Connecticut. A similar action occurred in the 1970s, in France, when Jean Dubuffet was commissioned by Renault in 1973 to build a 2,000 square-yard sculpture at the company's headquarters near Paris. When the president of the company, Pierre Dreyfus, stepped down in 1975, his successor wanted the project abandoned, claiming that "the automobile business has nothing to do with art."

In another instance, Sohio of Cleveland's chairman, Alton W. Whitehouse Jr., commissioned Pop Art sculptor Claes Oldenburg to create a giant rubber stamp called "Free Stamp" in 1985. However, Whitehouse was ousted soon after by British

Petroleum, which bought a 55 percent share in Standard Oil at that time, and his successor, Robert B. Horton, cancelled the commission, reportedly interpreting the sculpture to suggest that Standard Oil is a "rubber stamp" for British Petroleum. After a period of considerable embarrassment for the company over questions of censorship, Horton finally paid Oldenburg for the piece and arranged for the sculpture to be completed and sited elsewhere in Cleveland. Perhaps, the reason for the commission in the first place was to cause the embarrassment.

The retirement of the chairmen of the First National Bank of Chicago and the Chase Manhattan Bank in New York City, both of whom were the guiding forces in their banks' collections, however, did not result in a diminution of the collections. Their successors have continued the acquisitions policies. In these companies, it is clear that the art collection has become not a symbol of one person's interests, but a part of the entire corporation's self-image.

Corporations, unlike government agencies and foundations, generally have no standardized applications for artists and seeking commissions or sales and project. Also, unlike agencies and foundations, these businesses rarely have an independent or professional review committee to evaluate art patronage; instead, an individual or two is often in charge of reading letters from artists and then deciding whether or not the company is interested. Artists enter a realm that is not accountable to the public (unlike government agencies and private foundations), and their success in selling to corporations depends on how they present themselves and their works or projects to the person in charge of the art collection or budget.

Artists should look carefully in the available books at what kinds of pieces a corporation collects in the same way they would when looking at prospective art dealers or galleries. A collection of abstract paintings and minimalist sculpture would be an unlikely market for a realist watercolor artist, for example. Books about corporate art buyers generally list the largest collectors, those with established annual art budgets and even full-time staff to care for the objects. More companies than those purchase art, although they may not do so regularly. Businesses in the artist's own area—large or small, headquarters or branch offices—are reasonable places to try to sell artwork, although this is a hit-or-miss affair. It's hard to prepare since, if art hasn't been purchased in the past, an artist cannot know what company executives will like.

Artists should start with a simple telephone call in order to determine who is in charge of buying artwork (that person's name should be spelled correctly), the name of the company and its address. Additional information about the company may be available on its Web site (if there is one) or in standard business reference publications in a local library. If the company has collected artwork in the past, artists should know what type (two- or three-dimensional) was purchased, the size of the works in the collection, and where it is displayed. Some companies are thematic in the types of art they purchase (Campbell's Soup, for instance, has a collection of soup tureens) or buy pieces by local artists; Pepsi, on the other hand, has a sculpture garden.

The next step should be a letter or telephone call to the individual in charge of buying artwork, describing succinctly what the artist has in mind (sell a work or be commissioned, who will benefit and how, what the work looks like, stated as graphically as possible), the cost, when the project might take place, how it is to be publicized, and the artist's own background and qualifications for this work. Even after a telephone call, this information should be put in a letter to either the person with whom the artist spoke or to whoever in the company makes the decisions about artwork.

Of course, corporate employees generally are not as immersed in the arts as the creator, and the work or project should be described in terms that would be understandable to a wide audience. Additional materials, such as reviews of past exhibitions by the artist, published profiles of the artist, and slides or good-quality photographs of the artist's work, should be included with the letter. Pictures often explain better than explanations, and the reviews of a newspaper critic—another nonexpert—are likely to be closer to the company executive's level of understanding than the commentary of the artist. A resume is optional, depending on the strength of the other materials.

Also, ask for a personal interview and call a day or so after the expected receipt of the letter to set up a meeting. It's easier to reject someone unmet than a person with whom a personal rapport may have developed.

In any meeting, an artist must present him- or herself as a professional, someone who deserves to be accorded respect, rather than as a supplicant. Self-respect garners respect from others. Many people secretly (or not so secretly) wish that they were artists, and artists should understand that this vicarious feeling about art and artists is part of the reason the company sponsors cultural activities or a collection in the first place.

4

A WEB SITE?

"It's here," said artists' advisor Carol Michels, speaking of the Internet, "we might as well use it." Certainly, a constantly growing number of artists have done just that, creating their own Web sites and hoping that someone (collectors, critics, dealers, publishers, other artists) finds them. Getting found is no easy thing, and what is supposed to happen after an artist's site is discovered is not necessarily obvious, either.

"Many people are very confused about how things work on the Internet," said Peter Platz, director of Internet marketing at Integrated Communications Enterprises in Rochester, New York. "They think, 'if you build a Web site, people will come,' and it just isn't true."

THE BUSINESS OF MARKETING ART ONLINE

How to get potential buyers to come to your site is a matter of a considerable difference of opinion. Geri Stengel, owner of the New York City–based marketing company Stengel Solutions, recommended that artists purchase e-mail addresses from companies (Web Promote and Net Creations, for instance, which charge 20 cents per address) and do a test marketing of between 5,000 and 20,000, informing these people where their sites are and what can be found on them. Because the individuals on these lists have agreed to receive advertisements, she noted, the likely return rate—those who visit the site and decide to make a purchase—is between 2 and 5 percent. (Bad e-mail, where the recipients don't want solicitations, is referred to as "spamming" and is more frequently deleted sight unseen.) Platz, on the other hand, said that he is "bombarded with e-mail all day long, and every e-mail tells me 'Hey, take a look at the stuff on my Web site.' I delete all of those. I don't know why I should go there." He added that he prefers regular mailed postcards or brochures that show an artist's work and includes a Web address so that he can see more, if he chooses.

Undoubtedly, the Internet has become a huge growth area in commerce. In 1998, according to Internet.com, which tracks electronic commerce worldwide, $11 billion in goods and services were purchased online and another $51 billion offline (that is, initial contacts were made through a Web site, leading to other, more traditional forms of contacts, such as mailings, telephone call, or personal visits). The most popular items sold through the Internet are books and computer software, followed by apparel, music, and gift items. Most of these products are nationally known, and Internet buyers shop on the Web because of the convenience, the ability to compare prices, to avoid pressure from salespeople, to save time, to obtain information on vendors, and to learn the availability of products.

Selling works of art through the Internet doesn't fit any of those criteria for shopping. Rather than expecting numerous online sales, artists are more likely to make sales offline to those who encounter their work first on a Web site. Various types of artist Web sites may be spotted on the Internet, but they generally fall into three categories: The first is a personal Web site, the focus of which is to provide information about the individual (who I am, what I've been doing lately); there is as likely to be a photograph of that person's cat as samples of artwork. The second type resembles a portfolio, with representative images (but usually no prices) that an interested collector, dealer, or art director (for an illustrator or designer) might want to see. The third type has a more commercial feeling, with a sales pitch heading ("Best contemporary landscape painting") and prices next to each image; online galleries generally take this approach. All of them have some way of contacting the artist (click on e-mail or an address and telephone number, sometimes both) and many contain biographical material, such as a curriculum vitae or biography and an artist statement.

Marketing experts generally recommend that artists promote their work in all the traditional ways (exhibiting, advertising, meeting prospective buyers, and corresponding with them) and use the Web site as a sales support tool; that is, more like a portfolio that interested parties may examine for a more complete sense of the artist. Eric Rakov, director of Web development at IBS International, a business marketing company in Rochester, New York, suggested that artists put their URL (http://...) on business cards, brochures, and any other piece of mail they send out. "You want to direct people as much as you can to your Web site and not just hope that they find you," he said.

In general, an artist's Web site rarely works in the manner of a merchandise catalog from which browsers will pick something they like and place an order. The Web site permits browsers to look at the subject matter and style of artwork available, as well as to learn more about the artist. After that, the potential buyer may simply place an order but will more likely contact the artist, either through e-mail, telephone, or regular mail, in order to obtain more information about the artist (where studied, where exhibited, if and where represented by a gallery, who has collected his or her work in the past, in what publications has the artist been reviewed or profiled in the past) and the work (size, medium, price). Because images on a computer screen or those that have been downloaded on a printer are not likely to be as sharp as a photograph, the artist may

be asked to send a slide or photograph to the prospective buyer. If the work in question is a limited edition print, artists may be required to provide the same type of information as art dealers (the size of the edition, who printed the edition, other versions of the print that may be in existence), as well as documentation.

GETTING PEOPLE TO YOUR SITE

There are vastly differing opinions on how to get found on the Web, of which personally telling potential and past collectors is but one solution. Through networking, you can create a large Rolodex of names to whom postcards and brochures may be mailed, listing your Web site. However, the world and all the possible art collectors in it inevitably will be larger than your mailing list, which is one of the appeals of the Internet. Between 75 and 85 percent of all Internet sales comes from browsers, who find Web sites through search engines, and some marketing analysts recommend that artists register with Internet search engines, news groups, and directories. You may be fully registered with most search engines in a matter of days, although Yahoo!—the largest of the search engines—can take a month or two, because actual people there look at each proposed Web site to ensure that the key words are relevant to the site. (With a lot of smut on the Internet, many companies that have nothing whatsoever to do with pornography use sexual language in their keywords in order to attract browsers.)

Properly registering your site may take as much thought and care as what is found on the Web page. Anyone who has ever done a Web search on one of the larger search engines, such as Yahoo!, Lycos, Infoseek, Excite, or Altavista, finds that it is common for over 1 million sites to be located, using even the most specific keywords. Search engines look for a group of words, and then rank the sites on the number of keywords found. Your Web site needs to rank high in a search, because no one is going to examine everything that a search engine finds. "If you rank below 40 in a search, you won't be found," said Lorelei Teamore, president of Ad-Web Marketing in Lewiston, New York.

A Web site is indexed in search engines through what are called "META tags," which are a title, a description, and keywords. The keywords are the most important element, consisting of up to 255 characters, including punctuation. Teamore recommended that one test different keywords for different search engines to determine which ones bring the greatest browser response. Certainly, the more unusual the object one is selling, the more likely that distinct keywords can be found that will match a potential buyer who is looking for that very thing. Artists are less likely to be found by browsers who just want a painting to hang over the sofa, as artists usually don't describe their work in that way.

TRACKING THE NUMBER OF HITS

A "hitometer," a service that generally costs $5 per month to use, will tally up how many visits there were to your Web site, where they came from, and when in the day they came. Other available services will check that your Web site will display in different browsers and how many other sites are linking to your own. (Someone else may link his

or her Web site to yours unbeknownst to you. "If you have an interesting property," Peter Platz said, "people will want to link up to you," as it may induce browsers to come to their sites.) Artists may also find out how long it takes for their Web pages to load; slow-developing Web sites are often blamed for losing browsers, who lose patience and click off. According to Human Factors International, a company based in Fairfield, Iowa, that studies how humans interact with machines, the rule of thumb is fifteen seconds maximum for downloading sites: Five seconds to figure out where you are, another five seconds to take in the site, and a final five seconds to figure out where you are going in the site. Web sites featuring artwork are always going to be at a disadvantage in this count, because images simply take longer than text to fully materialize, and probably the fifteen-second rule is less applicable to artists' pages since browsers soon learn that the process simply takes longer. However, technology is available to compress images significantly, making them load more quickly.

As new sites are coming online all the time, your Web site's place in a search engine is likely to fluctuate. The easiest way to determine your ranking is to type in the keywords for a search and see how far down the list the Web site now is. Online businesses systematically track their Web pages, requiring them to regularly change keywords in order to improve their rank, and there are companies that will perform this service for the owners of Web sites.

Linking to an Online Mall

This constant worry about one's ranking on a search engine may be quite wearing for artists (corporations have Webmasters and marketing directors on staff whose jobs include the maintenance and locatability of the Web site) and, according to Platz, "you can't really force your place in a Web search anyway." General Internet searches may not be the means by which art collectors discover artists. Todd Drake, an artist and Web designer for artists, prefers linking up one's Web page to popular gallery sites (known as "directory" or "mall" sites), such as Art Garden, ArtistsOnline, Art Odyssey, ArtistRegister *(www.artgarden.com, www.artistsonline.com, www.artodyssey.com, www.artregister.com)*, and others focusing on artwork.

"You can spend every waking minute trying to find the right keywords, but you're still likely to be only one of a million Web sites to search engines," he said. "But, in a good site, you get people coming directly to you." These gallery sites advertise themselves in publications that art collectors read, which may lessen the need for individual artists with Web pages there to make their own separate promotional efforts, and they direct browsers to specific artists or types of artwork. The database at Art Odyssey, which is based in Winston-Salem, North Carolina, allows browsers to select in the categories of medium, artist, and price.

Some costs are associated with linking to a gallery site. ArtistsOnline, which is based in Santa Barbara, California, calls itself a "free" Web site, but it charges a one-time fee of up to $150 to create a one-page portfolio (artists with their own Web site still must pay for a one-page "personal profile"); additional pages are $50 per page plus a fee of $1.95 per month, and any changes made to the Web site are billed at $40 per hour.

Gallery Art Garden, which comes out of the city of Alkmaar in The Netherlands, costs a monthly fee of $25, affording an artist four images and a description of his or her work; there are also costs for changes and additional pages.

The New York City–based ArtistRegister charges $450 for a one-year "membership" that includes one color illustration and text (up to ten lines); additional illustrations are $60 each. The Web site itself is not actively promoted—either by direct mailings or advertising—by its operators, but Marie Fischer, who designed ArtistRegister, claimed it receives an average of 12,000 hits every week from all over the world. "I tell artists to support their Web site with direct mailings; that's the best way to let people know where they can find the artists' work," she said. ArtistRegister will also create an artist's direct mailing ("We'll write a nice letter, putting the artist's Web site on it") and provide a stamp and an envelope at the price of $1 per name.

A spokesman for World Wide Arts Resources (located in Columbus, Ohio) claimed that the site receives 100,000 visitors per month, but there are no figures for the number of sales actually made on- or offline from the artists and galleries that have Web pages attached. ArtistRegister also has only anecdotal information about works sold, commissions, artists taken on by dealers or hired to lecture, teach, or give demonstrations. It only counts the number of overall hits, not the quality or the result of browsing, and it does not actively survey the artists. The gallery sites remain in business because artists pay them for services and the rental of cyberspace. Success in making sales of art through the Web cannot be established definitively, although there are signs of concern. Art Odyssey, which began in 1995, has been steadily losing artists because "artists aren't making any money," said Julia Fox, a customer representative at BizNexus, which owns Art Odyssey. "Our sense is that people want to physically see and touch the art."

Many mall and directory sites on the Internet try to develop collections of Web sites attracting and retaining a large number of users, often referred to in e-commerce as "stickiness." The most successful of these directories try to combine in one site all of the services and resources that a likely browser would want. Success for a directory site is measured by the amount of time a user stays connected to the site, as the longer the user remains, the greater the likelihood that he or she will become a customer of one or more of the businesses on the site. Before paying any money to a directory, artists should inquire as to the length of time that browsers stay there (on the average), how many visitors come on the weekly or monthly basis (and how is this information determined), how much turnover there is among artists on the site, and what types of advertising the company producing the gallery does and will continue to do. Finally, an artist considering an online gallery should visit the site regularly over a period of time to see how it looks, how easy or difficult it is to navigate, whether (and what kinds) of changes take place from one month to the next, and what quality of art is represented on the site (is this good company for my art to keep?).

"The problem with gallery sites is that there is too much for anyone to see," said Chris Maher, an artist, artists' advisor, and creator of the free online newsletter "Selling Your Art Online" *(http://1xcom/advisor/index.html)*. "No one has time to look at

everyone's site." He, like Eric Rakov, recommended that artists market their work in traditional ways, using their Web site in the manner of a portfolio, "to refresh the memory of people who have heard about you through word-of-mouth or who have already seen your work and want to see a larger representation of your art. When real collectors come to an artist's Web site, they already know a fair amount about the artist, and the issue is not if to buy but what to pick."

Buyers of artwork by artists they have never heard of before, he noted, are apt to purchase inexpensive pieces, such as a $25 lithograph of a wildlife animal that interests them: "It's stuff in the impulse range." Only through more personal associations do collectors become willing to purchase more costly artworks.

Maher praised the World Wide Web as an "extremely cost-effective way to show work, less expensive by far than putting on a gallery show or doing an arts fair. However, simply marketing online is shortsighted and to not market your work traditionally is foolhardy."

No way of operating on the Web comes without risk. Take advertising, for instance: Internet advertising generally consists of banners across the top, bottom, or sides of another Web site that, when clicked on, will lead browsers directly to one's own Web page. However, banners are expensive and not likely to attract a serious buyer. The most customary way to advertise on the Web is by linking your Web page with someone else's (presumably a site that is similar to your own), which is often free, based on a mutual agreement: The visitors to another Web site will be able to move to yours with a simple click. However, the reverse is true as well, since browsers to your Web page will gain access to someone else's, they may never return. Their failure to come back may not be a reflection on the linked site having better art on display; they may have to click again and again to see things and, by the time they have done so, there may be too many back clicks to bother with (or the browser may have forgotten where he or she started).

SOME GENERAL RULES OF THE INTERNET

When an artist's work does not attract buyers from a Web site, does that mean that the artist is doing something wrong or that fine art is unlikely to sell in this way? Half of the homes in the United States are already connected to the Internet, and the rest of the world is moving slowly to catch up. Perhaps, in time, art will be regularly sold online, and the answer to this question will be more apparent. Until then, some general rules about developing a Web site are applicable to artists:

- The URL or "domain name"—*www.danielgrant.com,* for example—should be relatively short and easily remembered without having to be written down. Overly long routes to the site *(www.server/artsorganization/art/writing/ danielgrant/help)* creates opportunities for typing errors and gives prospective buyers an incentive to look for something easier.
- Make sure that finding the way through the Web site is clear and logical, putting the most important information first (first, what you are selling; sec-

ond, who is the artist). Avoid tiny buttons, computer concepts unknown to users and art world jargon (speak like your users). Avoid clutter, creating groups by color, proximity, shape, or alignment. Consider adopting a theme to aid users' understanding. Ask friends or acquaintances to inspect your Web site to check how clear it is to navigate (do they understand in advance where a link will take them?).

- Keep text brief and succinct. People's reading habits are very different on the Internet, according to studies conducted by Human Factors, International, as almost 80 percent of Web users only scan text rather than read word for word. To increase usability, you might consider using bullets, tables, headings, bold type, graphics, and columns of text that minimize horizontal scanning.

- As your Web site may be visited by people all over the globe, culturally insensitive idioms and stereotypes, as well as images of body parts, should be avoided.

- Avoid distractions, such as banner advertising (some other vendor's logo or promotional copy at the top of the page or running down the sides), constant animation, or music (many Internet users already have a radio or TV on). If animation is used, it should stop after the page is fully loaded. In a physical art gallery, piped-in music helps to set people at ease or to set a mood; on a Web site, music tends to come across as a gimmick. If music is played, an on-off button should be offered to users.

- As art brings out a lack of confidence in many people, who fear that they will be making a mistake if they buy something, the Web site should answer as many of the questions as a visitor to an art gallery might ask: What is the size of the work? What is the artist's background, and who has collected his or her work in the past? How soon could it be delivered? May one pay with a credit card? Does the artist guarantee to take the work back if the textures or colors aren't exactly as seen or described? It is often the case that colors vary from screen to screen and, knowing that, artists should reassure potential buyers that they will honor their money-back guarantees.

- Include a sign-in area on the Web page, asking visitors for their comments (Do they like the work? Which works in particular? What other types of work would they like to see? Would they like to receive a newsletter?), and save those e-mail addresses for future electronic mailings about new work, new exhibitions, or other correspondence.

- Change the content of the site regularly, which encourages visitors to return. In addition, some search engines will drop sites if the content does not change periodically.

- The domain name should be registered with InterNIC *(www.internic.net)*, which costs $100 for two years. In addition, the domain name should belong to the artist rather than to any server, since if the site is moved to another server, the artist will be able to take along the name.

- Similar to the portfolios or slide sheets that artists present to a prospective deal-er, all of the works shown on a Web site should be consistent in terms of style and medium. Unlike the presentation to a dealer, there is no fixed count on how many images should appear; there can be just a few images or dozens. "You don't want to overwhelm someone with one hundred works, but you can cer-tainly have more than twenty," said artists' advisor Susan Schear. "What's most important is that the art makes a cohesive statement and isn't all over the board. You don't want someone to say, 'What's this doing here?'"

As yet, the jury is still out on the effectiveness of selling through the Internet for artists. However, a growing number of artists have created their own Web sites and, eventually, the benefits (or belief in the benefits) of having an online presence may be a given. Since Web sites can be expensive and time-consuming, artists should evalu-ate the options (Do I need one? Why do I need one? What do I expect will happen from it? How will collectors learn about it? Who will design the site? What existing sites are attractive and user-friendly?) before jumping on the bandwagon. Some artists (a small percentage) have reported making contacts with collectors and dealers, resulting in sales; others point not so much to actual sales but to useful connections with artists elsewhere who were exploring the Web and came upon their home page; yet others claim that their site has generated neither sales nor communication. Obviously, as all art is not equal, a variety of factors are involved in why one artist may achieve success while another does not.

REPORTS FROM THE FIELD
A check of artists and craftspeople who have attached a Web site to Artswire (www.artswire.org) and ArtistRegister reveals differing levels of success in attracting attention to both themselves and their work. Karen Guzak of Seattle, Washington, who calls herself a "multidisciplinary artist," noted that "my Web site has had very minimal effects on my career," while furniture-maker John Hein claimed that he sold "two pieces of furniture to a collector who was able to first see my work on my home page and later came over to see my furniture in person." He added that "it seems as if more people know of me and my furniture through the Internet than all the museum and gallery exhibitions I have so far participated in." Patrice Brisbois, a painter in Paris, France, claimed that he has found buyers and others to commission his work through his Web site; while Birgitte Knaus, a painter in London, England, noted that "strictly from the Web site I don't recollect having received a fixed order." When asked about any con-tacts, sales, commissions, or other tangible benefits derived from their respective Web sites, Chicago performance artist and writer Linda Burnham and New York City painter Ruth Roosevelt both responded with one word, "No."

In other art disciplines, one finds the same positives and negatives. David Gamper, a composer and performer in New York City, said that "I have not had any direct tan-gible benefit from my Web site. Although I have been contacted by people I did not

previously know, nothing direct"—such as a concert or a commission—"has come of those contacts." On the other hand, San Francisco composer Carl Stone credited his Web site with leading to bookings and purchases of recordings, as well as being hired to teach.

Athens, Georgia, painter Joanna Whitney's experience was somewhere in between helpful and useless, describing her Web site as "a great networking tool. I have met a lot of like-minded artists and folks. I have introduced many galleries and others to my work via my Web site, but no galleries, collectors, dealers, museums, publishers, or agents have sought me out from my Web site."

Other artists also viewed their Web site as a promotional rather than as a sales-generating vehicle. Boston portrait photographer Elsa Dorfman said that her Web site "has been very helpful in letting potential clients see my work and find out what I charge without bothering to call me. Also, when someone calls me and they want to visit my studio, a huge soaker of time, I can easily say that I don't do studio visits but that the person can see a wide range of my work at the Web site." Sculptor Steven Durland called his Web site a "virtual portfolio," adding that the material on his Web site is "basically there for biographical rather than promotion and marketing purposes." No sales of artwork have come about through collectors or dealers who learned of him solely through the Web site. In some cases, having a Web site may largely be a feel-good experience for an artist, providing the sense that something has been done on behalf of his or her career and that something good may come out of it. "I have not sold any paintings nor been commissioned," Ann Verni said of her Web site. "The only tangible thing is ego satisfaction from knowing that the site is being viewed worldwide."

The costs of creating a Web site also vary widely, depending upon who is designing it (an artist with computer skills will obviously save money than if outsiders do all the work), the number of images included, and the complexity of the site. Karen Guzak spent $1,800 for her site, "a figure that is approximately equivalent to a printed color mailer sent to 1,000 people," while John Hein's Web site was created by a designer in Holland who charges him $500 per year. At the higher end, Elsa Dorfman spent $2,500. Typical artist Web sites tend to cost $1,000 for setup and between $30 and $50 per month for upkeep.

Gallery Web sites are frequently more expensive, because of both the greater number of images to include and the need to add and drop images on a frequent basis. Branon A. Edwards paid a Web designer $60 per hour for 1,000 hours of work to create his Virtual Muse Online Art Gallery, which he considered to be "a shoestring budget."

Gallery Web sites offer opportunities for money making beyond the purchase and sale of artworks. Artists may purchase a Web site at the Virtual Museum Online Art Gallery, costing $50 for setup (home page, biography or résumé, and e-mail address), $11 per work for scanning and sizing of images, and $15 per month for updates and continuing promotion.

Virtual Muse is one of the many galleries to be found on the WorldWide Art Resources Web site (www.wwar.com), a number of which were contacted about their history of online sales. As with artists' own Web sites, galleries have a mixed record in

this area. Joan Grona, owner of the Joan Grona Gallery in San Antonio, Texas, said that "sales from the Web site have not been significant, but I have sold a few paintings from the site"; and William Matar, director of Lebanon Art Gallery, claimed that the Bristol Hotel in Beirut was its only sale from its Web site. Patrik Schedler, director of Galerie Schedler in Zurich, Switzerland, noted that "there are no significant number of sales of artwork through the Web site," adding that a "good Web site is, like most advertisements, just for reputation." Sylvia White of Los Angeles, California, who is both an art dealer and a career advisor to fine artists, stated that sales of art wouldn't cover the cost of creating her Web site. However, "I can say that my Web site has generated a lot of interest in my career services and, at this point in time, I can't imagine any business that is thinking about surviving in the future living without one."

"Ninety percent of my sales are on the Internet," said Jane Haslem, owner of a shop in Washington, D.C., which has an address on ArtLine. "I used to have my shop open all the time, but now I'm open only by appointment because so much of my business is through the Web." Haslem noted that most of her online buyers know the kind of work she represents. "It is rare that someone I don't know calls me and says, 'I saw an image on your home page, and I want to buy it,'" she said. "In most cases, someone who has been a customer in the past calls and says, 'I am looking at an image on your home page. Please tell me more about it.' I will talk to that person and send a brochure. There will probably be more conversations and eventually, perhaps, a sale." The Web site does not replace the traditional brochure in her business, she added, but supplements it. "In a brochure, you can only show five or so images. On a Web site, I can do a complete retrospective, plus include everything else in my gallery's inventory."

More and more galleries are going online, not all with the same results as Jane Haslem. "Nobody's really selling anything of real value through the Web," said Sarah Hasted, director of Ricco/Maresca Gallery in New York City, which has a home page because "it seems the thing to do." Komei Wachi, director of Gallery K in Washington, D.C., which has had a Web site on ArtLine for two years, also noted that "we haven't sold anything. With all these sites on the Internet, it seems like an inefficient way to show or sell anything."

On the other hand, the Web site for the Third Stone Gallery in Saugatuck, Michigan, was "not originally designed to generate direct sales but to bring people to the gallery in person," said Bruce Joel Cutean, director of the gallery. "However, much to my delight and surprise, folks keep inquiring about purchase of the works they see and I've been happy to sell them to them." As a sideline, Cutean has begun a Web site design business for artists and galleries.

In general, the computer technology used by galleries is tailored to include a database for both objects and clients (names, addresses, telephone numbers, what each collects, what each has purchased in the past, what each shows interest in). Some gallery owners have replaced the expensive brochures, which contain color photographs, that they send to customers on their mailing lists with much less costly computer disks containing all the same material, including the image. Imaging technology frequently

equals and sometimes surpasses traditional photography, because of the ability to cap-
ture a three-dimensional element. Over time, too, computer imaging may cost less than
photography, which is currently a sizeable part of many galleries' budgets.

In some cases, the digitalized information is transmitted instantaneously by
modem to a collector's own computer. In this circumstance, the speed of information
may be crucial in making a sale. Bruce Mazer, co-owner of the New York City–based
Art Systems, Ltd., which creates software for galleries and museums, noted that "it's a
lot cheaper to send something by modem than by Fed Ex."

As yet, home pages have not replaced the printed brochures, which means that
galleries are spending more in the hope of larger future sales. You may spend as few as
several hundred dollars to create a Web site, or much more. Jane Haslem spent between
$30,000 and $40,000.

A Word About Payment

Payment can be a tricky issue for those selling through the WorldWideWeb, and there
are a number of methods that may be employed:

- The first and most popular is through credit cards (the more cards that may be
 accepted, the better), although many would-be buyers may require that the Web
 site is "secure," that is, third parties cannot gain access to the credit card num-
 bers. Internet servers may be able to set up a page with SSL (Secure Sockets
 Layer) encryption, or artists may purchase encryption software on their own.
- Traditional methods of payment, such as paper checks or cash-on-delivery, may
 help buyers feel more secure. Obviously, it is important for the Web site to list a
 physical address. Other collectors may be willing to provide their credit card
 numbers, but only through a telephone call or by FAX. (As calls may come in 24
 hours a day seven days a week, artists may want to set up a separate telephone
 line with a answering machine or use a voice mail service.) Offering browsers a
 range of payment options may alleviate a degree of anxiety.
- Orders may also be accepted by third-party companies, which process the
 orders (forwarding them for fulfillment) and accept payment. The fees for these
 services range widely.
- Among the complexities that computer sales have added to the marketplace are
 digital cash (or e-cash), in which both the artist and the buyer have accounts
 with a bank that issues it, and e-charges that permit buyers to charge the cost
 of a purchase to their normal telephone bills.
- As the WorldWideWeb is a global market, buyers may come from all over the
 world with various forms of currency. Credit card payments are the easiest to
 process, since the credit card companies will convert the currency into dollars at
 current market rates and with minimal fees for the service. (Individual banks
 may charge a 10 or 20 percent conversion fee for foreign checks.) Regardless of
 how individuals are permitted to pay, all prices should be in U.S. dollars; other-
 wise, fluctuating exchange rates might actually reduce the value of the work.

5

WHEN DOES INVESTING IN YOUR CAREER BECOME A RIP-OFF?

*I*n the beginning (of the art world), there were just artists and patrons. Then along came art dealers, critics, museum officials, arts funders, art advisors (to patrons), and artists' advisors (to artists) as well as business managers and artists' representatives, all of them making a living off that primary artist-patron relationship.

Many go-betweens and various services have become available to artists, some quite expensive, which may or may not help advance a career.

BUSINESS MANAGERS

To prosper as an artist, career counselors to visual artists continually advise, you have to devote as much serious attention to the business aspects of art as to its creation. There is the matter of contacting prospective customers and art galleries; working out consignment agreements with dealers; photographing, crating, shipping, and keeping track of every piece of artwork; preparing and mailing out promotional material; making and taking telephone calls; writing and answering letters; as well as keeping a budget, overseeing accounts payable and receivable; determining business expenses for tax purposes, and all the other this-and-thats.

To some people, the business part of art may take precedence over anything else. "I always tell artists that they should research the market and have a marketing plan in place before they create for the market," Sue Viders, an artists' advisor, said. "There is no use creating something for which there is no market."

But what if you are just not very good at the business stuff or, like Corpus Christi, Texas, wildlife sculptor Kent Ullberg, you "dislike the business part of being an artist with a purple passion. If I have to haggle over a price or stew over a business letter, it can ruin my creativity for the entire day."

Then, an artist might want to consider hiring a business manager. Ullberg hired Robert Pitzer, who works full-time in the artist's studio with a range of administrative and selling duties.

"I keep track of inventory, the accounting, prepare advertising budgets," Pitzer stated. "I've created new markets, increased market shares with galleries already exhibiting Kent's work and increased galleries' production of sales."

Pitzer, who used to own an art gallery that sold Ullberg's work before going to work for the artist, earns a base salary plus commissions on sales (between 3 and 15 percent, depending upon whether he personally arranged the sale or it took place in a gallery) plus "incentives" (another 5–10 percent after certain projected sales figures have been reached).

Daniel Anthony, business manager for Santa Fe, New Mexico, sculptor Glenna Goodacre, also works in-house (with roughly the same pay arrangement), assisting the artist with a variety of tasks, from selling to answering the telephone. "When I started here in 1987, Glenna didn't even have a secretary," said Anthony, who used to manage a bronze foundry. "She sculpted with a phone cradle, so that she could work with both hands when answering a call. Now, she doesn't have to talk to dealers, collectors, the foundry, reporters, suppliers. She has more than doubled her output."

Increasing output (for selling artists) is vital, if only to earn the additional money required to pay such intermediaries as secretaries and business managers, not to mention the costs of their health insurance, Social Security and other taxes, and benefits. "What I gained is time and money," Goodacre said. "Time is money. The amount of time I've gained from not having to deal personally with the foundries about every little thing is enormous right there." She added that "I can't chart exactly that I earn so much more to cover the added expenses, but I feel it."

Not all business managers are full-time employees; in fact, most are not. Friends and spouses frequently handle selling and administrative work for artists and, for many of the artists who earn enough money from their art—usually, in excess of $100,000 annually—to afford to hire others, dealers or art galleries assume many of those tasks.

"My dealers, Sidney Janis and his son Carroll, have taken care of all the contract negotiations for me when, for instance, a work is loaned to a museum for an exhibition," sculptor George Segal stated. "They also arrange to buy my materials and answer correspondence."

Artist Robert Rauschenberg relies on the Knoedler Gallery in New York City to "handle publicity and marketing, respond to correspondence and work on other business matters," according to Knoedler director Anne Friedman, but he also has an accountant, a lawyer, and an in-house, full-time curator, David White, who does some business manager activities. "I do a lot of talking with museums and galleries on the phone or in person—a lot of office stuff."

A common complaint of artists, however, is that their dealers don't do very much for them—administratively, financially, or in terms of sales—and some of them have chosen to get additional help. Perhaps the late sculptor Donald Judd held the record for assistants by a contemporary artist with twenty-two, all of them are involved in a variety of activities, including overseeing contracts and financial matters with galleries,

checking inventory, sales and payment, acting as liaison between the artist and his gal-
leries, procuring materials, and answering mail and telephone calls, as well as running
personal errands.

According to one of those assistants, Jeff, the purpose of all these helpers was not
so much to free Judd's time to pursue his art as to see to the details of the numerous pro-
jects on which the artist was working. "The more people he has working for him, the
more time he has to spend directing each of them on what to do," he said.

Business managers can mean and be many different things to artists. Some man-
agers take part in the selling end and may be thought of as an artist's representative. At
times, accountants, dealers, and lawyers for artists may take on some administrative or
business functions for their clients. New York City accountant Rubin Gorewitz noted
that the role he has had with Robert Rauschenberg, Jasper Johns, Martha Graham, and
other artists grew from strictly accounting to financial and business manager.

"I've negotiated contracts with dealers and museums, paid their personal bills,
worked out lease agreements with landlords, protected their copyright, handled taxes,
set up corporations and foundations, which give them a big income tax savings. I've
negotiated a home purchase for some artists using their art as barter," Gorewitz said.
"Artists are fair prey for many people, and they can be taken advantage of unless some-
one make sure their interests are being protected."

Gorewitz completely avoids the selling end of working as a business manager for
an artist, as friction between artists and their managers most often develops there.

"I've done business managing for artists, and I hated it," Nina Pratt, who has con-
sulted to artists and art galleries on how to increase sales, said. "You work pretty hard
to get an artist into a gallery and, soon, the gallery and the artist are talking with each
other and you get cut out. Dealers—and I understand this—don't want to share their
commission with a third person." Karen Amiel, now an art dealer in New York City who
worked as business manager/artist's representative for a half-dozen artists between
1985 and 1988, noted bitterly that all of her artists dropped her as soon as they became
established in a gallery. "I ended up listening to a lot of complaints and neurosis for very
little reward," she said.

Not only dealers occasionally find themselves at odds with an artist's manager.
James Clark, former executive director of the New York City–based Public Art Fund,
stated that he much prefers to work with the artist than with the artist's business man-
ager. "I prefer to know what the artist thinks, not what the manager thinks," he said. "I
prefer to negotiate with the artist directly and avoid the manager completely, because
that person may misrepresent what we're doing to the artist. I was talking with one man-
ager on the phone the other day who got me so angry by almost willfully misunder-
standing what I was saying that I almost said, 'I think we should hang up now. We're
not going to get anywhere like this.'"

Yet a different style of business management is found with Susanna Singer, who
is shared by three artists: Sol Lewitt, Robert Mangold, and Adrian Piper. Paid a salary
split by all three, the only things she doesn't do for these artists is create their work or

become involved in selling it. Among her tasks, she indicated, is to set prices, keep track of inventory, maintain the computer catalog raisonnés, select writers for catalogs and edit those catalogs as well as approve their design, handle all correspondence and telephone inquiries, OK private and public art commissions, serve as intermediary between the artists and both galleries and museums, crate and ship their work, ensure that the artists have been paid what they are owed, authenticate their work, have their work photographed, and prepare all promotional material.

"The requirements for this job is that I am the artists' Number One fan and that I know more about their work than anyone else," she said. "Sol [Lewitt] once said to someone, 'When you're talking with Susanna, you're talking with me. When you're dealing with Susanna, you're dealing with me.'"

A somewhat less all-encompassing (and less expensive) form of this kind of business management might be found in one of the companies that specialize in helping artists. Anne Kohs of the San Francisco–based Anne Kohs & Associates stated that "what I do no one wants to do—a lot of artistic grunt work," such as tracking all artwork pieces; maintaining records on past, present, and future exhibitions, as well as writings on the artist; keeping up-to-date résumés and slides of artwork (and labeling them); and taking correspondence. For this service, she is paid a monthly retainer of between $100 and $500, depending upon the artist and the kind of artwork created.

For artists who can afford a payroll or just some extra help, a business manager may make their creative time more productive and enjoyable. Managers don't ease all business worries for artists, however. Kent Ullberg noted that the only drawback to the arrangement he has with Robert Pitzer is "feeling a little extra pressure, because I'm responsible not only for myself and my own family but for someone else's family. I can't just decide to sleep in some days or decide to take a sabbatical, taking off for Africa for two years. I know that I have to keep producing to keep him busy, especially because he works largely on a commission basis."

ARTISTS' REPRESENTATIVES

Among the most nebulous of the middlemen are the artists' representatives. Unlike art dealers, they generally have neither gallery space nor inventory of art and, instead, send photographs (or slides) of their artists' work through the mail or deliver individual pieces to potential buyers. Unlike art advisors, who are often hired by corporations to build a collection, they represent certain artists rather than potential collectors. Unlike artists' advisors, who are hired at an hourly rate by artists to help focus their careers (creating a press kit, résumé, or portfolio, as well as examining potential markets and career goals), they are more involved in selling than packaging.

Artists' reps act as agents for commercial and fine artists, soliciting buyers or consigners and taking a percentage of whatever sells. They are more of a presence in the realm of commercial illustration, where reps use their contacts among art directors of magazines, book publishers, corporations, and advertising agencies to drum up business, but a sizeable number exist in the area of fine arts.

"The majority of artists find it very difficult to hustle on their own," said Doyle Pitman, director of The Management Team in Universal City, California, a company whose roots go back to the days when Pitman first began promoting the work of his wife, who is a painter. "What we do that the artist cannot do is brag about their work."

The Management Team signs artists to five-year exclusive contracts, during which time it markets their works to art print publishers, private collectors, and art dealers. "We do all the legwork and generate all the prices," Pitman stated, adding that neither he nor any of his three colleagues "makes a cent" unless the artist's work is sold.

In addition to bragging about their artists, reps emphasize their skills at presenting an artist's work to a potential buyer in a particularly positive way. "There is an incredible amount of telecommunicative sales," Kathy Braun, a commercial art rep in San Francisco, said. "I can do that much better than some of these kids right out of art school who sound like the village idiot on the phone."

She pointed out that a good rep needs a high-quality copier and a FAX machine "to get the communications across" since potential clients are often well beyond driving distance. Braun also stated that the rep "can become a liaison between the artist and the art director, smoothing rough edges. A job may be worth, for instance, $5,000, but the art director only has $2,000 to spend. The artist may start feeling that he's being used and not do his best work or bring things in late. I can get the artist to do his best work on time by explaining why this job is important and may lead to others."

Artists' reps don't so much supplant art dealers as help find more markets and individual buyers for their clients' work. They often advertise their services in art magazines (for fine artists) and commercial directories (for illustrators), but artists frequently hear of them through word of mouth. Reps ask to see examples of an artist's work (tearsheets or promotional brochures for commercial artists, slides or photographs of paintings and sculpture for fine artists) that will be test marketed if the agent feels a relationship is possible.

There are various issues that will have to be negotiated between artist and rep, involving a fixed-period contract, varying methods of payment (a percentage or hourly rate), geographical coverage, and method of sharing costs (advertising brochures or spots in magazines, for example). In addition, the artist's current needs (more commercial work) or career aspirations (getting into a fine arts gallery) will be discussed and planned for. The rep's job is to take care of the details.

"It can be very frustrating and time consuming for an artist to try to get into a gallery," said Karen Spiro, a rep in Philadelphia who specializes in portrait artists. "You may get 100 rejections before a gallery finally takes you on, and lots of artists just don't want to go through that process. I'll handle the rejections so the artist doesn't have to."

Spiro noted that she charges an hourly rate of $50 when attempting to place an artist with a gallery—her average fee is between $2,000 and $4,000—but obtaining gallery representation is generally not what she or most other reps concentrate on. Rather, their aim is generating direct sales.

There are some reasons for that. Gallery dealers are often unwelcoming and even hostile to agents, whom they see as one more layer between the artist and the buyer, and both the dealer's and rep's percentage on any sale is less when the other is involved. A dealer, for instance, usually takes between a 40 and 50 percent commission for sales while the rep's commission is closer to 25 or 30 percent. When a gallery consigns an artist's work through a rep, the dealer's take often goes down to between 30 and 35 percent while the rep makes closer to 15 percent.

Artist reps can be anyone and frequently are friends or family members who believe in the artists and want to move their careers along. They may have fewer professional art world contacts to draw upon but make up for it with extra ardor.

There is no association of artist representatives, but ArtNetwork (see "Selling Art Through Mailing Lists" in this chapter) offers an *Art Marketing Sourcebook* that lists a number of the people who do this kind of work full-time.

PUBLICISTS

A growing number of artists have also turned to publicists and public relations firms to assist them in their careers. Again, as with artists' reps, the intention is not to replace dealers as the primary sellers of work; rather, it is to increase the artist's (and the work's) exposure to the public. Publicists may not be for everyone, but they do represent a positive effort by certain artists to take greater control over the business aspects of their lives.

"There are just not enough hours in the day to do everything," said Edward Ruscha, a Los Angeles artist who hired the New York City firm Livet Richard to help promote his work in Europe. "If I had tried to do all the business stuff—the letter writing and contacting people—I would not have been able to create as much art. I'd have to cut up the pie, as it were, of the facets of being an artist. I also wouldn't have been as successful if I had tried to do it all on my own. The thing about public relations people is that they're so tenacious about it. I couldn't do what they do; I wouldn't want to do it."

The range of services publicists provide is vast, depending on what the particular artists are looking for. Usually with lesser-known artists, the need is to "package" the artists by putting together a comprehensive press kit so that they can present themselves more professionally. In fact, many newspaper art critics and art magazine editors first find out about new artists through receiving a press packet from some public relations company.

That often involves the publicist getting to know the artist, in order to write a biographical statement that also discusses the art, pulling together published write-ups of the artist's work, preparing black-and-white glossies or color slides of the art, and writing either a press release or cover letter for this press kit that lets the critic, curator, or dealer (or whomever is being targeted) know what the artist is about.

Knowing how to put one's life and artistic ideas into words is an important skill. "Some artists can speak and articulate their ideas very well, but they are definitely in the minority," Susan Hewitt, a freelance publicist, said. "The people you want to be con-

tacting—the dealers, editors, curators—come from an academic background. They are 'word people' who are accustomed to people who are good with language. I try to help artists find the right words for who they are and what they are doing, and that usually goes a long way."

Some publicists also help artists in other, larger aspects of their careers, such as analyzing the strengths and weaknesses of their development, what collections the artist's work is in, who is buying the work, where the work is being shown, and who represents the artist.

At other times, publicists can focus attention on something newsworthy happening in an artist's career, such as an exhibition of new work or the completion of a major project. Peter Max, who is best known for his psychedelic posters of the late 1960s, hired Howard J. Rubenstein Associates in New York City to publicize a 1988 exhibition of his paintings that showed a change in style from his customary hard-edge figurative to a more abstract, painterly look. Robert Rauschenberg sought out the international press contacts of Washington, D.C–based Hill and Knowles for his 1985–1986 "Rauschenberg Overseas Cultural Interchange," which took the artist and his work to various countries.

Another Washington, D.C. firm, Rogers & Cowan, was hired by the Portland, Oregon–based dealer of painter Bart Forbes to inform the press that the artist had been selected to create thirty-one paintings for Seoul's Olympics Museum. The dealer, a publisher of art prints, hoped that the publicity would generate a demand for the artist's prints.

Dealers have traditionally taken care of all of the promotional work relating to their artists but, increasingly, these artists are complaining that their dealers do too little or nothing at all. Possibly, their understanding of the business aspects of the art world has made them impatient with the limited activity of these dealers.

Joseph Kosuth, the conceptual artist who is represented by the high-powered Leo Castelli Gallery in New York City, noted that "Castelli has a lot of artists to publicize, and it's hard to keep track of everybody, making sure every one of his artists stays in the public eye. Keeping photographs of all my work, letting people know where I'll be shown next, answering questions about me—they just can't do it all."

That realization brought him to Livet Richard in order to "generate good attention to what I'm doing or to projects I've done that have been ignored." He added that "there is a real need to take responsibility for how one's work is presented and made meaningful to the world, and that's what I need a public relations firm to help me do."

The price for this help is not cheap. Publicists and public relations firms charge anywhere from $45 to $150 an hour, and their work can be time consuming. At Rogers & Cowan, promoting an artist's exhibition, which includes preparing and sending out a press release as well as following it up with telephone calls to critics and radio and television stations, would run $1,200–$2,000. William Amelia, president of Amelia Associates in Baltimore, Maryland, stated that his firm charged the late Herman Maril ("the dean of Baltimore artists," Amelia said) $5,000 a year to publicize his exhibits in Baltimore and around the country.

At these rates, many artists would need to see some demonstrable increase in sales to offset the fees, but that is something which cannot be guaranteed. Neither publicists nor the artists who use them claim that there is any cost-benefit ratio between the amount of money spent on public relations and additional sales that they can identify. For everyone involved, this is a matter of faith.

"We can't say to some artist, 'We're going to get you on the cover of *Time* magazine,'" Amelia said. "All we guarantee is our best effort." Amelia Associates took on the account of one painter, a health care consultant who was completely unknown to the art world, but was unable to interest a single art dealer or museum curator in exhibiting or purchasing his works. The health care consultant spent $1,400 for that experience of rejection.

Another artist, San Francisco watercolorist Gary Bukovnik, spent over $2,000 between 1982 and 1983 with the large public relations firm Ruder and Finn to promote his work but only found himself in debt at the end of the experience.

"I had been working for a museum for a while and got to be familiar with Ruder and Finn through that," he stated. "They did the publicity for the King Tut show. I figured, if they could move King Tut, why couldn't they move a few Gary Bukovnik watercolors?"

They didn't or couldn't. Bukovnik felt that his was the smallest account in the agency and that his work received minimal attention. He also said that he found careless factual errors in press materials on him that were prepared by the agency.

Artists can certainly come up with ways on their own to generate publicity about themselves or their work. They can write their own press releases, put together their own press kits, and create their own events. A typical approach is for an artist to offer a free "demonstration" of artmaking in his or her studio or at a community center. Another is to offer a talk on some aspect of the arts; yet another is to make a donation of work to a hospital or some other charitable organization. Any number of activities give an artist public visibility.

ARTISTS' ADVISORS

Career advice to artists comes in a variety of forms. Nonprofit arts service organizations offer workshops from time to time, focusing on specific topics (tax time accounting, law, finding a gallery, for instance). The continuing education divisions of some art schools or universities that offer art degrees may also hold workshops and classes on these and other subjects. State arts agencies periodically offer seminars on how to apply for funding to them. An assortment of business and career books for artists are available as well.

Yet another version of how-to information for artists may be found increasingly in video- and audiocassette, whose advice ranges from the inspirational ("I believe in myself, my ideas, and my creations") to specific business tips.

For those who prefer the more personal touch, artists may consult with artists' advisors on a wide range of career matters, either face-to-face or over the telephone, depending upon where each party happens to live.

Advice sometimes is free, oftentimes not. State arts agencies usually do not charge for their seminars, and continuing education talks are either free to the public or a nominal fee is asked. Nonprofit arts service agencies generally charge their members lower rates for attending the workshops than nonmembers ($20, for example, as opposed to $30), and career books usually cost somewhere between $10 and $30. Artists' advisors are the most expensive option, charging hourly rates (not including the cost of the telephone call) of between $30 and $175 per hour.

Artists' advisors can be distinguished from business managers (whose job is to run the artist's career), reps (whose aim is to sell work), and public relations firms (whose aim is to publicize) by their primary goal, which is to set the artist on a career path. Advisors may draft a press release or a press packet for an artist, in the manner of a publicist, but more likely they will offer ideas on how the artist could create his or her own release. Rarely, if ever, will an artists' advisor take on the job of contacting members of the press.

In some instances, advisors will help artists set up simple bookkeeping procedures, establish a basic price structure for the art, provide rudimentary instruction on copyright and other legal protections for artists, and assist in negotiating any agreements with dealers or print publishers.

Advisors offer business and career information tailored to what individual artists need to know, and they also offer suggestions about a given artist's work. Some tell artists how to locate appropriate galleries or shows where their work might be displayed, while others may produce a list of likely galleries or exhibition opportunities that the artist might try. Some take a very hands-on approach—suggesting that a particular artist concentrate on prints instead of painting, for instance, recommending an artist develop his or her work to a full extent before attempting to market it, or even advising an artist use certain popular colors in a painting—while others choose not to meddle with the artist's own creative processes.

Some advisors are best equipped to help emerging artists, while others have experience assisting mid-career or even relatively successful artists. Some advisors have greater success with artists who work in a specific medium, such as prints, for example; and others may not know as much about the market for abstract or progressive art.

Artists should approach advisors not as supplicants but as critical consumers, looking for the best match for their art and for their own temperament. They should not be timid asking about the rates or what specific services will be rendered. Artists need to know the basis of the advisor's expertise: How many years has the advisor done this kind of work? Has the advisor conducted any surveys or research about artists? Has the advisor ever written a successful grant proposal? Has the advisor ever been involved in the art trade? Artists should also ask for the names, addresses, and telephone numbers of artists with whom the advisors have worked in the past in order to verify what they have been told. As many advisors have also written books or articles in which their ideas are expressed, artists should ask for copies as a way of evaluating the approach taken. In some cases, the books and articles may lessen the need for as many sessions with a particular advisor.

The world of artists' advisors is not huge, and many advisors know each other and each other's work. If a particular advisor does not seem suitable, artists should ask for a reference to another. Advisors are not appropriate for everyone; their clients are rarely right out of school and have had some experience exhibiting and selling (or, at least, trying to sell) their work. The artists who are most likely to benefit from an advisor have established the kind of artwork that they want to pursue (rather than being all over the board in terms of style or medium), know that there is an audience for their work, but want assistance in reaching that market. The more basics that have to be covered by an advisor and an artist ("Well, what kind of work do you want to specialize in?"), the longer and more expensive the process of putting a marketing plan into effect.

Advisors will evaluate artwork in terms of where best to market it, but they almost never offer a value judgment about its quality or level of interest. Dan Concholar, director of the Art Information Center in New York City, noted that he has consulted with a number of artists who seem to have no talent, "but I've never said that to anyone. Telling someone that their art is bad is like telling them their children are ugly." Advisors see clients who will pay for their services; they may hold their noses the entire time, but they take their money. Fees are never based on the artist's success but on the advisor's hourly rate. "It's not my job to comment on their aesthetic ability," said Santa Monica, California, advisor Sylvia White. Her job is to make people feel that they can succeed in finding an audience for the art that they make. "Artists walk in the door with their shoulders hunched, feeling helpless, hopeless, and they leave an hour or so later feeling like they know what they have to do next." Los Angeles advisor Calvin Goodman also views the problem of an artist not selling as a practical one, of the artist "not working in a direction that will get them an audience," and offers various types of advice, regardless of how likely he sees an artist-client ever selling work. The alternative—to say that he doesn't like the art or that he cannot do anything to make someone's art marketable—is "to commit a crime against the culture."

Susan Schear, who runs the Artists Career Planning Service in New York, has recommended a therapist to certain clients. "Some artists live in a fantasy world and don't realize what's happening to them," she said. "They've created a lot of defense mechanisms that don't allow them to see clearly, and they need to treat these problems before we can do much for their art."

The job of an artists' advisor is not easily summarized, as it may involve a variety of chores—developing a marketing plan with this person, coaching another person to take a more positive attitude—and the line between career planner and therapist is often crossed. If the art world has its unknown soldiers—artists who forge on with their art even in the face of indifference or hostility—it also has its Willy Lomans. Just as the central character of Arthur Miller's play *Death of a Salesman* continues to talk up his successes and how well thought-of he is as his life and career collapse around him, there are artists who exist on fantasies about their place in the art world or, to borrow a term from psychology, live in a state of denial.

Denial and other defense mechanisms may help artists protect themselves emotionally from the disillusionment, disappointment, and the overall frustrations that the art world regularly metes out. However, the job of marketing—that is, finding an audience for one's art work—requires clear-sightedness and a positive attitude.

"I've talked to a lot of artists who are constantly making up excuses for themselves," Concholar said. "They say, 'The art world is a political system. It's who-you-know,' and I say, 'Yes, that's true, but why don't you try to meet someone?' I've talked to artists who expect their work to get into the most prestigious galleries and won't consider any other places to show their art. I try to get them to start at the bottom and work their way up, but that idea is sometimes too much for them to handle."

Artists develop unrealistic expectations—notions of what they are unlikely to ever achieve—for various reasons: They may have absorbed a limited and limiting sense of the art world from art school; some might inflate their sense of worth as a means of mitigating years of having little or no professional success to show; they may view the art world too starkly in terms of superstar success (museum retrospectives, Whitney Biennial, top name New York City galleries, cover of *Art in America*) or nothing. Ideas that are wrong or simply inappropriate for a particular artist may be the largest hurdle to overcome, destroying the very real opportunities before them. In some cases, artists may need psychological counseling to overcome feelings of inadequacy and depression. Their productivity declines, and they present themselves unfavorably, not believing that they can achieve success. Other artists may simply need to understand what they can achieve if they break it down into small steps.

"Too many artists are grasping at straws; they don't know how to begin, and the task in front of them looks so big," said Sylvia White. "If you give an artist a strategy—goals to accomplish in a methodical way—you give that person hope. The question isn't, should this person make art but where could this person be successful with the art they make?"

Advisors don't travel from artist to artist, and artists who do not live in the same town or state as a particular advisor usually must speak to them by telephone. As Goodman noted, "I have a cauliflower ear, and my voice never gives out." Artists pay for their own calls, and consultation fees are paid either by check or credit card.

After an initial consultation, in which basic questions about what the advisor will do and what the artist needs are decided, the artist sends one or more slide sheets (or photograph albums) of his or her work, as well as a résumé, clippings, and other documentary material to the advisor. The advisor studies these in order to prepare recommendations. Those recommendations may come in the form of a worksheet or workbook, listing a step-by-step method of what to do first, second, third, and so forth, or a time for a telephone call is arranged.

Because artists are paying for the telephone call as well as perhaps an hourly consultation (divided into 15-minute segments), they should come to the telephone with prepared questions and stick to the point.

The wide assortment in types of advice one may receive through various media (book, face-to-face, telephone, video) indicates the growing amount of information that artists require. If all the ideas that an artist needed could be found in one book, there would be no need for anything but that one book. However, different people have different perspectives and sources of information, revealed in the less general tips they provide. Nowadays, artists need to develop their own resource libraries that include various career guides (books or videos) and telephone numbers.

CAN A SLIDE REGISTRY LEAD TO SALES?

In various publications where artist groups and arts organizations are listed, many associations claim to maintain a slide registry, which is available for viewing by individual and corporate collectors, art gallery owners, architects, and anyone else. Presumably, having a slide registry is a good thing—or is it?

Artists submit one or more (sometimes ten or twenty) slides of their work, hoping that they are looked at and generate interest. Few registries, however, do more than take up space in an organization's filing cabinets. Rarely promoted, they are unknown to the very people artists want to see their work. Worse, these registries are frequently unknown to many of the staff members of the organization, making it more difficult for interested people to gain access to the work of artists, increasing their overall invisibility.

Slides are expensive, and there is no reason for artists to uselessly expend their money and hopes for a service that is created simply because it seems like a good thing to do for artists.

That is not to say that slide registries, effectively publicized and made a part of an organization's primary focus, cannot prove quite valuable to artists. An example of a slide registry's central importance to an arts organization is Wisconsin Women in the Arts, in Brookfield, which not only maintains a slide registry in its offices (visited, perhaps, once a month by area gallery owners and interior decorators) but periodically places them in a slide carousel, which is taken by members of the group (along with a projector) to show museum curators, gallery owners, and directors around the Midwest.

One of the art galleries at Northwestern University in Evanston, Illinois, for example, created two exhibitions from viewing this slide show, and a commercial art gallery in West Bend, Wisconsin, assembled a year's worth of shows based on it.

Another slide registry success story concerns The Copley Society of Boston, where "hundreds of people come in every year to look at the slides," according to Georgiana A. Druchyk, director of the society. "We view the slide registry as a critical point of reference, which we use for presentations to corporations, individual collectors, art associations, and even art galleries."

Richard Love, director of R.H. Love Galleries in Chicago, selected three pastel artists, whose work he had never before seen, for exhibitions after combing The Copley Society's slide registry.

Yet another example of a slide registry assuming an integral part of an organization is the slide bank of the Connecticut Commission on the Arts. The state arts agency

established a policy of selecting artists for public art projects through Connecticut's Percent-for-Art law from only those included in the slide bank, and almost 2,000 artists have sent in more than 20,000 slides. In addition, the arts commission chooses work for exhibit in its offices from this pool of slides.

The slide bank has also been used by area galleries, collectors, architects, museums, art consultants, and even other artists (who want to see what others are doing). Peat, Marwick, the accounting firm with offices in downtown Hartford, sought to buy the work of Connecticut artists and sent over an art consultant to look through the commission's slide bank. From that, $100,000 of artwork was purchased.

However, these successes appear to be more the exception than the rule. The slide registry of Associated Artists of Winston-Salem (North Carolina), for example, is looked at only "several times a year" by someone or another, according to the group's director, Marietta Smith. Rock Kershaw, executive director of Artspace Inc., in Raleigh, North Carolina, said that visitors ask about his organization's slide registry "less than once a month. We don't promote the slide registry because we don't have that much call for it. It's just an extra effort."

Even potentially viable slide registries are made less useful when the organization has no light tables, requiring someone to hold up the slide to a fluorescent light fixture on the ceiling. Carousels containing only a few slides are equally frustrating. In addition, the failure to sort slides according to specific categories (discipline, media, scale, and style of work), as well as the lack of additional information, such as the artist's full name and address or a résumé, may make the experience of examining a pool of slides a tedious and meaningless chore. As the organizations that maintain registries often require artists to pay a membership fee to join in order to be included in the slide bank, artists should look carefully at the physical presentation of the slides and information; they should also ask about who uses the registry, how often, and how the community is made aware of its existence.

One useful source is the *Directory of Artists Slide Registeries* (Americans for the Arts, One East 53rd Street, New York, NY 10022, 212-223-2787). Some registries have been computerized, enabling potential users to make very specific searches, such as female watercolorists or artists living in a certain town. The International Sculpture Center in Washington, D.C., also created a computerized Sculpture Source System that has placed types of work as well as information on its 1,800 members into 110 categories. The center, which promotes its registry through advertising, direct mailings to architects and interior designers, and by attending regional art fairs, created videodiscs of members' works for visitors to view and also sends out photographic images of work in its slide registry and provides biographical information for potential buyers.

Certainly, you can find online registries operated by a growing number of state and regional public arts agencies. Visitors to these agencies' Web sites may browse the images and biographical information of the artists included. Once again, however, these Web sites are not promoted to potential collectors—these sites largely include a staff directory, press releases, grant guidelines and application due dates, related opportuni-

ties for artists and organizations, and links to other arts agencies and organizations—since their intended audience is the very individuals and groups that apply to them for funding. These agencies' commitment to their registries may seem shallow, as they don't measure the number of "hits" or visits to these sites, nor do they survey the artists on their registries to discover whether or not there have been inquiries, sales, commissions, hiring, or anything else tangible or positive that can be attributed to the existence of the registry.

THE VALUE OF PRIZES AND AWARDS

There are many points at which the lives and careers of visual and performing artists diverge, and one of them is how they are honored and what those honors mean. Top film actors are nominated for Academy Awards; their stage counterparts may receive Tony Awards, while musicians are eligible for a Grammy. These honors subsequently define the careers of these performers and certainly lead to career adjustments, such as receiving an avalanche of scripts and contract offers. In short, the artists' prestige is heightened in and out of their fields: An Academy Award winner will always be one—years later, the honor will feature prominently in that person's obituary—regardless of whatever else takes place in the individual's life or career.

In the visual arts, there are various prizes and awards; some offered by art material suppliers (the cash value of which often is redeemable in the manufacturer's own products), some that are purchase awards by museums, others established by art schools, advertising agencies, and art show sponsors that provide modest amounts of money. In addition to top awards, second- and third-place prizes, as well as honorable mentions, are also frequently offered and may involve money or a certificate—something to include on a résumé.

All of these visual arts awards and prizes have far less value to the artist than an Oscar or Tony. It is not uncommon that someone is described as an "award-winning artist" without ever noting which award(s) the artist has won. That may be just as well, as few people would have heard of the particular award anyway. Receiving a Grumbacher medal does not assure a visual artist that a line of patrons will appear at his or her door the next day or that the artist will make the cover of *People* magazine or be ranked among the top artists of the time. In fact, the most lionized and successful artists, whose works are featured in museum retrospectives or whose faces adorn the covers of *ARTnews* or *Art in America* are unlikely to ever enter the competitions that offer prizes and awards. It is not even much of an event, for instance, when a Jasper Johns wins the top prize at the 1988 Venice Biennial, as his standing in the art world was already greater than that of the award.

Still, thousands of artists compete annually for awards, and for many, the awards and prizes area on their résumés is quite expansive. However, there is a wide range of opinion concerning to whom these prizes actually matter. On one end of the spectrum, there is a belief that prizes and awards do not matter at all. "It is absolutely of no importance to me whether or not an artist has won any prizes. It is absolutely of no importance

to my collectors," said Jill Sussman, director of the Marian Goodman Gallery in New York City. "None of the artists here get prizes. Those artists who get prizes just are not in our league."

"Winning an award is nice when it happens for the artist," stated Janelle Reiring, director of New York's Metro Pictures gallery. "It makes the artist feel good, I guess. It doesn't make any difference to me or to the collectors I deal with. Our collectors are certainly concerned with what critics and museum curators think, but not at all with what prizes or awards the artist may have won."

Other art dealers take a different view. "Which awards the artist has won matters to me, and matters to collectors," said Benjamin Mangel, owner of the Mangel Gallery in Philadelphia. "They are especially beneficial to an emerging artist, who may have little else to show. I have collectors who need to see that the artist has credibility, and it helps when I can talk about the artist's scholarships, awards, prizes. It's not a crucial factor in selling a work, but when you've got someone who is on the fence and says, 'Let me read something about this artist,' if you show the collector a blank sheet of paper, that collector is not going to buy the work. If you can show that the artist has won awards and prizes—that the artist has credibility in someone else's eyes—nine times out of ten that collector is going to buy the work. The only time that kind of information doesn't matter at all is when the collector falls in love with the work and doesn't care who the artist is."

A number of other dealers around the United States agree that prizes are of greatest importance for artists who are younger or who need some kind of third-party validation because they don't yet have a reliable market for their work. Lisa Harris, an art gallery owner in Seattle, Washington, noted that, when an artist is just starting out in his or her career, listing prizes and awards "helps affirm the collector's own feelings about the artist. As the artist enters a later stage of his or her career, those credentials tend to be jettisoned, and the prizes and awards category disappears from the résumé. The artist shouldn't need to refer to first prizes anymore."

The category of prizes and awards is frequently elastic, expanded by artists to include fellowships from foundations and government agencies, as well as project grants from those (or other) sources. The differences in prestige between who gives awards or prizes may be enormous. A number of art dealers, who otherwise claim that the artist's winning a prize is of no importance to them, stated that their interest is piqued by artists who have received a Guggenheim fellowship, for instance. "A grant or fellowship from the National Endowment for the Arts carries some weight with me," said Donald Russell, director of the Washington Project for the Arts, an alternative art space. "I think the panel structure they have is good, and the choices for who is on those panels is also quite good." Nina Nielsen, a gallery owner in Boston, also claimed that she pays more attention to awards that are "well-decided."

Gregory Amenoff, a New York City painter, said that "when I am to give a talk somewhere, I am frequently introduced to the audience as the recipient of three NEA grants. Obviously, that has given me a certain status with some people, but I wouldn't

want to overemphasize its importance. I've never heard a collector say, 'I heard you've received three NEAs and wanted to see what your work looks like.'"

Winning the top prize in the Venice Biennial in 1964 did prove a tremendous boost in the career of Robert Rauschenberg, then 39 years old and without a long history of showing his art, as it vastly increased the demand for his work and elevated prices in some cases 1,000 percent. Having her design selected for the Vietnam War Memorial in Washington, D.C., in 1981 propelled Maya Lin, an undergraduate architecture student at Yale University, to international renown.

Most awards and prizes are not career makers, however, and the amount of money an artist may receive is a few hundred dollars or less, more of a pat-on-the-back than a vault into stardom. The degree to which potential collectors are impressed by them is not always clear—some are highly influenced by validation from other sources, while others never ask about an artist's awards and seem uninterested when told—but artists themselves almost unanimously welcome these forms of recognition.

Winning the top prize from the National Sculpture Society in 1993, which included a $1,000 award, was heartening for Seattle, Washington, sculptor John Sisko. "Getting this kind of recognition from your peers gives you a lot of confidence that someone is paying attention to your work," he said. "It made me feel more convinced that I was on the right track with my work."

An additional benefit of receiving the prize was the new, higher regard with which he found himself treated. "I noticed that, when I went to my foundry in Santa Fe, I was introduced to people as this award-winner," Sisko stated. "I think that the foundry saw that its prestige had risen because it was associated with me."

Another Seattle sculptor who has won fellowships from the Washington State Arts Commission and elsewhere, Terry Furchgott, also noted that "people know me from the awards. Three years ago, I would call some art agency for a project grant, but I didn't feel like an equal with the people I was talking to, like I had to ask them for favors. Now, when I call, I notice that they treat me as an equal or as someone they are honored to be speaking with."

Other artists also stated that prizes and awards help build their confidence—for instance, to start some new work that may be in a new direction—and enhance their standing with fellow artists. Many artists emphasize the value of receiving encouragement in the art field, where there is often so little to be had, and the recognition of their peers over the likelihood that a prize will lead to commercial success. "Of all the prizes I've won at art center shows, I think that I've only sold one painting," said Bill Scott of Philadelphia. "You can't build your career around winning prizes and awards."

For some artists, however, the search to win prizes becomes a career in itself. Forgetting that a great many very important artists never received awards and believing that the more prizes listed on a résumé, the more dealers and collectors will be impressed, they enter contest after contest. According to Paul Bassista, executive director of the Graphic Artists Guild, a New York City–based membership organization of designers, illustrators, and other graphic artists, there is a growing number of awards

offered by advertising agencies, magazines, foundations, organizations, schools, museums, art centers, and show sponsors. He noted that the Graphic Artists Guild's foundation monitors hundreds of contests that claim to offer prizes, with the intention of alerting artists to unethical practices in this area.

"Some magazines and advertising agencies create contests in order to get original art that they can publish, paying the artists very little but telling the artists that they have achieved a great honor by winning," Bassista said. "We tell artists to make sure that whoever judges their artwork is qualified, to find out in advance what is to be done with their artwork, to find out in advance what copyrights may be transferred and how they will be transferred, and make sure that prize money is commensurate with the uses of their art."

With the most prized forms of recognition, such as an NEA grant or fellowship, there is a frequent coincidence of awards occurring in an artist's career at the very time that he or she is having more important exhibitions and selling more work. This coincidence may be seen as a cultural consensus.

A history of receiving less coveted awards and prizes may or may not impress dealers, collectors, prospective clients, or other artists, and artists with a closetful of citations may be no wealthier for the experience. However, selection criteria at foundations and government agencies that provide artist fellowships frequently include "outside recognition," such as having received awards and prizes. In a process that sometimes seems to feed upon itself, it may be all too seductive to try to amass prizes, oblivious to what the awards mean and to whom they mean anything.

DO BUSINESS CARDS AND STATIONERY MAKE THE PROFESSIONAL?

What defines an artist as a professional? The Internal Revenue Service of the federal government has one definition, based on an artist making a profit in three out of five years, and dealers use the yardstick of having sold work in the past. Yet others speak of that ethereal thing called "seriousness of intent" or "artistic quality."

For a growing number of artists, however, professionalism means having a business card that, besides noting the artist's name, address, and telephone number, lists that person by the title "artist."

To some artists, a business card puts everything on a more professional basis because other people associate business cards with professionalism. It might suggest that the artist is making money from his or her art, and that aura of success would impress others. Further, a number of artists claim, everybody and his cousin seems to have a card these days, announcing what they do, so why shouldn't artists have them?

These cards are often as individual as the artists themselves. While some are quite plain and matter-of-fact (a simple white card with one's name, address, and telephone number), others are decorated with pictures of paint brushes or designs that indicate something about the artist. Certain cards also reproduce whole paintings or details from them.

"When someone says to me, 'Gee, I love your paintings. I'd like to see more,' I hand out a business card," said Richard Whitney, a painter in Marlborough, New Hampshire. "They look at the card and the design on it. They see the gold-embossed signature and think, 'Boy, this guy must be really good.'"

Artists point out that passing out a card is a more effective way to make oneself known than hunting around for a pen and a piece of scrap paper to write down a name and address. The card itself, they claim, is easy to hold onto and may keep the artist from being forgotten.

A number of artists state that they have handed out cards to people who have looked at their work at juried shows, as well as to friends who may in turn give them to potential collectors they know. "I know that cards have helped sell a couple of my paintings," one artist stated. "People whom I have given the cards to have called me to buy something. The cards pay for themselves."

Not everyone who receives artists' business cards thinks well of them. Many dealers are turned off by the "commercialism" of the card, especially those with artistic designs or the title "artist" by the name and may discriminate against artists with business cards. "I'm confounded when I get a card that gives the person's name and, above that, 'artist,'" a dealer complained. "The person proclaims himself an artist, and I may not agree." Other dealers noted that it is the quality of the work and the ability to attract buyers that define both the good artist and the professional, not a business card that says "artist."

"An artist's business card is just a waste of money," said Sigmund Wenger, a Los Angeles art dealer. Linda Durham, a dealer in Santa Fe, New Mexico, noted that cards "say 'inexperienced' and 'commercial' to me," and Ivan Karp, director of New York City's O.K. Harris Gallery, stated that "avant-garde artists never use business cards. The kind who gets a business card printed up is usually a watercolorist over the age of 60 or someone who lives in the boondocks."

Business cards are not the only sign of the quest for outward professionalism. Artists' business stationery and brochures as well as periodic newsletters to collectors (the artist's version of the annual report) are becoming increasingly common. Cards and brochures actually may arouse some curiosity about an artist's work. They clearly are not welcome everywhere, and it is rare that a direct connection between handing out cards or brochures and the sale of works of art can be established. They may permit artists to feel better about themselves and their desire to market their work in a professional manner—perhaps, that is value enough—but artists may not want to invest in what only has psychological value.

PAYING TO PLAY THE ART GAME

Visual artists, unlike artists in other disciplines, are people who have to pay for their career aspirations. According to one National Endowment for the Arts study, the average artist's costs (materials, studio space) are a little more than twice his or her earnings from the sale of works. With this in mind, it is especially important for artists to know what they are buying.

Artists are generally thought of as producers, but they are also consumers, targeted by individuals, companies, and institutions who offer a lot for them to buy. They pay for their art training, art materials and studio space, and often the photographing, framing, crating, shipping, and advertising of their work. The past number of years have seen the emergence of various services catering to artists—artists' advisors, publishers of artist directories and how-to-make-money-as-artists books, for-rent exhibition spaces, mailing-list sellers—whose benefit to artists is not always measurable. Perhaps this benefit does not even exist. More than anything else, most artists are desperate to find some way to show and sell their work, and they will often pay for these opportunities. Many people and companies are aware of that and feed on the desperation.

Selling Art Through Mailing Lists

Take, for example, mailing lists. A number of companies sell lists of dealers, corporate collectors, art publishers, museums that show contemporary artists, art competitions, and other groups and organizations of interest to artists. These lists have hundreds, sometimes thousands, of names and addresses of potential buyers or contacts who have shown a specific interest in works by living artists.

Announcements about upcoming exhibitions or the completion of new works of art can be sent to the people on these lists and, perhaps, some sales may result. Companies specializing in direct mail solicitations claim to average a 3 or 4 percent return; for artists sending out material to 1,000 art galleries where their work might be represented, that suggests between 30 and 40 positive responses.

The reality is less promising. The names on the mailing lists are not so carefully weeded through by the companies selling them that they don't include a lot of frame and card shops. Outside of major cities, lots of furniture stores and gift shops call themselves galleries, too. No explanatory information is provided with the labels to indicate which actual art galleries are primarily interested in abstract or representational works, the kind of media they prefer to show, and some of the other artists shown.

These companies don't check with the people on their lists to see if they want to be included (or are appropriate for inclusion), and they might delete a name only if an art dealer wrote or called to say that the gallery shouldn't be on it.

It is wiser for artists to market their works with greater precision than with random mailing lists; instead, as noted above, they must become familiar with their markets. As tedious as it may be, there is no getting away from artists having to research galleries.

That kind of research is largely identical to, but more meaningful than, what the mailing list sellers do themselves. "There are two or three books in libraries that tell you which corporations collect art," said Constance Franklin, owner of ArtNetwork, which sells mailing lists and other books for artists and collectors. "For galleries, we also look in art magazines for ads by galleries."

Considering that the prices for mailing lists range from $27 to $160, depending upon how large they are, a few hours in a library looking at those same books and magazines might well save artists money and headaches.

By the way, any artist who orders a list from these list sellers is automatically placed on the company's artist mailing list, which is available to anyone wanting to sell something to artists.

Artists may buy lists of collectors, which may be equally problematical and unproductive. "The fundamental problem with trying to sell your work to people on a mailing list is that collecting starts at the grass roots," said Boston art dealer Jennifer Gilbert. "You have to develop a relationship with people, educating them about your work. I've found that many clients become friends of the artists. Sending out a solicitation to someone you don't know personally may work for L.L. Bean, but it's not the way you sell art. However, my guess is that those who sell mailing lists have never sold a work of art in their lives."

The one mailing list Gilbert recommended is from local realtors of new homeowners. "People who have bought homes want to buy a piece or two of artwork for their homes," she said. "Every gallery buys lists of new homeowners."

For some artists, the reasons for buying a mailing list or taking out an advertisement or paying money in some other way to get work into the market reflect a misconception about how the market works. Most dealers, for instance, would agree with New York City art gallery owner Stephen Rosenberg who stated that he takes a look at an artist's work or thinks about representing that artist "through recommendation of other artists in my gallery, or other dealers or critics. I wouldn't respond to an ad by an artist looking for a dealer." However, Andre Bogslowskiy, a painter and sculptor, paid to run small advertisements in various art publications for himself: "WANTED: Extremely Talented Russian Artist is looking for art dealer. Only seriously interested call . . ."

"I wouldn't do it again," Bogslowskiy stated. "I didn't find a real dealer. What I got was two calls from Russian artists like myself, who didn't really understand English that well and thought that I was a dealer in Russian artists."

Can You Put a Dollar Value on Exposure?
Getting ahead in the art world means getting exposure for your art. If lots of people see your work, some of them are likely to become buyers. This concept is well known in the business world; for instance, in the mail order field, where companies send out thousands of flyers and catalogs to households based on mailing lists and deem a response rate of 3 percent (on the average) profitable. Magazines, newspapers, and radio and television channels are filled with advertisements; highways are dotted with billboards; clothing is prominently emblazoned with the logos of the manufacturers—we live in a world filled with notices screaming for our attention.

Sarah Knock, a painter in Freeport, Maine, had to grapple with issues of exposure when Freeport's largest company, L.L. Bean, commissioned her to create catalog covers for 1994. Her land- and seascapes have been exhibited in art galleries in the nearby towns of Portland and Belfast. She has also taught students privately out of her studio and has sold paintings to the Maine offices of both Blue Cross/Blue Shield and the national accounting firm Coopers & Lybrand. But none of that exposure compares to

the commission to do the L.L. Bean catalogs. These catalogs of clothing and sporting items are mailed to between 8 and 30 million past, current, and potential future customers throughout the United States. The inside covers of the catalogs notes the artist's name and gallery association.

After just two of her images appeared on the L.L.Bean catalog covers, her gallery—Greenhut Galleries in Portland—received scores of telephone inquiries from all over the country: Are those catalog cover paintings for sale? What other works of hers are for sale? Does she have print editions of these works? What are the prices for her work? Greenhut Galleries owner Peg Golden mailed slide sheets of fifteen of Knock's available paintings to callers interested in purchasing her original art, and some of those works were snapped up.

"I think about trying to produce more work for a larger audience," Knock said, "because I've really sold out of everything. The problem is, I paint slowly, building up layers and using glazes. I have a show I need to have work for, and it's hard keeping up—all these people calling up wanting my work is another stress." The huge number of people who had seen her work over a period of months—L.L. Bean catalogs frequently lay on tables for months before being thrown out—is "intimidating," she said. "I just try to mix my greens and not think about it."

Sarah Knock did what every artist is advised to do, put her work in front of as many people as possible. Widespread exposure, of course, is not necessarily synonymous with achieving success as an artist, as many other artists could attest. A painting by Walter Robinson appeared on the cover of the summer 1995 issue of the magazine *Art in America*. A painting by David Coughtry was reproduced on the cover of the February 1997 Lands' End catalog, one of many pictures from a landscape exhibition featured in that issue. *Art in America*, Lands' End, and L.L. Bean are widely, in some cases massively, circulated publications (the Lands' End catalog is mailed to approximately 6.5 million people, the majority aged thirty-five to fifty-five, in dual-income families with advanced education, according to a company spokeswoman), but the result has been little to nothing in the way of sales of these artists' works. Among the adages of the media age is that publicity sells. Artists, like everyone else, know that, in order to achieve success in an overpopulated market, they need to generate the maximum amount of exposure to their artwork. At times, the art becomes louder, larger, tying up traffic, or aiming to shock—anything to ensure some sort of coverage. Has publicity been oversold as a marketing tool?

"I can't say that more exposure translates into more sales," said Gail Maxon-Edgerton, director of the Gerald Peters Gallery, which organized the "Rediscovering the Landscape of the Americas" exhibition featured in the Land's End catalog. "We have had a lot of people call up after the Lands' End catalog came out, mostly to find out where to see the show. Some people asked about buying posters of the works, but many of them seemed turned off by the $1,000 that a print would cost if we were to sell prints here, which we don't." Maxon-Edgerton added, however, that she has sold a number of exhibition catalogs to callers, costing $19 apiece.

Despite the demographic wealth of their buyers, neither Lands' End nor L.L. Bean has any sense of their artistic tastes or art buying patterns. The monthly magazine *Art in America*, on the other hand, is read by the very art-interested people to whom painter Walter Robinson's career would want to direct his work, and the artist's work *Vacation* appeared on the magazine's 1995 *Sourcebook* cover. As it turned out, "the cover didn't generate any sales. I don't remember any inquiries, either," said Tricia Collins, a New York City dealer who represents Robinson's work. "If you had a big review inside the magazine, with your art on the cover, then there might be some interest. But, even when you get both of those, you still may not sell anything. Having your work written about, put on the cover, often brings in more viewers, but those people might be other artists who aren't buyers, or they may be buyers but not ones who want your work."

Another source of wide exposure for artwork is the back cover of *Reader's Digest*, which is sent out monthly to 60 million people in the United States. Reproduced on these back pages are images of original art that appeals to the progressive tastes of the magazine's worldwide art director, Richard Berenson. *Reader's Digest* does not commission work but obtains rights to use the image, trading the huge opportunity for artistic exposure for any cash payment to the artist. "I feel I am here to educate my readers," he stated. "I believe that there is artwork that should be seen by our readers, whose tastes—how should I describe them—are conservative."

One of these back cover images that proved quite popular, judging by the number of telephone calls from readers interested in buying something by the artist, was George Nick's painting "The Cole Hahn Building," a Boston Back Bay scene, which had been sold a few years earlier for $14,000.

"We had a lot of inquiries," said Neil Winkel, associate director of New York's Fischbach Gallery, which represents Nick, "but when these people hear the prices for original work they are very surprised and back off. They're mostly looking for prints, which we don't sell and, even if we did sell them, we'd never sell them for as little as these people are willing to pay." Winkel added that a number of Fischbach's artists have had their work reproduced on the back covers of *Reader's Digest*, but he doesn't "remember anyone ever coming into the gallery saying that they saw an artist's work in the magazine and wanted to see more."

To George Nick's mind, making the cover of *Reader's Digest* is "like politics: You're a hit for a couple of weeks and then it passes. A couple of weeks later, who remembers you. I'm not convinced I got any benefit from it."

He added that "what makes a career is getting into the right galleries, getting written up by the right critics, getting your work into the right collections. Real collectors get their information from critics, not from seeing your work reproduced on the cover of a non-art publication. Having one of my works on the cover of *Reader's Digest* doesn't have much to do with what my career is about."

Most of the calls that have been placed to Greenhut Galleries about Sarah Knock's artwork have been from people looking for reproductions, generally in the $15–20 price range that L.L. Bean is planning to charge. Few of these callers have shown much inter-

est in the artist's original art or paying original art prices—from $400, for a 12″ × 14″ oil on paper, to $4,000, for a 2½″ × 4″ oil on canvas.

Tom Crotty, owner of the Frost Gully Gallery in Portland, which represents Alfred "Chip" Chadbourne, who has done a number of covers for L.L. Bean, stated that he lost money on publishing a poster edition of one of the artist's paintings because "the market was too small. We received maybe twelve calls a year. I needed 100 sales to break even, pricing the works at $95 apiece."

Chadbourne's original art has sold well since doing the L.L. Bean covers, but it sold well before then, too. To the artist's mind, it is not clear if having his paintings reproduced on catalog covers helped him and, if so, how. "The people who order from L.L. Bean are outdoor people, who want a back pack or flannel shirt or something. Art is the last thing on their list," Chadbourne said. "I didn't expect to make tons of money from doing the covers, and I certainly didn't get it. My dealers may have received 200 or so inquiries over the years and, out of that, I got maybe two commissions."

The decision to hire Chadbourne represented a shift by L.L. Bean in how it conceived of its cover art, and the company began to look almost exclusively for fine artists who lived in Maine. Until 1990, L.L. Bean had generally commissioned illustrators to show people wearing or using Bean products in a Maine setting, "but we decided we wanted a more painterly style for the covers, something that looks more like real art and less like advertising, which everyone sees too much of these days," said Jennifer Lawson, director of the company's creative department.

Neither Chadbourne's nor Sarah Knock's paintings that have been used as catalog covers have any identifiable L.L. Bean product. "We are looking to project an essential Bean image that exists apart from the products the company sells," Tom Sidar, vice-president of L.L. Bean's creative department, stated. "Outdoor, New Englandy, natural beauty—we feel that is as much of our brand as the products. We will use photographs to show features of specific products, but a painting creates a deeper connection with our heritage."

Lawson added that customer surveys suggest that buyers want the covers "to reflect the romance of Maine: Christmas in Maine, Autumn in New England. There are people who still think we get around by horse-drawn carriages."

Having one's work seen by millions of people increases an artist's name recognition immensely. Several magazines and a book publisher have contacted Knock about painting covers for them, and some corporations have inquired about her availability for commissions. "There is a rippling effect from this that takes my breath away," Knock said.

However, name recognition may also mean that an artist is permanently identified with a certain look or subject matter from which it may be difficult to break free, especially if the one well-known image is anomalous in his or her body of work. A gouache of a French vineyard by John Wellington, a New York City painter, was used on the Summer 1993 cover of the catalog of Sherry-Lehmann, a wines and spirits shop in Manhattan that also sells through its seasonal catalogs. According to Sarah Weinberg, vice-president for advertising at Sherry-Lehmann, the company has used artist's wine-

related artwork on catalog covers since the early 1980s. The catalog is sent to some of the wealthiest people in the country, some of whom may also be art collectors as well as oenophiles.

Wellington's vineyard scenes were part of a series that he painted while traveling in France, but he is "nervous about being tagged with this kind of label, because vineyards aren't really what I do. A lot of my work is very erotic and very strange. It's right for the New York art world, but not right for Sherry-Lehmann."

Annette Elowitch is also aware that what works for L.L. Bean may not appeal to serious art collectors. In fact, she stated, "warm, schmaltzy pictures may work against an artist." Certainly, Sarah Knock hopes to avoid recognition within a narrow context. "I don't want a lot of calls from people who want pictures of boats on the water," she said. "It's easy to lose your authenticity when people are offering you money."

Knock has a number of career goals, of which the Bean covers may help her achieve one—gain more collectors and allow her the freedom that more money buys. Echoing her dealer, she noted that "doing the catalog covers is going to change my career," although she is proceeding cautiously. Despite the increase in demand for her work, for instance, prices for them have not risen appreciably, perhaps out of the fear that her new popularity is still too fragile to risk change of this (or any) sort. "I'm still finding my way in the woods," she said.

Her other aspirations include "getting into some museums" (both collections and exhibits) and seeing her work on the cover of an art periodical. "In terms of those other goals," she stated, "being on the cover of the L.L. Bean catalog is a neutral—it doesn't hurt or help."

Name recognition is rated quite highly in the art world, yet it is an intangible element with no assignable dollar value. Collectors are assumed to be more willing to purchase something from an artist they have heard of, yet they may not buy anything for years. To the mind of Reader's Digest's Richard Berenson, having one's work seen by 60 million people may do nothing more than "raise the artist in the gallery's esteem. It may help the artist in the artist-gallery relationship, where the artist is often in a less powerful position. That may not necessarily translate into more money for the artist, but it is still a very good thing for the artist."

Exposure isn't tangible, but artists hope that it will lead to something tangible. In the January 1998 issue of the magazine Southwest Artist, painters William Kalwick (of Houston, Texas) and Ted Larsen (of Santa Fe, New Mexico) were highlighted as "Artists to Watch," accompanied by color images of their work and brief biographies. The immediate result for the two were telephone calls from gallery owners who wanted to represent them and congratulatory calls from friends and past collectors. Kalwick also was asked to teach several art workshops, which put some money in his pocket ("People who can't afford to buy artworks but like to paint will pay for a workshop," he said, adding that he sold some demonstration paintings at the workshops). They both viewed the article as giving them "credibility" with buyers, critics, dealers, and other magazines, too, because other publications began to seek them out for profiles. What

neither of them could discern was an increase in sales after the *Southwest Art* or subsequent articles.

"No one called up after reading about me and said that they wanted to buy something they saw in a magazine right now—can they come over?" Kalwick said. "I got more calls from people who had bought my work and were thrilled to see their paintings reproduced in the magazine. I think exposure in a magazine adds value to artwork, for a collector."

Newspaper and magazine exposure certainly has a feel-good value for artists, because they see that someone is paying attention to them, and that sense is heightened when additional articles are written. For Larsen, the main benefit of being written up is that it leads to other write-ups; it is not so much a single article in a periodical but the cumulative effect of many articles that leads buyers to see an artist as good or safe. For many people in the art world, art careers exist on the pages of magazines, since they may not see the artists or their works anywhere else. Repeated exposure reinforces the name and the work on people who are inundated with the names and images of other artists. "Dealers and curators read magazines, too," he said, "and seeing the same artist's work again and again has a psychological effect on them."

The Connection Between Advertising and Sales

What actually sells art? Is it the work itself, the way the art is exhibited, the artist, the artist's reputation, or something else? There may be no one answer, as certain factors outweigh others in different circumstances. Some art may just strike a viewer's fancy—love at first sight—and major name artists frequently have waiting lists for their new work, collectors who will buy them sight unseen.

Advertising sells almost everything these days, and one often sees notices of new exhibitions at art galleries. However, different dealers have their own purposes in mind when they place an advertisement in a newspaper or magazine, and there are a variety of opinions regarding the effectiveness of using a photographic reproduction of the artwork in the advertisement. Those reproductions, especially ones in color, usually cost two, three, or four times that of simple black-and-white text notices. Ads may bring into the gallery visitors who may one day turn into buyers, of the particular artist in the advertisement or someone else. The ads may serve as a reminder to specific collectors on a gallery's mailing list about the event.

James Yohe, director of the Andre Emmerich Gallery in New York City, stated that advertisements, especially those with color images, make the artists feel better about their relationship with the gallery. "Artists want a reproduction of their work," he noted, "a document, as it were. It means a lot to them."

Taking out an advertisement, some dealers believe, also increases the chances of seeing a write-up of the exhibition in the particular publication. The ability to afford a large ad with photographic reproductions is occasionally seen as a sign of success, impressing artists and collectors. With other dealers, ads have greater importance for the long-term viability of the gallery than for the short-term exhibition. "An advertise-

ment attracts attention," New York gallery owner Thomas Erben said. "It secures the gallery's position in the market. People have to see that we are still here. In effect, I'm advertising myself through the market."

Gallery owners give considerable thought to how to most effectively design an advertisement, paying graphic designers handsomely. Arguments become heated over questions of type size, typeface, black-on-white or white-on-black, with or without a color, not to mention whether or not to use an image and (if so) which image to use. In a few instances, art advertising uses as illustrations not the artwork visitors to a gallery might see but photographs of the artists themselves. Associated American Artists gallery in New York, unsure which work was emblematic of the entire show and unhappy with the way a colorful painting looked in a black-and-white ad, chose to use a black-and-white photograph of Rufino Tamayo at work in the studio to announce an exhibition of his art. In another example, for years, the Thomas Erben Gallery used a photograph of one of its artists, Lilo Kinne, in advertising her work. "Her paintings would reproduce badly in black-and-white, and I didn't want to spend money for a color ad," Erben stated, "so I decided to use a portrait." Shown wearing a turban, Kinne herself stated that the portrait "conveyed a sense of me as a colorful artist. The art world wants you to be eccentric."

The magazine advertisements for Lexington, North Carolina, landscape painter Bob Timberlake also feature a black-and-white photograph of him looking contemplatively out a window: That picture fills up more than half the page; underneath the photograph are three color reproductions of his paintings, which are somewhat smaller than images on slides, and information on where his works may be seen or purchased. "What you do in advertising is the same thing over and over, so that people recognize you when they see you," Timberlake said, noting that he has been interviewed repeatedly about his artwork on television. "I've been told that I'm recognizable and that the name Timberlake is recognizable."

He spoke disparagingly about most artists' advertisements, which largely consist of one large reproduced image in a one-time ad, as not being part of any marketing plan. He places ads in the same publications on a regular basis, in order to familiarize readers with his name. "Do I want to sell the name or the product?" Timberlake asked. "I want to sell the name, because you'll see the name many more times than you'll see that one picture." His photograph "gives an air of who I am and where I'm from. It's all the mood and the person," adding that "the window is in my own studio."

Timberlake attributes his high volume of sales to advertising, but neither he nor any of his employees (or even the Hammer Galleries in New York City, which represents his work) has surveyed buyers about how they learned of him or were led to purchase his work. What no dealer or gallery owner can say definitively is that there is a direct connection between placing an advertisement, with or without a photographic reproduction, and making a sale. It is not an uncommon problem in the art world and elsewhere that no one can be certain whether or not a business or career investment has actually paid off. "Advertising, especially advertising with illustrations, affects atten-

dance, not so much sales," said Bridget Moore, director of New York's Midtown-Payson Galleries. Other dealers report that ads with reproductions result in a number of telephone inquiries as to price and the availability of works, which also do not quickly translate into sales, and the advertisements placed by the Andre Emmerich Gallery bring in "maybe a general inquiry, but the phone is not ringing off the hook," James Yohe stated.

Amidst questions of whether or not to take out an ad, and whether to include a reproduction in it, is a certain principle on which most art dealers agree: Advertisements should be placed in art publications. Departing from most, if not all, accepted wisdom on art advertising is sculptor J. Seward Johnson, who every year sells millions of dollars of art without a gallery that regularly exhibits his work and who doesn't target his ads to traditional art buyers. Notices to current and potential collectors of Johnson's outdoor and public sculpture rarely appear in art magazines. These ads are more likely to run in *Architectural Digest* or *The New Yorker,* as well as in various business and travel magazines, where people with money and sophistication but perhaps no ongoing experience as art collectors might be found.

The advertisements contain a full-color reproduction of a particular figurative bronze. Running between a quarter-page and a full-page, the advertisements also note that a catalog of the artist's work is available to those who call or write in, where his work will next be exhibited, and that a $24 book on Johnson's sculpture *(Celebrating the Familiar: The Sculpture of J. Seward Johnson)* has been published and may be purchased only through his agent.

As the exhibitions may take place not in a regular location but, rather, irregularly at various locations in the United States or Europe, most of the actual marketing of Johnson's work is done through the 25-page catalog or the book. A series of photographs of other Johnson sculptures, as well as a file of articles about the artist (interestingly, Johnson is more likely to be written up in a magazine's or newspaper's feature pages than to receive an art review) and a price list (between $60,000 and $180,000) accompany the catalog.

"We send out 100 or so packages every two weeks," said Paula A. Stoeke, owner and curator of Sculpture Placement, Ltd., which has handled Johnson's work exclusively since the late 1970s, adding that "hardly anyone buys from the ads or from the catalog. People generally don't spend $100,000 for something in a mail order catalog."

Many of the people who call or write for the catalog, Stoeke claimed, have seen one of Johnson's sculptures somewhere before. "It's a subconscious thing," she stated. "Someone may walk by one of these works at one point or another and say, 'Gee, that looks fun,' but people are very busy and they forget the name of the artist. It's when they come upon the ads that they remember seeing another work by Johnson, and then they have more time to follow up their interests. The more people are exposed to the art in the ads, the more the link will be made to what they've seen, and these people will want to see more works. People want to be directed to existing works."

According to Stoeke, Johnson's aversion to commercial galleries reflects the "need to show the pieces in the context of the actual environment rather than in a closed, artificial space like a gallery." The fact that Johnson has not fared particularly well with art critics also may have prompted the search for a market outside the confines of the art world. Stoeke refers to herself, not as Sculpture Placement's owner or president or director but, as the company's curator, since she organizes every one of Johnson's shows. She locates art spaces (such as the Jacksonville Art Museum in Florida, the New Jersey State Museum in Trenton, and the High Museum in Atlanta, Georgia), as well as other available spaces (such as the Boca Raton Hotel and Beach Club in Florida, Nabisco Corporation in East Hanover, New Jersey, and a radio-television station in Rome, Italy) that would be interested in an exhibition of the sculptor's work and makes all of the arrangements, creating half a dozen or more shows per year. Not many institutions, and certainly no major galleries or museums, have contacted her about shows of Johnson's art that they would like to organize. This is an artist and his agent continually generating their own momentum and market.

Sculpture Placement, Ltd., itself has no gallery showroom, only administrative offices in Los Angeles and Washington, D.C., and potential buyers obtain information about the artist and the artwork largely through correspondence or by telephone. For the most seriously interested collectors, Stoeke said, "I may come out to the collector's home, walk around the grounds and select the most appropriate pieces."

Another difference from the traditional gallery approach to sales is that, for Sculpture Placement, Ltd., precious little reliance is placed on a mailing list—the backbone of collectors who patronize the gallery's roster of artists—in selling Johnson's work. "Seventy-five percent of our sales come from our mailing list," stated Sique Spence, director of New York's Nancy Hoffman Gallery. As a result, the gallery's advertisements tend to be typeset and imageless, merely stating the name of the artist who will next have an exhibition and the dates of the show. "The ads we place are a reinforcement for the information sent out to our mailing list."

Ian Harvey, one of the four associate directors at Associated American Artists, also noted that "the mailing list is our collectors. As a marketing tool, placing ads is really scattershot; it's like sending your résumé to everybody in the country in order to get a job."

He and many dealers prefer to spend their budgeted money for advertising on catalogs for artists' shows and reproductions of the artists' work on cards that will be sent to the collectors on the mailing list rather than on magazine spreads. "If you're going to do it right," George Adams, director of New York's Frumkin/Adams Gallery, said, "you have to take out full-page ads in at least two art magazines, and that's going to cost you $10,000 and up. The money is better invested in a catalog, because the ad may not be looked at twice, while the catalog will be there for a while."

A number of gallery advertisements mention that a catalog (usually not free) is available. Requests for a copy of a catalog, gallery owners and dealers claim, are often the largest area of inquiry. No one seems to track inquiries for catalogs for later pur-

chases of original artworks. Publicity may have no higher purpose than to keep the artist's or the gallery's name current in people's minds.

For Johnson's sculptures, however, advertisements in a variety of non-art publications appears to be the most on-target approach, Stoeke stated, as "new collectors are the largest source of buyers. We also have some repeat buyers, but the past buyer may no longer be in the market for a new work. They may not have a place for it in their homes. That's one of the differences between collecting paintings and sculpture. You can rotate paintings and keep some in storage, but a sculpture tends to be there permanently."

Stoeke declined to reveal what Sculpture Placement, Ltd., spends annually on advertising and promoting Johnson's work, although his volume of sales range from between $1 and $2 million per year, or more. Anyway, Johnson, a scion of the founding brothers of Johnson & Johnson, could probably withstand a year or two of paying more for advertising than he received in sales.

The marketing of J. Seward Johnson is anomalous in yet one more way. In the fine art gallery world, artists with established reputations and buyers are the least likely to need extensive advertising, especially the type of notices that include photographic reproductions of their work. Images offer much more information than just text and tend to be necessary for lesser-known artists who need some way to be recalled to mind by the art-buying public. Unfortunately, gallery owners are least likely to spend thousands of dollars on large-scale ads involving four-color separation for artists who have not proven themselves in the market. These artists are usually asked to contribute up to half, and sometimes more, of the cost of the gallery's advertising. More ads with images do not appear, because these emerging artists are the least able to afford them.

Advertising as extensively as he does, using color reproductions, Johnson combines the resources of the established artist with the search for name recognition of the emerging artist. This may be a necessity when concentrating promotional efforts so heavily on non-art collectors in non-art publications.

In some ways, art promotion is at a disadvantage to advertisements of more mundane objects. A photograph of a kitchen appliance or other product in an ad sells, not only the machine itself, but a sense of what it will mean in one's life: This car will impress my friends; that coffee maker will make great espresso for dinner parties; this food processor will allow me to make gourmet treats in just minutes. In effect, these ads offer an image of one's own ideal life rather than just a thing with a specific use. However, when showing works of art, ads present just the images themselves, and potential buyers must imagine how the artwork would fit into their lives and homes. Also, as photographic reproductions of art in ads are shown smaller than the originals, in almost all cases, they tend to conceal the very details that give them character.

Advertising does offer the opportunity to establish name recognition and, along with the familiarity of seeing someone's name or images repeatedly, a sense of celebrity: People know the names of more laundry detergents than they ever will use. This may be the reason that art advertising may add to the number of inquiries or visitors to

a gallery without necessarily increasing sales of artwork. Advertising is an expensive way for an artist to put his or her work before the public, and only for a few is it certain to be effective.

Buying Advertising Space in a Directory

Certain kinds of attention carry more weight or prestige than others. A favorable write-up in a newspaper on the arts pages or in an art magazine is more likely to be completely read by would-be art collectors than a flyer sent by an artist to thousands of unknown people on a purchased mailing list. Images of one's work in an art book are also more apt to be seen by art buyers than classified art-for-sale advertisements.

A "who's who" directory may seem to satisfy the requirements for more weighted attention. Artists and their images are included in—presumably selected to be in—a book that is available, and sent free, to a targeted audience of architects, designers, private collectors, art consultants, art dealers, libraries, and museums, the very people and institutions that might advance their careers.

If effect, these directories act as group shows in book form, which gives them a greater permanence than exhibits lasting only a matter of days or weeks, and they may supplant the need for artists to take part in as many shows. Artists could reach the same potential buyers through a book without having to drive or ship their artwork all over the country. "Everyone is looking to cut down on the number of shows they do," said Toni Sikes, president of Kraus Sikes Inc., which publishes The Guild "sourcebooks" of artists and craftspeople. "Buyers come back from these shows with their eyes glazed over. They've seen too much stuff, and it's hard to remember what they saw."

An artist directory is a who's-who book or catalog listing artists (often those working in the same general medium), their addresses (sometimes telephone numbers), gallery associations, backgrounds, awards or other professional recognition, major exhibitions, and possibly, representative samples of their art. Their value is twofold for the artist: On the one hand, they provide exposure and information for prospective buyers; on the other hand, they have a "résumé" value in outwardly suggesting professionalism and acceptance (artists are in the directory presumably because of their accomplishments and the level of their work).

There are many such publications, from *Who's Who in American Art* to those aimed specifically at the commercial art field. Some list artists for free, others don't; some "jury" artists applying for inclusion, others appear to take all comers; some are carefully distributed by the publishers to the most likely buyers, others send out their directories more haphazardly, based on mailing lists from art magazines, museums, and other sources; some can be found in libraries and book stores, others seem intended to be purchased by only the very artists who are afforded space in them.

Some directories are published regularly, while others last a small period of time and then disappear, seemingly without a trace. American References Inc., publisher of *American Artists, The New York Review of Art, The Chicago Review of Art, The California Review of Art, The Southwest Review of Art, American Photographers,* and

American Architects, went out of business in 1993, having received $1.7 million from 3,000 artists. Artists accepted for inclusion in American References' books (selected by the editors) did not need to pay any fee, although those 3,000 purchased the publisher's "reproduction package" ($695) that provided them with 1,000 postcard reproductions in color of the work that was submitted with the application and appeared in the particular directory. They were also to receive one complimentary copy of the book.

Another defunct directory publisher, Art Services Association *(Artists of Alabama, Artists of Central and Northern California,* and *Artists of Southern California),* charged $900 for a half page, $1,500 for a full page. Art Services Association provided 50 or 75 copies of its directories to each advertising artist, depending on whether a half- or full-page listing was purchased, and 1,000 tearsheets of that page. Artists seem to pay one way or the other, and it is implicitly assumed with these and other directories that the artists will do much of their own distribution, by mailing or handing out the tearsheets or postcards with their images and addresses on them to prospective collectors.

Advertisers in the Art Services Association offered mixed reviews of the directories. One artist complained of "guilt by association" with some artists' work in the *Southern California* catalog that he felt was of low quality: "There's good and bad art in it, and that immediately averages out the quality. On a scale of 1 to 10, I would give it a 2 or 3 at most." Another painter who bought a half-page listing also noted the mixed quality as a drawback, adding that "for those who already have galleries, the catalog doesn't have a lot of value."

However, David Linton of San Diego stated that he received inquiries for his pastels from a few artist representatives around the country who saw his half-page listing, and Janet Lee Parrish of Vista, California noted that the catalog "got two galleries to pick us up," based on the notice she and her husband paid for.

Directories often relieve an artist of the urgency to actively promote his or her own work. Not everyone can find the time to create work, sell it, earn a living in some other fashion, and have time for the rest of their lives. Susan Gardels of Des Moines, Iowa, whose art consists of works on paper, stated that her ability to produce pieces and market them at shows had slowed considerably after the birth of her twins. Even when she was able to create more pieces, Gardels still could not leave her young children behind in order to set up a booth at lots of shows, making the *Sourcebook* directory an attractive alternative for her. "It becomes its own show," she said, "and took away from me the need to make the initial sales. I started getting calls from galleries who had seen my work, and I've been able to sell thousands of dollars [worth]."

According to Constance Franklin, owner of ArtNetwork Press, which produces the annual *Encyclopedia of Living Artists,* artists should not rely on a directory to do all the marketing of their work. "You use the book to expand your market, but you also have to market your work with your feet and hands, going to shows and meeting people, selling your work in a personal way." Of course, artists with a limited budget for promotional activities may choose not to enter as many shows because of the cost of getting into a directory, as these books are advertising vehicles in which one must buy space.

Kraus Sikes's *Sourcebooks,* for instance, range between $740 and $2,000, depending upon whether you want a half-page ad, a full-page ad, or a two-page spread; and the separate cost of 500 individual reprints (tearsheets) of your advertisement is $130. As a point of reference, the *Encyclopedia of Living Artists* charges $625 for a half-page, $849 for a full-page (add $150 for a second image), and $1,485 for two pages, offering 1,000 reprints for $275. Artists who would like their work on the front or back covers of the *Encyclopedia* may pay an additional $35 to enter a contest in which those decisions are made.

There is usually some suggestion of jurying the slides received by these directories. However, as these books consist entirely of advertisements, a far higher percentage of artists will have their work accepted into a directory than into most juried shows. Constance Franklin stated that "I am the judge, although I also bring in an artist to help me go over the slides." She claims to reject approximately 20 percent of the applicants, mostly for reasons of poor photographic quality, overt political or erotic content, or "too many pieces in one style."

Toni Sikes, on the other hand, asks some of the very people to whom she sends her *Sourcebooks*—gallery owners, interior designers, and architects—to make selections for her, establishing as criteria good-quality photographs and the works' "salability." Clearly, no one is overly fussy, as 152 artists were selected and only 4 rejected. Sikes credits her "advertisers"—the artists—"who tend to be serious individuals. We don't have the space considerations of a show, so we would like to sell many, many more artists."

Several paragraphs of text accompanying the photographic images in the *Sourcebook* suggest a curatorial hand. However, they are all written by the individual advertising artists, edited largely for grammar and to ensure the artist is described in the third person. Occasionally, the writing verges on puffery: "Anthony Corradetti's extraordinary understanding of form, coupled with a unique painting style, place his sophisticated glass objects in a class of their own," or "Lillian Kefalos has been an artist her entire life." It is unclear whether the text is intended to be seen as traditional artist statements or as descriptions by some unknown art authority. These books are a strange hybrid, looking like museum catalogs at times but having very different intentions.

The high acceptance rates does not always sit well with every artist included. New York City painter Philip Sherrod called most of the artwork in the *Encyclopedia* "lightweight and decorative. It hurt my art to be surrounded by it"; and Jersey City, New Jersey, sculptor Robert Pfitzenmeier called the artwork in the *Sourcebook* "a little eclectic and, well, let's say there are pieces I don't necessarily like." Sherrod did not make any sales on the basis of his advertisement, receiving inquiries from only "low-level galleries," and he has chosen to no longer place ads in the *Encyclopedia,* while Pfitzenmeier has earned a half dozen commissions for public artworks through art consultants who had seen the *Sourcebook.*

The costs of advertising in a directory are high, but the artist's investment is more likely to be rewarded if the publisher's mailing list is on target and those who receive the book view it as a reliable source of information. A good mailing list is of paramount importance, as none of the recipients buys or even orders these books, and these directories are never found in libraries or bookstores. One significant group to receive these

books are art consultants, as their private and corporate clients look to them for knowledge of artists' work. There is no organization of art consultants—some advertise, most don't—and, as a result, there is no list of member consultants that a publisher could buy. The publishers of directories, therefore, must locate names and addresses as best they can, often through advertisements these consultants have placed in magazines or through word of mouth.

Many publishers have had success locating consultants, according to Denver, Colorado–based art consultant Mary Ann Goley, who stated that "the subject of these books comes up a lot among consultants, because they get barraged by these books and they don't like it."

Judging from the examples of Pfitzenmeier and some other artists in these directories who have received commissions through consultants, obviously not all consultants react as negatively to these books. Patricia George, a painter in Cypress, California, stated that she has "gone from emerging to being a totally established artist, in part from art consultants who have seen my ads in the *Encyclopedia*." A publisher of calendars bought several paintings from Welcome, North Carolina, artist Dempsey Essick, also based on his advertisements in the *Encyclopedia*. However, most artists who have received inquiries from their advertisements in a directory note that it is galleries and shows that contact them, sometimes leading to sales.

Creating a space for artists to advertise apparently has become quite profitable, since both *Art New England* and *ARTnews* have created "Artist Directory" sections in which artists may display their work. *Art New England* charges $279 for one four-color image and a short text (name, address, telephone number, e-mail address plus a comment or two) that fits within a three-by-five inch space, while *ARTnews* asks $400 (for one image, name of artist and contact information—$3.50 per additional word) for an advertisement fitting into a space that measures two-and-three-quarters inches high by two-and-one-eighth inches wide. Similarly, *The Crafts Report* has a regular "Showcase" section, which costs $400 for a quarter-page advertisement (one image plus 15 words of descriptive copy and artist contact information).

A survey of artists who placed advertisements in the December 1999 issue of *ARTnews*, conducted in March 2000, reveals that none of the respondents could report any sales of artwork, commissions to create a piece, being asked to exhibit in a gallery or hired to teach, lecture or give a demonstration of their techniques. Curtis Salonick, a photographer in Wilkes-Barre, Pennsylvania, had a typical experience for the artists, reporting that "what has transpired since the ad are very few inquiries; nothing concrete." Ana Maria Sarlat, a painter in Miami, Florida, noted that she was "contacted by a gallery in Puerto Rico that was interested in my work, but they dealt with realism so it wasn't a good fit. Someone else called about my work, but it sort of fizzled out." Kathleen McKenna, a painter in Shakes Heights, Ohio, stated that she had been contacted by a couple of galleries, "and we'll see if anything comes of that." Los Angeles painter Ione Citrin claimed that she has received "about a dozen responses to which I immediately replied and followed through." However, "they were totally zero insofar as

anything concrete." Barbara Starr, a painter in St. Louis, Missouri, reported no buyers and no contacts. "It's not likely that I'd place another ad in *ARTnews*," she said. Certainly, there is more to advertising than simply generating immediate sales: Developing product recognition frequently takes a long time. In order to be effective, advertising must be part of an ongoing marketing campaign rather than a one-shot effort. The result of ads in *ARTnews* or any other publication may be nothing more than names and addresses of collectors and art dealers who are interested in receiving more information about the artist's work (other works completed, where exhibited in the past or future). Selling art is the culmination of a relationship between a collector and a work of art (or an artist), and that requires initial exposure, the opportunity to see the work again (and again), perhaps meeting the artist directly and learning about the artist's standing in the art world. An advertising campaign must be researched and budgeted; however, at $400 per ad, artists need to determine if this is the type of marketing effort they truly want to undertake.

Blurring the distinction between a contest and an advertisement are *Art Calendar* and *The Artist's Magazine,* both of which hold competitions for artists to have their work displayed in the respective publications. *Art Calendar* has a centerfold contest four times per year (in which the work of 20 artists out of 400–500 applicants is displayed), as well as a separate annual magazine cover competition, and the entry fee for submitting three slides is $25 for each. For its part, *The Artist's Magazine* holds an annual contest (in which the work of 30 artists out of an average of 13,400 applicants is exhibited in the December issue), with each applicant paying an entry fee of $10 per slide.

The respective magazines do not keep track of how well these artists have done in terms of sales of work, commissions, opportunities to teach or contacts from dealers, collectors and museum curators resulting from the advertisements or exposure. Artists who are interested might want to contact those who have placed advertisements or won the contests to determine whether or not the expense is a good investment. Perhaps, the magazines themselves are the biggest winners. According to Sandy Luppert, manager of ancillary products and marketing for F&W Publications and the coordinator of *The Artist's Magazine*'s art competition, the average applicant submits three slides. At $10 per slide, multiplied by the 13,400 applicants, the magazine takes in over $400,000 in entry fees, well in excess of the $16,500 in contest prizes awarded, payments to jurors and other administrative costs related to the competition. Although slightly less expensive to take part in, the benefits of entering *Art Calendar*'s contests are less tangible, since there are no cash prizes and because this is a publication primarily read by artists, rather than buyers, dealers and collectors. (See below for further discussion of entry fees.)

Fine artists placing their own advertisements in newspapers and magazines is a relatively new phenomenon and a carryover from the world of illustration and design, where commercial artists regularly spend up to one third of their gross earnings on ads in directories and other publications. Acceptance may come in time, as directory editions are published regularly and as the artwork reproductions in them are of high quality. Susan Gardels, who has bought advertisements in several editions of the *Sourcebook,*

stated that "taking out ads year after year has a cumulative effect in terms of building a market. The more gallery owners see your work, the more they begin to like it. If they see your work consistently in the same publications, it lets gallery owners know you're not a fly-by-night operation."

Publishing Your Own Catalog

An artist's exhibition, while usually a source of great hopes, is often an evanescent event. Visitors and potential collectors walk through, perhaps some sales take place, but an art show rarely changes the world, and artists can only hope that those who saw their work (and liked it) will remember it by the time the next exhibit takes place—perhaps a year or more down the road. After the show comes down, most artists are left with nothing more to show than some receipts or press clippings, if they are lucky, and another line for their résumés.

This is why artists appreciate exhibitions that are accompanied by catalogs. Here is a tangible thing to come out of an art show, a record of an event that contains reproductions of the work in the exhibit and an essay by a third party (not the artist, not the visitor or buyer) that makes a case for the art.

Art shows that have catalogs are rare, but the artist's hunger for them never abates. Some artists have sought to help themselves by producing their own catalogs of their current art, complete with their own penned essays on who they are and what distinguishes the artwork they create. It is an expensive way to fill a void in one's career, but a growing number of artists are attempting to give themselves and their (real or perceived) audience something to hold onto after they leave the exhibit.

These catalogs differ from brochures that many artists produce in order to publicize their recent work and to send to past buyers as well as those who have shown interest in the artist's career. Many artists develop mailing lists for exactly this purpose. Brochures generally have fewer pages than a catalog—four or eight, or perhaps just one long page folded several times—and are unlikely to include more than the briefest text. That text, in fact, tends to mention where and when the artist's work may next be exhibited, prices, and perhaps, a quick update on the artist's life and work.

Catalogs, on the other hand, are small books, reaching forty and sometimes more pages, with larger full-color reproductions of more artworks than found in most brochures and a text that rarely (if ever) discusses the potential for buying something. They are frequently intended to be identified by readers as a traditional art gallery or museum catalog, rather than as a self-published promotional effort, although the artist never has claimed that he or she aims purposefully to deceive anyone. Call it *trompe l'oeil* promotion, and the jury is not yet in on its effectiveness.

Many people are introduced to the ideas and artwork of Todd Siler through the twelve books and catalogs he has written since 1979, many of which have been self-published. A painter with a doctorate in Interdisciplinary Studies in Psychology and Art from the Massachusetts Institute of Technology, Siler noted that these publications "present my ideas about how the mind works and the art I've created that illustrates my ideas. I'm not exactly making a catalog for a show but, rather, an informative tool for the public."

That tool is not cheap, and the 3,000 copies of the forty-two–page *Cerebralism* catalog that came out in 1993 cost $16,000, although Siler was able to cut the cost in half through bartering some of his artwork with the printer. A large number of these catalogs are sent to collectors, cultural centers, dealers, museum curators, and "newspaper people who have expressed interest in writing about my work"—Siler's own mailing list includes 1,000 names—although the artist has been able to sell copies at galleries, where his work is exhibited, at $20 apiece. "I get 3,000 printed and think, 'What am I going to do with all these catalogs,'" he stated, "but over a two- or three-year period, I find that they end up being sold out."

Siler's catalogs "pay for themselves," he believes, by bringing prospective buyers to his exhibitions and through direct sales. "I think of them as informative tools but, when people get the catalog, a number of them call up and say, 'I'm interested in this or that piece. Has it been sold yet?'"

Siler's New York art dealer, Ronald Feldman, contributes between 200 and 250 names from his own mailing list for the artist's mailings but does not offer to pay for any part of the catalog's printing or postage. Nor is Feldman particularly interested in producing a gallery book on Siler's art with an essay by someone other than the artist. "Some dealers do that for their artists," Siler said. "Mine won't." Perhaps as a consolation to Siler, Feldman refuses to accept a commission on direct sales generated by the catalog.

Through reviews of his exhibitions around the world, Siler has seen his art and ideas described by a number of different writers, "which is interesting," but he prefers to be his own apologist. Stated quite roughly, Siler's "cerebralism" views the mind as storing bits of memory and knowledge, which he labels "informatons," and which exist in the brain as units of energy or electricity. When these informatons form a connection with each other, a "metaphorm"—Siler's writing is laden with coinages—is created, which itself is the basis of language, morality, and cultural advancement. How these metaphorms are created distinguishes one individual from another and gives color to a personality. Siler's artwork is presented as an illustration of these and other ideas he has developed about mental processes.

"I love writing, and I look at the book form as a way to express myself in another medium, to experiment in word form," he stated. "My catalogs are definitely not vanity publications, because I look at my essays as experimental, not self-aggrandizing and not self-promotional."

Many dealers are not convinced of the overall benefit of artists publishing catalogs about their own work, sensing a vanity element that implies no one else would go on record in discussing or praising the artwork. Siler's own dealer, Ronald Feldman, stated that he is "inundated by zillions of catalogs every day, many of them from and published by artists. I have to admit that self-publishing is a kind of red flag to me, because it immediately makes me wonder, 'Why does the artist need to resort to this?'"

Other dealers, however, claim that this kind of catalog is an excellent way to present oneself to new collectors and reflects the self-confidence of an artist who will put up his or her own money in order to make a good impression. According to a number of art

dealers, some of these catalogs, especially those containing a thought-provoking essay by the artist, are viewed later on in the artist's career less as promotional material and more in the category of artists' books, and their limited numbers make them prized, valuable possessions. In this regard, a self-published catalog need not be specifically related to a particular exhibition, although most dealers believe that the concurrence of an art show makes them far more effective.

Recognizing that Siler's catalogs have resulted in "a lot of feedback on the art in the catalogs," Feldman noted that the desire to publish catalogs on one's own work "comes at a certain time in an artist's career, when they are trying to build a larger audience and have more ideas than works in which to incorporate them all. Artists are full of frustrations and worries, and it is that self-criticism that makes them artists. They are not satisfied with the way things are, and that includes seeing their market develop slowly over time. Their innate restlessness prompts some of them to take matters into their own hands."

Sue Viders, an artist's advisor, stated that an artist's self-published catalog "strikes me as a good idea, if it is done well. It's self-promotion, but what isn't self-promotion? An art exhibit is a form of self-promotion." She cautioned, however, that a self-published catalog is not appropriate for every artist. "The right artist for this catalog has to be mature, needs to have been in the marketplace for a while and, of course, have a good mailing list. It's not for the emerging artist whose work may be evolving. You don't sink that kind of money into a publication when the artist may not know where he or she is going."

An example of a riskier venture is the "Spiritrealism" catalog for which painter Robert Masla paid $8,000 for a printing of 1,500. Without a regular dealer or an established market or even an up-to-date mailing list ("I'm going to look into some of the lists I see advertised in magazines"), Masla is using his catalog "as part of my stepping back into the art market"—he had given up actively trying to sell his work for a period of four years starting in the late 1980s, during which time he taught art at various schools and "just painted."

So far, Masla claims to have received favorable responses to his catalog from those who have seen it, and some have purchased it for $10 apiece when he has an exhibition. He believes that it is no more of a vanity publication than the books of art and poetry that William Blake self-published in the late eighteenth and early nineteenth centuries or Wassily Kandinsky's famous essay, "Concerning the Spiritual in Art," which the artist brought out in 1912. "I published 'Spiritrealism' for promotional reasons," Masla noted, "to get my work to a larger audience."

As with Todd Siler, Masla's "Spiritrealism" catalog is not oriented toward a particular art exhibition but, instead, was published "to air the philosophical content." Drawing on Eastern religions, Masla sees "The Supreme Personality of Godhead" manifested in painting "through the unity of content, context, image and symbol. . . . By dissolving false ego, the spirit can shine through the artist and become manifest in his or her artwork. That state of pure consciousness is transferred to the viewer, thereby uplifting the viewer's consciousness to the platform of the transcendental."

Masla also believes that it is preferable to write his own essay, rather than entrust the issue to someone else. "I've written about my ideas for a long time, and I think I do it pretty well. I think I can do it better than anyone else."

While a relatively new phenomenon in the fine arts, self-published catalogs have been in existence for some time in the crafts field, although there is some dispute as to their intended audience. According to Joanne Brown, director of American Crafts Enterprises, the marketing arm of the American Crafts Council, these catalogs offer artisans an opportunity to explain their artistic ideas, philosophy, and especially, their techniques to potential collectors. On the other hand, Rebecca Cason of The Rosen Agency, which also sponsors crafts shows around the country, noted that "the cost of producing a catalog is very high, too high in fact for the retail market, considering how relatively inexpensive most craft pieces are when compared to works of fine art. These catalogs are created for craft galleries and museum stores, because volume is in whole-sale." Cason added that "prices and terms" are the only written statements printed in the catalogs she sees.

An artist's catalog creates a permanent art exhibition, testifying to your ideas and achievements. The degree to which they may actually expand an artist's market (in their capacity of promotional material) or be regarded seriously as an artist's book (rather than frowned upon as a vanity publication by the very collectors, curators, and dealers you hope to impress) is not well determined. Certainly, they are an expensive long-shot, more or less of a waste of money depending upon what the artist does once the catalogs come off the press.

THE ARTIST STATEMENT

Not so long ago, it was believed that art spoke for itself, but no longer. Art museums have made their wall labels longer and longer, offering paragraphs of background information and interpretation to visitors who now spend as much time reading as looking. Deconstructivist critics, for their part, have announced that art itself is simply "text," which needs to be deciphered by a critic in order to be rendered intelligible by the public.

Increasingly, artists have become part of this word culture. More and more of them now write Artist Statements, which are tacked up on the walls of exhibition spaces where their work is displayed or that accompany packets of slides mailed to art dealers whose galleries they wish to join. Many artists and dealers dislike the trend or are unhappy with most of the artist statements they see, but the growing number of these documents in the art world is undeniable.

An artist statement presumably offers some information about the art one sees—such as who the artist is, how the work was made, the artist's philosophy and belief system, as well as how the art fits within either the artist's overall body of work or the political and cultural times—enabling a viewer to grasp something essential about it. Frequently, however, these statements draw negative reactions for what they say (or don't say) and how they are written. "A lot of artist statements are just hot air or sales pitches," said Hilton Kramer, editor of *The New Criterion*.

"I don't allow statements in the rooms where exhibitions take place," stated Ivan Karp, director of New York City's O.K. Harris gallery. "They are generally cryptic, esoteric, ungrammatical, and beside the point."

"Most artist statements, 99 out of 100, are not useful, and they're often ludicrous," said *Philadelphia Inquirer* art critic Edward Sozanski. "A poorly written statement has turned me off an artist's work. Being a literary person, I am influenced by the way people speak and write. A badly written or poorly conceived statement pushes me in the wrong direction. It shouldn't, but a bad statement makes me say, 'To hell with it. That person doesn't know what he's talking about.'"

"It's rare that any collectors read them," said Christopher Addison, director of the Addison/Ripley Gallery in Washington, D.C. "If collectors want to know more about the artist or the art, they'll usually ask me directly. I have found that it is mostly artists who read these artist statements, in order to see how other artists write them and what kinds of things they say about their work. Artists' agents and others who create press packages for artists recommend that artists include some sort of statement as part of the supporting material. After a while, with everyone doing it, they seem pro forma."

Undoubtedly, one of the reasons for the proliferation of these statements is that artists' advisors, career consultants to mostly younger or less established artists, unanimously recommend that artists include them with any written or visual material they send out to collectors, critics, and dealers. "An artist statement exists in another dimension than just the art itself, that is, the psychology and personality of the artist," said Calvin Goodman, an artists' advisor. "The statement is directed at the purpose and not just the appearance of the art." He added, "it is important that an artist makes a statement that is different than every other artist statement." Obviously, artists must now compete not only with images but with their commentaries.

Clearly, there are two issues here: The first is whether or not to include an artist statement as part of an exhibition or in a packet of slides sent to a dealer; the second is how to conceive of, and write, a statement that helps the viewer appreciate the artwork and, at least, doesn't alienate readers. On both subjects, the opinions are contradictory.

Certainly, there are occasional instances when an artist statement is not only helpful to the artist, but important in itself. Henri Matisse's likening of his art to a "good armchair" in a 1908 journal essay, entitled "Notes of a Painter," established a way for contemporary collectors and future art historians alike to appreciate his painting: "What I dream of is an art of balance, of purity and serenity, devoid of troubling or depressing subject matter, an art which might be for every mental worker, be he businessman or writer, like an appeasing influence, like a mental soother, something like a good armchair in which to rest from physical fatigue." An even more oft-quoted artist statement, this by Robert Rauschenberg, was included in the catalog of New York's Museum of Modern Art's 1959 "Sixteen Americans" exhibition: "Painting relates to both art and life. Neither can be made. (I try to act in that gap between the two.)"

With both Matisse and Rauschenberg, their statements describe an approach to making art. Matisse's essay reveals his method of capturing sensations of form and

color within a composition, noting his indebtedness to Paul Cezanne and his differences with the Impressionists; Rauschenberg's comments are Duchampian without ever mentioning Marcel Duchamp.

Most art dealers claim that an artist statement is never an important consideration in selecting an artist to show or represent and that a poorly written statement may have a detrimental effect if the artist's slides had otherwise interested the dealer. No one believes that an artist should be judged on the basis of his or her command of the English language but, as Philadelphia gallery owner Charles More noted, "a badly written statement colors the work negatively for me."

Many others agree. "What they say about the work often totally destroys my interest," said David Cohen, director of the Elizabeth Leach Gallery in Portland, Oregon. "If the artist is inarticulate or doesn't sound confident about what he or she is doing, I become very reluctant to make an investment in that artist." He added that "we are rarely interested in artists we don't already know about, so the statement doesn't matter much."

Margo Dolan, director of the Dolan/Maxwell gallery in Philadelphia, concurred, stating that "being articulate is a major basis on which we choose to represent an artist."

New York City art dealer Stephen Rosenberg was not quite as harsh, noting that "bad writing may not turn me off art I like, but it may let me know something about the level of maturity of the artist I'm dealing with."

While dealers may not be as interested in a formal artist statement, which usually takes up between a half and a whole page, any packet of slides sent to them by an artist should include a cover letter and a résumé. Artists need to introduce themselves in some manner.

Both Cohen and Rosenberg stated that they have included artist statements in exhibitions at their galleries. They and other dealers point out that visual literacy is not always high with the public, and visitors to galleries need—and are often grateful for— any help they can get in understanding what an artist is doing and why the artist is doing it that way. In general, those visitors with less knowledge of contemporary art are more apt to seek out a statement. In addition, no evidence exists that these people become collectors through reading artist statements. However, Cohen stated, "we must educate the public before they're ready to buy things."

Artists should probably consult with the dealer or gallery owner about what might be the most appropriate information to include in a statement. Perhaps describing the technical process is appropriate in certain instances where a viewer's first reaction may be "How did the artist do that?" For artists who have had significant events occur in their lives, such as living in a particular foreign country or being taught by a noted artist, biographical information may be most pertinent. A discussion of an artist's thought process is also often useful, as the visual language of art may be more difficult for viewers to understand than the specific ideas behind an image, as well as how the artist's ideas (and works) have evolved over time. Whatever the content, "a statement needs to be written in a straight-out language, like you're talking to someone," stated Barbara Krakow, an art dealer in Boston.

"Grandiose statements about the nature of man or how the artist is at one with God or why the world needs peace should be eliminated completely," Stephen Rosenberg said. "A lot of the artist statements I read sound as though they came from the Miss America contest."

Not every artist is willing to write a statement or needs one. Big name artists generally don't need to write one because other people will write about their work for them. Other artists, who find the process of writing overly difficult or whose results are full of art world jargon or read as labored, may choose to ask someone else to write the statement for them. In many instances, the gallery will create its own press release that provides the type of information an artist would otherwise include in a statement. Edith Baker, an art dealer in Dallas, Texas, stated that "some of my artists are wonderful writers, but most of them are not. I may try to edit what they have written or just incorporate key descriptive phrases from their statement in a press release."

Rosenberg said that he often helps the artist draft a statement: "It's not censorship, but I try to make sure that there are complete sentences, that it is logically consistent, that it doesn't go on and on or is redundant."

Another approach that certain dealers have tried is creating a video that runs continuously in the gallery during an exhibition. The video shows the artists at work or answering questions about themselves or their art. As many artist statements are written as though answering questions that the artist hopes someone might ask about his or her art, this alternative to the written statement may be quite useful if done well.

Not all art needs to be introduced by an artist statement. A statement actually may detract from artwork that is self-explanatory or ambiguous by being overly directive. When done well and for the right kind of artwork, an artist statement may expand the audience with whom the art is in dialogue.

ENTRY FEES FOR JURIED SHOWS

No one would expect a dancer or actor to pay in order to audition for a part, nor would a writer be asked to send a publisher a check along with the manuscript for it to be read. The visual arts, however, are different. Visual artists usually must pay an entry fee to be considered for a juried competition. Whether or not they are selected to be in the show, they have to pay. People don't look at their work for free.

The thousands of invitational arts and crafts shows (many of which charge entry fees) taking place somewhere in the country throughout the year—held by private companies, nonprofit groups, and small towns—enable lesser-known artists and craftspeople to show their work to the public. A growing number of artists, however, have been voicing their objections to the entry fees that, they feel, place the financial burden for these shows on the shoulders of people who have little money to begin with. The fact that almost none of these shows pay for insurance on the shipment of the objects in their displays or provide any security measures to protect them while the exhibition is up rubs salt in artists' financial wounds.

"Entry fees are a bit like a lottery," said Shirley Levy, an official of National Artists Equity Association, the membership organization of visual artists based in Washington, D.C. "You pay for the privilege of having someone look at your slides, even if they are rejected. Emerging artists are told, 'Pay your own way until you've made it.'"

Levy and others noted that most show sponsors believe that artists should contribute something for these shows, since they're the beneficiaries of them, but that is a faulty assumption. "Artists don't generally benefit all that much from a given show, but the organizations that put on the shows often make a great deal of money by exploiting artists who need to show their work somewhere," she stated.

Originally, entry fees were established as a means both to control the number of participants in juried fine art competitions—it was assumed that rank amateurs could not afford the fees—and to provide organizations with up-front money with which to rent a hall, pay some notable art expert to evaluate the artists' work (or slides of the work), and create prize money. Times have changed, however.

George Koch, president of National Artists Equity Association, complained that "the money a lot of these show sponsors are raising is far more than needed to meet their expenses." He added that they could easily earn this money in other ways than taxing artists, including soliciting contributions from local companies, charging admissions, creating prints of works on display, marketing a catalog of works in the show and holding an auction of some of the pieces.

National Artists Equity has been uneasy with the existence of entry fees since the organization came into being in 1947, and in 1981, it wrote ethical guidelines for its membership, stipulating that artists should refuse to participate in events where there are these fees.

This issue has caught on. Other artists organizations in the United States and Canada have adopted similar guidelines. A statement by the Boston Visual Artists Union, for instance, notes that "Exhibitions do take money to mount. However, it is inappropriate for artists (accepted or rejected) to be a source of these funds," and Canadian Artists' Representation/Le Front des Artistes Canadiens in Ottawa also claims that its membership "does not consider that the payment of entry fees is appropriate to an exhibition of work by professional artists."

Artists Equity has pressed agencies of the United States government to develop a policy prohibiting them from funding groups that put on juried art shows requiring artists to pay an entry fee. So far this effort has met with limited success.

The National Endowment for the Arts has been reluctant to create a policy of this kind although, on a practical level, it has generally refused funds for groups charging entry fees. Many of the applicants to the NEA's visual arts program are exhibiting organizations that may put on ten shows a year, one of which might be a regional juried show that requires a fee. It's unlikely that the panelists would deny a good organization funding because of the one show, although they are apt to decide that none of the money that's given to the organization can be used for that show.

National Artists Equity has also attempted to pressure the U.S. Interior Department to drop the $50 entry fee it requires for its annual duck stamp competition. This is the only annual juried art competition sponsored by the federal government, and over 1,000 artists a year pay the fee to submit drawings for a duck stamp commissioned by the Fish and Wildlife Service of the Interior Department. "Why," Koch said, "does the Interior Department need to make money off artists?"

The case against entry fees has found more sympathetic ears on the state and local levels, as both the Oregon Arts Commission and the New York State Council on the Arts as well as the D.C. Commission on the Arts and Humanities in Washington prohibit funds from going to organizations that charge entry fees. The Berkshire Art Association in western Massachusetts decided in 1985 to eliminate its entry fee, and other small town–sponsored events around the country have done the same, looking for money elsewhere. Many other show sponsors have chosen to maintain the entry fee system, however, realizing that so many artists are willing to send in money for the chance to be shown that they might as well let them.

It may be too much to ask that artists individually refuse to take part in juried exhibitions that demand entry fees, as that may be tantamount to cutting off their few opportunities. National Artists Equity's ethical guidelines are not intended to browbeat anyone into harming his or her career. However, artists can be effective in eliminating these fees by discussing their objections to them with show sponsors and, failing to find success there, organizing others to protest the policy.

ARE YOU DELUDING YOURSELF?

Vanity galleries are no better for an artist's career than vanity directories. Many artists are willing to rent a space in which to hold an exhibit of their work. As with commercial art galleries, walk-in sales to collectors generally cannot be counted on to cover the overhead. Rarely do these kinds of shows result in sales—potential buyers who aren't friends or family members generally prefer to buy from third parties, such as dealers, who are putting their reputations on the line with the particular artist—but the point of the vanity gallery show for the artist is not necessarily to sell; rather, it is to have something to include on a résumé.

The growth of these services, in fact, is the reflection of a newly developed résumé-building industry, and many artists will pay to load up their résumés with apparent accomplishments. Why? Because there are too many artists and not enough galleries and museums to show their work. As a result, artists have had to change their orientation from seeking to make a living from the sale of their work to trying to convince other people (and, possibly, themselves) that they are not simply Sunday painters or hobbyists. No one would have ever thought to ask young Jackson Pollock about his résumé, but now serious young artists are led to believe that they should keep a résumé up to date and packed with experiences and achievements.

And, like the résumés of other professionals in our society, the importance of these activities and achievements tends to become somewhat inflated. Unimportant exhibits

and unread directories loom in significance as artists hope that someone will believe that their careers have truly progressed and that their work has received critical recognition. Paying for a show or a number of shows to include on a résumé might suggest to someone that the artist's career is progressing, even when none of these shows breaks even for the artist.

It's fair to say that Jackson Pollock set out to make paintings, not to build a résumé as a professional artist. Today's artists, however, feel that they have to do both.

"Being an artist today is a lot harder than it was in the past," painter Chuck Close said. "There is a sense of raised expectations today, due to art schools and other institutions with which artists are associated. You see Frank Stella have a one-man show when he's 21, or Julian Schnabel have a retrospective when he's 30. If you've been hanging in there and haven't achieved any measurable success, you begin to ask yourself, 'What do I have to point to that shows I'm a professional, too?' An enormous résumé can help someone deny the reality of his situation. I mean, why am I an artist? I guess it's because I have a résumé that says I'm an artist."

Ultimately, the largest change in the art world since the end of World War II is the idea that artists can consider themselves failures if they don't achieve some quantifiable measure of success. Over the past few decades, despite a great increase in the number of people who can support themselves from the sale of their work, most do not. That majority continues to hold various "day jobs" (the lucky ones teach) and dream through their résumés.

A lengthy résumé may suggest that an artist is in great demand, but the items listed must have importance in and of themselves. A résumé is ultimately a way for artists and others to keep track of their careers, and no quantity of listings on it will substitute for high-quality exhibitions and a market. When a résumé is filled with group or one-person exhibitions that turn out, on closer inspection, to be a few pictures that a bank placed in its windows or gallery shows in which the artist rented out the exhibition space or when there is a vanity element to many or most of accomplishments listed, the résumé becomes a statement of failure. And, the very people whom the lengthy résumé is intended to impress can see that quite clearly. It is wiser to have a shorter résumé that lists events that are truly meaningful—perhaps, in a category of "Selected One-Person Exhibitions"—than a massive hodge-podge of good, bad, and indifferent. Artists have good reason to put together a well-presented résumé, and various consultants (career advisors, artists' advisors) can assist them in this effort. It is time, however, for artists to de-emphasize the résumé as the barometer of how their careers are going.

Art dealers, for whom these résumés are often intended, are usually not impressed by the number of exhibitions an artist has had—once again, they select artists based on recommendation of others whom they trust (artists, critics, curators, and other dealers)—and who have bought that person's work in the past. No artists have ever been rejected by a dealer for having too short a résumé, although many dealers dismiss artists out-of-hand who have previously paid for shows, considering them not to be professionals. These days, artists have to be professionals from the word go.

With everything that an artist might pay for, the costs need to be weighed against the potential benefits. The costs are certainly real, but if the benefits are only a dreamy impression of good things, one may want to hold off for something more solid.

Some of these services do nothing more than play off the desperation of artists for whom finding a way to show and sell their work is inordinately difficult; others exist because someone thought up a solution and tried to convince others that they had a problem. Consumer advertising is full of success stories in this area, but the art world tends to act differently. Direct mail fliers, vanity galleries, and classified advertisements usually don't lead to fame and riches in the art world. Changing the way success is found in the art world, in the future, may be another service to add to the list.

6

Artists and the Law

It probably doesn't occur to many art collectors to purposefully alter, mutilate, or destroy a work of art that they have purchased, but it has happened occasionally. Among others, it has happened to the creations of sculptors Alexander Calder, Isamu Noguchi, and David Smith as well as painters Arshile Gorky and Pablo Picasso.

However, because of the Visual Artists Rights Act of 1990, it is less likely to happen in the future. The law, an amendment to the federal copyright law, provides visual artists (narrowly defined as painters and sculptors as well as printmakers and photographers who produce limited editions of 200 or fewer copies of their work) with the right of attribution (to claim "authorship" of their work and object to false attribution). The law also affords artists the right to prevent the owners of their work from distorting or altering their creations without their consent and, in the case of works of "recognized stature," to prevent their destruction.

Artists have become more versed in the law, and the legal profession has become acquainted with the arts. The Visual Artists Rights Act was the outcome of more than a decade of political activism on the part of artists, but it is also a symptom of an ongoing campaign around the country to regulate the art trade and ensure fair treatment for artists. Looking around, one sees a growing body of art law on the state and federal levels over the past twenty years.

Among the main points in this already sizeable body of law are these:

- State consignment agreements between artists and art dealers, requiring dealers to whom artists have consigned their work to pay the artists after any sales within a reasonable period of time, as well as provide an accurate accounting of what sold and for how much.
- Art print disclosure laws for the sale of graphic works of art in eleven states (Arkansas, California, Georgia, Hawaii, Illinois, Maryland, Michigan, Minnesota, New York, Oregon, and South Carolina).

- Warranties of authenticity, requiring art dealers to take back works they had sold that had not been created by the artist ascribed to the works at the time of the purchase.
- Permission for artists to submit their artwork in lieu of a check for the payment of taxes (ten states—Arkansas, California, Kansas, Kentucky, Maryland, Michigan, Nevada, Oregon, Rhode Island, and South Carolina—have passed laws allowing artists to deduct their own charitable contributions of artwork on the basis of the pieces' fair market value for state tax purposes, and six states—Connecticut, Kentucky, Maine, Michigan, New Mexico, and North Carolina—allow inheritance taxes to be paid with artworks.
- Federal labeling requirements for art materials with potentially toxic ingredients.
- State "moral rights" codes similar to the Visual Artists Rights Act and even (in California) a "resale royalties" statute that requires art collectors to turn over to artists a percentage of the profit when their work is sold again. In addition, three states (Massachusetts, New York, and North Carolina) permit artists to deduct the cost of their living-working space for tax purposes. Massachusetts even has a "Schlock Art" law, requiring dealers of low-cost, imitative paintings to label these works "nonoriginal."

These and other laws reflect the growing sense that the art world is a business like any other, where a great deal of money changes hands, and needs increased governance. "Art has gotten more expensive and has attracted new laws," said Stephen Weil, former deputy director of the Hirshhorn Museum in Washington, D.C. "Anything that attracts that much money is bound to be a target for frauds and governmental legislation."

The art market has traditionally been a business where a good many of the deals are made on a handshake, without benefit of lawyerly provisos. That sense of trust and good faith has been eroded with the rise in prices for art as well as in the numbers of buyers and art galleries all over the country. These laws, as art sometimes is itself, are frequently imports—sometimes, not particularly welcome imports. For instance, the United States did not become a signator to the Berne Convention, an international copyright law first devised in 1886 that stipulates moral rights for artists, until 1988.

The relationship between artists and the government is and always has been uneven. In 1965, with much fanfare, the National Endowment for the Arts was established by act of Congress, providing a mechanism for federal support of the arts. Since 1981, however, a steady effort has been underway to abolish the agency, which has not met with success but led in 1995 to Congress cutting the arts endowment's budget by 40 percent, bringing it back to 1970s levels. This cutback has strained the budgets of regional, state, and local arts agencies, many of which found themselves giving up individual fellowships. In 1969, the federal government revised the tax law to permit artists to declare deductions based on work-related expenses only if they made a profit in three out of five years (if that requirement isn't met, any net loss from the art activity is considered a nondeductible "hobby" expense); it also changed the law to allow artists to

deduct only the cost of materials when donating a work of art to a museum or other charitable tax-exempt institution. (Collectors of art, on the other hand, are entitled to deduct the fair market value of the objects they donate.) The first rule has been a monumental headache for artists come the annual tax season; the second has proven a headache for museums, which saw gifts by artists to their collections drastically reduced. Before 1970, when the legislation took effect, museums with modern and contemporary art collections regularly received sizeable quantities of objects from artists, usually toward the end of the year when these institutions also were given cash and art objects by other donors.

In truth, the hobby-loss provision was aimed not at artists but at "gentlemen farmers" who annually declared great losses for what was not their prime source of income. (There has been an occasional instance where an artist has attempted to write off losses for pursuits unrelated to his or her vocation, such as, musician Victor Borge and his rock Cornish-hen farm and portrait painter Peter Hurd and his ranch—both were denied by the government.) The rights or interests of artists, as well as public financing of the arts, are rarely high on legislators' agendas; considering that the arts have been a political battleground for much of the 1990s, perhaps that inattention is a good thing. However, while federal support of the arts has been reduced during the last decade of the twentieth century, public financing of the arts on the state level has increased to record levels, to $370.7 million in fiscal year 1999, compared to $211 million in 1993. Clearly, not all lawmakers repudiate the arts.

Artists should understand their legal rights, stay abreast of legislation affecting them, and work in concert with others to ensure that the law represents their interests.

COPYRIGHT

Alexander Calder made it clear what he thinks of copyrighting works of art. Somewhere in the South of France, he constructed a large metal cow defecating small ©s, the universal copyright symbol. Ironically, it is the only work the artist ever copyrighted, but it is hardly an endorsement.

Many artists see copyright as a commercial issue, not something for fine artists, and don't bother finding out more. Of course, if artists ignore copyright, so do many other people. Every year, entrepreneurs make unauthorized use of artists' work in order to create prints, posters, clothing, dishes, pillows, rugs, and bath towels with their imagery; and many artists find themselves unable to stop this or even to receive any of the money that others are making with their imagery. Furthermore, unauthorized use of imagery may reflect badly on the reputation of the artist when, for instance, colors are different from the original or shapes are distorted.

An uncopyrighted sculpture Calder created for the city of Grand Rapids, Michigan, was reproduced as an image on government stationery and also on the city's fleet of garbage trucks. Grand Rapids' city fathers were clearly proud of the work and viewed it as a civic logo, but their use of it was embarrassing.

Copyright is the right to reproduce one's own work, and it comes into being as soon as the artist completes his or her work. However, problems may occur when the piece is "published"; that is, when it leaves the studio on loan or consignment or when it is sold. At this time, the copyright notice should be attached to the work, looking like this: © Jane Doe 2000.

The spelled-out "Copyright" or abbreviated "Copr." is just as good as ©; initials or some designation by which the creator is well known (Mark Twain for Samuel Clemens, for instance) may be substituted for one's full name; the year, which can be spelled out (Two Thousand) or written in Arabic (2000) or Roman (MM) numerals or even something more eclectic (2K), refers to the date the object is first published and may be omitted only when the work is a useful article, such as a postcard, dish, toy, article of clothing, stationery, or piece of jewelry.

Most artists are reluctant to deface or, at least, distract people from their work by sticking a copyright notice on it and, under the old Copyright Law of 1909, artists were obliged to put the notice in the most conspicuous place possible in order to assure the public that copyright was claimed. However, under the Copyright Law that went into effect in 1978, artists are permitted maximum discretion in placing their copyright notice, which includes the back of a canvas, frame, or mat or the underside of a sculpture. The onus is now on the potential infringer to determine whether or not the work is copyrighted. Also, since March 1, 1989, when the United States officially joined the international Berne Copyright Convention, omission of copyright notice does not result in a loss of the copyright privileges. However, notice should still be placed on works so that maximum damages can be obtained from infringers.

The 1978 law clarified that copyright ownership and sale of the physical work of art have been separated. All a collector buys is the work itself. The reproduction rights remain with the artist. A buyer who wants the reproduction rights as well must now bargain for them, and smart buyers sometimes do just that.

The copyright is potentially worth money if, for instance, the image is used for prints, posters, tapestries, or whatnots that are sold to the public. A painting may sell for $5,000, but an edition of 100 prints made from that image, each selling for $100, would bring the copyright holder $10,000. The copyright may be worth more than the original work (for which the artist received a one-time payment), and artists such as sports painter Leroy Neiman and Art Deco stylist Erte have become known more from prints than from their oil paintings.

Copyright confers several exclusive rights to an artist for the life of the creator plus 75 years: The first is the right to reproduce the copyrighted work; second is the right to make derivative works (making a motion picture from a book such as *Gone With the Wind*, for instance, or a poster from a sculpture); third is the right to control the first sale of a work (of course, a buyer of a legally made copy may resell it); the last is the right to display the copyrighted work. The owner of a work has the right to display it to people who are physically present for the display, but people and institutions that borrow works have no right to display them without permission from the copyright owner. According

to Paul Goldstein, a copyright expert at Stanford University Law School, "the copyright notice is like a no trespassing sign, reminding people that the work is protected, and that helps to take away the innocence defense."

Artists may still bring legal action against infringers, but the amount of actual damages (generally, the infringer's net profit) awarded by a court are likely to be low— low enough to not cover even the artist's attorneys' fees. An artist will be able to get injunctive relief—that is, stopping the infringer from continuing to distribute the copies—and a federal marshall may be assigned to seize and impound the infringer's unauthorized copies.

The high cost of litigation may be a reason that few cases of copyright infringement in the visual arts are brought to court. "There is pressure on the artist to settle out of court," E. Fulton Brylawski, a Washington, D.C., copyright attorney, said, "but there is also the same amount of pressure on the infringer. There is not enough money in any of this to pay for the legal costs. When a claim is made, the settlement is usually easy to achieve, with the infringer paying a reasonable license fee to the artist."

The issue of how to publicize artworks has been a major area of tension among artists, dealers, and museums. Dealers and museums frequently seek to advertise works in their collections through brochures, postcards, catalogs, and on the Web, with no regard for, or display of, copyright. The effect is to open the door for someone other than the dealer or museum to use the image to create reproductions without paying the artist anything or even asking for approval since the image has entered the "public domain."

There is, of course, "fair use" of a work of art, which usually refers to photographs of it that accompany a news article or critique or to slides that may be used in teaching. Fair use, however, does not lessen an artist's ability to earn money or control the use of the image.

"To many elements of the art market, artists are tolerated as necessary evils, but a lot of people would be just as happy if all art were done by automatons," said Martin Bressler of the Visual Artists and Galleries Association, which acts as an agent for artists in negotiating licenses for publication of art and policing unauthorized use of their work. "Museums are the worst in this regard. To them, the best artists are dead ones with no estates. They don't like to pay royalties, either."

Bressler noted that museums, which are constantly in search of new sources of revenue, often treat works in their possession as though they were in the public domain, regardless of whether or not the objects are copyrighted. He cited the Baltimore Museum of Art, which made dinnerware, T-shirts, and tote bags using images from Matisse and Picasso without permission of the artists' heirs or estates, and the Chicago Art Institute, which permitted a copyrighted scale model of a sculpture by Picasso to fall into the public domain when it exhibited the work without attaching its copyright notice.

Artwork can be registered with the federal Copyright Office (Library of Congress, Washington, D.C. 20559, tel. 202-287-9100). Registration prior to an infringement allows the artist to receive statutory damages of up to $20,000 for each work infringed, plus legal fees and court costs. One may call or write to request an application (Form VA

for visual artists), which should be filled out and returned with a check for $20 along with a copy of the work (two copies, if the work has previously been published). A cancelled check by the Copyright Office ensures that the work has been registered, and a copyright certificate will be sent out within four months.

While published works must be registered one at a time (and the $20 fee paid), unpublished works can be registered in groups for a single $20 fee. Also, valuable or unique art does not have be deposited with the Copyright Office—instead, slides or photocopies can be used. Contact the Copyright Office for its free *Visual Artists Copyright Information Kit,* which explains this in detail.

A variety of copyright questions arise over time in an artist's career. Among the good sources of information are the Visual Artists and Galleries Association (VAGA, 350 Fifth Avenue, Suite 6305, New York, NY 10118, 212-736-6666) and the Graphic Artists Guild (90 John Street, Suite 403, New York, NY 10038, 212-791-3400) as well as any of the volunteer lawyers for the arts groups around the country. Basic information is provided to artists at no cost.

As the art reproduction and multiples market has grown more and more in a world already overloaded with images, there is a declining need for the original work of art, much less its creator. Copyright represents the main way for artists to ensure their relevance in the art world—if they use it.

Copyright and the Internet

A scene that could come from any of the past four centuries: An artist paints a picture and attempts to exhibit and sell the work. However, this scenario has been possible only over the past decade: The artist's image is scanned into a computer, placed on the Internet, and downloaded worldwide, wherever someone wants a copy of the artwork.

Fortunately for Michael Whelan, a book illustrator in Danbury, Connecticut, a friend of his happened to be looking through a computer bulletin board when he recognized a few of Whelan's images that were being offered for sale. Nowhere did it say that Whelan was the artist and, in fact, the copyright notice had been deleted. The images themselves had been somewhat altered with, in one case, mountains replaced by a sign that said, "Welcome to the World of Macintosh."

At least two copyright laws were violated by an unknown number of electronic services that had appropriated Whelan's work. If Whelan was lucky to have a friend find his work on a computer bulletin board, New York City illustrator Bill Lombardo was a little less fortunate. A friend found his work on a bulletin board but, "before I could bring a lawsuit, the company that had done this had gone out of business."

It was slightly easier to steal Lombardo's work than Whelan's because Lombardo creates images directly on the computer—sending disks of his artwork to the companies that employ his services, which unfortunately allows anyone with access to these disks to copy his designs—whereas Whelan is a painter whose works were reproduced on or in books. To appropriate these, someone needs an electronic scanner to pick up the image from a book (or print or poster) where it becomes "digitalized" within a computer.

The danger that scanners pose to an artist's copyright isn't a point of arcane concern for artists as most major advertising agencies, design studios, and magazines have this very advanced equipment. Picture resolution is so good with these high-powered computers that it is now far more difficult to determine which is the original and which is the copy than it was in the precomputer past when photographic reproduction was the main source of copyright infringement.

"The ability of so many people to gain access to an original work of art in this way, the ease with which images can be digitalized, manipulated, and then transferred, overshadows the question of right and wrong for a lot of people," said Paul Bassista, executive director of the Graphic Artists Guild. "It is now so easy to do, and the chances of getting caught relatively nil, that people believe that infringing on an artist's copyright is basically OK."

New computer technology has presented a serious challenge to artists' copyright protections. Copyright, which refers to the right to make and distribute copies of one's artwork involves the exclusive use of private property, while the computer world values usable and immediate public access. "The ethos of the Internet," said Marci Hamilton, a professor at Cardozo Law School of Yeshiva University in New York City, "is that anything online may be downloaded, cut, copied, and sent along to others."

Copyright has proven to be an elastic concept over the past two centuries that it has existed in law. Statutes first referred exclusively to the printed word but were later amended to encompass works of visual art, then expanded to permit artists ownership of copyright even after they sold the physical artwork, and again broadened to include "moral rights" (preventing intentional alteration, damage, and destruction of the physical work of art). Periodic judicial rulings also have widened the scope of copyright protections here and there.

All of these changes and additions have given increased control to creators over their artwork. The Internet, on the other hand, makes that control all the more tenuous because of the computer world ethos and the technology to place written and visual information wherever there is a computer, a modem, and a telephone.

Traditional copyright law does cover the areas of potential high tech infringement, such as scanning (unless specifically permitted by the artist) and manipulating an image on the computer screen, perhaps creating a derivative work based on the original image. The problems of enforcing copyright are related to the speed with which images may be scanned, altered, and transmitted: First, one must track who is doing what with an artist's work; second, the process of seeking an injunction or trying a copyright infringement case in the courts is time consuming and expensive. The art world, currently, has no organization like ASCAP or BMI in the music industry that extracts royalty payments whenever a composer's or musician's work is performed or broadcast.

The laws are definitely on the side of artists, yet copyright infringement by high-tech means is reaching epidemic proportions. Computer bulletin boards, which are filled with "share-wear" that users can appropriate for their own uses (sending in a few dollars to whoever put the program on the board if they like it), breed the idea that people

can take whatever they want. Myrna Davis, who manages the Paul Davis Design Studio with her husband Paul, stated that she "met a young man who showed me his portfolio. The imagery was pretty good, since it belonged originally to a well-known commercial artist named Michael Schwab. This young man had been scanning in someone else's images without credit, changing things here and there, and he was stunned when I told him that he had violated the law, that he had violated someone's copyright. He just thought that once you put something in the computer, it's all yours."

Technological changes have been so rapid that, Michael Whelan said, "the law strains to deal with them. Artists can do everything correctly and still get ripped off, because it's hard to find the infringers, it's hard to go after them. What's more, it's not profitable to try and track down every single infringer. I'm annoyed that there are people out there who would require me to be a watchdog."

Proponents of traditional copyright protections are met by advocates of free access to information, who believe that more information disseminated widely is a public good and it should be encouraged rather than impeded by antique legal concepts of limiting the use of intellectual property. "The underlying theme is that copyright is rather ungenerous," Hamilton stated. "Increasingly, the courts have been saying that copyright should not prohibit the creation of interesting, original work."

Creating something new out of copyrighted material may be accomplished when an artist's image is downloaded and appears on someone's computer screen. Basic keyboard commands enable all manner of changes, and the resultant work may bear close, moderate, or minimal resemblance to the original artist's work. Whether or not this activity is an infringement on an artist's copyright and moral rights depends on how "original" the derivative work may seem and if one is an adherent of the ethos of Internet or of traditional artists' rights.

"The model that we have in copyright—I have this property, and I can control how this property is used for seventy-five years—is going to change," said Ethan Katsh, professor of legal studies at the University of Massachusetts and author of *Law in a Digital World.*

For instance, Katsh does not fault rap singers for "sampling," or borrowing, music from other singers' work as a violation of copyright, viewing the legally challenged practice as "fair use. I don't think sampling takes away from the market from the original work," he said. Creating something does not mean controlling it absolutely. The new technology culture "tends to see that what you created was really built on something else," he added. "The law should want to encourage people to take one thing and make something new out of it, and the question then becomes, when does something become new. That's a more interesting issue than should the original something be kept under tight controls."

The courts are increasingly of the same view, limiting the ability of copyright owners to seek injunctions against the unauthorized use of their work. As a result, attorneys involved in the arts are advocating solutions that don't as much contest infringement as ensure that artists will be paid for the use of their artwork, however it is used.

"If you can't fight them—and right now you can't—join them," said Martin Bressler of the Visual Artists and Galleries Association. "ASCAP didn't try to fight the technology of radio and records but worked with broadcasters to establish a royalty system, setting up licensing arrangements with the distributors."

France and Germany have both adopted this approach, enacting a royalty on blank film and video cassettes in 1985 as part of their respective copyright laws as a means of reimbursing filmmakers for lost income from presumed taping. Some attorneys in this country have suggested that instituting a royalty on blank computer disks is the way of the future. Another way to ensure that copyright holders are paid for the use of their work, Marci Hamilton noted, is by developing a system of itemizing everything that is downloaded into one's computer—similar to a detailed telephone bill, where every outgoing call is noted—and charging the individual at generally established rates.

Under the current copyright law of the United States, artists and other copyright owners may seek not to prohibit the use of their work but to receive remuneration through compulsory licensing, which requires those who make certain uses of copyrighted material to pay royalties (predetermined by the U.S. Copyright Office and at somewhat low rates) to the copyright owners. The basis of compulsory licensing is the belief that the public's interest in free access to copyrighted material outweighs the copyright owner's rights to control that access. In the area of the new computer technology, that appears to be the growing sentiment of the courts.

On a more individual level, artists may negotiate contracts that "specify the area of use," according to Joshua Kaufman, a lawyer in Washington, D.C., who represents many artists in copyright disputes, adding that a clause should be inserted, stating that all rights not assigned belong to the artist. Separate fees may be paid if an artist's work is put online or on just one compact disk and two fees if used in both ways. "If an artist gives someone the right to reproduce a painting in a magazine or brochure," he said, "and that person then wants to use the art electronically, that person should have to get new permission from the artist, which would probably involve an additional payment."

Kaufman added that another method by which artists could protect themselves from unauthorized use of their work is by ensuring that anyone who downloads it receives a low-resolution image that can only be viewed for content and is not otherwise marketable. "The low-resolution precludes the ability to reuse it," he said, "and anyone who wants to use the image would have to make arrangements with the artist to get the original."

However, many other arts attorneys claim, such an idea, while technically feasible, is also contrary to the state of the art—most artists want their work to look as sharp as possible as a way of attracting potential customers, worrying about copyright infringement somewhat later.

Clearly, the new computer-based technology offers exciting opportunities for everyone. Artists may be able to use the Web system to communicate and show their work to other artists, collectors, critics, dealers, and museum officials instantaneously. New ideas for projects, collaboration among artists living quite far apart, and sales to

collectors on the Internet may be the result. The new technology, however, also offers new opportunities for those people who are ready to use a freedom-of-access rationale in order to excuse a case of traditional copyright infringement when stealing from artists.

Making a Copyright Search

In a world already filled with images, there is still a constant search for more. Publishers and entrepreneurs look for new designs for prints, posters, T-shirts and sweatshirts, wallpaper, coloring books, placemats, and almost any other flat surface on which an image may be printed. A publisher like Franklin Mint commissions artists to create new designs, buying all rights to these images, but others need to determine the copyright status of artworks they would like to use. As important as it is for artists to understand the protections that copyright affords them is comprehending the process by which someone else discovers the copyright status of their work.

As noted above, artists are most protected when the copyright notice is evident and their work is registered with the United States Copyright Office. Registration is required in order for an artist to bring an infringement suit and, if a work is registered before or within five years of publication—and, generally, before an infringement takes place—the artist may seek statutory damages up to $20,000 (up to $100,000 if the infringement is ruled "willful") as well as attorneys' fees. The statute of limitations for bringing legal action against an infringer is three years. Considering the amount of money involved, artists should not be led to believe that, since affixing the copyright notice is now no longer strictly required, registering works of art most likely to be copied is optional as well.

The first place a law-abiding prospective copyright user would check is the Catalog of Copyright Entries in the Copyright Office, which is located within the Library of Congress. There, works are cataloged by title, author (or artist), and name of the copyright claimant if not the author. A search for work registered between 1870 (the first year that drawings, paintings, and sculpture were afforded copyright protection) and 1977 is made manually, by computer from 1978 to the present.

Registration of works of art before 1978 lasted twenty-eight years, with another twenty-eight years renewal permitted. If that copyright was in its first twenty-eight year term after 1978, the registration may be renewed for sixty-seven years; if the copyright was already in its renewal period, the Copyright Office would extend the registration to ninety-five years from the date the work was first published. For works created within the past ninety-five years, a prospective publisher would want to know whether a work's copyright had been registered, to whom, and if it had been renewed (checking in the Catalog of Copyright Entries from the twenty-seventh through the twenty-ninth years from the date of original publication). One may safely assume that works of art that had been published more than ninety-five years ago to be in the public domain.

The copyright law enacted in 1976 authorized copyright protection for works created on or after January 1, 1978, to last the life of the artist plus 75 years. For such works, one is advised to wait between 95 and 120 years to reasonably assume that the copyright has fallen into the public domain.

So far so good, but there are a variety of complications for those looking to use someone else's copyrighted images. John Singer Sargent's famous 1884 painting "Madame Gautreau" is in the public domain, but a particular copy of it—such as a photographic reproduction in an art history text—may be copyrighted in the name of the book publisher. A publisher of posters using Sargent's image might be found guilty of infringement unless it could prove that its "Madame Gautreau" wasn't taken from the textbook.

The work's title may have been changed or the piece may go by a different name; "Madame Gautreau" is also called "Madame X," for example. A prospective copyright user may be found guilty of copyright infringement for failing to know some basic art history. In addition, the copyright may have been reassigned by the artist or his or her heirs to one or more other persons (this company to make posters in North America, that company to produce posters in Europe, for instance) for short or extended periods of time. This information should be available in the Copyright Office's Assignment and Document File, if it has been recorded with the Copyright Office. In most cases, the transfer of copyright takes place privately between the artist and another party; on occasion, the copyright has been reassigned more than once. Someone looking to use a copyrighted image may need to contact the artist, or whoever originally registered the artwork, to find out the names of the various parties with whom to negotiate.

In general, copyright searches are conducted by staff members of the Copyright Office at a cost of $20 per hour. Finding out whether a work of art has been registered and, if so, the date of its registration, the registration number, and who registered the work tends to take no more than one hour. A search of a copyright that has been assigned to someone else may take twice as long. A number of copyright attorneys and one company (Thomson & Thomson), all based in Washington, D.C., do these searches for clients, charging more than the Copyright Office but also adding other services.

Although many works of art are registered each year, most are not, which means that a prospective copyright user will have a far more cumbersome search than simply looking through files and catalogs at the Copyright Office. Once again, a prospective copyright user would have to locate the artist (or his or her heirs) in order to either obtain permission or find out who currently owns the copyright.

TRADEMARK PROTECTION FOR ARTISTS

When is imitation not flattery? When the purpose of the imitation is to confuse the public and undermine a better-known artist's market. Some legal decisions have established a relatively new area of art law, protecting the trademark qualities of artists' work, such as the style and overall impression of the art.

Trademark law is usually associated with manufacturing, protecting a company's logo or other distinct mark, although it has been applied to the arts as rights of publicity, such as the face, name, signature, or endorsement of the artist. However, legal judgments have also extended trademark protection to "words, symbols, collections of colors and designs." Trademark infringement is different than copyright

infringement, as the artwork is not copied exactly or copied with only minor changes made (those are copyright issues), as it refers to aping significant elements of another artist's unique style.

Artistic style itself cannot be copyrighted—neither, for that matter, can perspective, color, medium, use of light, and subject matter—but the "feel" of the work is subject to trademark (in legal parlance, trade dress) protections under the Lanham Act. That federal statute, a law governing unfair competition, prohibits one individual or company from offering products or services that are confusingly similar to those of a competitor.

There is no fixed point when one may claim that one artwork has been copied from another, and some judge or arbitrator will simply have to look at the two pieces for similarities that go beyond influence and conventions of the genre. In the legal cases that have been decided, compelling evidence has revealed specific intent to imitate another's work. Two of the most noted decisions have been for musical performers—Bette Midler and Tom Waits—who sued Ford Motor Company and Frito-Lay, respectively, as well as their advertising agencies for hiring singers whose voices were very similar to Midler's and Waits's to sing songs identified with the noted performers for product commercials on television. Neither performer's name was mentioned, nor were the actual singers identified. However, as neither well-known performer wanted to endorse these, or any other, products, the sound-alikes were found to have infringed on their trademarks, and the companies as well as their advertising agencies were ordered to pay substantial settlements and legal fees.

In the visual arts, there have been a number of decisions. One of these, in 1992, involved an Israeli artist, Itzchak Tarkay, whose painting was found to have been copied stylistically and thematically by another artist, Patricia Govezensky, at the bidding of an art distribution company, Simcha International. "At the trial," said Sondra Harris, one of the attorneys representing Tarkay, "defendant's counsel mixed up works by Tarkay and Govenzesky. They were that close." No awards or damages were assigned, she added, as "the company basically went out of business and, when Govezensky went back to painting, her work was in a completely different style."

Another case, decided in 1994, concluded that Florida art dealer Philip Wasserman persuaded a Florida sculptor, Dwight Conley, to create works in the unique "fragmentation" style of Paul Wegner. In that latter case, all of the waxes and molds for the offending Conley sculptures were ordered destroyed and the completed pieces turned over to Wegner as well as payment of costs, damages, and attorneys' fees.

"Consumer confusion" may arise when similar-looking works are exhibited to collectors who do not immediately look for the artist's signature, according to Joshua Kaufman, who represented Paul Wegner. "Within a span of one week, Wegner received calls from three of his collectors who asked him, 'What happened to your work? It looks like it deteriorated.' They had seen Conley's imitations of Wegner's work from a distance and just assumed it was Wegner's. That can affect an artist's reputation as well as sales, if people think the quality has gone downhill."

Damage awards result from the fact that imitators' work is usually priced lower than that of the better-known artist, which may affect sales.

Despite the degree to which artists attempt to find a unique mode of expression, similarities between artists' work, especially those working within the same genre or even at the same time, are bound to occur. Oliver Wendell Holmes once wrote that "literature is full of coincidences which some love to believe plagiarisms. There are thoughts always abroad in the air which it takes more wit to avoid than hit upon."

If so much art didn't look alike stylistically, at least to the nonexpert, there would not have been a need for the decade-long Rembrandt Project, which deattributed 90 percent of the paintings around the world called Rembrandts. Museum labels in general tell the story of failed attempts at determining who painted which picture. This painting is the "School of" some Old Master, that picture was created by "Follower of" someone else. A designation of "Workshop of" so-and-so gets one closer—the more famous artist may at least have seen the work or even participated in its creation in some minor way—but the creator's identity still remains unknown. Those disciples and followers were not accused of fraud, unless they intentionally attempted to sell their own paintings as the work of the better known artists. The fact that many artists did not sign their works as well as the practice of apprentices learning to create in the style of their master artists resulted in headaches for later art historians.

Nowadays, deciding when one contemporary artist imitates the feel and impression of the work of another is not up to art experts but to judges of the legal system. There may be some factual evidence to rely upon: Did Artist B ever see the work of Artist A? When were the respective works made? Will someone admit to being told to stylistically copy another's work? Are there certain idiosyncrasies or errors (misplaced thumbnail, for instance) in common. The strength of Paul Wegner's case rested on "sworn affidavits by three people who were on hand when Wasserman brought photographs of Wegner's work to Conley and said 'make your work as close to these as you can,'" Joshua Kaufman said. However, in less clear-cut situations, much relies upon a judge finding a striking visual similarity between two works. In the Tarkay case, according to the written decision, the court examined "the color patterns and shading of the Tarkay works, the placement of figures in each of the pictures examined, the physical attributes of his women, the depiction of women sitting and reclining, their characteristic clothing vis-à-vis those portrayed by Patricia [Govezensky]" to find that "consumer confusion is a likely result."

The courts apply two main tests for trademark cases in determining whether or not one artist may have stylistically copied another: The first is establishing that the allegedly copied work is identified by the public with the particular artist (in legal parlance, the art has acquired a "secondary meaning"); the second is proving that the imitation is likely to cause confusion in the market. "What better for showing probable confusion than actual confusion," Kaufman stated. "Three people called up Wegner in one week."

COPYRIGHTED AND TRADEMARKED MATERIAL IN ARTISTS' WORK

An artist sets up an easel at Times Square in New York City and paints a picture. Other than a passing thought as to muggers and pickpockets, the artist believes he has found in urban bustle a safe subject matter. But legal worries enter in: Am I infringing any trademarks by including company logos and advertising slogans, of which there are hundreds in Times Square, in the painting? Should the building owners and their architects be asked permission to include their buildings in the picture? If an image on a billboard, of which there are many in Times Square, is included in my painting, have I violated copyright? If an individual on the street is recognizably portrayed in the picture, have that person's rights of privacy or publicity been violated? Should a lawyer have accompanied me to Times Square?

Lawyers hold differing opinions on these questions, and the issues are complicated by the way in which the finished artwork may be used and distributed and in what form. An original painting, for instance, has greater first amendment protections of free expression than a large edition of prints or images scanned onto limitless numbers of calendars or T-shirts. Artist Andy Warhol did not seek—nor did he need to seek—permission from the Campbell's Soup Company for his famous 1962 painting of a can of Campbell's soup because it was a noninfringing use of a trademarked label, created by Warhol in an artistic medium and displayed in an art setting. "The public was unlikely to see the painting as sponsored by the soup company or representing a competing product," said Jerome Gilson, a Chicago trademark attorney. "Paintings and soup cans are not in themselves competing products."

Freedom of commercial speech, on the other hand, is more restricted than artistic speech. "If Warhol had put the soup can image on T-shirts or greeting cards, he would have had more of a problem in defending a trademark infringement lawsuit because they aren't traditional artistic media," said J. Thomas McCarthy, trademark expert at the University of San Francisco School of Law.

He added that, by virtue of the volume and distribution of the T-shirts and greeting cards, Campbell's might have argued, "what's really selling the product is the product name rather than the artist's name or image. Therefore, people might have assumed that Campbell's authorized Warhol" to make T-shirts and greeting cards.

Many images are copyrighted or trademarked, and the legal use of them by artists is a matter of considerable debate; however, specific lawsuits are resolved not by an adherence to general principles but on a case-by-case basis. The issue of what artists may or may not legally be able to do came to a head in a lawsuit brought by the New York Racing Association against an Averill Park, New York, artist, Jenness Cortez, and decided in 1997 by the U.S. District Court in the Northern District of New York. Cortez had painted horse-racing scenes since the mid-1970s, many of which take place at Saratoga Race Course in Saratoga Springs, New York. In addition to the original paintings, the artist markets a "Cortez Saratoga Collection" of lithographic prints.

Beginning in 1980, Cortez began to use her horse-racing images on greeting cards and, in 1992, on T-shirts ("art shirts" as they are called by the artist). According to the

artist's husband and dealer, Leonard T. Perlmutter, the prints, cards and T-shirts accounted for 80 percent of her annual sales during the early 1990s. The entirety of Cortez's work is sold either through a mail order catalog sent out to past buyers or at an annual Summertime exhibition at the Holiday Inn in Saratoga Springs, where her husband rents the ballroom for a one-person show. "We've never sold any works at the race track, and we've never asked to do so," Perlmutter said.

The New York Racing Association has federally registered trademarks on the words "Saratoga," "Saratoga Racecourse," "Travers," and "The Summer Place to Be," as well as for the logos for Saratoga and the racing association itself, all of which have appeared in one form or another on Cortez's work. Charging trademark infringement, the racing association demanded that she sign a licensing agreement for the use of these trademarked words and logos on the prints, greeting cards, and T-shirts or cease using them and the horse-racing scenes that suggest them.

The racing association claimed that her work gives the public the false impression that the organization sponsors or authorizes her work and undercuts the licenses signed with the fifty or so other artists and merchants selling horse-racing memorabilia (including key chains, notecards, pins, T-shirts, polo shirts, sweatshirts, and posters). "She is trading on our good name," said Steven Crist, director of communications and development for the New York Racing Association. "She is creating souvenir products, very much like some of the merchandise sold by vendors with whom we have licensing agreements, and buyers are likely to be confused about which products we license and which we don't. This is purely a matter of protecting our licenses and our trademarks."

The artist contended in court papers and during the trial that her work represented the free expression of her ideas, and that the words and logos used are merely descriptive—that is, indicating a time and place—rather than suggesting sponsorship. "The courts have always recognized that there is a difference between stealing a trademark and having one appear in one's work," said Albert Schmeiser, the patents and trademark attorney representing Cortez. "In that regard, there is no trademark infringement. With regard to the question of whether an ordinary person would assume Cortez's work is sponsored by the New York Racing Association, there is no reason anyone would make that assumption. The work she creates has her name on it and isn't sold in the same way as the merchandise licensed by the racing association."

Trademarks are words, logos, or images (for instance, Jolly Green Giant, Aunt Jemima, Betty Crocker, or Mickey Mouse) that specifically symbolize, or refer, to a company's products and services. The New York Racing Association cannot broadly assert the sole right to the town or name "Saratoga." As "Saratoga" is the name of both a town and a county, the racing association's federally registered trademark cannot prohibit other companies from using the name, such as Saratoga Spring Water, on their products. The racing association could not bar an artist from painting general scenes of horse-racing at the race course. The association, however, believed that images, which are so specific to Saratoga Race Course as to be identified with the track or which contain the trademarked words that symbolize the track infringed upon the trademark by

confusing the public as to the artist's sponsorship by the racing association. The court ruled that "even though plaintiff's registered marks appear in some Cortez paintings, the Court finds that the interest of free expression weighs conclusively in defendants' favor with respect to defendants' products displaying these paintings." She was enjoined, however, from using these same images for T-shirts and postcards without taking out a license, because these were more commercial and less artistic products.

There are not a lot of "precedents in this area," according to J. Thomas McCarthy, "no case law on point. Companies generally don't sue artists." Many other lawyers noted that much depends upon the particular image. "It's a gray area," said Tad Crawford, author of *Legal Guide for the Visual Artist*. "You don't always know how the public will respond; will it think the artwork is the product or an artwork?"

If the trademark is part of a street scene, he noted, the public is more likely to be warned that the image is something other than just a product. If there are a number of different companies' trademarks in an image, such as a street scene at Times Square, the public is unlikely to associate the picture with any one company.

In another victory for artists, this in 1999, the Cleveland, Ohio–based Rock & Roll Hall of Fame lost its attempt to prohibit Chuck Gentile from selling posters based on his photographs of the facility. Three years earlier, the Hall of Fame and Museum had sued the photographer for infringing its trademark by selling posters of the I. M. Pei–designed building, and Gentile was initially ordered by a district court to destroy all of the works. However, a higher court overturned that decision, later affirmed by the U.S. District Court in Cleveland, claiming that "when we view the photograph in Gentile's poster, we do not readily recognize the design of the Museum's building as an indicator of source or sponsorship. What we see, rather, is a photograph of an accessible, well-known, public landmark."

The legal test for trademark infringement is what the "ordinary person" is likely to believe, and there is no rule of thumb concerning how much of the image may be taken up by the trademark before an artist is apt to lose an infringement lawsuit. "Is the trademark an incidental use as part of the scenery or so prominent that someone might think the trademark owner had something to do with the picture?" said William M. Borshard, a New York City trademark lawyer. "The principles of these laws are clear and easy to state, but the application of those principles to fact is not at all so clear."

Borshard added that difficulty in knowing in advance what may be deemed trademark infringement is compounded by the fact that judges generally have different beliefs as to how much protection a trademark deserves. "On one side, there is the view that trademarks help consumers distinguish between products, which is helpful in our free enterprise economy," he said. "The other view is that trademarks are anticompetitive, in that they cause consumers to behave irrationally, selecting one product over another when both are identical. Judges take one side or another on the issue of trademark. The 'ordinary person' turns out to be the judge, and you don't know what kind of judge you'll get on any given day."

Just as a trademark may find its way into an artist's work, so might a copyrighted image, such as a billboard image or someone else's artwork. In general, an artist cannot use copyrighted subject matter unless as "fair use"; that is, as commentary or criticism. Just as with trademark infringement, the legal test is whether or not an ordinary person would believe that mere copying has taken place.

The two main concerns the courts would have in evaluating a fine artist's fair use of copyrighted material are how much of the material is used in the artist's work and how does this use affect the value of, or market for, the copyrighted work. It is unlikely that a painting of Times Square that contains a large billboard for, say, Calvin Klein sportswear will affect the market for that clothing, yet the artist may still have violated the manufacturer's copyright—and subject to fines—for including too much of the advertisement in a prominent manner in his or her painting.

Most paintings of Times Square are apt to include people and buildings, and both people and building owners may object to their recognizable inclusion, for whatever reason. People generally have the law on their side; in most cases, the building owners do not.

The right to privacy is the right to be left alone, and an individual cannot be recognizably included in an advertisement or for commercial uses (such as in a painting or fine art photograph) without his or her consent. That permission is not required for news publications or specifically educational purposes. An artist, however, would have to either persuade the individual to sign a model release form—which may be difficult to achieve, especially when the person doesn't know the artist or the artist's intentions— or disguise the individual in such a way that no specifically recognizable characteristic is visible.

People who are not famous have no significant right to publicity, that is, the right to benefit from the commercial value of their name and image. This right applies to celebrities, living and dead, who may sue to stop the use of their pictures where they have not been authorized. Again, publications may use their pictures as part of news accounts, and a celebrity's picture is generally allowed in single and original works of fine art, but a more commercial use—such as on greeting cards or T-shirts—would likely invite a viable legal challenge.

Animals, such as dogs or even race horses, have no rights of privacy or publicity. Their owners, however, may prohibit an artist from access to the animals in order to create a likeness. Buildings (and any other inanimate objects) also have no rights of privacy, and an artist can freely paint the exteriors, although an owner may charge an artist with trespassing if the artist enters the property grounds uninvited. On the other hand, an artist would likely need permission to paint the interior of a building, especially if entrance admissions are charged.

"There are a lot of competing rights, and it is difficult to say without looking at a particular picture whether or not an artist is violating someone else's rights," William Borshard said. "It probably isn't a bad idea to let someone, like a lawyer, look at your work to make sure everything is OK."

ARTISTS' MORAL RIGHTS

As noted above, the Visual Artists Rights Act of 1990 represented a sea change in the legal protections afforded to artists by the federal government. The law is based on legal concepts established in French law for decades, including the right to determine when a work has been completed (first brought to court by James MacNeil Whistler in 1900, later tested by the heirs of Georges Rouault), the right to always have one's name credited with the work (including advertisements), and the right to prevent one's work from being shown in a way that might harm the artist's reputation (tested in the French courts by painter Bernard Buffet in 1962).

"Moral rights" statutes reflect a changing view of property rights in this country, at least as far as artwork is concerned. Allen Sieroty, former California state senator who sponsored the nation's first state "moral rights" law for artists in the mid-1970s, stated that "Americans are very concerned with private property and, when we were pushing through the legislation, we were constantly asked whether the concept serves as a deprivation of private property since artists will still retain an interest in their works. We had to convince legislators that there are already restrictions on the use of private property. Just think about what zoning is."

One of the first highly publicized instances of intentional distortion of a work of art occurred in 1958 when a black-and-white mobile by Alexander Calder, displayed in a building at the Greater Pittsburgh International Airport, was turned into a stationary sculpture and painted the city's official colors, green and gold. A few years before that, sculptor David Smith condemned a purchaser of one of his painted metal sculptures for "willful vandalism" for removing the industrial green paint, and in 1980, the Bank of Tokyo outraged the art world when it removed a 1,600-pound aluminum diamond-shaped sculpture by Isamu Noguchi that hung in the bank's New York City headquarters by cutting it into pieces.

The problem hasn't been wholly confined to sculptors, as a mural by Arshile Gorky at the Newark (New Jersey) Airport was subsequently whitewashed and a painting by Pablo Picasso was cut into numerous one inch square pieces to be sold through magazine advertisements as "original" Picasso works of art by a couple of entrepreneurs in Australia. One of those Australians commented at the time, "If this works, we're going to put the chop to a lot of Old Masters."

Mutilation or destruction of an artist's work (for which the artist owns the copyright) is now considered an infringement on copyright, with artists able to sue for both compensatory (out-of-pocket) and statutory (up to $20,000) damages as well as actual damages. Those actual damages refer to harm caused an artist's professional reputation by the destruction or distorted appearance of his or her work.

This kind of copyright infringement would not be a criminal violation—the copyright law does include possible jail terms and fines for instances of commercial exploitation, such as bootleg films, books, or records—since the damage or destruction of artwork is seen as an area for civil litigation. An artist must hire an attorney to bring action against someone altering or destroying his or her creations.

The general term of copyright protection does not apply to the moral rights created in this new federal law. Instead, the moral rights last for the life of the artist, the same period of coverage for invasion of privacy, libel, slander, and defamation of character. One aspect of the law of particular interest to muralists and wall sculptors concerns artwork that is attached to a building, and there are special rules that balance the rights of artists and property owners. The owner of a building on which artwork is attached is required to notify the artist that the work should be removed, if it can be removed. The building owner is to write to the last known address of the artist or, if there is no response, to the Copyright Office in Washington, D.C. A special department within the Copyright Office has been created by the Visual Artists Rights Act for the addresses of artists, and artists are advised to send a current address there.

Once the artist is notified that the building owner wishes the artwork removed, the artist has 90 days in which to remove it (at his or her own expense), at which point the artist regains title to the piece. If the artist fails to collect the artwork, cannot be physically removed, or cannot be located, all rights under the Visual Artists Rights Act are negated.

VALUING AN ARTIST'S ESTATE

This story begins where most end: The artist dies. Unless that artist has sold every piece he or she ever created, there is likely to be a potentially sizeable inventory of artwork that must be valued as part of the artist's estate for tax purposes. How to value that art can be tricky, as it involves speculating about the market for an artist's work when that artist is dead.

It was no easy matter when sculptor David Smith died in an automobile accident in 1965. The fifty-nine-year-old artist had only begun to receive major art world recognition and appreciation late in life. Between 1940 and 1965, he had sold but seventy-five works, only five in the last two years of his life. Part of the reason for this was the fact that Smith deliberately kept prices high, with the result that 425 sizeable sculptures were in his estate when he died. Within two years of his death, sixty-eight works were sold for just under $1 million. The remaining body of work in his estate, with each piece appraised at the fair market value, was originally valued at $4,284,000, ensuring that a hefty tax payment was due to the Internal Revenue Service within the standard nine month period. After a hearing before Tax Court and some complicated negotiations between the IRS and lawyers for the Smith estate, the entire estate was discounted to 37 percent of the fair market value, greatly decreasing the amount of tax money due the federal government.

The Smith case developed in the field of artists' estates what is called the "blockage rule" or "blockage discount," which previously had been applied only to securities and recognizes that forcing an artist's heirs to sell most or all the art in the estate for the purpose of paying death duties would result in fire sale or "distressed" prices that are likely to be well below fair market value. Expected fair market prices are more readily obtained when individual works are sold gradually.

Over the years, this principle has been applied to such artists as Jean-Michel Basquiat (who received a 70 percent blockage discount), Alexander Calder (60 percent), and Georgia O'Keeffe (50 percent). There is no rule of thumb for determining the percentage discount, which clearly is elastic. "Different discount percentages reflect different judges, different jurisdictions and different lawyers representing the estate, and some lawyers are better and more persuasive than others," said Bernard Rosen, a New York City attorney with a number of artist clients. Additionally, a number of other considerations are taken into account in determining the discount, such as the subject of the works, the period in the artist's career in which works were created, and the medium.

For instance, there were 1,292 gouache paintings in the estate of sculptor Alexander Calder. Since these gouaches were not the artist's principal medium, along with the fact that Calder's estate executors claimed it would take the art market twenty-five years to absorb this number of his paintings (at fifty-two per year), the IRS permitted the estate to discount these works by almost 68 percent.

Predicting what art is worth after the artist dies cannot be scientifically measured, and a number of factors may apply. "The death of the artist may sabotage the market," said Karen Carolan, head of art evaluation at the IRS. "If the artist doesn't have a regular dealer, his death may have a very negative impact on prices." She added that having "a ready market, being a well-known artist, being represented by dealers, selling work all over the country" make valuing artwork in an artist's estate considerably easier. Artists without one or all of those elements produce work that is far more difficult to appraise after they are dead.

Complicating variables are frequently found in these kinds of valuations: There may be a record of sales in a nondepressed art market but, when the market goes down, formerly salable works have no prospective buyers. Some artists sell very well, but their success may depend upon their presence to actually sell the work—without the benefits of the artist's personality, works may not sell at all. Artists without a gallery connection may be the least likely to have works sell after they are dead. The IRS combs through auction records to see what prices were paid for an artist's work, but most contemporary art is not resold at auction (if it is resold at all). Another way in which the IRS often tries to determine the value of artworks is by examining an insurance policy, which requires an expert appraisal, but this is more applicable to collectors than to artists, who rarely insure their own work.

Basquiat, Calder, O'Keeffe, and Smith, of course, were all renowned artists who supported themselves exclusively from the sale of their artwork. Many more artists hold teaching positions or other jobs (arts-related or otherwise) from which they receive their main income. These artists may also sell their work; however, the market is limited, perhaps almost nonexistent. What the deceased artist's work is worth is a question on which lawyers and the IRS sometimes disagree. "A lot of people teach or do something else and sell one painting every three years to a cousin," said James R. Cohen, an estates attorney in New York City. "The IRS couldn't really demonstrate that the art has any value. You don't get into the discount issue because no one is really buying their art in the first place."

Another New York lawyer, Susan Duke Biederman, coauthor of *Art Law*, agreed, noting that "you don't want someone who paints 16″ × 24″ oils, and only sells one painting a year for $1,000 and has a backlog of 500 pictures when he dies, to have the art in his estate valued at $500,000. My interest would be to say the art is worth zero. If the IRS said that people have bought this work in the past, I'd say, 'You go find me 500 people who want to spend $1,000 on each work.'"

Certainly, the IRS is in the business of collecting money, not selling artworks. Still, Karen Carolan stated, "you can't say that art has no value if the artist has sold during his lifetime. You have to place a value on all the property in the estate." The IRS has no rule-of-thumb cutoff for the amount of money earned through sales or the percentage of one's income derived from sales of art to determine whether a deceased artist's work has market value at all or if a blockage discount (and the amount of that discount) applies.

These artists may have just as many works in inventory as David Smith or Alexander Calder, but with a far less reliable market than either Calder or Smith, estate executors face a far greater challenge when determining value and any potential discount on that amount.

The problem is not necessarily an immediate one for all artists. The entire estate goes tax-free to the surviving spouse, and the first $600,000 of the estate is tax-free to the heirs. There is no need to individually appraise works of art in an estate if the entire estate is worth less than $600,000. In fact, according to Martin Bressler of the Visual Artists and Galleries Associations, if the rest of the estate is small, "it behooves you to value the art high enough to get as close to that $600,000 number as you can. This protects the heirs if they some day sell the art. For instance, an heir who values a work at $10,000 and sells it for $15,000 only pays tax on the $5,000. However, an heir who claimed that the art was worth nothing and sells it for $15,000 pays a tax on the entire $15,000."

Not everyone goes along with Bressler's reasoning. James R. Cohen stated that, as soon as an heir begins to claim that the art has some value, "reasonable men may disagree, and the IRS may come in and value the art higher, moving you above that $600,000 tax-free limit and then taxing the heir at 35 percent."

Certainly, some heirs may expect to sell these artworks eventually and earn a considerable amount of money from them. Sales during an artist's lifetime are no absolute indication of future value, as the art of Vincent van Gogh is a clear example. During his life, van Gogh only sold three paintings, but his work became far more popular and earned record prices at auctions years later.

Competing values are involved in this issue: On the one hand, heirs look to minimize the value of an estate in order to lower inheritance taxes; yet, if they plan to sell works from that estate later on, heirs hope to limit the tax burden on those sales. Many well-known artists, such as Adolph Gottlieb, Lee Krasner, Robert Mapplethorpe, and Andy Warhol, have resolved this problem in a third way, establishing a trust or charitable foundation for their art through their wills and using the periodic sale of artwork to create and replenish the foundation's endowment. Yet others, including photographer Ansel Adams and painter Hans Hofman, donated a large number of their works to edu-

cational institutions. Artists who are concerned with keeping their inventory of works intact for their heirs might also plan for money, such as through a life insurance policy, that would pay the inheritance tax. Any of these choices is preferable to the decision by an Arizona artist in the early 1980s to publicly incinerate all his paintings in order to spare his heirs the burden of paying taxes on them. Artists, their attorneys and their heirs need to examine what they reasonably expect to do with the artwork after the creator dies and plan accordingly.

No less important than properly valuing the artwork of a deceased artist is maintaining and developing the posthumous market. There is a widespread myth—it is quoted enough that it could have come out of the Bible—that "an artist is only appreciated after he is dead." However, the concept of the starving artist whose death gives his or her works new life is more mystique than truth. In a few, very rare instances do works immediately go up in value. In some cases, prices go up gradually (or eventually). In general, demand drops and the prices go with it.

Take, for example, Ivan Albright (1897–1983) and Philip Evergood (1901–1975), well-known artists in their time and for whom interest diminished significantly after their deaths and prices took years to approach those achieved during their lifetimes. Another example is Bernard Karfiol (1886–1952), a Hungarian-born American painter who was a darling of the Whitney Museum in its early days. "After he died, everything came to a standstill," stated Bella Fishko, his dealer. Yet another example is Mark Tobey (1890–1976), a Zen-influenced abstract surrealist for whom there had been a decline in the market since his death.

The factors determining whether prices will go up or down are much the same when an artist is dead or alive. They include the degree to which the market of an artist's work is controlled; changes in critical and popular appreciation; the manner in which dealers, heirs, or estate executors handle works in their possession; and how collectors behave.

One of these factors is to keep the deceased artist's work in the public eye to maintain or improve prices. If the dealer does not continue to promote the artist, or there are no subsequent exhibitions, the market may fall apart. Changing tastes of the art buying public may also affect demand. When Fairfield Porter (1907–1975) died, prices dropped to the $5,000–$20,000 range and stayed there for a number of years due to "limited collector interest," according to Porter's dealer. Porter's "problem" was his adherence to realistic imagery, which, in the context of minimalism and conceptual art that ruled the art world when he died, looked old hat. A return to realism and a touring retrospective of the artist's work in the early 1980s helped revive his market.

William Baziotes (1912–1963), a member of the abstract expressionist group, died during the rise of Pop Art, when his paintings were also no longer in fashion, and demand for his works was "poor," according to the Marlborough Gallery, which represented the artist until 1983. The resuscitation of the Baziotes market in the mid-1980s had a lot to do with the skyrocketing prices for works by other New York School artists, "and Baziotes' work was not all that different," said Franklin Riehlman of the Phillips Auction House.

Another factor is how the artist's estate is handled. Lee Krasner, who managed her husband Jackson Pollock's estate until her death in 1984, provided an even flow of works onto the market in order to keep prices high and maintain a scarcity. The estates of painters Milton Avery and Philip Guston were also handled in this way. On the other hand, the estate of Mark Rothko was handled in a particularly egregious manner, resulting in a major art world lawsuit that removed the executors. The death of Rothko, a leader in the chromatic school of abstract expressionism, created far more excitement than his life but, unfortunately, in a way that depressed the prices of his works for a number of years.

Artists often own the largest collection of their own works—partly because they couldn't sell them and partly because they didn't want to (both of which were unfortunately the case with sculptor David Smith)—and heirs sometimes make mistakes with this vast quantity of pieces. The families of painters Raoul Dufy and Thomas Hart Benton helped depress the prices for their paintings by dumping a large number of them onto the market after their deaths.

The widows of sculptors Sir Jacob Epstein (1880–1959) and Julio Gonzalez inadvertently hurt the market for their late husbands' works when they began recasting their pieces—failing to keep good records on how many reproductions were made in Epstein's case, failing to label the recasts as posthumous with Gonzalez. The widows of sculptors Ossip Archipenko and Jacques Lipchitz also recast many of their late husbands' works. In some cases, families are completing editions for the artists, but the opportunity to earn money also may be a major incentive.

Most of the time, the people who sell these posthumously created works indicate in some way that they are copies or recasts. There may be something in writing about the work being made from the original, for example. The price may also be a tip-off, or possibly the work itself may reveal its origins to the trained eye. Replicas lose the sharpness of the original, and they are often a bit smaller than the original, as the wax recasts for the mold usually shrink 2 or 3 percent. The name of the foundry that recast the piece is often scratched into the copy, and experts in a particular artist will know from that.

Not only heirs but collectors, too, may flood the market upon the death of an artist, assuming a large jump in prices. Riehlman noted that Pablo Picasso's paintings and prints as well as many of Alexander Calder's pictorial works went down by 15–20 percent for a period of years following their deaths because of a flood of their pictures coming onto the market.

The prices for Josef Albers's paintings also fell shortly after his death as "the market became flooded with collectors trying to sell the 'Homage to the Square,'" said Nicholas Webber, director of the Josef Albers Foundation. "Everyone saw that there were going to be an endless number of 'Homages' on the market, and it cut the prices dramatically." He stated that whereas, before Albers died, his paintings were selling for approximately $1,000 per square inch, they have sold for between $500 and $750 per square inch ever since.

"I would have to say that a deathwatch does exist for many older artists," said Robert Schonfeld, a private art dealer and one-time head of the appraisal department at Sotheby's auction house. "This has been a common practice as far back as I can remember. All dealers and collectors anticipate changes in circumstances that make works more available or more valuable. There's nothing morbid about it."

The concern with an artist's age frequently leads collectors to start hoarding or buying up works by artists who are getting on in years or who are in poor health." A lot of people speculate in the works of older artists," said Gilbert Edelson of the Art Dealers Association of America. "They think they'll make a lot of money when the artist dies."

Possibly, the biggest bottoming-out of a market was felt with Norman Rockwell (1894–1978). The Rockwell deathwatch had been strong following a 1971 auction at Sotheby's in which one of his paintings sold for $40,000, more than twice what had been estimated, according to Martin Diamond, a Rockwell dealer. This had been the first time any of the artist's works had gone to auction, and the results were a surprise to those who never before took Rockwell seriously as an artist. Prices went up continuously, in expectation of enormous profits. However, when he died, the market turned out to be all sellers and few buyers, and prices took years to stabilize.

It is more likely that an artist's work will go up in value after he dies if the market for pieces is already strong and there is some sort of waiting list. When Robert Smithson, an environmental artist, died in a plane crash in 1973 at the age of 35, the sudden realization of the rarity of his drawings created a tremendous jump in prices for them.

Art is long and life is short, the ancient Romans said, but artists and their families must bear in mind that, if the art is to be esteemed and sought after, the marketing of it must be an ongoing process and not left to chance. Artists need to talk with their dealers, estate executors, children, relatives, and spouses about how their work will be distributed to the market, leaving clear written instructions.

7

FROM SCHOOL TO THE WORKING WORLD

The most meaningful things we learn are usually what we've taught ourselves, but most people look to the four walls of a school for a head start. High school students who are interested in making art, for instance, think about going to art school or majoring in art at college, while those in college give thought to going on for a Masters of Fine Arts degree.

Theoretically, such training should lead to greater success in terms of the quality of an artist's work and the ability to sell it. Unfortunately, with both quality and sales, there is no evidence that the quantity of one's education makes any difference. This is most apparent in the amount of money an artist makes.

According to a study of 900 artists applying for fellowships to the New York Foundation for the Arts, 95 percent had completed college and another 59 percent had graduate art degrees, yet 20 percent of them had pretax household incomes under $10,000 and 56 percent of the total had household incomes between $10,000 and $30,000. The median was slightly under $20,000, and only a small percentage (if any) of that derived from selling actual works of art. Another study by the National Endowment for the Arts found that artists in Houston, Minneapolis, San Francisco, and Washington, D.C., spent twice as much to purchase art materials (an average of $1,500) as they earned in selling it ($718). Art, it seems, is a losing proposition, despite the fact that so many artists have college and graduate school degrees.

A main reason for the continued difficulty of artists as a whole to earn enough to support themselves is that there are so many of them. According to one report, the U.S. work force increased 43 percent between 1960 and 1980, while the number of artists, writers, and entertainers shot up 144 percent during that same period. The increase in prices for art over this period and the widening art market have not been able to overcome the massive infusion of artists.

Many of the real-world problems of pursuing a career as an artist would be better known to young artists if more art schools offered what are frequently called "survival

courses." These classes are designed to teach everything from protecting copyright and writing up consignment agreements for art galleries to how to put together grant proposals, prepare a portfolio, and even how to find and keep a loft. The absence of this body of information tends to result in a fresh crop of psychologically unprepared artists who are released into the world every year.

THE ADVENT OF "SURVIVAL COURSES" AT ART SCHOOLS

"I certainly learned nothing about how to conduct myself as a professional artist when I was an art student," Larry Edwards said, "and I made a lot of mistakes over the years." In order to save his students from making those same mistakes, Edwards, a member of the art faculty at Memphis State University in Tennessee, has been teaching a semester-long, three-credit course called "Professional Art Practices" since the early 1980s. His course examines such issues as how to put together a résumé; how to write a letter to a school for a teaching position, to an art dealer, or to an arts agency for a grant proposal; and how to determine which art galleries—local, regional, and elsewhere around the United States—might be interested in exhibiting one's work.

"If the students keep those letters, those lists of galleries, et cetera, all other things being equal, they will have an edge on students who didn't take the course," he stated.

Before the 1990s, such "survival" courses as these were rare and irregularly offered at art schools and in art departments in colleges and universities: These courses take away from the purity of art, some argued; gave students the false impression there was a specific path one might take for success; or even implied that most or all students are likely to achieve success as full-time, practicing artists. In addition, opponents of these classes claimed, students aren't interested in art law or how to write a grant proposal while in school; anyway, they will have plenty of time to learn all these things once they are out in the world.

Many art faculty members still resent or oppose these courses, but a consensus of opinion has emerged that artists and art students need to be taught something about basic survival techniques, such as how to write a résumé, find a job or internship, prepare a portfolio, photograph one's artwork, crate and ship one's art, locate a studio or live-work space, present oneself to a gallery owner, and write a grant proposal.

These courses have various names at different art schools—such as, "Careers in the Arts" at the School of the Art Institute of Chicago, "Professional Practices" at the Memphis College of Art, "Survival Skills for Fine Artists" at the Ringling School of Art and Design in Sarasota, Florida, "Survival Skills for Artists" at the University of Illinois at Chicago, "Support Resources for Artists" at the Maryland Institute College of Art in Baltimore, "Seminar in Professional Practices" at Northwestern University, and "Business Survival Skills" at the School of the Museum of Fine Arts in Boston, Massachusetts—but they all teach a general area of practical information.

Only a relative handful of schools still offer elective three-credit survival courses for their students. Northwestern University has the only Master of Fine Arts program that requires its students to take a survival course, although for its undergraduates it is

an elective, in keeping with every other school around the country. Brian Sikes, who teaches survival courses at both the Northwestern and at the Art Institute of Chicago, noted that less than 10 percent of the Art Institute's students sign up for the "Career Issues in Art" class, and "a preponderance of them are women and minorities. I've asked my students about this, and they felt that they had to find out in a more formal way how the mechanisms of the art world work. They didn't think it would work as naturally for them as it does for their white, male fellow students."

Some other schools, including the Minneapolis College of Art and Design, Pacific Northwest College of Art in Portland, Oregon, include business-of-art talks within a "senior seminar" program that fourth-year bachelor of fine arts students are required to take. Yet others, including Pratt Institute in Brooklyn, the School of Visual Arts in New York City, the California Institute of the Arts in Valencia, and the California College of Arts and Crafts in Oakland, provide a series of generally noncredit workshops on specific subjects, such as taxes, sources of art patronage, or how to find an art dealer; and these programs may be offered during the day to degree students or in the evenings and on weekends through a continuing education division to students, alumni, and artists in the community.

Sometimes, these courses and workshops are taught beginning to end by a faculty member or career development administrator at the school; but more often than not, the school brings in a series of speakers—an artist, an accountant, an arts agency official, a museum curator, an art dealer, a lawyer—who describe their own experiences as well as what they do. Students are rarely assigned a professional artist's career guide, although many of the speakers provide handout material, such as a completed artist's tax form, and a portion of class time is often spent learning how to draft a résumé or cover letter—information contained in many career guides.

No one claims that taking a survival course guarantees an artist's success. At most, a knowledge of the process of making a career in the art world is offered. "We certainly aren't trying to tell anyone how to become the next David Salle and make a million dollars in the art world," said Lisa Pines, director of career services at Parsons School of Design in New York City. "We try instead to demystify the art world, show how the art world is structured."

Whether these courses and workshops will result in artists who are more likely to achieve success in their careers or at least make fewer mistakes along the way is more a matter of belief than of hard evidence. "I have no idea if the 'Survival as an Artist' workshop helps students in their careers," said Tom Lawson, dean of the art school at California Institute of the Arts. "We operate on the assumption that all information is helpful and useful, and students make of it what they can."

At best, most school administrators and faculty offer anecdotal support on behalf of the career information they provide. "I've heard from students who said the course was invaluable," said Deborah Dluhy, dean of the School of the Museum of Fine Arts in Boston." Fred Lazarus, president of the Maryland Institute College of Art, noted that "all of the students we've heard from say that they wished they had received more of this kind of information."

The Minneapolis College of Art and Design has conducted what the school calls "exit interviews" on students—given to graduating seniors in April before they leave in May—in which students are asked if they have a job waiting for them. According to Heidi Dick, associate dean of students for career development, 47 percent of the fine art students had full- or part-time jobs lined up (more than two thirds of those jobs were art-related), which was higher than for the school's other majors, media and design. "Maybe, it is a matter of fine art students scrambling harder for jobs than the other majors," she stated. "I can't say definitely that this is a result of what they are taught in the Senior Seminar, but a correlation seems likely to me."

Of course, the effort to teach art students something about the ways of the art world is so new at most schools that there has not been sufficient time to evaluate how well graduates have done. Even at art schools that have provided survival courses to their students for a number of years, the process of tracking alumni and sending them questionnaires on what they are doing in art, how they earn money, and how much they earn has not been a high priority. The Rhode Island School of Design surveys its alumni one year after graduation, asking for information about their current employer, how the alumni found the job, the alumni's salary, whether the job is art related, and whether the alumnus felt prepared for the working world upon receiving a degree. As might be expected, design graduates have had an easier time finding jobs, earning between $25,000 and $30,000 (for 1998 graduates), than fine art alumni. Many of the fine art graduates claimed that they left school unprepared.

The few surveys of alumni that most other art schools have done are quite recent and only in response to new reporting requirements from higher education groups (such as the National Association of Schools of Art and Design) as well as from state agencies and the federal government's Department of Education, which have threatened the loss of accreditation or financial and student aid to schools whose graduate employment rates are considered too low.

"When schools began to realize that student loans might be denied if employment rates were so low that the students wouldn't be able to pay back their college loans, they panicked," said Nat Dean, an artist and educator who has developed career planning programs and taught survival workshops at the Ringling School of Art and Design, California Institute of the Arts, Iowa State University College of Design, Minneapolis College of Art and Design, and elsewhere. "School administrators ran to their career development offices and begged them to come up with some way to increase the employment rate. The result has been a lot of career courses; some are good, others not. Some of these courses have follow-up, in terms of finding out how the student is doing out of school and offering assistance where possible, most don't."

Many art schools and college art departments have found themselves needing to play catch-up, breaking down their longstanding isolation from the larger world. Their graduates have long complained that they were never told about how to support themselves as artists, and current students themselves are asking for more career assistance. Memphis College of Art, which had offered a workshop every so often on professional

practices, made an informal survey of students to determine whether to create an entire course on this subject and found overwhelming support for the idea. "There has been a growing and legitimate concern on the part of parents that their kids are employable when they leave here, or at least understand the marketplace they are entering," said Elonzo Davis, dean of the Memphis College of Art. "What's new is that schools are taking these concerns more seriously."

By now, almost all art schools have a career office, providing various services to both current students and alumni. All have job and opportunity notices, some business-of-art books, workshops on how to write a résumé or how to approach a gallery, perhaps résumé referrals (matching up a student's résumé to a company job listing), and one-on-one career counseling. The directors of these career offices now hold a regular conference—entitled "Career Issues in Art and Design," which is informally sponsored by the Association of Independent Colleges of Art and Design—in which the question of how to better inform students and graduates about succeeding in the outside world are discussed.

Art schools have taken the challenge to better their alumni's chances at earning a living in their field in a serious way. Unfortunately, most artists are not trained at the thirty-five or so degree-granting art schools in the United States and Canada but in art departments at colleges and universities. Only the University of Texas at Austin has a fine arts career office specifically for its art majors, with information available at an office and online. At most other universities, it is rare that even an art career workshop is offered.

The first year out of college tends to be an emotionally charged one for all graduates; for fine artists, the psychological adjustment may be even more troublesome, as they frequently do not see themselves as qualified to do any particular job, a view often shared by much of the working world. Career offices generally field the calls from alumni who have experienced difficulty in establishing themselves either as artists or as wage earners, offering advice, job listings, and sometimes referrals for counseling. "I'm in touch with a number of alumni, especially those who call up saying 'Help, I'm stuck. I'm out of money. I haven't had a show in a year,'" said Leslie Mehren, director of the career office at San Francisco Art Institute. "Leaving school can be really shocking for many students, especially the MFAs. Some of them go into a coma phase, just staring at the walls, not knowing what to do."

The degree to which a survival course or a series of business-of-art workshops effectively informs students about the world they will face upon graduation and how to make their way in it depends upon a number of factors. One factor is if the information offered in a course or workshop is reiterated in the other classes that a student takes. In some instances, art faculty will discuss how they or other artists got a first exhibition or earned money in some other field while pursuing their art. Other faculty members may not ever mention practical issues either out of scorn for the subject or because they don't know, having never established a significant market for their own work.

Almost all art school deans and presidents are quick to declare, as did Robert Farber, head of the fine arts department at Ringling School of Art and Design, that "our

faculty are all practicing, exhibiting artists who know very well what it takes to make it in the art world," but that claim is rarely tested. Certainly, art faculty don't lose their jobs if they haven't had a show or sold a work of art in many years.

"There aren't many in the faculty who have any real market for their work, or spend much time attempting to get their work in front of a larger audience," Brian Sikes said. "The circumscribed nature of their own careers is probably a point of embarrassment for them; they don't handle that embarrassment well and prefer not to talk about practical issues. In addition, as tenured faculty, they are shielded from really paying attention to these issues." Gary Justice, who alternates with Brian Sikes in teaching the "Career Issues in Art" course at the School of the Art Institute of Chicago, stated that the information he provides students "is reinforced somewhat by those faculty who are out in the world." Otherwise, many teachers are "uncomfortable with the subject of how to survive as an artist and with my course in general."

At most art schools, freshmen are led around in tour groups and shown where various departments and facilities are, including the career services office; at most schools, the directors of the career services office do not see these students again until they are seniors and close to graduation. "It's not unusual for a senior to come to me and say, 'Help. I don't know what I'm qualified to do,'" said Holly Lentz, director of career services at Moore College of Art. "The key is to get to sophomores and juniors, talking with them about what they can prepare themselves for." She seeks to accomplish this through outreach, arranging with faculty to go into the studio classes for brief presentations to the students about what the career office is and the types of information that students are likely to need in order to succeed. At some art schools, students are referred to the career office by faculty.

Those students who hear about career issues only in the survival course often require a considerable amount of persuading that certain professional practices and marketing skills actually matter. In some instances, students enter the class expecting to be taught the "trick" of becoming a success and are disappointed to learn that marketing their art and earning a living requires a lot of time and effort. "Getting the students to write a cover letter or a résumé is like pulling teeth," said Sue Belton, a painter who teaches the "Business Survival Skills" course at the School of the Museum of Fine Arts in Boston. "I've frequently heard from students, 'I don't have to know how to write a résumé. My gallery will do that for me.' I have to tell them again and again, 'No, you have to know how to do this. Your career is in your hands.'" The school supports the course information by publishing a free biweekly newsletter for students that lists and describes jobs and careers in the arts. However, Belton noted, "half the class may never read the newsletter or even know that it exists."

When the survival courses or workshops are led by someone in the career development office, rather than by a member of the art faculty—as they are at Parsons School of Design, Maryland Institute College of Art, School of the Art Institute of Chicago, and elsewhere—there is the possibility of friction between faculty and administration, resulting in very little reinforcement of the career information provided. Students themselves

may be apt to pay less attention to nonartist administrators talking about their careers than to the artist faculty, implicitly adopting (at least for the time being) the attitude that, if the artists aren't talking about this, it is not particularly important.

"It is a problem," Lisa Pines of Parsons School of Design noted. "The art faculty often doesn't augment or support what we say to students. There are a lot of people here from the old school of thought, who believe that artists should drive a cab or take a construction job. It's a 1950s macho idea that artists should have a hard life."

The equivocal attitude about survival courses may be seen at the Minneapolis College of Art and Design, where information about career issues—such as preparing a portfolio, writing a résumé and a grant proposal, finding a gallery or alternative space, finding an art-related job, and bookkeeping—is included in the Senior Seminar class. "Up until 1992, the class was much more introspective, dealing with the students' personal opinions about art," Heidi Dick said. "It didn't really connect to the outside world, and we heard a real outcry from students, 'How am I going to make a living?'"

The president of the college, John Slorp, however, holds a pessimistic view on survival courses and what they attempt to accomplish. "Trying to teach entrepreneurship to a young student is a very tough business," he stated. "That's not what they're interested in at this point in their lives; it's not what we should be spending a lot of time teaching them. In truth, you have to take your knocks in the world before you can begin to understand why any of this career information might be important."

Finding ways to interest students in career issues that may be far down the road for them is a problem that all supporters of survival skills classes and workshops acknowledge. "It certainly doesn't happen very often that a first semester sophomore comes to me and says, 'I want to know what will happen in my career,'" Liz Pointer, associate dean of students at California College of Arts and Crafts, said. "More likely, they'll start to ask when they're seniors and beginning to panic about what to do next. With our professional practices series, we tend to see a lot of alumni, who have had some experience in the world and know what they need."

There is a mix of approaches. On the one hand, the Maryland Institute College of Art has given muscle to its "Support Resources for Artists" course by scheduling periodic lectures and talks on career issues throughout the academic year, organizing a career day in which school alumni are brought in to discuss their own experiences with current students, and through an internship program that places students in arts organizations, museums, and artists' studios so that they learn facets of the art world.

A more typical approach to career assistance are workshops and seminars offered by a school's continuing education division or arts extension service. Much of the same information is offered as in the workshops or courses in the regular degree programs, but these events are usually scheduled in the evenings or on weekends, when alumni or artists in the community are more apt to take advantage of them. Pratt Institute's continuing education division of the School of Professional Studies, for instance, holds noncredit weekend classes that are largely attended by professional artists. Degree students may attend, and some do, but they are not the targeted audience. Perhaps, continuing

education is the only place within the academy that an art school administration or fac-
ulty is willing to accept career workshops as a part of an artist's education; perhaps it
reflects John Slorp's view that a survival course is more appropriate for those artists who
have been out in the world and are now ready for the practical information they need.

FIRST STEPS

What do fine artists do when they graduate art school? Teach? Sell their art? Win state
and federal grants and fellowships? Dream of better things while working in a compa-
ny's mailroom?

Certainly, they can keep each other company since there are so many of them.
According to the National Association of Schools of Art and Design, from July 1, 1998,
to June 30, 1999, 7,063 Bachelor of Fine Arts and 886 Master of Fine Arts degrees were
awarded to students. It is unlikely that the art market expanded to accommodate and
support this throng. It is even less likely that many, if any, of these graduates found
teaching positions, since (according to the College Art Association) schools in the mar-
ket for experienced artist-teachers received, on the average, 150–200 applications for
every job opening.

What degree-holding art students do right after completing school is not docu-
mented, although there are many anecdotal unhappy stories. While in school and cer-
tainly not long after, artists should begin to think about a second career. In effect, recent
graduates have two not-necessarily-related problems: The first is to earn a living, which
may be easier for younger people without children, spouses, or parents to support (per-
haps themselves supported by parents) than for those with dependent family members
and possibly student loans to repay; and the second is to begin building a track record
of exhibitions and eventual sales. Working at a job often takes artists away from their
art, sometimes permanently. Career advisors to artists have recommendations for first
steps after graduation.

Dan Poncholar, director of the Art Information Center in New York City, stated
that art school graduates need to "conduct a skills assessment for themselves, to see
what they are able to do and try to find a job in it." In some instances, the work artists
find has little relationship to their art interests. For instance, Poncholar's own first job
out of art school in 1961 was as a janitor "because there were no illustration jobs."
Eventually, he began to find work as a sign painter and a display artist, later teaching
courses to students at art schools.

Sooner or later, he noted, artists find a type of work that suits their style:
"Sculptors tend to be macho, and many of them do Sheetrocking or other physical kinds
of work. It may be physically exhausting, but you can do it mechanically and it's not a
drain on your creative energy. A job with set hours also gives you a steady income and
time to work on your own art."

While non-art-related jobs may not impinge on an artist's personal work, they do
take time, energy, and commitment if the job will be a long-term one. Can the belief in
oneself as an artist first and something else second last indefinitely? "Based on what I've

seen," said Susan Joy Sager, an artists' advisor, "five years after graduating art school, most people are not doing their art anymore." The commitment to a job makes Sunday painters of a lot of talented artists.

A job that does not somehow refer to one's art training may lead artists away from art permanently, according to artists' advisor Caroll Michels. "You hear people say, 'I'm going to take ten years and make some money so that I can be an artist.' The problem is, the further and further away they get from their art, the more likely they will feel out-of-it or too old and not have faith in themselves to want to start again."

She stated that one method of earning money in a setting that reflects one's art background is by working as an artist's assistant or apprentice. This work may involve everything from making coffee and mundane telephone calls to helping in the fabrication of major pieces. Certainly, starting-out artists are likely to see how an established artist operates both as a creator and a businessperson. This kind of relatively low-paying job, which may be obtained either by asking an art dealer about artists who might need an assistant or by contacting an artist directly, introduce young artists to collectors, critics, curators, and dealers who may be of use to them in later years.

Sue Viders, another advisor, also suggested that recent graduates consider working in an art gallery, "so that you can see what the public likes. Some people only want to paint for themselves and don't want to know what the public is interested in. Years later, after never selling any of their work, they begin to wonder, 'Well, what do people want anyway?'"

As opposed to a skills assessment, Michels recommended that artists conduct a self-assessment in order to determine the commitment to developing an art career: "Do I want to make a full-time living from the sale of my work, or do I want to work part-time and do art the rest of the time, or do I want to get a job and do my art on the side?" she said. "If they want to be artists full time, are they really willing to do all the administrative, business, and paperwork involved? That takes some soul-searching."

Artists' advisors generally suggest that young artists hire an advisor—or read one of the many business-of-art books on the market—in order to help them in their skills and personal assessments, setting them on a practical course for exhibiting and selling their artwork. However, most of them noted, it is rare that any of their clients are under 30; these artists have tried one thing or another, with little or no success on their own, and have finally decided to get help. According to Po Lowenberg, an advisor, those years of fumbling are a crucial part of the maturation process for many artists as they learn to know themselves.

"People right out of art school are usually not fully formed personally or as artists," she said. "People in their twenties are very idealistic, and the idea of security or long-term planning isn't very important to them. Someone right out of school may not be ready for the kind of help I could provide."

In truth, few art schools do much, if anything, to ready their students for life or career after graduation, such as offering business-of-art courses or workshops. Many art students spend their last year at school preparing for a senior or masters show, and the issue of what they will do next may not arise until after they have left school.

Noting that artists need to be made aware of what comes next before they graduate, Lowenberg recommended that art students take business courses, learning computer skills, fundraising, or computer graphics, that would help them stay financially afloat. Sue Viders offered the idea that students should "maybe get a minor in business. Otherwise, they're lost souls." Most artists' advisors offer similar advice.

"Whether you like it or not, an artist is a businessperson," said advisor Calvin Goodman. "Just as any other small businessperson, the artist makes a product, offers it to the public, inventories it, reports sales of it to the government. Artists need to learn about accounting, advertising, public relations, and selling, and it is wise to take a class or two in these areas."

Many artists, Goodman noted, steadfastly maintain the belief that, if they can find a gallery or dealer to represent their work, they needn't concern themselves with business concerns again. In actuality, most galleries do very little for the artists whose works they carry, and both dealers and galleries primarily look for artists who already have an established and growing market.

"Most artists right out of school are not ready for dealers, and dealers aren't ready for them," Goodman said. He recommended that starting-out artists look into street art fairs ("a low investment way to get exposure for one's art") and juried art competitions ("publishers look for new artists in juried shows") to find buyers for their work.

Artists' advisors generally take a broad view toward helping their clients promote and market their art, which may include shaping how artists present themselves to collectors and dealers and speak about their work as well as even what kind of work the artists should produce. "Some artists want to construct huge installation or politically-charged pieces, and that's fine for trend-setting nonprofit spaces and museums," said artists' advisor Katharine T. Carter. "I generally try to steer artists to making art that is more practical for marketing purposes—the kinds of work that real people who live in real homes would be more likely to want. A lot of those people don't want to spend thousands of dollars for a painting or sculpture, but they might be willing to spend $200–$400 for a print of the same image, so I might try to steer an artist toward creating multiples."

Learning business and other skills helps equip artists to market their own work as well as find employment, either full time or part time, somewhere else. Part-time and freelance work is frequently attractive to artists who want to set aside time for their art-making. Commercial art activities, such as illustration for books and magazine articles or design and layout for publishers, draw upon an artist's basic technical (how to communicate) and theoretical (how images are perceived psychologically) training, although fine artists may need to undertake some additional study in order to hone specific skills and prepare a portfolio.

Eva Doman Bruck, an advisor, said that artists come to her after "they have found that being a fine artist is too lonesome or doesn't pay the bills, and they want some practical application for their art skills." She suggested that artists learn several basic computer programs, such as Quark (for layout and typeface design in desktop publishing),

Photoshop (for image creation and manipulation), Illustrator (for drawing on the computer), Macromedia Director (for CD-ROM and interactive media production), and even Softimage (for animation).

Along with developing technical skills, fine artists planning to freelance in the commercial art field will need to learn how to negotiate rights, terms and fees, the appropriate directories in which to advertise one's work—such as *Art Directors Annual, Creative Blackbook, Chicago Talent, Graphic Artists Guild Directory, Society of Illustrators Annual, RSVP, LA Workbook, ASMP* (photographers) and *AIGA Annual* (designers)—as well as which employment agencies to use, how to present oneself and one's work to an art director, how to locate an agent, and the general terminology of the commercial art field (such as complete or limited buyout, exclusivity, licensing, and subsidiary rights). Try as they might, artists cannot get away from the business of being an artist.

Jobs related or unrelated to art may lead artists away from their own work unless they stay in contact with other artists and the art world in general. Susan Joy Sager recommended that they join a local, state, or national artists' club or society or association, which builds a network with others. Many of these groups also send out newsletters, providing information on exhibition opportunities and other artist news. Subscribing to an arts magazine, teaching art at a local arts center on weekends, and even taking a class through the local adult education program ("they don't cost much, and you get to use expensive equipment," she noted) also helps keep you involved. "Another idea is to move into an artists' studio building," Sager said, "which is a built-in community of artists. Even if you have a paycheck job, you still have art-making going on around you, and that tends to push people to keep doing their own artwork. Otherwise, it can be very hard to work alone in your apartment."

Being an artist means developing careers on two tracks: The first is finding a paying job, and the second is creating a presence in the art world. In time, perhaps, the art may become the entire source of income or art sales may supplement an income; for some, the job and the artwork may be so closely related that the two tracks do not seem disparate activities.

The meaning of "career" and "work" has changed dramatically over the past two decades, and more people in all fields are working in the manner of artists. One sees people working at more than one job, working at home part or full time, creating their own benefit plans (health insurance and pensions, for example), and defining their own hours, rather than relying on a single employer for everything. The view of the employer providing a lifetime's job path and income dates from the 1930s and has become increasingly out of step with the present-day world of people switching from one company to another, regularly changing their careers, losing their jobs as part of downsizing, losing benefits as a company's cost-cutting efforts, working part of the time at home through their computers, demanding flextime, leaving corporate jobs to consult or start up their own businesses, leaving a job to start a business and returning to the corporate world in a different capacity. Artists have long needed to juggle various forms of income and separate activities; their success depends on understanding that they have mar-

ketable skills, on visualizing what they can do with these talents, and on recognizing that they can learn other skills or get assistance in achieving their goals and that their circumstances are the same as virtually everyone else in the country.

APPRENTICING AND INTERNSHIPS

Catching the eye of a noted critic or meeting people at art openings or other social gatherings are ways to make contact with the larger art world. Another way is to work alongside artists, dealers, or museum curators in some professional capacity. In addition to meeting important people, this can provide an opportunity to learn how the art market operates, how to set up a studio or prepare a portfolio, how to write a grant proposal, where to purchase different kinds of art materials, and generally how to approach the business of being an artist in a professional manner.

Graduating art school often comes as a slap in the face to young artists. Usually departing without a plan for how to pursue a career as an artist, students leave behind a world in which they had free studio space and use of expensive equipment, time to develop their art, fellow students with whom to share ideas regularly and professional artists-instructors who paid serious attention to them. They enter a world of high rents, small apartments, and low-paying jobs that may have little relationship to their skills. Professional artists they encounter may have little interest in, or time to spare for, a mentor relationship, and fellow starting-out artists are only likely to offer their own tough-luck tales, of not knowing how to meet the right people, of wanting a better-paying job, of having little time or space in which to create their art.

Getting started as an artist is perhaps the most difficult problem art school graduates face. One possibility that offers some rewards—and perhaps a drawback here or there—is to work as an assistant or apprentice to a professional artist. Working for an established artist enables young artists to learn both technical skills (how to paint or sculpt or make prints in a particular manner, how to use certain tools or machinery) and career lessons (how to bargain with a dealer, how to apply for a grant, how to organize one's time and inventory). Assistants are also able to meet collectors, critics, dealers, and other artists—fellow apprentices as well as colleagues of their employer—as well as to create art (albeit someone else's) every day in a professional studio. In other words, it can mean a foot in the door of the art world.

Becoming an artist's assistant is generally not something done by answering an advertisement in the newspaper. Art dealers could be contacted, since they tend to know which, if any, of their artists may be looking for an assistant; and gallery openings provide opportunities to meet these artists. The pay is often not high (starting salaries are not far removed from minimum wage), health insurance is a rarity, and the turnover is sizable, which indicates both that opportunities are never long in coming and that this is not a career for everyone. Frequently, the work is more menial than artistic, such as cleaning the studio, crating work, and making telephone calls to suppliers or movers; and one's artistic input is only permitted within certain narrow parameters. Christo, for instance, sometimes uses hundreds of assistants on his major projects who, according to

his wife and collaborator, Jeanne-Claude, "are not hired as artists but as workers. We generally need people to carry heavy things." Christo's workers are paid 25 cents above minimum wage and, provided workers' compensation but no medical insurance coverage. She added that the people working under Christo learn that "art is not easy. Your knees are bruised, hands are bleeding, backs in pain. People also learn to be persistent, generous and not to give up. They learn that by example."

Some of today's more renowned artists have groups of people working regularly with them, often acting as personal secretaries (answering the telephone, making appointments, etc.) and occasionally working directly on the work of art itself. One artist's assistant, who worked for Julian Schnabel and previously for Richard Haas, noted that he "schedules appointments, books reservations and, if needed, will strip down and model."

Most people who work as artists' assistants are in their early to mid-twenties, staying for between a few months and five, six, or even ten years. They generally obtain these jobs through recommendation, such as from an artist's dealer or another professional artist, although some art schools place their students in an artist's studio as part of their degree program. The Great Lakes Colleges Association, a consortium of schools in the Midwest, arranged in the early 1960s for sophomore painting major Walter Hatke to apprentice in Jack Beal's New York City studio for a semester. "It was the first time I ever lived and worked in New York," Hatke said. "It was the watershed period of my life. I was around other artists, like Red Grooms, Al Held, Lee Bontecou. Jack and his wife, Sondra, were such gregarious personalities and were always being visited by artists whom I had only read about in art magazines. I remember visiting Al Held's studio. He had a really huge studio. Jack, Sondra, and I were walking past the building one night and we saw the light on. Jack yelled from the street, 'Hey, Al,' until he heard and let us up."

At other times, artists may be approached directly about taking on an assistant. Nicholas Maravell, a painter who worked for Alex Katz from 1978 to 1987, had a brief conversation with the artist during a break in a seminar at New York's School of Visual Arts. "I asked him if he needed an assistant," Maravell stated. "He took my name down on a piece of paper, but I didn't really expect to hear from him. I thought he was just being polite, but he called two days later and offered me a job."

Over the years, artists like Jack Beal and Alex Katz have seen scores of young assistants come and go. These assistants may have learned a lot or a little, and what they learned may have helped them develop their own professional careers as working artists or it may have been the closest they ever came to this career. Only rarely do these and other artists know what became of their former assistants, which suggests that making and using contacts to further one's career is only a slight possibility. Apprenticeship is clearly not a ticket to success; rather, artists' assistants need to both help the artist—the job they were hired for—and learn by the artist's example, identifying which factors enable the artist to achieve success both in a work of art and in a career.

Those lessons may be varied. Nicholas Maravell claimed that he learned about "the process of painting more than how to paint. I saw all the steps Alex took from the

initial drawing to the final painting, and I learned a professional attitude: How to con-centrate on your work, putting aside other distractions." Dana Van Horn, a painter in Philadelphia who worked for Jack Beal from 1975 to 1983, stated that he was able to learn what, for an artist, makes for a good art dealer ("a long-term commitment by the dealer to the artist without worrying whether the gallery is making a profit") and what kinds of dealers to avoid ("people who whine, or don't tell you what they think of your art, or don't understand your art to begin with").

Jonathan Williams, who has worked off and on for Richard Haas since 1976 and for Frank Stella from 1988 to 1991, noted that, from Haas, "I learned how to draw, how to drink and everything in between, including a few vices." For both he and Robert Franca, who worked for Haas from 1984 to 1989, the majority of their paying work now comes from painting scenery for television and motion pictures, a type of artwork that is not far removed from the *trompe l'oeil* architectural murals that Haas is commissioned to create.

Franca stated that, in addition to picking up a lot of mural techniques from Haas, he also learned "how to work quickly in broad areas, for commission. I learned how to meet a deadline, how to get hired." He added that working for a well-known artist also has significant résumé value, noting that, "for those who know Dick's [Haas] work, telling them that I worked on this or that piece has been very helpful in getting commissions."

As well as working directly with an artist, you can take on an internship with an art dealer or nonprofit art center (running the gamut from alternative spaces to major museums), although this tends to be as much a career path for a future dealer or student of arts management as for an artist. One of the fastest ways to find out which organiza-tions have internship programs is to ask, by writing or calling, and then apply, with a résumé and cover letter, following up with a telephone call to arrange an interview. The National Network for Artist Placement (935 West Avenue 37, Los Angeles, CA 90065, tel. 213-222-4035) also publishes a *National Directory of Arts Internships* (Warren Christensen, ed.; $35), which lists programs of this sort at small and large arts organi-zations around the country.

Artists might contact state and local arts agencies, which sometimes keep listings of, and sometimes just hear about, job openings at cultural organizations and institu-tions. Another way to learn about potential positions in the arts field is through publi-cations that list available jobs, such as *Artjob* (WESTAF, 236 Montezuma Avenue, Santa Fe, NM 87501, tel. 505-988-1166, $30 for six monthly issues), *Artsearch* (355 Lexington Avenue, New York, NY 10017, tel. 212-697-5230, $54 for 24 issues), *Current Jobs in the Arts* (P.O. Box 40550, Washington, D.C. 20016, tel. 703-506-4400, $19 for three month-ly issues), and Artswire *(www.artswire.org/current/jobs.html)*. In addition, Artlinks (P.O. Box 223, Berkeley, CA 94701, tel. 510-528-2668) and DC Art/Works (410 Eighth Street, N.W., Washington, DC 20004, tel. 202-727-3412) act as employment agencies for jobs in the art world.

An internship is a useful way for artists to learn about the art world and support themselves while continuing to do their artwork. Many artists have some museum or art space experience on their résumés, regardless of their later renown. Conceptual artist Sol Lewitt, for instance, worked for a time as a museum guard at New York City's Museum of Modern Art. Painter Howardena Pindell lasted longer than Lewitt, working in various curatorial capacities in the Department of Prints and Illustrated Books at the Museum of Modern Art for twelve years, before she finally left to devote more time to her own art (she also teaches at the State University of New York at Stony Brook).

Being an employee of the museum had previously tainted relations with the dealers Pindell approached. "A lot of their actions seemed to say, 'I'm only looking at your work because you're with the museum, and I want you to help me out there,'" she said. "There was a sigh of relief by a lot of people when I left that 'she's finally out of there.' People would say to me after I left the museum, 'Gee, your work has gotten better,' when they had actually seen the same painting two or three years earlier."

There are some hazards to working for an arts institution or with a successful artist, as many artists have discovered.

Pindell found that her life became more coherent after quitting the Museum of Modern Art. She no longer worked days at one full-time job and nights and weekends at her painting, maintaining two separate résumés, neither of which referred to the life she led in the other. In addition, Pindell found that artistic expression was not wanted in the curatorial realm.

"The best thing that has happened for me since leaving the museum is that no one says to me now that I must be speaking for the university when I have something to say," Pindell stated. "Back then, it was assumed that I spoke for the museum, which was nonsense. There is academic freedom, and there isn't curatorial freedom. There may be people at the university who despise me, who don't believe in cultural diversity or equality for women, but the stance of the university is diversity of opinion, and what I say is protected. I'm also tenured and my job is protected. At the museum, your job isn't protected, and you have to present a corporate front, which controls the way you speak, the way you look, and your politics."

Working for an artist may also stunt one's development. One painter who has worked for Frank Stella ("mostly paperwork") over the period of a few years, complained of feeling "pressure when I do my own artwork. You are so exposed to someone else's sensibility that you can become stymied. Stella's works are so supported by the art business world that my own starts to seem so insignificant." She added that "people who work with Stella have largely stopped doing their own art. It's hard knowing how to deal with these problems."

It is frequently the case that assistants learn how to assist a noted artist all too well, as their own artwork comes to resemble that of their artist-employer, and it requires a break in the relationship for the assistants to fully emerge as expressive artists in their own right. That problem is to be expected in some degree, as it is the job of the assistant who works directly on the artwork to "get into the artists' minds, figure out what the

artists are after, what they mean to do, in their work," Williams noted. Walter Hatke also stated that his job was "to learn to paint in such a manner that what I did would pass, for all intents and purposes, as a Jack Beal." After a full day of adopting a specific style or approach to painting, it is likely to be difficult to settle down to one's own artwork. All artists' assistants need to keep in mind what their role is, which is not self-expression but carrying out another artist's plans.

"One of the main things I look for in an assistant is, Can I work with that person vis-à-vis his or her ego?" Richard Haas said. "If someone's ego becomes a problem, it leads to tensions and a bad experience. There have been many instances over the years where mistakes were made in hiring assistants. The person had a personality flaw that led to a conflict where parting was not sweet—sometimes, the parting involved lawyers, once a cop."

However, tensions aren't only a result of assistants who want the final artwork to look different, Haas noted. "Where the assistant's work is too close stylistically to mine, there can be tensions. I don't encourage people to copy me—the opposite is true—because someone else doing your thing isn't flattering or comfortable. What I really want is an artist whose own talents challenge me, whose ideas are fresh and interesting, not derivative."

Haas's expectations can be a very tall order: An assistant who can ultimately work in his style yet brings new ideas that can be subsumed into Haas's art without a conflict of artistic egos. Perhaps, this is the reason that most assistants do not stay very long with a particular artist. "As I matured," Williams said, "I didn't want to give my ideas away anymore. I wanted to save my ideas and my techniques for my own work."

Also, the more established an artist is, the less likely he or she will want an ongoing turnover of assistants, each of whom stays a year or two or less. "It takes a couple of years in order to get an assistant to do his work efficiently," Alex Katz said. "I like it when they stay around five or six years. I lose time and money with kids right out of art school who leave as soon as they're trained. The younger ones also destroy a lot of things because of their lack of experience, and that costs me money, too."

Philip Grausman, a sculptor in Washington, Connecticut, who has used apprentices since the late 1970s, noted that it is rare for an assistant to stay as long as two years. "With only a few of them have I ever gotten anything back on my investment in time and materials," he stated. He added that his expectations for his largely short-term assistants are limited. "I have to design my pieces for the skills of the particular people who work for me, breaking down each process into very small steps." The final artworks are "maybe a little different than if I had done it all myself" and, because he has lost patience with apprentices who aren't "serious or committed," Grausman has decided to rely increasingly on foundries for help in fabrication.

He added that apprentices sometimes become very "possessive of specific work they've done. I'll come in later and take it all apart, and they get very upset. They don't understand their role here."

Whether or not it is realistic to expect that young artists will be willing to devote themselves selflessly for many years to the production schedules of established artists is uncertain. However, it is likely that the interest of established artists in stability and the desire of their younger apprentices to strike out on their own will collide regularly and create tensions.

In addition, while the established artists are inevitably getting older, their short-term apprentices are forever in their early twenties, which may lessen the ability of both sides to communicate effectively. Richard Haas, for instance, noted dryly that "I have better conversations with people who are older," and Alex Katz flatly stated that "I don't talk much with my assistants." Jonathan Williams's experience of Frank Stella also did not include much conversation other than shop talk. "Everything that mattered with Stella was the work at hand, and we really didn't talk about anything else," Williams said. "I don't remember him ever asking me much about myself."

Certainly, there are risks in asking an assistant personal questions, for instance, that the action may be reciprocated; and established artists may prefer that their employees not know potentially compromising information about themselves. Perhaps a reason that relationships may not become personal is that certain jobs assigned to an assistant are contrary to friendship, such as sweeping the floor. Younger artists may assume they will have a more intense, even collegial, relationship with the artists for whom they are working than in a traditional employer-employee situation, and those upset expectations may lead to tensions in the studio.

"Once upon a time, I had an apprentice," sculptor William King said, "but there were days when there was nothing for him to do. I asked him to clean up the shop, and he didn't want to do that. He was a budding artist, not a janitor." King added that he does not recommend working as an apprentice to younger artists. "You have to get out on your own and find out things for yourself. If you have anything to do with other artists, do it as a peer, not as an underling."

Another assumption that younger artists may have, especially those who work three-dimensionally, is that they will be able to use the tools and machinery in the established artist's studio for their own work. Sometimes, the artist will permit it; sometimes not. Some artists will charge an hourly rate for using studio machinery or allow only certain, long-term assistants to use it. This issue, and a number of other hopes on the part of the would-be apprentice, should be discussed before the young artist agrees to work in the studio.

Many assistants also discover that there are drawbacks to becoming closely identified with another artist. "An apprentice's work may not be taken so seriously," Dana Van Horn stated. "If there is any resemblance in the work, it is the kiss of death for the apprentice." Jack Beal also pointed out that, "when you take artists away from their own work for too long, the experience proves too influential on their own work and careers. I tell every apprentice to get all they can from me and then move on."

Developing one's own artistic voice, and generating the energy to create one's own art, however, may begin to seem futile for artists' assistants when confronted with daily

reminders of how sought after an employer's artwork is. If working for an artist is con-
ceived as a means of establishing a career as an artist, artists' assistants should stay
alert to signs that their apprenticeship may have lasted too long and is becoming an
obstacle to their careers. One who recognized that possibility was Constantin Brancusi,
the Romanian-born sculptor who left Rodin's studio saying "Nothing will ever grow in
the shade of a big tree."

The artists' assistants of today are far different from the journeymen apprentices
of the Middle Ages or Renaissance. Then, the relationship between master artist and
apprentice was that of teacher and pupil, and young hopefuls were contracted out to
artists for specified periods of time, doing certain duties in exchange for instruction. Often,
these duties included helping the artist complete a piece. One began as an apprentice,
became a journeyman, and then a master, in turn. The studio of Peter Paul Rubens, for
example, had such promising apprentices as Anthony van Dyck and Franz Snyders,
who worked directly on the master's paintings.

By the seventeenth century, the officially recognized art academies in Europe
spelled the end of the guild system, although apprentice-type conditions lingered on, if
in different form. Academies were the creation of artists who wanted their profession
elevated into something higher than artisan; they brought more structured art schools
into existence. With the advent of Romanticism, greater emphasis was placed on indi-
vidual style and working alone. Being able to do the same kind of art as one of the great
masters was no longer highly regarded, as distinctiveness became the predominant
artistic virtue.

Still, the master-disciple relationship continued in various forms and exists today.
Eugene Delacroix, often considered the father of Romanticism in painting, worked with
several apprentices (most of whom are not household names) as did classicist Jacques
Louis David, who taught such notable talents as Baron Antoine-Jean Gros, Jean-
Auguste-Dominique Ingres, and Theodore Gericault. Jackson Pollock, one of the most
original artists of the twentieth century, worked first with Thomas Hart Benton in some-
thing like an apprenticeship, and later with Mexican revolutionary muralist David
Alfaro Siqueiros. Pollock learned much about painting from both artists and made con-
tacts that helped him later on.

An artist who has assistants and "fabricators" is more and more the norm.
Sculptor Henry Moore made small models and handed them to others to turn into large
pieces. Andy Warhol had what he called "the factory," from which works that ultimate-
ly bore his signature emerged. Red Grooms's family and friends helped him out. Art is
very much the process of doing it and not solely the conception in the artist's own mind,
but the complicated processes of creating works and being a successful artist these days
lead many artists to look for assistance from others.

While most, if not all, of the young artists who go to work as assistants look to
achieve similar professional and financial standing as the established artists they work
for, the number who will actually arrive at this point (or even set up their own studios)
is small. Some assistants find that their career has become helping artists with their

work, perhaps working at a sculpture foundry or print studio (where many artists bring their projects, looking for help in technical areas), or sticking with a particular artist for a very long period of time. Robin Roi, who has worked since 1983 for Jeff Green, owner of the New York City–based Evergreen Studios, which is commissioned to paint murals in homes and commercial spaces, stated that establishing an independent art career involves "a lot of networking, meeting dealers and other artists, and you need to have your life being about networking and meeting people. Right now, my life is about my family and raising two small children. I need the steady paycheck more than I want the insecurity of trying to be a full-time artist. What I do at Evergreen is very connected to my own style, and I try to impart my ideas to the work."

Roi did pursue an independent art career, selling paintings through a noted New York City gallery for a number of years before becoming an artists' assistant. Joel Meisner, on the other hand, never got around to creating his own artwork at all. Not long after he received his Masters of Fine Arts from Columbia University in 1960, Meisner got married, needing to support a wife and, soon afterwards, a child. By chance, he happened to read in a magazine that the assistant to Jacques Lipchitz (the Lithuanian-born School of Paris sculptor who had been living in New York City since 1941) recently had been drafted into the army, and Meisner called the 70-year-old sculptor to ask for the job.

Lipchitz was not overly encouraging toward Meisner's own artwork, setting aside the younger man's portfolio and saying, "You should go to museums more and try not to invent things that have already been invented," but he gave him the job. Meisner helped Lipchitz make enlargements from the artist's maquettes as well as restored models as they came out of the foundries. Meisner's work with Lipchitz had nothing to do with the design but with seeing that foundries Lipchitz used made the sculpture editions properly. In time, Meisner's expertise became foundry work.

"The problem that Lipchitz had with foundries was that the nuances of his work were being lost," he stated. "He was always retouching the waxes. Over time, I developed a process that helped duplicate the nuances, the fingerprints (as it were) of the sculpture."

Meisner called working for Lipchitz "the best thing that ever happened to me. I found that foundry work was something I really could do and do well. I rededicated my life to founding other people's art. I made a judgment on my own work, that maybe I'm really not that good but that I could use my understanding of art to help other artists. I also realized that I could frankly make a better living at foundry work than trying to sell art that I could make."

Shortly after starting work with Lipchitz, Meisner convinced a commercial foundry in Long Island, New York, to let him establish an artist's foundry section. "What really opened the door for me," he stated, "was telling the foundry owner that I was Lipchitz's assistant." In 1973, Meisner bought the entire foundry, renaming it the Joel Meisner Foundry, which currently works with scores of artists all over the country.

Artists' Assistants and the IRS

Sometimes, gray areas are gray because no one wants them any other color. Take the issue of artists' assistants, for instance: Are they the artists' employees, or are they "independent contractors"? There are reasons why artists may want them to be a little bit of both.

Many employers, including artists, prefer to forgo the paperwork and payment of employee taxes (withholding, unemployment insurance, and social security, among others) by labeling those who work for them independent contractors. The IRS simply needs to receive a 1099 tax form from the employer for the independent contractor, listing the amount paid to that person, who is otherwise responsible for reporting his or her own income and paying estimated taxes on that amount.

Attempting to make the issue of who is an employee more black-and-white is the Internal Revenue Service, which initiated a drive in 1995 to collect unpaid taxes from employers in all sectors of the economy for independent contractors who are actually salaried employees. "There has been concern for some time about compliance with IRS guidelines," said Ken Hubenak, a spokesman for the federal agency. "Some employers aren't withholding taxes as they should, and some aren't even filing 1099s for the people they claim are independent contractors."

For artists, the IRS action has meant that they must establish a new relationship with their assistants, one that involves more structure and accountability than the traditional flow of artistic help in and out of their studios. "The IRS wants to make everyone who works for me employees," said painter Tom Wesselman. "To my mind, all those who work for me are independent artists, who work out of their own studios as well as in my studio. They have their own income apart from me and deduct the costs of their own materials and studios. The IRS is causing complications for me and for a lot of other artists who hire assistants."

Rubin Gorewitz, a New York accountant who frequently handles the financial affairs of artists, also noted that "an artist's studio isn't like General Motors or AT&T. The people working in the studio are more involved specifically in the arts and are hired for their aesthetic sense, which they pursue in their own art." He added that, increasingly, "I tell artists to hire a business manager who will be in charge of the employees and who can see that things get done so that the artists can do their own work."

Accountants for a number of major artists have been busy readjusting the payroll taxes for the assistants their clients employ. One who came into conflict with the IRS over the issue of independent contractor versus employee was Seattle glassmaker Dale Chihuly. Another, who shifted accounting procedures in advance of an audit, is Arman, the New York sculptor. "We used to treat these assistants as independent contractors, but then we saw the writing on the wall," said Arman's accountant, Kenneth Goldglit, "and we changed them to employees."

While some artists prefer not to pay taxes for their assistants by calling them independent contractors, their assistants may have a legal basis to be considered joint authors of the artists' work if they were involved directly with the finished pieces, a right that employees do not have. That joint authorship would depend upon the degree to which the

assistant could prove that his or her original ideas and decision making is part of the final work, according to Joshua Kaufman, a Washington, D.C. lawyer. "Employees, on the other hand, have no claims to copyright ownership," he said. "Artists would rather their assistants be independent contractors for tax purposes, but prefer them to be employees for the purposes of retaining copyright," he said.

A number of lawsuits have been brought by former assistants against the artists for whom they worked for joint copyright ownership of works, but they have all been settled out of court. Proving that one has made a significant contribution to another artist's work is not a simple process, "as it is usually only the artist and the assistant who knows who did what, and ego gets in the way," Kaufman said. "If I say to an assistant, 'finish the sky in my painting,' that person might be able to make a good case for being a joint author, but if I say, 'do this area here just as I blocked it out,' joint authorship becomes more difficult to establish."

Kaufman, who in 1989 successfully argued before the United States Supreme Court the right of sculptor James Earl Reid to claim copyright ownership of a work that a nonprofit group had commissioned him to create, noted that employers should require assistants whom they hire as independent contractors to waive all claims to copyright for all works created during the period of their relationship.

It is not uncommon for certain artists to have a large number of assistants in their employ. The complexity of the process involved in sculpture and printmaking, for example, often requires artists to hire others to perform certain technical tasks, from creating maquettes and inking printing plates to ordering materials and supervising foundry work. Other artists' assistants may work in bookkeeping, clerical, or marketing positions; and often the tasks demanded depend upon what is needed to be done on a particular day. Artists with very high volume sales sometimes seem like the presidents of small companies, with office managers and department heads overseeing a variety of activities. Peter Max, for instance, has separate retail and wholesale marketing staffs as well as two publicists, a receptionist, and assistants performing various other functions, adding up to more than thirty-five employees. Many of these employees have voice mail. Robert Rauschenberg employs more than a dozen people in his studios in New York City and Captiva Island, Florida. Dale Chihuly has between fifteen and twenty employees, among them a comptroller, several bookkeepers, publicists, sales staff, and others who assist this partially blind artist create his work.

The IRS developed a list of twenty criteria for establishing whether someone is actually an independent contractor or an employee. An independent contractor, for instance, may be defined as someone who determines his or her own hours, hires his or her own assistants, decides how a particular job is to be performed, and supplies all materials necessary to complete the work. On the other hand, an employee is under the control and direction of the employer, given specific instructions on how the work is to be done, with set wages and fixed hours at the employer's work site. A dozen or so criteria, many of them virtually the same, determine who is an independent contractor and who an employee in questions of copyright ownership.

The rules for deciding whether or not an assistant is an actual employee are clear, Kenneth Goldglit said, "and the amount of taxes an artist will have to pay are really not all that significant. These are normal costs of any business. If the artist earns enough to hire an assistant, he's making enough to pay the taxes on that person. And, if the artist can produce more works because of the assistant's help, then he'll have more to sell and make more money."

FINDING A JOB AS AN ART TEACHER

Clearly, the decision whether or not to obtain an art degree on the bachelor's or master's level is not an economic one. Many college students believe, however, that the MFA is the road to a teaching position at a college or university, where salaries are better than what most artists are able to earn by selling their work. They imagine only a few hours per week of required teaching with the remaining time open for art making. It is true that most art instructors have that degree and that few art schools or departments will hire someone to be an instructor without an MFA. However, there are so many MFAs around these days—more than sixty-eight for each available teaching position at the college or university level, according to a survey conducted by the College Art Association—that the teaching prospects for an art student today are poor at best.

The 68-to-1 ratio may not sound hopeful to most artists, but it is better than the situation at Yale University School of Art in New Haven, where 200–300 applications come in for each available job, or at Pratt Institute in Brooklyn, where, according to Mel Alexenberg, chairman of the fine arts department, "we may save one résumé out of a hundred. We never really hire anyone unless someone on our faculty knows the person." About half of all college art teaching positions are fixed term, or non-tenure track, and the artist will soon have to look elsewhere for employment.

The Pratt Institute may embody the dilemma facing artists. The school gives out more MFA degrees—500 a year—than any other institution in the country, yet it would be unlikely to hire any teachers unless they were "at least ten years out of school" and "had gone out into the world and made it as artists" while "gaining teaching experience" somewhere along the way, Alexenberg said.

The prospects for teaching are not wholly dire for artists. Moving away from Modernist canons of art, most schools are looking to maintain a wide range of styles and artistic ideas—from realistic to conceptual—in their departments, and they are also increasingly hiring women and members of minority groups for teaching positions.

The College Art Association has also found an increase in non-university teaching jobs for artists, such as at museums and nonprofit arts centers, as well as teaching opportunities at less prestigious institutions, including junior colleges, summer retreats (art camps, cruise line art classes), senior citizen centers, Veterans Administration hospitals, and YMCAs. One finds these jobs through contacting the individual institutions, as each has its own areas of availability and budgets.

Another growing area of hiring for art teachers, according to the National Art Education Association, is the nation's public schools, where twenty-nine state boards of

education across the country now require high school students to take at least one art course in order to graduate—a requirement that did not exist before 1980. In addition, 58 percent of the country's elementary schools have full- or part-time art teachers, a substantial increase since the early 1980s. Approximately 50,700 public school art teachers work in the nation's 15,600 school districts, with a turnover rate of between 2 and 5 percent, or between 400 and 1,000 jobs, a year. These jobs, however, are available only to those holding state teaching licenses or certification (or both), and requirements differ from school to school or from district to district. Nowhere is the road to relevant employment easy for artists.

Private schools, which must be contacted individually, do not have the same requirements for teachers and may be worth pursuing. Charter schools, on the other hand, while frequently emphasizing the arts more than many traditional public schools, are still public schools and have the same state licensing mandates for their teachers. While a source of potential employment, professional artists generally do not arise out of the faculty of private and public primary or secondary schools; perhaps, the reason has been that career-minded artists historically have not pursued this avenue as an art-related career option. Another factor is that K–12 art projects focus on the product— something to have finished in 50 minutes to bring home to show the parents that day—rather than on process, the slow development of skills and experimentation with materials. Where school art classes are more than once a week, such as at certain charter schools, there may be an opportunity for real art teaching and art making, but those who are committed to serious teaching or who want to be accorded respect as professional artists will likely feel more comfortable at the college or university level.

An additional concern for artists who teach in public and private schools is the fact that they may be placed in the position of censoring the work that their students create. The National Art Education Association discourages any form of censorship in a policy statement: "The art educator should impress upon students the vital importance of freedom of expression as a basic premise in a free and democratic society and urge students to guard against any efforts to limit or curtail that freedom." However, as a practical matter, students' work is regularly censored (not hung up in the classroom, not submissible for classroom assignments and grading). Bruce Bowman, a public high school art teacher in the process of completing a doctorate in art education from the University of Georgia, conducted a formal survey of art teachers in Georgia in which he found that drug, gang, racist, or sacrilegious imagery, as well as artwork depicting sexual acts, gambling, obscene gestures, nudity, and violence, were often censored by teachers. The reasons for this action ranged from "it challenged school policy," "it disturbed the class," "it offends the general public," and "it celebrated illegal actions" to "parents complained" and it was "produced just to shock."

Clearly, there is a wide disparity between what the National Art Education Association claims as a right and how art teachers must operate in the school system. Even outside the school system, K–12 art teachers who exhibit their work may realistically worry that their own potentially offensive imagery results in increased scrutiny of

their classrooms or even dismissal. Faculty whose training is primarily in education rather than studio art may find the issue of censorship far less worrisome. There is less overt censorship of students' work at the college level or even at community art schools, but it still occurs, which may place teachers in a very uncomfortable position.

ART SCHOOLS AND CONTROVERSIAL ART

In our post-Duchampian world, art can be anything the artist calls "art," and it is generally seen by supporters and detractors alike as a free-for-all. Perhaps nowhere is it as free as in art schools and university art programs, where student work is not inhibited by the perceived interests and tastes of the marketplace. Students try out different materials, media, styles, theories, and personas in order to discover what affect their work produces; along the way, they may "push the envelope," "transgress," or otherwise seek to shock their fellow students and instructors with or without a definite goal in mind. Everyone has a right to be young.

With few exceptions, studio art faculty generally try to facilitate that experimentation, offering technical advice and critical perspective rather than directives for what students should or shouldn't do. "Freedom of expression and inquiry must be supported and protected," reads a section of the code of ethics of the College Art Association, and one would be hard-pressed to find a studio art faculty member or college administrator who would disagree. No one supports outright censorship, but art as a free-for-all sometimes creates considerable controversy either within the school or from outside groups, which often catches both faculty and administrators unprepared.

After two controversial student exhibitions in the late 1980s at the School of the Art Institute of Chicago—one featuring a portrait of then Mayor Harold Washington wearing lingerie by David Nelson (resulting in thirty-seven bomb threats and the work being confiscated by several African-American city council members) and the other including an American flag on the floor that visitors were invited to step on by Dread Scott Tyler—"the school developed a culture of paranoia," said Joyce Fernandez, the director of exhibitions and events at the school from 1983 to 1993. "Any kind of publicity became the subject of intense scrutiny." During the flag show, she found herself stalked by men in militia uniform, blamed personally for the work by visitors to the gallery, and arrested after she put the flag back on the floor after an Illinois state senator picked it up and stapled it to a flag pole ("the school's lawyer told me I should drive carefully until the arrest was cleared up," she said). Fernandez noted that it took her several years to overcome the trauma of the experience of working at the art school. During her most harried days at the School of the Art Institute, she "went to work worrying about what would go wrong today."

In large measure, the loudest complaints about what goes in both art schools and university art programs is directed at the student exhibitions. Some schools have tried to protect the public more by putting up signs that warn visitors of potentially disturbing artwork or by making more controversial pieces less accessible. Valencia Community College in Orlando, Florida, once kept its gallery locked during an AIDS-

related exhibition of nude men, allowing visitors to enter only when accompanied by a docent to explain the artwork. Carol Becker, dean of faculty at the School of the Art Institute of Chicago, recommended placing certain pieces not in the main corridors of an exhibition space but around corners "so people don't have to see it." She added that exhibitions are planned with considerable care: "I will meet with faculty and the gallery director and the students to plan out which works may need signage or a press release, planning in advance for controversy—who might be offended, what might happen as a result, and how we should respond." At the School of the Art Institute and elsewhere, there is more than one gallery available for student work, one of which will be for the more free-for-all, anything goes type of work, while another gallery will present artwork that is less likely to offend the public or that might be unsuitable for children.

These measures raise a number of questions that are difficult for art school faculty and administrators to answer. Is protecting people from art a form of censorship? Is making art more difficult to see or find, or letting visitors know that they have a "choice" not to see it, an answer to controversy? Art is thought of as a public good until at least some members of the public denounce it as a symptom of a sickness or a disease in itself. Encouraging free expression and fearing to offend are concepts that coexist uneasily. One sees more of free speech succumbing to public sensitivities at colleges and universities with fine arts programs than at art schools—colleges and universities generally have a more diverse population, including people with a limited exposure to and knowledge of art—but art schools are no less concerned about their status in the community.

Art frequently challenges received wisdom and customs, but sometimes, it is the teaching itself that is under attack. Michael Auerbach, an art faculty member of Vanderbilt University and chairman of the Professional Practices Committee at the College Art Association, was summoned to a state legislative hearing to defend the school's right to use live, nude models, which the state of Tennessee might have outlawed along with topless dancing in saloons. Preparing for the worst, Vanalyne Green, an associate professor in the video department at the School of the Art Institute who is offering a "production course" in pornography, consulted with the school's lawyer "to make sure that the school and I are protected." Green noted that, when she had studied art herself, it had never occurred to her "that someday I would need a lawyer to decide what I can and can't do in art school."

In large measure, artists learn how to teach from the experience of having been taught, and the rest is usually trial and error. What is an instructor supposed to do when a student's work is overtly racist, sexually explicit, or physically threatening? "Some teachers believe it's their job to produce revolutionaries and to push the edge. It's all anything goes," Auerbach said. On the other side of the free speech issue, he noted, are teachers who attempt to moderate or disallow objectionable work. "Some teachers grade down students based on their political beliefs, forcing students to adjust their work to get the grade. I've known a teacher or two who has required psychological counseling for students."

Knowing what a teacher should say to a student about work that is likely to engender an immediate and powerful reaction is quite difficult. The ideal pedagogic goal is not to grade content but to lead the students to a greater understanding of their intention for their work, what the audience for a work should experience, and evaluate how successful the work is in creating that experience. In addition, all this should occur without making the students feel defensive. It may be quite difficult to view racist art, for instance, as an educational opportunity, Auerbach said, "but I feel it's my obligation to work the students to determine if they are trying to be ironic or satirical or just provocative, to help them see what the response to their work might be. Maybe, my job as teacher is to help them make their statement stronger."

The focus on how people might respond to a student's work is very much at the core of an art program's critique sessions, in which other students and faculty members evaluate pieces produced during a semester. Carol Fisher, director of undergraduate and graduate programs at the Minneapolis College of Art and Design, defined critiques as "looking at what's there and coming up with some sort of resolution through a group process." Ideally, this interaction should be respectful of the artist, with no ganging up or "group think"—hazards that sometimes beset art schools and art programs. Schools are emphasizing more and more how art is experienced by others, and three schools— the Corcoran College of Art, the San Francisco Art Institute, and the School of the Art Institute of Chicago—offer "artist as citizen" courses that view the role art plays in the general society. Artists should not think of art as "anything goes," according to Dr. Leslie King-Hammond, dean of graduate studies at the Maryland Institute College of Art in Baltimore: "Artists must learn to be responsible to the community and culture they live in."

Carol Becker lamented the fact that Dread Scott Tyler's flag piece went into a show by jurying rather than through a critique, "because other people's input might have kept what happened from happening. Tyler didn't care that he put everybody in jeopardy. We lost donors and millions of dollars, and his piece obliterated every other work in the show, but he just wanted to make his political statement, and that was that."

Of course, it may be impossible to provoke without offending someone. All school administrators and faculty may be able to do with a clear conscience is to limit the damage to the educational institution itself. When Roger Shimomura, an art professor at the University of Kansas at Lawrence, offers his annual class for performance art, students are given a list of thirteen things they may not do. These include hurting themselves or others, the use or discharge of firearms, bloodletting or the exchange of bodily fluids, harming animals, sex acts or acts of sadomasochism, use of drugs or other illicit substances, setting fires or igniting stink bombs, calling in a false alarm to the police, or intentionally vomiting. (Over the years that he has offered this class, all of these have been tried at one point or another. Vomiting took place a half a dozen times.) If students create a mess, they must clean it up; in one instance, in which a student threw food around the room, that person was required to pay for the cleaning of everyone's clothes. To a degree, the rules ensure that lives are not put in danger and property is not dam-

aged but, to Shimomura, an equal concern is that "nothing is done that threatens the offering of this class in the future."

That threat may define how faculty and administrators see the problem of controversial artwork. Some worry that their institutions may be tarnished by negative publicity or that their jobs may be threatened. Buffeted by the calls for almost limitless free speech and the potential black eye that negative publicity over controversial artwork may create, schools and universities tend to establish few rules about what is unacceptable—those that are codified stipulate that students can't cause property damage or hurt someone or destroy someone else's art—but many are also reluctant to fully support their students and faculty in the event of complaints over the content of the art. As a result, faculty may feel inhibited about speaking freely to their students.

Bill Paul, a professor of art at the University of Georgia, whose AIDS-related artwork became the focus of a Christian Coalition campaign against sexually explicit art and whose classes have been picketed by local ministers, noted that "I've become increasingly careful about what I say in class. I'm not so worried about being fired; I've been here for thirty-four years. The younger faculty might find themselves in trouble in terms of promotions and tenure if they do what I've done. I just don't want all the flap anymore."

Don Evans, a teacher at Vanderbilt University, also noted that the experience of controversy "has changed the way I teach." Back in 1994, the students in a photography class he taught were asked to do a report on any photographer that interested them, and one of those students did a class presentation on the work of Robert Mapplethorpe, bringing in copies of some of his more sexually explicit works that were in the university's library. Another student, offended by those photographs, brought a complaint about them—and about Evans, for allowing the pictures to be shown in class—to the dean of the college of arts and sciences. The university administration then began an investigation of Evans, holding confidential interviews with every student in his class about what they thought of him and his teaching abilities. "The dean never asked the girl who brought the complaint if she had ever talked to me about not being comfortable seeing these photographs in class. She never said a word to me," Evans said. "The administration just tried to see what they could get on me." Eventually, news of the investigation was picked up first by the school newspaper, then by the Nashville *Tennessean* and other newspapers around the country. Evans found that his situation became one more battlefield in the ongoing national culture wars between right- and left-wing groups. "The university looked bad for the way it handled the complaint, and I became known as the guy who teaches nude in front of his class," he said. "The whole experience was emotionally debilitating." Eventually, the complaint faded away without anything said or written to Evans by the university administration.

The fears about what could happen if controversial art is presented in class not only affected Evans but others in the art department as well. "I was scared that something like that could happen to me," Michael Auerbach said. "No one wants to be investigated. Everybody likes to talk about academic freedom and free speech, but what does

that mean anymore? There are things that I used to talk about in class, but not anymore. I may speak privately about those things to students after I've gotten to know them."

He noted that "I used to show a video about [sexually explicit cartoonist] R. Crumb in one of my classes, but I won't now. I won't even go there. I did a few years ago and a couple of girls walked out. I thought, 'Oh, no, here it starts again.'"

Weighing the Pros and Cons of Teaching

The benefits of college-level teaching are clear—long vacations, time and space in which to pursue your own work, and having to teach only part of the day—but they may also be overstated. Artists have not always felt at peace with the academic life, and many find themselves uncomfortable with it now. In the past, there used to be a lively tradition of artists meeting in a few central locations (at a studio or tavern, perhaps) and hashing out ideas and comparing notes. They were able both to create art and live in the world more immediately. With the growth of teaching jobs in art around the country, the result has been to separate and isolate artists in far reaches of the country, limiting their ability to converse and share ideas.

Looking at this very issue, the critic Harold Rosenberg wrote that "If good artists are needed to teach art, the situation seems irremediable. Where are art departments to obtain first-rate artists willing to spend their time teaching, especially in colleges remote from art centers. And, thus isolated, how long would these artists remain first-rate?" The result, he found, is that many artists lose their sharpness and their students begin to get more of their inspiration and ideas from looking at art journals than by paying attention to their instructors.

The academy has become the main source of employment for artists in all disciplines, and the entire structure of art in the United States has been affected by this. When artists are spread out around the country, removed from the major art markets and critical notice, their ability to exhibit their work becomes much more limited and the desire to show their artwork grows more intense. Members of college or university art faculties frequently find themselves at war with the directors of the institution's art gallery over whether or not their work will be exhibited.

The division between the two is obvious. Artists want to use the available space to show what they do, which is the principal way they can maintain their belief in themselves as artists first and teachers second. On the other hand, university gallery directors don't want to be simply booking agents for the faculty, but prefer to act as regular museum directors, curating their own exhibits and bringing onto the campus the work of artists (old and new) from outside the school. Each side has a point, but it is often an irreconcilable area of contention unless, as at some colleges, there is more than one gallery for art shows on campus. Some schools have galleries that are student run or principally for student exhibitions, while other spaces exist for the faculty and out-of-town artists or traveling shows. When there isn't this multiplicity of art spaces, a state of war may develop at a college that embitters the artist and exhausts his or her time not in art making but in departmental in-fighting.

Away from the major art centers, stimulation may be lacking for artists who need things going on around them, and academia tends to have its own special set of concerns. "In the hinterlands," said Robert Yarber, a painter who has taught in California and Texas, "all the other artists you meet are teachers, and that can be inhibiting." Bill Christenberry, a painter and photographer at the school of the Corcoran Art Gallery in Washington, D.C., noted that he was offered tenure at Memphis State University and was making a good salary there, "but I thought, 'Heck, if I'm not careful, I'm going to be trapped here.' I never regretted leaving Memphis."

When there is no community of artists but, rather, an art faculty, discussions about art become less centered within a particular group of artists and may be limited to taking place at formal settings, such as at the annual meetings of the College Art Association (where teachers otherwise convene to look for jobs) or are in the form of critical articles in specialized journals. The ascendance of theory as a starting point for art making over the past two or three decades may reflect the degree to which teaching artists find each other through a discussion of ideas rather than by shared experiences and close proximity. Additionally, teaching artists are asked to both provide technical instruction, frequently offering an analytical discussion of works by the old and new masters (and by their students), and be creative artists themselves, finding the inspiration to make their own art. This is an age-old problem, one that will continue as long as artists also teach.

Another problem for artists who teach is balancing their professional careers with what they do for their students. Artist-faculty members, like faculty members in every school department, are required to hold office hours for their students, attend staff meetings, and participate in some campus activities. This is essential for both the students and the college or university as a whole, although it does take time out of the artist's day. It is unlikely that someone would be hired for a teaching position who made his or her lack of interest in these activities known.

MAKING PEACE WITH THE ACADEMIC LIFE

It is said that, when the Italian Renaissance artist Verrocchio saw the work of his student, Leonardo da Vinci, he decided to quit painting since he knew that his work had certainly been surpassed. The story is probably apocryphal—it is also told of Ghirlandaio, when he first saw the work of Michelangelo, of Pablo Picasso and his father, and of a few other pairings of artists—but the idea of a teacher selflessly stepping aside for the superior work of a pupil makes one's jaw drop.

More likely, many artists who teach today would tend to agree with Henri Matisse, who complained during his teaching years (1907–1909), "When I had sixty students there were one or two that one could push and hold out hope for. From Monday to Saturday I would set about trying to change these lambs into lions. The following Monday one had to begin all over again, which meant I had to put a lot of energy into it. So I asked myself: Should I be a teacher or a painter? And I closed the studio."

Most artists fall somewhere between Verrocchio and Matisse, continuing to both teach and create art but finding that doing both is exhausting. Giving up sleep is frequently the solution.

"My schedule was very tight," said painter Will Barnet, who taught at the Art Students League and Cooper Union in New York City for forty-five years and thirty-three years, respectively, as well as over twenty years at the Pennsylvania Academy of Fine Arts in Philadelphia. "It was tough to find time to do my own work, but I could get along on very little sleep and was able to work day and night on weekends. Also, I never took a vacation."

Many, if not most, of the world's greatest artists have also been teachers. However, between the years that Verrocchio and Matisse were both working and teaching, the concept of what a teaching artist is and does changed radically. Verrocchio was a highly touted fifteenth century painter and sculptor, backed up with commissions, who needed "pupils" to be trained in order to help him complete his work. Lorenzo di Credi, Perugino, and Leonardo all worked directly on his paintings as the final lessons of their education. It would never have occurred to Matisse to let his students touch his canvases. In the more modern style, Matisse taught basic figure drawing rather than how to work in the same style as himself.

Teaching now obliges an artist to instruct others in techniques and styles that, at times, may be wholly opposed to his or her own work. Even when the teaching and creating are related in method and style, instruction requires that activity be labeled with words, whereas the artist tries to work outside of fixed descriptions—that's the difference between teaching, which is an externalized activity, and creating, which is inherently private and personal. Anyone agreeing with Ernest Hemingway's comment, "When you talk about it, you lose it," would likely feel uncomfortable in the academic environment.

Teaching, which has long been held out as the most sympathetic "second career" for artists who need a way to support their principal interests, may work insidiously at times to destroy or undermine an artist's vocation. Hans Hofmann, for instance, gave up painting for a long stretch in his career because he was fearful of influencing his students in any particular direction. Keeping open-minded to various possibilities in painting was problematic to his career when he did paint, critics have argued, as his work bounced around in a variety of techniques and styles. To be a more decisive, fully realized artist, it was necessary for him to finally give up teaching.

"The experience of teaching can be very detrimental to some artists," said Leonard Baskin, the sculptor and graphic artist who taught at Smith College in Massachusetts between 1953 and 1974. "The overwhelming phenomenon is that these people quit being artists and only teach, but that's the overwhelming phenomenon anyway. Most artists quit sooner or later for something else. You have to make peace with being an artist in a larger society."

Artists make peace with teaching in a variety of ways. Baskin noted that teaching had no real negative effect on his art—it "didn't impinge on my work. It didn't affect it

or relate to it. It merely existed coincidentally"—and did provide a few positive benefits. "You have to rearticulate what you've long taken for granted," he said, "and you stay young being around people who are always questioning things."

A number of artists note that teaching helps clarify their own ideas simply by forcing them to put feelings into words. Some who began to feel a sense of teaching burnout have chosen to leave the academy altogether in order to pursue their own work, while others bunch up their classes on two full days so as to free up the remainder of the week. Still others have developed strategies for not letting their classroom work take over their lives.

Painter Alex Katz, for instance, who taught at Yale in the early 1960s and at New York University in the mid-1980s, noted that he tried not to think about his teaching when he was out of the class—"out of sight, out of mind," he said.

Others, male teachers, mostly, found their teaching had so little to do with the kind of work they did that forgetting the classroom was easy. Painter Philip Pearlstein, who has taught at both Pratt Institute and Brooklyn College, stated that his secret was to keep a distance from his students.

"I never wanted to be someone's guru," he said. "I never wanted to have any psychological or spiritual involvement with my students, getting all tangled up in a student's personality or helping anyone launch a career. I call that using teaching as therapy and, when you get into that, you're in trouble."

Teaching, however, is not all negatives or full of potential pitfalls for these or other artists, and many claim that the experience has been positive overall and, indirectly, beneficial to their work. "Sure, I get exhausted by teaching," said photographer Emmet Gowin, who teaches at Princeton University in New Jersey. "I come home some nights not wanting to talk for a month, just curl up on a couch and see no one. But, if it's physically wearing, it's mentally stimulating. Teaching and creating are the same thing to me because you are bringing to your class or to your work what's important to you at the moment. You're always exploring whether or not things go together. And when it works, whether it's a class or a work of art, it's magic. That's vivifying."

With other artists, the very need to do away with some sleep or vacations or social outings in order to make time for creating art has, in a number of instances, instilled a discipline that makes their use of time all the more effective.

"I think that having a job has led to an intensification of my work," Pearlstein stated. "I had to use the little time I had to paint, and it made me work all that much harder. Something had to give, so I cut down on my social life. I decided it was more important to stay home and paint."

Another benefit of teaching is seeing students stimulated and gaining emotional freedom to use what they know. Verrocchio may not have been the equal of Leonardo, but he taught his student a standard of craftsmanship. In the same way, photographer Harry Callahan, who headed the department of photography at the Rhode Island School of Design from 1961 to 1977, was able to encourage Emmet Gowin to a high level of professionalism. Similarly, conceptual artist Joseph Beuys developed in his student

Anselm Kiefer a feeling for certain materials and a desire to reflect on Germany's recent past. In this way, thousands of artists have inspired tens of thousands of others as teachers. That certainly does more for both artist and pupil than either giving up one's art or one's students.

PUTTING YOUR ART TO WORK

Call them "day jobs," "second careers," or a "gig," but every artist needs to find some way of earning money, and that may be specifically related to one's art or not. Novelist William Faulkner, for instance, did a bit of both, working at one point as a Hollywood scriptwriter and another time as a mail carrier (he had other jobs as well); Paul Gauguin and T. S. Eliot both worked in banks; James Rosenquist painted billboards, while Andy Warhol worked in advertising and window displays; Vassily Kandinsky and Henri Matisse both studied the law; Charles Ives and Wallace Stevens had jobs in the insurance industry; painter Henri Rousseau was called "le douanier" by his contemporaries because he worked as a customs official, the same job that novelist Herman Melville held.

Seventeenth century Dutch artists were the first to paint without prearranged commissions, needing to leave their studios to look for buyers, and they were also the first to learn about second careers. Meindert Hobbema earned money as a tax collector, Jan van Goyen as a realtor; Jan Steen was an innkeeper; and Jacob van Ruisdael made a living as a barber. Both Johannes Vermeer and Rembrandt set up as dealers.

Of course, we know these artists for their creations, and most of them were able to leave their paid jobs for what history has viewed as more memorable work. Many others—most artists, actually—are not so lucky.

There are two major career decisions an artist may have to make: The first is, what kind of pay-the-bills job to get—should it be related or not to the individual's abilities in the arts (for instance, a painter doing book illustrations or a novelist writing advertising copy)? Second, whether or not the job is related to one's art training, should the artist just keep the job as extra money or look to move up in the company or in the field? The second question is the hardest, and it makes Sunday painters of a lot of talented artists.

Relatively few people knew Robert Kulicke as a painter, although he studied to be one for eight years. The French artist, Fernand Leger, was his teacher for a year and a half, and he attended various art schools as well as befriended many of the leaders of the abstract expressionist school. But making a name for himself and a living as a painter was not in the cards for him. Rather, many people will think of him as the creator of handsome modular metal frames. The Kulicke frames are known and copied around the world for their simplicity, elegance, and modern design. What began for him as a way to make some money to support himself and his art became a full-time profession, eclipsing his art while making him a wealthy man.

He started making frames in the early 1950s after a prolonged period of self-doubt and frustration led him to consider a second career. "My career as a painter has suffered tremendously from the renown of the frames," he stated. "I never really

stopped painting, but all anyone would say is, 'Oh, Kulicke the framemaker is trying to be a painter, now.'"

Robert Kulicke's situation is unique in a way but also very common for people who started out trying to succeed as artists but found themselves moving on quite different paths. The word "artist" is extremely value laden in this century. It means a creator of something significant, something of beauty, power, and reflection, and it represents the highest level of achievement to a society conscious of its free time and its homogeneity. It is a psychologically traumatic event for someone to conclude that he or she is not an artist, but considering how little money most visual artists earn from their creative work, finding a paying occupation is an absolute economic necessity for almost all.

Frame making is but one related career possibility—there are many others. Painter Alexander Liberman worked as art director at Conde Nast publications for years, while sculptor Donald Judd and Fairfield Porter wrote art reviews in the early part of their careers. Artists may find income or a satisfying career in numerous, rewarding art-related fields outside of academia, such as art therapy, art conservation, art appraisal, arts management, architecture, interior design, theater design, printmaking, foundry work, medical illustration, museum curating, art dealing, children's book illustration, and Web design. Some of these may require additional study, while others artists may pick up on their own. (For a fuller discussion of these and other career possibilities for artists, read my *Fine Artist's Career Guide*, Allworth Press.)

Some artists are led to become entrepreneurs. Virginia Gardner spent a number of years counseling artists on how to manage the business aspects of their careers, putting to use the knowledge and experience she gained from working in business jobs after receiving her art degree. Art Guerra, on the other hand, put to work his increasing interest in creating his own paints, starting up Guerra Paints and Pigments in the mid-1980s to "make paint chemistry and technology available to artists."

It is also not uncommon for artists to become art dealers. Many artists have established art galleries that include their own work. Robert Angeloch, a landscape painter in Woodstock, New York, set up a gallery in that town "as a way to show my own work. I had been in some New York City galleries, but they always folded or the owners died."

Entrepreneurism has its own price, especially during the first few years, when the entrepreneur may seem to work around the clock on everything from bookkeeping to sweeping the floor. The financial risks may be considerable, too. The freedom to do one's artwork regularly becomes, for many artists, a question of discipline, a tortuous effort to beat the sunrise to get in a few hours a day in front of the easel or to make art after the kids have been put to bed.

Few American artists have had the opportunity to lead any different kind of life. It is an enormous gamble for anyone to take—picking up odd jobs and part-time work in order to support one's art—in the hope of some day being able to live off one's work. Discipline and stick-to-itiveness are key ingredients, but no one is rewarded just for hanging in there. The art world is full of unknown soldiers. A few ways in which artists may earn a living from their art skills are noted below:

Decorative and Custom Art

There is no one way in which artists work or show their art. Some produce alone in their studios, while others work collaboratively with others. Some create works for exhibits at galleries, while others prepare for juried shows or look for commissions. Custom or decorative artists generally work in homes and offices, hired to paint a mural on a wall or ceiling, perhaps even a tabletop; and their work is seen by the people who live, work, or visit there.

"Almost all of my work is in powder rooms, lavatories—bathrooms without showers," said Jeffrey Damberg of Cos Cob, Connecticut, noting that the steam from a shower would damage his paintings. One of his powder room wall creations was a picture of an outhouse with a forest around it. Another was a mural of a group of men, all well dressed. "You don't see their faces, only their backs," he said. "The homeowner wanted me to paint it that way, as though the men were turning their backs to give her privacy."

Judith Eisler, a New York City artist, also has been hired regularly to paint bathrooms and bedrooms. "People feel they can go wild in their bathrooms," she said. "They feel hidden there, and so they let loose and want lots of different colors that they'd never allow elsewhere in the house." However, she has painted murals in every other room of a house, as do most decorative artists, Damberg included.

A growing number of homeowners are becoming interested in bringing artists into their homes to create custom works, according to several interior designers. "Clients are getting more cultured, more knowledgeable about art, and they like to tell an artist what to do," said Lourdis Catao, an interior designer in New York City. "It makes them feel like artists, too."

One of Damberg's clients, Marian Hvolbeck of Greenwich, Connecticut, commissioned him to create a composite of famous landscapes, including Thomas Cole's "Oxbow," Vincent van Gogh's "Cypress Trees," and Claude Monet's "Water Lilies," as well as images from Corot, Cezanne, and some others. Damberg was an ideal choice for this project as he specializes in art copies, and most of his murals are replicas of the work of other artists, such as Grandma Moses, John Singer Sargent, Albert Bierstadt, and various nineteenth-century French painters. "I have a whole lot of art books," Hvolbeck said, "and I opened to pages in my books and told Jeff, 'Put that in, and this one, too.' Jeff made photographs of the paintings in the books and enlarged them, so he could work from them." The ability to direct an artist made Hvolbeck feel as though she were collaborating in the process. "Paintings are interesting. I enjoy paintings and have a number of paintings in my living room, but here I was part creator. The final work is very personal to me because, while some of the copied paintings are well-known, some are not and I am the only one to know the reference."

Decorative artists encompass a wide group of talent and techniques, some straddling the fence between fine and purely decorative art, while others are more like artisans. Some, such as New Yorker Raymond Bugara, specialize in trompe l'oeil, creating realistic images that fool the viewer into believing they are three-dimensional, such as book shelves filled with classic tomes. Others, "faux artists," create simulated finishes

on surfaces, such as the look of marble on a staircase or gold leaf on molding or clouds on the ceiling. Yet others add pigment to plaster or give a wall the look of Italian colored stucco. Certain artists do both murals and wall finishes.

Decorative artists are generally found through interior designers or architects (many architectural firms have in-house designers) or by word of mouth. All of Damberg's newer clients have come through past ones, "as someone comes into the house and sees my work and asks 'Who did that?'" Bugara, whose jobs all come through interior designers, on the other hand, said that "word of mouth isn't all it's cracked up to be. People don't want the same painter in their house as their friends; it's like two women wearing the same dress at a party. They get competitive and want a different artist."

It is rare that an artist places an advertisement in a magazine or newspaper ("an ad might bring me too much business," Damberg said), although some are listed in the Yellow Pages. However, many artists and craftspeople have joined the American Society of Interior Designers (608 Massachusetts Avenue, N.E., Washington, D.C. 20002-6006, 202-546-3480, *www.asid.org*) as "industry partners," a category of membership for people providing products and services that interior designers can use.

When a homeowner contacts an artist individually, it is usually to paint a mural in a particular room of the house; however, when an interior designer hires the artist, the mural is part of a larger redecorating job for which the artist is one of the subcontractors. Some artists enjoy the one-on-one relationship with the homeowner, while others prefer having a designer handle the financial and technical arrangements with the client. Frequently, the designer suggests to the client the idea of bringing in an artist to add accent colors or an entire mural. "Artists are basically problem solvers," Catao said, "and the problem here is how to fill a commercial or residential space. In a small room, the question is how can an artist give the sense of three dimensions."

"I like to have the designer as a buffer," said Katie Merz, a New York City artist who creates cartoony imagery for homeowners. "It's a nightmare to deal with the owner all the time. So many of them want to make suggestions while I'm working. Some clients have a kind of neurotic way of communicating—they feel that the only way they can talk to me is to find something wrong with what I'm doing."

Merz noted her greatest fear, once the mural has been completed, is that the client doesn't like it ("You hold your breath until you hear someone tell you it's OK," she said), but the process of determining what will be painted on the walls usually includes sample designs and renderings for the client's approval. Eisler, who is both contacted by homeowners directly and hired by interior designers, meets repeatedly with the client to ensure that they have same imagery in mind. "Someone will say to me, 'I want it to be sand-colored, you know what I mean?' and I say, 'No, I'm not sure I know what you mean.' I ask people for visual clues as to what they want in a picture. I tell them, 'Let's find that color on a Benjamin Moore color chart.'"

She added that interpreting what potential clients want from their descriptions can be trying, as they themselves may not be certain. "You have to be a psychiatrist sometimes." she said. "One woman told me at the end of a job that she didn't really like

what I had done. I told her, 'You approved the samples,' and she said 'Yes, but that's because I didn't want to hurt your feelings.' I told her that this is a service industry—it's not about feelings." Clearly, this defines the difference between a gallery artist, who creates personally motivated artwork for a more generalized audience, and a decorative artist who is being commissioned to create a very specific artwork for a particular client. The final artwork may be the same in terms of imagery and style, but far more personal entanglements are involved in the decorative arts field.

Graduates of art schools, both Eisler and Merz are active as gallery artists, occasionally selling their paintings to the same people who hired them as muralists. Charles Gandy, an interior designer in Atlanta, Georgia, noted that many of the artists he uses are "right out of the galleries here, and some of them sign their murals." Gandy added that he regularly looks in at art galleries to find artists who might be suitable for custom work in someone's home.

Not every gallery artist will find the transition to decorative work so natural, according to Laura Richardson, president of Miller-Richardson Galleries in Washington, D.C. Some of the challenges are technical ones, such as painting on a wall instead of on a canvas (requiring different preparation and media), and the scale is usually larger. "Some artists feel constricted by a commission, because of the desire to please, and they may not like to make changes," she said. "You're also not painting in your studio but in a public area, with an audience all the time. A lot of artists aren't aware of what they're in for."

The letters of agreement or contracts that artists and homeowners sign are similar to those for public art projects, with paragraphs detailing the requirements of the homeowner (specific wall, for instance); the medium, palette, and artist; the creation of a maquette and the nature of the approval process; the manner in which the final work will be delivered or installed; the cost of the project; and a payment schedule.

Many artists charge for their renderings (between $100 and $700, on the average, depending upon the intricacy of the maquette), although the price will be subsumed into the overall cost of the project if the client accepts. Artists establish fees for an entire project in a variety of ways. Some charge by the square foot, while Damberg prices murals by the job, estimating the amount of time it will take, multiplied by a $55 per hour wage. His average mural costs $4,000. Both Eisler and Merz charge between $350 and $600 per day (Bugara's fee is between $400 and $800 per day), and they also estimate how much time the work will require. All of the prices include the cost of materials. One of Eisler's biggest jobs was painting murals on the walls of an entire Manhattan apartment, a project that went on for several months and for which she charged $25,000. As most other contractors, decorative artists receive a deposit of either one third or one half at the outset and the remainder at the completion.

Prices are often higher when middlemen are involved, as gallery owners who arrange commissions take a percentage of the artists' fees (between 10 and 30 percent) and interior designers customarily include a 15–25 percent additional charge.

Trompe l'Oeil Painting

Trompe l'oeil (French for "fool the eye") is one of the oldest forms of two-dimensional art, dating back to the fourth–century B.C. Greek artist Apelles, whose painting of grapes was so lifelike that birds pecked at them. During the Renaissance, the Florentine banking family Medici had their entire counting room painted with trompe l'oeil bookshelves and doors in order to confuse anyone who thought to steal some money.

In the years since the Renaissance, trompe l'oeil has remained a subspecialty in the arts, created in large part to show an artist's virtuosity rather than expressing any larger view of the world. It remains a real money maker, however, for artists with the requisite skill at highly detailed painting who are interested in creating murals for hotels, restaurants, and private homes or apartments.

Marble effects for plaster or drywall and clouds-in-the-sky scenes for ceilings are among the most sought-after images, but what is new is a willingness on the part of patrons to allow artists to be artists; that is, to create expressive and imaginative pictures. According to many artists and gallery owners who set up commissions for the painters they represent, customers look for people who are first and foremost artists and also happen to do mural work. These customers want painters who have their own ideas and are willing to take some chances.

"In general, I am brought in by an interior decorator to solve a problem, such as the way an apartment is laid out," said Ted Jacobs, a New York City painter who has done trompe l'oeil murals for thirty years. "There was one apartment I worked in where, when you opened the front door, the first thing you saw was a kitchen sink. The decorator wanted some way to make it look different, and I was given a lot of latitude."

Jacobs used that latitude for a project at the Copley Plaza Hotel in Boston for which he painted portraits of prominent past and present Bostonians on a mirror at the hotel's bar, as though to suggest that all these great men were fun-loving drinkers.

Back in the early 1950s, Jacobs had tried to solicit this kind of work from decorators and architects, submitting slides and his résumé to a number of people, but without much luck. Only when a decorator saw his easel paintings on display in a gallery was he asked to take on a mural in someone's apartment. Some artists who do interior murals get started after being discovered by home or apartment dwellers (or decorators), while others are successful in seeking out architects or decorators.

There is no trade association for artists in this field, nor job listings in any art or home decorating publications for those wishing to pursue trompe l'oeil as a full-time career or as a sideline activity. Art dealers sometimes arrange commissions, and in fact, customers appear to like the idea that the painter working in their home or apartment may someday have his or her work displayed in a museum.

Nature scenes tend to predominate in this field. Marianne von Zestrow of New York City, for instance, did an African landscape with animals on a Manhattan living room wall; and Everett Molinari, president of the National Society of Mural Painters, has done a variety of birds in trees over the years in the houses of his customers.

Architectural motifs are also quite common, with Greek columns, marbleized door casings and statuary, "tile" floors, or even fake fireplaces found in many private homes. Brooklyn painter John Kelley, whose easel pictures frequently contain ancient Greek mythological scenes, uses many of those same images for his trompe l'oeil murals in houses and apartments.

"One of my favorite works was a dining room wall that I painted to look like the Aegean Sea, with doric columns on both sides," Kelley said. He added that the move from easel painting to trompe l'oeil murals is not such a large leap for realist artists as "all representational painting has a trompe l'oeil element to it in that you are giving the illusion of three dimensions."

Of course, not all wall murals need to be trompe l'oeil—Stewart and Dena Stewart of Miami Beach, Florida, for example, collaborate on folk art images that recall a rustic colonial living room while not fooling anyone entering the room—but that style tends to be most in demand.

Fees for interior murals vary widely, with most artists charging by the square foot (between $10 and $100, depending on the level of complexity or if any changes are requested), although some painters ask a per diem fee of, on the average, $250. Prices tend to be higher for office buildings and hotels, which generally have more money to spend on decorations, than for private homeowners or restaurants and bars. Restaurants and bars often go in and out of business rather quickly and are loath to spend large sums of money at the outset. Fees may also be higher when the painter has to hire assistants, for whom the artist must pay insurance, workers' compensation, and a salary that may reach $150 per day per person or pay for special equipment. Rates also vary, depending upon whether the artist paints directly on the wall or onto canvas that is affixed to the wall afterwards. Travel, meals, and accommodations are often billed to the customer separately. Hotels and some homeowners solve the latter problem by putting up the artist.

Art in Hospitals

Art has long been thought of as good for the soul, but it has been seen increasingly as good for one's health as well. Based on studies of the beneficial effects of having art around, a growing number of hospitals have created art galleries in their public areas, purchased artworks for a permanent collection, and employed artists to hold regular workshops with patients. "For patients, art is a diversion and a resource to deal with their afflication or problem," said John Graham-Pole, a pediatrician and codirector of the Arts in Medicine department at Shands Hospital of the University of Florida at Gainesville. "It is also a way in which we rehumanize the connection between patient and caregiver."

Shands Hospital has two art galleries, offering a changing series of exhibits of the work of patients as well as of professional artists in the area, and an artist-in-residence program that employs up to eighty artists per year (part and full time). These artists work with patients individually or in groups on art projects; on occasion, they work with the families of patients.

Running workshops for patients is a very different experience than other types of teaching. Dona Ann McAdams, a New York City photographer who teaches at Hostos Community College in the Bronx and Empire State College, as well as to schizophrenic patients every Friday since 1983 at the Brooklyn Day Program in Coney Island, noted that her mental patient students "are more interested in the final image than in the technique. I take the pictures, process the film and make prints; they set up scenes and hand-color the prints." Employed through Hospital Audiences, Inc., a nonprofit organization that pays her $32.50 per hour plus transportation and the costs of some of the materials used, she said that the patients are "not working for a grade or to finish a semester. It's not just a means to an end but a part of their life experience. I'm very much a part of their lives, so I come every week."

Professional artists working with patients are not expected to know or practice art therapy, although at times it may appear that there is a certain overlap in roles, since they frequently work with the same types of patients with similar materials. "The artists we employ don't have psychological training," said Elizabeth Marks, director of Hospital Audiences. "Our mission is to provide cultural access to the arts to everyone other than as a form of therapy. We believe in the healing power of the arts. We don't use art as a means of emotional outlet, and we shy away from purposeful interpretation, which you find in art therapy."

In addition to gaining full-time employment, McAdams used the experience to photograph her Brooklyn Day Program students, which resulted in an exhibition and a book, entitled *The Garden of Eden,* published in 1998. Other artists have been able to exhibit their work in hospitals or sold pieces to the institutions. In 1980, Tracy Sugarman, a Westport, Connecticut, "reportorial artist," approached the director of the hospital in the neighboring town of Norwalk about creating "a series of reportorial drawings of each department, showing what goes on in the hospital in a warm, unbuttoned way." In all, Sugarman turned in more than 100 black-and-white line and wash drawings. Ten years later, the hospital invited him back to create a mural for its then newly refurbished pediatric wing. He painted a series of seventeen full-sheet (22″ × 28″) watercolors, which were then enlarged by computer and affixed to panels that became the murals—the original watercolors themselves were hung in pediatric patient rooms.

By chance, the architect for the renovation of Elmhurst Hospital in Queens, New York, happened to see Sugarman's mural and recommended the artist to the president of Elmhurst Hospital. Again, the artist created a series of watercolors, and the images were blown up for a mural in the corridor.

The building of a new hospital, or the renovation of an existing facility, is a particularly apt time to sell artwork, as decoration is often a part of the budget. When the hospital is a city- or state-run institution, percent-for-art laws may apply (see chapter 7). Dorothy Holden, a fiber artist in Charlottesville, Virginia, sold a wall-hung quilt to the University of Virginia when its Medical Center was built, and the piece was purchased through a percent-for-art program. The Medical Center has a permanent collection with its own exhibition space—brochures provide information about the works and the

artists for visitors' self-guided tours—and there is a gallery for temporary exhibits near the elevators. Whether en route to visiting a patient or waiting to see someone, visitors have an unavoidable opportunity to look at the work of local professional artists. Holden has had a one-person show in the gallery and participated in a group exhibit. "I've had tremendous exposure through the shows," she said. "A lot of people have told me that they saw my work. Someone who was visiting a patient in the hospital stopped into the gallery and ended up buying a piece."

Another visitor to the hospital's gallery, a patient whose architect husband was currently designing Charlottesville's City Hall renovation, "recommended my work to the city of Charlottesville, which commissioned me to make two quilts for City Hall," she said."

The largest number of arts in medicine programs is found in university medical centers, "which have taken the lead in advancing the arts in healthcare," said Maggie Price, president of the Society for the Arts in Healthcare. "They are interested in promoting a holistic approach to healing." Duke University Medical Center, for example, has a cultural affairs department with a five-person staff. On the other hand, a private institution, Trumbull Memorial Hospital in Warren, Ohio, has exhibition spaces, musical events, artwork for children, and an "open studio" in which "artists work with both patients and hospital staff," according to Marianne Nissen, the institution's art director. "They're all facing a lot of stress."

Many other hospital art programs tend to be smaller, with one staff member and budgets under $100,000 (which includes staff salaries). Price added that pediatric and psychiatric hospitals, as well as cancer care centers, tend to be more amenable to incorporating the arts into the healthcare environment than acute care facilities where the patients' average stay is shorter and their ability to participate in arts activities considerably less.

Many of the hospitals with arts in medicine programs are members of the Society for the Arts in Healthcare (3867 Tennyson Street, Denver, CO 80212-2107, 303-433-4446 or 800-243-1233, *www.societyartshealthcare.org*), and the organization's membership list, categorized by state, may be a useful resource for artists. Other possible sources of information are the International Arts Medicine Association (714 Old Lancaster Road, Bryn Mawr, PA 19010, 610-523-3784, *http://members.aol.com/iamaorg/*) and Hospital Audiences, Inc. (220 West 42nd Street, New York, NY 10036, 212-575-7696, *www.hospitalaudiences.org*)—the latter group employs artists to work in largely outpatient settings (nursing homes, residences, shelters, and day programs) within the five boroughs of New York City.

When a hospital has no arts program, artists who want to work or exhibit in or to sell work to the institution should contact the president or chief executive officer. Many hospitals also have volunteer auxillary groups, one of which may be involved in decoration or cultural activities. In most cases, hospitals, especially municipal or state facilities, work with local artists.

Church Support of the Arts

"There has been a general feeling that we in the church have neglected the relationship of the arts and religion, and there has been a movement towards church support of arts activities," said David Read, minister at the Madison Avenue Presbyterian Church in New York City and one of the founders in the early 1960s of the Society for the Arts, Religion, and Contemporary Culture.

Churches of all denominations have reemerged as patrons of artists, although their role has changed greatly since the Middle Ages and Renaissance. They are less commissioners of art (although that does sometimes take place) than promoters of the arts, frequently inviting art exhibitions, concerts, and theatrical performances to be held on church premises. The Episcopal Cathedral of St. John the Divine in New York City, for instance, has its own in-house composer, avant-gardist Paul Winter, as well as an apprenticeship program for sculptors and artists in stained glass and other media. Also in New York City, at the base of the Citicorp Building in midtown, is St. Peter's Lutheran Church, whose chapel was designed by sculptor Louise Nevelson and which holds twenty-three short-term (one to three months) and long-term (three to six months) exhibits of both well-known and lesser-known artists.

Equally novel is the Boston Jazz Ministry, led by Mark Harvey, a Methodist minister and jazz trumpeter, at Boston's Emmanuel Church, an Episcopal church. The jazz ministry presents jazz liturgies in regular concerts and also provides counseling (career and psychological) and community organizing for artists.

In Miami, Temple Beth Sholom opened a "selling" gallery, highlighting the work of Jewish artists—such as Ben Shahn, Chaim Gross, Jack Levine, and a number of contemporary Israelis—with profits going toward the purchase of other works of art to establish a permanent collection of art and Judaica for the synagogue.

The Pacific School of Religion in Berkeley, California, and the Wesley Theological Seminary of American University in Washington, D.C., both have artist-in-residence programs; and the Metropolitan Memorial Methodist Church in Washington, D.C., has a ministry of the arts that integrates all of the arts into the worship setting. Other artist-in-residence programs are at churches around the country, and the Ford Foundation's Affiliate Artist Program (run from its New York City headquarters) pays a full year's salary to participants of an artist-in-residence program, which can take place in a church as well as at a public school.

Commissioning artists to create new works for a church still goes on, with opportunities becoming available all the time. Most church national headquarters have art and architecture committees, in charge of selecting artists for churches that are being built or renovated. (See *The Artist's Resource Handbook* for names and addresses of religious organizations.) All of these churches accept slides and biographic information from artists and will pass on recommendations to member churches in need of someone to create some object for a church.

Artists may have just as much luck applying to churches in their areas as well, regardless of whether art has ever been purchased, commissioned, or displayed in the

past. It also doesn't hurt to ask the clergyman; even if that church is unable or uninterested in having anything to do with art, there may be other churches looking for more of an art presence in the local community.

Churches vary greatly in terms of whether they seek works that are religious in orientation or simply that reflect a favored artist or style. The Union of American Hebrew Congregations looks for Judaica, such as Torah curtains and mantles, while St. Peter's Lutheran Church in New York City was free-wheeling enough to commission Willem de Kooning to create a $1 million three-panel altarpiece.

In addition, the Interfaith Forum on Religion, Faith, and Architecture keeps a registry of artists' slides and biographies, both for its annual juried show, which awards certificates of merit to thirteen winners and puts these works on display at the group's annual spring conference, and for referral, as church officials from all over the country frequently call to find appropriate artists and architects.

Other denominations have less central governance, and individual churches tend to be self-governing. With Baptists, Catholics, and Christian Scientists, churches need to be addressed individually. As opposed to the Catholic church of Renaissance times, churches today have far less money to spend on major works of art. A few here and there, however, develop collections.

Part of the reason for the changing attitude toward the arts by many churches has to do with the kind of seminary student increasingly embarking on this vocation. Often, they are no longer just philosophy or religion majors right out of college but, rather, older second career people who have had some experience with the arts and want to integrate culture with church teaching.

In addition, the change also reflects the influence of Paul Tillich (1886–1965), the German-born American theologian and philosopher who wrote that the arts posed questions that theology ought to answer. According to Doug Adams, a professor at the Pacific School of Religion in Berkeley, California, Tillich saw the arts as "an early warning system for theologians about questions that society and the general culture were raising."

Greeting Cards

In the late 1960s, Flavia Weedin was producing 200 paintings per year, selling most of them for a few hundred dollars apiece. She might still be painting 200 pictures every year to support herself and her family but fate and a greeting card company intervened. A few sales managers from a now-defunct card company (Buzza-Cardoza) saw her work at a gallery she set up with her husband at the Disneyland Hotel, "and they told me that my images belonged on greeting cards," she said. "Well, I had never thought of doing anything like that—I didn't even know any other artists who did that, either—but they asked to license my work."

After seven years of supplying images to Buzza-Cardoza and then two years of working as a freelancer for Hallmark Cards, Flavia (she doesn't use her last name professionally) set up her own company to market a line of greeting cards. Distribution—how to sell the cards—was the initial problem, but retailers at the trade shows where the

artist and her husband set up a booth remembered the name "Flavia" from the lines of cards that both Buzza-Cardoza and Hallmark had produced so profitably. Her company was off and running, completing her transformation from an artist who primarily sells canvases to one who licenses images and still owns the paintings that are sold separately (now priced between $12,000 and $18,000 apiece).

Flavia's company now earns $60 million per year from the sale of licensed images, and her work load has shifted to creating between five and ten paintings annually (to sell as fine artworks) and fifty commercially licensable images. She is a phenomenon but also emblematic of the new kind of successful artist that appears to be emerging at present. These artists, like many corporations, are diversifying their sources of income; for instance, selling work privately or through a gallery, creating a product line and licensing images, teaching workshops, and soliciting private and public commissions.

Traditionally, artists earn a living in a passive manner, producing work and waiting for someone to buy it. Today, many artists don't want to wait until their works are sold to buy food, and they adopt a more proactive approach. "There were a number of Christmases when the weather wasn't good and we didn't get many people buying the work," said Rick Weedin, president of his mother's company, Portofino Licensing in Santa Barbara, California. "There wasn't a lot for us those Christmases. My mother, who was supporting all of us, would just shrug her shoulders and say, 'I'm sorry, it's raining and people don't want to go out.'" Doubling her prices, he speculated, probably would have resulted in only half as many paintings being sold. Finding another source of art income was the only way to make her art career viable.

Creating freelance images for greeting card companies provides a source of income (rarely an entire income) for thousands of artists. There are approximately 2,000 of these companies in the United States, producing 6 billion cards per year and generating more than $7 billion in retail sales annually—the average household purchases thirty-five individual cards per year, and women reportedly purchase 80 percent of all cards. Some of these companies are family businesses in which the owners are the sole artists used, and a few larger businesses—most notably, Hallmark Cards—strictly use artists on staff rather than freelance work. Most card publishers, however, contract with artists to license images, paying either a flat fee (often between $100 and $500, depending upon the complexity of the image and the number of stages in the process of finalizing the work) or a royalty (5 percent of the wholesale cost of the greeting card, minus returns, is standard, although very popular artists sometimes receive more). Most artists prefer royalties, because of the opportunity to earn more money if many cards sell and if the same card is sold in succeeding seasons. Some artists also expand on the publishers' standard terms agreement, limiting how long the company may use the image and prohibiting its reuse, for instance, on paper plates and puzzles.

Occasionally, artists move from freelancing to starting their own greeting card companies. Flavia is one example; another is Donna Rozanski, who began to market a line of cards (Fan Mail Greeting Cards in Seattle, Washington) while on maternity leave from a food co-op where she was a merchandise manager. "Many artists don't even

realize the greeting card niche," she said. "It's an easy place for people who are untrained in art, like I was, or don't have a big name in the art world. You can be a nobody and make a big, fat living." Yet another full-time card designer is Andrea Liss, who in 1991 created Hannah Handmade Cards in Evanston, Illinois, after years of working in graphic design. "In 1990, I sent out a Christmas card to customers," Liss said, "and so many of them called me to say that I should go into greeting cards." Like many smaller artist-publishers, Liss and Rozanski have found that the marketing of their cards—creating catalogs of their work, building a booth and attending trade and gift shows, overseeing inventory and suppliers, hiring and firing as well as paying commissions to sales representatives—takes away much of the time that they would like to spend making art. Neither company has its own sales force but works with independent sales representatives, who "carry a lot of different companies' cards," Rozanski said. "Are your cards going to be the first ones pulled out of the bag when they're making a presentation to retailers? Are your cards going to be pulled out at all? Reps are your link to the future and to money and, because they are independent, you can't threaten them. What I do is offer rewards—a bonus tacked onto the normal commission for selling more than a certain number of cards—in order to motivate them." Liss also noted that "I need to spend a lot of time motivating the reps to really sell my cards to retailers, and I need to keep their sales line fresh. If you're not in contact with them a lot, things can really fall apart in a hurry."

Most artists, however, prefer to work on a freelance basis, often submitting designs and images for several card companies. There are many ways in which artists find out which greeting card companies are looking for freelance talent. Some companies advertise for artists in magazines, such as *Communication Arts* (P.O. Box 51785, Boulder, CO 80322, 800-258-9111, $53 for eight issues) or the industry trade publication *Greetings, Etc.* (4 Middlebury Boulevard, Randolph, NJ 07869, 800-948-6189, $36 for four issues), or in books, among which are *Artists and Graphic Designers Marketplace* ($24.99) and *Poetry Marketplace* ($23.99), both published by F&W Publications (1507 Dana Avenue, Cincinnati, OH 45207, 800-289-0963). The Greeting Card Association (1030 15th Street, N.W., Washington, D.C. 20005, 202-393-1778, *www.greetingcard.org*) publishes *The Greeting Card Industry Directory* ($99.95), listing all 1,200 of the association's members, and the *Artists and Writers Market List* ($54.95), which provides detailed information on how to submit freelance work and the contact people to whom it should be sent within the 125 member companies that agreed to be listed in the book.

The association also sponsors a National Stationery Show every May at the Javits Center in New York City, where virtually all of the companies are represented, drawing retailers and artists alike to look at what is being offered and—in the case of artists—to present their portfolios.

In general, artists should know the style of artwork that a company uses and obtain the guidelines for submitting work before sending any material to publishers. For example, most publishers prefer to look at slides, photographs, color copies, or tearsheets of completed pieces—if they want to use the work, they will ask the artist to

send the original—although some will accept e-mail submissions or a digital portfolio. (All images, of course, should be accompanied by a cover letter and a bio or résumé of the artist.) Some publishers also indicate what size artwork should be submitted for consideration, as well as the medium. A self-addressed stamped envelope should be included, although some companies do not promise to return all samples. Artists who send work to card companies for review should be patient, as the process of getting through the many portfolios frequently takes between six and eight weeks.

Among the ways to learn a company's taste in art is by visiting card shops (not just Hallmark stores) or stores that have greeting card displays. "Most stores carry between five and ten different brands," said Mira Albertson, publications coordinator at the Greeting Card Association. "You don't want to send abstract or African-American imagery to a company that specializes in Victoriana." Some card companies use only line drawings, while others prefer watercolors or an occasional acrylic or oil painting. (A number of companies use more than one medium.) Some greeting card publishers take stand-alone images, perhaps adding words to them, while others want artwork that illustrates a writer's words. Some companies primarily create humorous cards; others focus on specific holidays (for instance, Jewish celebrations) or events, such as birthdays or graduations; the largest companies, such as American Greeting Card and Hallmark, have cards for every conceivable occasion. According to the Greeting Card Association, 83 percent of all greeting cards sold in the United States are for five holidays—Christmas, Easter, Father's Day, Mother's Day, and Valentine's Day—and the majority of the remainder are for birthdays. Other than actually seeing sample cards in a store, artists may also view the type of artwork identified with a company on its Web site, when there is a Web site.

Most greeting card companies that use freelancers regularly receive submissions from artists. They are looked at by the company's art directors, who may return the work, file it for later review (for instance, when it is appropriate for a certain holiday, such as Christmas), send a letter to the artist requesting additional submissions, or snatch a piece right up then and there. "We have commissioned cold," said Linda Auclair, product development assistant at Renaissance Greeting Cards in Sanford, Maine. "Something comes in by someone we've never heard of before and we say, 'Ooh, get a contract offer on that right away.'" However, most of the artwork used by Renaissance is commissioned from specific freelance artists after having been conceived through marketing strategies and card needs by the company's product development group—Renaissance (like almost all card companies) decides what its art will look like and does not leave the process of establishing a product line up to freelance artists.

On the positive side, marketing images to greeting card companies is a highly democratic undertaking, since artists are selected solely on the basis of the quality and appropriateness of their work rather than on their renown in the art world or credentials or experience. Some artists, such as Flavia, become well-known as a result of their card images, but they did not need name recognition to enter the field. On the other hand, not every artist can create images for greeting card companies: Some art does not reproduce

well on a card (either coated or uncoated stock), and some art is not "wordable"—a writer might have a difficult time putting words to it. Most often, the words come first, and the artist is asked to illustrate or visually complement them.

In almost all instances, companies purchase the worldwide rights to the artwork for either a limited or indeterminate period of time. In effect, they are taking out a license for the image but do not own the physical work; after the license has expired, the artist may license the image to another firm, make prints or posters from it, or use it in any other commercial manner. (For more on art licensing, see chapter 3.)

8

THE MATERIALS
ARTISTS USE

A s important as it is for artists to know how to create art is their understanding of the physical properties of the materials they use and the durability of the works they make. Collectors, viewers, and other artists assume that art should last a long time; pieces that fall apart or lose their color within a few years can greatly damage an artist's reputation.

Beyond consideration of the durability of a work of art, there is another imperative: Artists should have a clear understanding of the materials they are using for quite personal reasons—their own health.

SAFE ART PRACTICES IN THE STUDIO

Many people—the United States Government says 63 million in this country—like to work on arts and crafts projects as hobbies. That is a quarter of the total population, or one person in every other dwelling in America, busy with painting, pottery, weaving, or some other like activity. Unfortunately, many of these people are poisoning themselves through using inappropriate materials, unaware that many of these products contain extremely toxic substances. Working on arts and crafts projects at home can be a source of both fun and chronic ailments for professional artists, amateurs, and especially, children.

Knowing what's in these products is the first step. Federal and state "right-to-know" laws have made this much easier for those artists who have art-related jobs, such as in publishing or teaching. Employers of these artists are required to provide information about the hazards of the products used on the job in the form of special data sheets. These sheets are called "Material Safety Data Sheets," and they include the products' manufacturers and distributors.

Self-employed artists may write to manufacturers for these Material Safety Data Sheets, although in many states the manufacturers and distributors are not required to provide them. Most responsible companies, however, will supply this information.

The data sheets are necessary because art materials labels do not list ingredients. And, until recently, only acute (immediate) hazards had to be listed, such as severe eye damage from splashes in the eyes or poisoning due to the ingestion of small amounts of a product.

In 1988, the federal government enacted a labeling law requiring art supply manufacturers to list chronic (long-term) hazards associated with the product on the label. This enables buyers to make safer choices and, if artists understand the hazards of particular chemicals, they can use the warnings to identify the contents. For example, a yellow material labeled with warnings about cancer and kidney damage is likely to contain a cadmium pigment. A material labeled with warnings about reproductive damage, birth defects, and nerve, brain, or kidney damage may contain lead. (Unlike ordinary consumer paints, artists' paints are still permitted to contain lead.) The table below lists some of the most common toxic materials found in arts and crafts materials.

Toxic Substances in Arts and Crafts Materials

CHEMICAL	ART MATERIAL	MAJOR ADVERSE EFFECTS
Ammonia	Most acrylic paint	Irritates skin, eyes, and lungs
Antimony	Pigments, patinas, solders, glass, plastics	Anemia, kidney, liver, and reproductive damage
Arsenic	Lead enamels and glass	Skin, kidney, and nerve damage; cancer
Asbestos	Some talcs and French chalk	Lung scarring and cancer
Barium	Metals, glazes, glass, pigments	Muscle spasms, heart irregularities
Cadmium	Pigment, glass and glaze colorant, solders	Kidney, liver, and reproductive damage; cancer
Chromium	Pigment, glass and glaze colorant, metals	Skin and respiratory irritation, allergies, cancer
Cobalt	Pigment, glass and glaze colorant, metals	Asthma, skin allergies, heart damage, respiratory irritation
Formaldehyde	Most acrylic paints, plywood	Skin, eye, and lung irritation; allergies; cancer
Hexane	Rubber cement and some spray products	Nerve damage
Lead	Pigment, enamels, glazes, solders	Nerve, kidney, and reproductive damage; birth defects
Manganese	Glass and ceramic colorants, pigments, metals	Nervous system damage, reproductive effects
Mercury	Luster glazes, pigments, photochemicals	Nervous system damage, reproductive effects
Uranium oxide	Ceramic, glass, and enamel colorant	Kidney damage, radioactive carcinogen

The federal law was clearly needed. Many chronically toxic substances are used in art materials, including metals (see table), toxic minerals such as asbestos, silica, and talc and a barrage of solvents. Exposure to these substances in art materials has resulted in many instances of injury to artists and children. Some artists and children are especially at risk because they work at home, where exposure is intimate and prolonged.

Michael McCann, an industrial hygienist and director of the nonprofit Center for Safety in the Arts and Crafts in New York City, found in a survey he conducted that a high proportion of professional artists did their work in rooms in their homes where their families lived and ate.

Half of the artists surveyed said that they worked at home, and half of those work at home in living areas. Even more disturbing than that, however, was finding that 40 percent of women artists with children did their work in living areas, presumably because, when they had children, they lost their art studios.

One finds a strong correlation between parents making art in living areas and the numerous calls to various local and regional poison control centers concerning children swallowing turpentine, pottery glazes, or other toxic substances. It is not unusual for an artist-parent to put turpentine or a similar material in a milk carton or other food container. Children, believing that there is just milk or something else they like in the container, will take a drink from it.

These data are reinforced by findings from other polls and surveys, in addition to individual cases of children who accidentally swallowed turpentine and other toxic art materials. The Centers for Disease Control, in "Preventing Lead Poisoning in Young Children—United States," specifically mentioned home activities involving lead, such as making stained glass or casting lead objects. Working at home with toxic paints, pastels, ceramic glazes, and other materials could be equally hazardous.

Exposure of family members to the toxic effects of art materials can occur in many ways. For example, they can breathe in dusts from pastels or clay, as well as vapors from turpentine and paints or inks containing solvents. Dust and vapors can travel all through the house, and dust may also be ingested when small amounts drift into kitchen areas, contaminating food.

To combat this kind of exposure, parents are generally advised to segregate their art activities in rooms that have a special outside entrance and that are locked to prevent small children from entering. Work tables and floors should be wet mopped regularly. Ordinary household and shop vacuums ought not to be used since their filters will pass the small toxic dust particles back into the air. Sweeping is even more hazardous, for this will cause dust to become airborne.

Running water should be available in the studio. Floors should be sealed to facilitate easy cleaning, and spills must be wiped up immediately. Separate clothing and shoes should be worn and left in the studio to avoid carrying and tracking contaminants into living areas.

Dust and debris should be disposed of in accordance with local, state, and federal disposal laws; one can find out what is required by calling the local sanitation, envi-

ronmental protection, or public works department. These laws vary widely, depending on the type of waste treatment in one's community. Pouring solvents down the drain is against environmental laws everywhere as well as being a danger to the artist and his or her family. Solvents in drains and sewers tend to evaporate, producing flammable vapors in the drain that may cause explosions.

Many communities have a toxic chemical disposal service that will accept waste solvents and other toxic waste created by households and hobbyists (defined for this purpose as people who do not make money from their work). Professional artists may be required to hire hazardous waste disposal companies to pick up their toxic refuse.

Usually, ordinary waste from consumer art paints and materials can be double bagged and placed in the regular trash. Lead metal scraps, on the other hand, can be recycled. Again, one should call local authorities for advice on disposal of art materials, as the fines for violating the laws can be quite high.

Monona Rossol, an industrial hygienist and president of the nonprofit organization Arts, Crafts, and Theater Safety in New York City, recommends that studios be properly ventilated. The ventilation should be tailored to fit the type of work done in the studio. For example, all kilns need to be vented, and there are several commercial systems that can be purchased for them. More complex equipment may require an engineer to design a proper system.

One simple system she recommends for many individual studios requires windows at opposite ends of the room. The window at one end is filled with an exhaust fan, and at the other it is opened to provide air to replace that which is exhausted by the fan. This system should not be used in studios where dust is created, although it is acceptable for painting and other arts activities that produce small amounts of solvent vapors.

The hazards associated with certain arts and crafts materials have been a growing area of concern for toxicologists and others. In a number of instances, the connection between the ailment and the materials is discovered posthumously. Doctors have suggested, for instance, that both van Gogh's insanity and Goya's mysterious illness resulted from ingesting lead paints they used, perhaps by "pointing" their paint brushes with their lips or just by both artists' poor hygiene. Dr. Bertram Carnow of the University of Illinois School of Public Health has speculated that the blurry stars and halos around lights in van Gogh's later works may have been caused by a swelling of the artist's optic nerve, which can be attributed to lead poisoning. Eyewitnesses reported that paint and turpentine covered the clothes he wore and the food he eventually ate. The theory about van Gogh stems from the knowledge that he used large amounts of white lead in his paint and occasionally fixed himself a "cocktail" of absinthe and turpentine and goes against the longstanding view of him as either schizophrenic or syphillitic. Likewise, Goya's bouts of mysterious illness always occurred after intense periods of work.

Children are considered to be at a much greater risk than adults when using hazardous art materials because they have a higher metabolic rate and are more likely to absorb toxic elements into their bodies. Younger children have incompletely developed body defenses, making them more susceptible to disease. One victim, 13-year-old Jon

Glowacki, who died in February 1985, spent a lot of his free time at home working on art projects that involved rubber cement. Rubber cement contains a form of hexane that has been known to cause nerve damage and irregular heartbeat, and Glowacki (according to the coroner who performed an autopsy on him) died from inhaling it.

Adult supervision of children's use of art materials is one way to lessen the risks but, according to Monona Rossol, the underlying rule is that "adult art materials are for adults. Children should simply not be using products that haven't been specifically tested to be safe for them. I've seen very young children using airbrushes and spray-painting, which creates a lot of toxic mists. I've seen kids using solvents that give off vapors that are really neuro-toxins—that is, they are narcotic, because they'll do just the same sort of damage."

For instance, adult permanent felt-tip marking pens as well as many oil paint solvents and varnishes contain these kinds of solvents. Most adult acrylic paints contain ammonia (irritates the skin, eyes, and lungs) and formaldehyde (irritates the skin, eyes, and lungs; causes allergies; and is a suspected of being a cancer agent). Dust from ceramic and sculpture clays contain lung-scarring silica and talc.

Children should use only water-based markers, water-based paints, and clays that are low in silica and talc free. Clays and paints should always be purchased and used premixed to avoid children's exposure to the powder or dust. In addition, all art materials for children should be known to be safe, such as dustless chalks, oil pastels, and dyes using vegetable or food coloring.

The Arts and Creative Materials Institute (100 Boylston Street, Boston, MA 02116, tel. 617-426-6400) has a list of products they have approved for children that includes all these kinds of materials. For additional information, one may contact Arts, Crafts and Theater Safety (181 Thompson Street, New York, NY 10012, tel. 212-777-0062, *www.caseweb.com/acts/*) or the Center for Safety in the Arts (2124 Broadway, New York, NY 10023 or c/o New York Foundation for the Arts, 155 Avenue of the Americas, New York, NY 10013-1507, tel. 212-366-6900, ext. 333, *www.artswire/1/Artswire/csa/*).

SUBSTITUTE INGREDIENTS IN ARTISTS' PAINTS

As noted above, federal law has been enacted to require art supply manufacturers to label the potential chronic health risks from ingredients in their paints and other products. That may answer questions, such as What is in the materials I use? Which known health risks do I face? But, sometimes, answers don't resolve problems as much as lead to more questions. Of course, the manufacturer's label may not answer the health questions unless known chronically hazardous ingredients are present.

What many have discovered in examining the new, more inclusive labels is that some of these supplies contain synthetic and substitute ingredients instead of what they believed they were buying. What painters thought was cadmium in a tube of paint actually, in many cases, was napthol or thioindigold red; similarly, "cobalt blue" doesn't contain any cobalt at all but, rather, contains ultramarine (itself now a synthetically produced

pigment), phthalocyanine blue, or something called "Pigment Blue 60." Lemon yellow is another pigment that, traditionally composed of barium yellow, is now nickel titanate.

What happened to the real stuff? The fact is, industry officials state, until labeling became a common practice, artists were not aware that the colors they were using might not be what the labels said they were. In the past, art supply makers took the position that substitutions were implicit. They said, in effect: "Look what we're charging. No one would think it's real cadmium at that price." Now, there is a different system.

That system, established by the American Society of Testing and Materials, is to call pigments "hues" when they contain substitute ingredients but still use the generic designation of, for instance, "cadmium red" or "cobalt blue." Some laboratory-created colors, of course, have long been known to contain substitute ingredients. Included are pigments marketed under company names, such as "Winsor & Newton Red," or sold under traditional names, such as "Naples Yellow." Historically, Naples Yellow was lead antimoniate, but most companies have reformulated this color from mixtures of other pigments for safety and economic reasons. The "hues" are a newer phenomenon.

To a significant degree, substitute pigments are a result of permanency and price. Certain colors, such as alizarine crimson or Hooker's Green, are terribly fugitive and tend to fade quickly. The color ingredients used to replace the traditional pigments are said to make these colors much more permanent. The cost of other pigments, such as cadmium and cobalt, for example, has become so high that some artists wouldn't be able to afford them.

High prices for certain materials are due to either scarcity or huge demand (or both). Cadmium, for instance, is used in batteries and for processing diamonds, while cobalt plays a role in tempering blades in jet engines and is used in nuclear devices and cobalt therapy. The major sources for cobalt also happen to be the republics of the former Soviet Union and Congo (Zaire), where export is not an inexpensive or simple matter.

Prices for the synthetically produced "hues" are between two thirds and one half the cost of the real thing. In one art supply store, the retail price for a small tube of Winsor & Newton Cadmium Red Medium was twice the cost of its Cadmium Red Hue, and Liquitex's Cerulean Blue cost 30 percent more than the Cerulean Blue Hue. The permanency rating for the "hues" is largely the same as the traditional colors they might substitute for—Wendell Upchurch did point out that "ultramarine is not as permanent as cobalt in the 'hue' form"—and the colors will not be identical.

The cadmium red hue and the cobalt blue hue, for instance, shift a bit to the violet, while phthalocyanine sometimes shifts to green. If they choose paints with synthetic ingredients, artists will pay less, but they'll have to be more observant, correcting the color shifts by adding yellow to the cadmium hue and green to the cobalt hue. The hues are not the same, and artists find themselves having to work harder to preserve what they thought they had.

Perhaps between 20 and 30 percent of all professional artist paints contain synthetic pigments, increasing to perhaps 40 percent for supplies just under artist grade, with almost all student grade paints being substitute ingredients.

The substitute pigments clearly have benefits and some drawbacks—or, at least, give rise to new battles among art supply manufacturers. The more expensive iron oxides, such as burnt siena, Indian red, or yellow and raw umber, are literally dug out of the ground and tend, because of their source, to have impurities. The lab-created pigments, on the other hand, have few impurities and also a higher tinting strength, requiring the addition of inert pigments—such as aluminum hydrate, berium sulphite, and calcium carbonate—to tone down the color. The result is that the new generation of paints tend to have less cadmium in cadmium, less cobalt in cobalt, with other ingredients added—such as enhancers or toners—for opacity, body, consistency, brightness, and value and to eliminate excess oil. All this requires artists to assume less about the paints they use and to learn more about what goes into their supplies.

This becomes a problem because not all manufacturers of artists' materials label their products in the same way. Part of the system established for labeling by the American Society of Testing and Materials requires manufacturers to list on the product label the enhancers used when they comprise more than 2 or 3 percent (by volume) of the material. Not all American companies, however, subscribe to the ASTM standard, and few European suppliers do. The result is that artists may find themselves purchasing what is labeled pure cadmium but that actually contains a considerable amount of toner (dye color). It is a concern for which few artists or hobbyists are prepared.

"In the old days, artists learned chapter and verse what you can and cannot do with materials," George Stegmeyer, artist consultant to Grumbacher, the paint manufacturer, said. "That aspect of art training has been largely eliminated from our culture, replaced by the intellectual and theoretical aspects of becoming an artist."

Only a handful of schools—the school of the Art Institute of Chicago, Boston University, University of Delaware, University of North Carolina at Greensboro, the Pennsylvania Academy of Art, and Yale University School of Art among them—offer courses on art materials, instructing students in the composition of the products they use and their durability. Artists who are accustomed to simply purchasing materials at a store and assuming that everything is basically the same as it always was find that they have more information (through the product labels) but not necessarily the ability to understand it.

Permanence and price are not the only factors that have led to the use of synthetic pigments, according to various people concerned with art materials. "I think the health concerns about some of the heavy metals have definitely resulted in, or at least accelerated, the use of substitutions," Michael McCann stated. "You have cadmium and the cancer question, and then there's cobalt and manganese. Companies now have to put warning labels with them. It's better to try to find a substitute, and they get to save money at the same time."

There will probably never be a return to nineteenth-century paints, and few artists would want it even if it were possible. Today's materials are purer, more affordable, and permanent, more buttery in texture, less damaging to one's health, and available in a far wider range of colors. Still, synthetic substitutes are not the same as the original pigments,

and artists can be a traditional bunch. Barium, for instance, is often used with cadmium, screening out ultraviolet light and thereby making the color more permanent but also reducing the tinting strength. The victory for permanence is potentially an uneven one. New concerns about what they are using are the price artists must pay for progress.

Increasingly, artists should refrain from making assumptions about the materials they purchase; instead, they ought to contact the manufacturers—specifically, the technical advisors at those companies, if the customer service representatives cannot answer detailed questions—to obtain a fuller understanding of the products.

A Primer on Paint Labels

What information should be on the label of a tube of paint? Presumably, prospective buyers would want to read about what is inside the tube, such as the pigment, medium (oil or acrylic, for instance), other admixtures (additives, binders, coarse particle content, extenders, preservatives), and the durability (or lightfastness) of the product. As noted above, art supply companies are also required by federal law to indicate which ingredients are known to cause either acute or chronic illnesses ("has been shown to cause cancer"), what those ailments are, and how the product should be used properly, as well as the name, address, and telephone number of the manufacturer.

Unfortunately, not all art supply makers provide all this, and many offer bits and pieces of information, often using proprietary names and terms or codes that mean different things to different manufacturers.

The hues and proprietary color descriptions are obviously one example. Most tubes of artist paints include a number that corresponds to a standardized *Color Index*, a nine-volume reference that is jointly produced by the Society of Dyers and Colourists in England (P.O. Box 244 Perkin House, 82 Grattan Road, Bradford, West Yorkshire BD1 2JB) and the American Association of Textile Chemists and Colorists in the United States (1 Davis Drive, P.O. Box 1215, Research Triangle Park, NC 27709-2215). This reference is expensive, costing $900 in a hard copy and $1,300 on CD-ROM, but it may be found in technical and art libraries. It lists by C.I. (color index) the name and number of all commercially available dyes and pigments and their intermediates. You also may contact the American Society of Testing and Materials (ASTM, 100 Barr Harbor Drive, West Conshohocken, PA 19428, 610-832-9500) for precise descriptions of pigments and the durability of pigments. For alkyds, oils, and resin paints, the specifications are contained in ASTM D-4302; for watercolors, ASTM D-5067; for acrylics, ASTM D-5098. Each ASTM standard costs $12. Artists may want to write to the manufacturers when tubes do not indicate the color index number or that number is not clear. The label for Liquitex's Cadmium Red Medium, for instance, says "Munsell 6.3 R," which is the index number (the R refers to a shift to the red).

Permanency ratings is another area in which one might contact the manufacturer for more information if the label is not clear or decipherable. The American Society of Testing and Materials rates paints I, II, and III for their resistance to fading in daylight, or lightfastness, with I the most resistant. Liquitex follows the ASTM format in its light-

fastness ratings, but Van Gogh ratings are +++ and ++, with +++ the higher degree of lightfastness and ++ what the company calls "normal degree of lightfastness." Rembrandt lists lightfastness, starting with the most permanent, as A, B, C, and D. Winsor & Newton has two different rating systems: ++++, +++, ++, and +; and AA, A, B, and C (++++ and AA are the most lightfast).

The ASTM standards are quite useful in terms of understanding the actual color, performance, and quality of an art product. Unfortunately, Mark David Gottsegen, a member of the committee on artists' paints and related materials at ASTM, stated that "very few companies are conforming to these standards. You pay $12 for a standard that few companies bother with."

Part of the system established for labeling by the American Society of Testing and Materials requires manufacturers to list on the product label the enhancers used when they comprise more than 2 or more percent (by volume) of the material. Not all American companies, however, subscribe to the ASTM standard, and few European suppliers do.

The paint's durability, as well as its color index name and number, are optional for manufacturers to include on the product label, but health and safety information is not. Since 1990, the federal Labeling of Hazardous Art Materials Act requires that all art materials sold in the United States include a conformance statement ("Conforms to ASTM D-4236") that ensures the manufacturers submitted its product formulas to a board-certified toxicologist for review. The toxicologist determines what labeling is required under the standard. Also required is a telephone number in the United States from which additional information may be obtained. There are a number of board-certified toxicologists working with art materials companies. Many companies subscribe to the labeling program of the Boston–based Arts and Creative Materials Institute: "AP Nontoxic," "CP Nontoxic," and "Health Label" seals appear on the labels of their paints. Both "AP" and "CP" indicate that the Institute certifies the products are safe even for children ("AP" specifically refers to nontoxicity, while "CP" includes both nontoxicity and performance requirements); "Health Label" signifies that the warning label on the product has been certified by an ACMI toxicologist and, if hazards are found, appropriate warnings are printed on the label. After review, the institute's toxicologist can allow the product to carry one of its seals. However, the same paints may be sold by a mail order company but without the ACMI emblems to indicate their safety.

Very small tubes of paint are exempted from including most of the required federal labeling. The safety information on a tube of Winsor-Newton cadmium red watercolor paint, for instance, was condensed to three words—"Warning: Contains Cadmium." By this standard, a cigarette pack might simply inform buyers that the product contains tobacco.

The appearance of a conformance statement and a health label does not instill confidence in every art product user that all acute and chronic health risks are identified and described. According to the U.S. Public Interest Research Group, which issued a report in October 1993 entitled "Poison Palettes: The Lack of Compliance of Toxic Art Supplies with Federal Law," the question of nontoxicity is a loophole-filled designation, and the

labeling law is itself buffeted by insufficient compliance. The report found that warnings about chronic health hazards and the manufacturers' telephone numbers were frequently missing from the product labels.

"Art materials are not as safe as many people have been led to believe," said Bill Wood, a researcher for the research group and author of the report. "Many products may be labeled nontoxic if they have never been tested for toxicity. The Environmental Protection Agency has complete test data on only 22 of the more than 70,000 chemicals produced by chemical manufacturers in this country. To call something nontoxic when you don't actually know is misleading."

Monona Rossol added that "a benzidine dye that hasn't been tested can still be marketed as nontoxic, even though it breaks down to free benzidine in the body, which is well known for causing bladder cancer as well as other diseases."

The "ASTM D-4236" on the label is supposed to mean that the toxicologist has reviewed the product's formula but, Rossol said, "there are mislabelers out there that just put this on the label. Artists should choose to buy paints from one of the large, reputable companies that has the proper label."

However, Woodhall Stopford, a consulting toxicologist for the Arts and Creative Materials Institute and director of the Occupational and Environmental Safety program at Duke University Medical Center, claimed that the U.S. Public Interest Research Group report was flawed in that it made no distinctions between higher risk, industrial uses of art materials, such as spray painting an automobile, and the more limited exposure in art making.

"With fine art materials," he noted, "you are dealing with amounts so small that the risks—even assuming that a child is going to be using the product, and ingesting, inhaling, or having it in contact with skin on a daily basis—are minimal."

EXPERIMENTING WITH MATERIALS, TAKING CARE OF ART

Knowing what is in the materials artists use is half the battle; the other half is knowing how to use these materials properly so they hold up over time. Aubrey Beardsley once commented that "a painting starts to disintegrate as soon as the artist puts his brush down," but some works last far longer than others. The work of an unknown and forgotten artist often languishes in the attic, subject to extremes of heat and cold, and neglect is the major scourge of art collections. Paintings of greater esteem and value are accorded more and better care but, still, some works are born trouble.

Early in his career, Spanish artist Antoni Tapies loaded up his oil paints with sand and other gritty material to give his paintings a sculptural quality on the canvas. A nice idea, except the canvas couldn't support all the weight, and the medium simply fell off time and again. As one of Tapies' former dealers noted, "it would just fall on the floor. You would sweep it up with a broom and send it back to Tapies who would put it back together again."

The maintenance problems of most contemporary artworks are not as extreme, but there is cause for some alarm. Much of the most important art created since the end

of World War II involves extensive experimentation, not only with style but with media. The whole concept of "action painting" (as abstract expressionism was labeled by critic Harold Rosenberg) was to get something down quickly, without undue concern for a finished job. In contrast, Picasso and Kandinsky both broke artistic ground by moving away from identifiable imagery, but their techniques were basically traditional.

The artists of the New York School of the 1940s and 1950s, on the other hand, eliminated all recognizable images from their works and heightened the emotional effect by mixing in various materials with their paints—dirt, metals, sand, wax, and more. Artists such as Mexican muralist David Alfaro Siqueiros and French cubist Fernand Leger both did paintings on burlap. Chagall made designs on bed sheets and Franz Kline, perennially short on cash, used house paints and occasionally worked on celatex board—a low-grade paper pulp. Their intention was to achieve different textures and effects without regard, it seems safe to say, for future conservation. For these artists and their followers, the surface of a painting became an integral part of the overall aesthetic statement, and there the problems began.

The introduction of new materials, the admixture of materials, and a fair amount of experimentation by artists have made many new movements in the arts possible, but the works of art frequently have been enfeebled as a result. Many works have what art conservators call an "inherent vice," something that will make them come apart.

Acrylic paints were first introduced in Mexico in the 1940s, finding their way into the United States in 1953. The durability of acrylics has been widely debated since then. Acrylics are actually pigments suspended in an emulsion of water and acrylic polymer (or plastic). The drying process is considerably faster than with oils, permitting artists to work more quickly and with a lighter material. Joy Turner Luke, a member of the technical committee of the American Society of Testing Materials, noted that "acrylics may not deteriorate as much as oils. There are chemical changes that go on for some time with oils but, with acrylics, these changes are over right away. Oils embrittle as they get older and often darken or get yellow. The canvas itself absorbs moisture and, as it dries, it moves a little. That movement can create cracking in an oil painting. Acrylics, on the other hand, keep their color and are able to 'breathe' much better and remain flexible longer."

The chemical changes that take place with oils are a process of oxidation, which may last sixty or seventy years. Over time, oil paints become stronger, less soluble, and possibly darker, as the linseed oil (which is their base) may cause the picture's colors to darken to a degree.

It is probably impossible to determine how much longer than oils acrylics could remain flexible, since oils have been around for centuries and acrylics have been with us only forty or fifty years. Luke's faith in acrylics is based on industry-held accelerated aging tests in which paints are exposed to high heat in coordination with high humidity and high ultraviolet light for periods of time. It's almost the definition of an educated guess.

Others in the conservation field are not as convinced about the long-term durability of acrylics, claiming that they don't dry as hard as oils and, thereby, are more diffi-

cult to clean. They can also freeze in subzero temperatures and shatter like glass. In addition, acrylics are sometimes found to powder on the surface of the picture.

The cleaning problem is a serious one for conservators. Lucy Belolli, a conservator at the Metropolitan Museum of Art in New York City, stated that acrylics "naturally draw in more dirt than oils" and are harder to clean, since "they are soluble in certain cleaning solvents, which can affect the paint. It's true even with synthetic solvents." Belolli added that applying varnish, which protects the outermost portion of a painting, becomes an ethical question with acrylics since, unlike oils, it is almost impossible to remove varnish from many acrylics. "It's a life decision you are making," she said.

Another potential problem with acrylics is their sensitivity to heat and cold. However, for most conservators, the issue is not so much oils versus acrylics, but the admixtures of media and materials that were improperly used. A large number of Andrew Wyeth's paintings developed considerable flaking, for instance, because the artist made mistakes mixing gesso and egg tempera. There have also been many problems with paintings by Willem de Kooning because of the artist's mixing of safflower oil and other materials with his paints. De Kooning wanted to make his medium buttery and sensuous—a perfectly acceptable intention—but that makes it difficult for the paint layer to dry.

Other problematic admixtures involve oil and acrylic paints, which generally don't bond well, and even successive coats of acrylic paints, if too much time elapses between one and the other. The different rates of drying—or contracting movement between successive coatings—inhibits bonding, as does any dirt that may attach itself to an undercoat. When a canvas is not (or is improperly) primed, the result can also be troublesome. When this chemical bonding does not adequately take place, flaking may result and, later, surface cracking.

Protecting Watercolors

Watercolors by their very nature have an even shorter life span than oil paintings or sculpture. The colors fade, the paper rots or gets eaten by insects. Over the long run, the collector—the person with the responsibility to properly mat, frame, store, and display the work—is usually the one at fault. Still, artists can do a great deal to create pieces that are not likely to deteriorate soon after leaving the studio.

First, they can purchase and use the most durable, high-quality materials available. For instance, their paints should optimally be made of mineral pigments, which hold their color longer (as they are chemically inactive) than those created from organic chemical dyes. However, mineral paints are not available in every color—they tend to be darker earth tones—and artists will probably have to use vegetable dyes.

Certain paint manufacturers, such as Winsor & Newton and Rembrandt, provide permanency ratings for their products, listing them as A (absolutely permanent), B (mostly permanent), C (utilitarian), and D (absolutely evanescent). An artist can also test the paints' durability by applying paint to paper, cutting the paper in half and putting one part in a window with a southern exposure for a few weeks or months and

the other part in a dark drawer. At the end of the test period, the degree of fading should be evident. Another aid to permanence is using the same brand of watercolors for any given piece, since manufacturers create their own chemical balances, which vary from one company to another.

No less important than the paint is the paper, which is made from wood pulp, cotton, linen, or some combination of these. Just as with paints, paper should be tested, using the window-and-drawer method or even baking it in an oven to age it artificially.

Another simple test is to run a wet brush over a piece of paper to see how much it buckles. A very heavy paper won't react as much as lighter paper to changes in the environment. One may also look to a heavy paper—140 pounds and up—when using a very thick watercolor, which tends to crack with the movement of the paper. Heavy paper is also a good choice when the work is moved a lot.

The main signs of trouble with an artist's paper are discoloration or overall darkening, as well as embrittlement, which are often the result of acids in the paper breaking down the cellulose polymers that hold the paper fibers together and make them flexible.

Acidity becomes a part of, or can attack, paper in various ways. Unrefined wood pulp is high in acidity and will cause yellowing in a short period of time (most newspapers are 80 percent unrefined wood pulp). Other internal problems that may damage the paper are due to chlorine from the bleach that wasn't completely rinsed out of the paper when it was washed. Sizing agents, which are used to give paper its absorbency and surface character, can leave behind metallic (that rust) or organic particles (which form fungus), and brighteners (which make the paper look very white) that also may leave behind chemical compounds.

Air pollution (acidic gases) is another cause of paper deterioration, as is contact with poor-quality framing and matting materials (acids in these discolor the paper where they come into contact). Of course, spills of coffee, oil, tea, or water may also lead to deterioration and staining. It is advisable for artists to maintain a clean workplace and for collectors to protect pieces from young children and their own clumsiness.

Leslie Paisley, paper conservator at the Williamstown Regional Conservation Laboratory in Massachusetts, recommended that artists "store their paper in a dark, acid-free environment; they should never leave their paper outdoors. I've seen instances of artists buying very good paper but, by the time they're ready to use it, the paper is all discolored from having absorbed too many acids from the environment."

She added that another way artists inadvertently damage their own paper is soaking it in tap water—a traditional technique that makes the paper more flexible so that it can be taped down on a drawing board. Distilled water should be used and the water ought to be changed daily. Water from a household tap may contain acidic minerals that will stain the paper or cause fungus. The same is true for water used to moisten the colors on the artist's palette or for a sponge that is used to keep the paper or the brush wet.

Other dangers for all works on paper are insects and rodents, which like to eat them. As insecticides may damage the paper, conservators generally advise collectors to store works on paper away from places to which these pests can gain access.

The remaining problems that may affect watercolors—overexposure, poor quality matting and framing, heat, light, and humidity—are often controlled by collectors rather than artists, but they still are important concerns for watercolorists who frame and display their own work. In addition, artists may want to advise collectors on proper handling techniques.

For instance, room temperature should be maintained between 60 and 75° Fahrenheit and the relative humidity (which can be measured with a hygrometer, a device carried by certain hardware stores and costing as little as $25) between 45 and 55 percent. In that humidity range, mold cannot grow.

All mats and backing, which provide physical support to the work, should be acid free. Cotton rag board, buffered rag board, and conservation board are all terms for these cardboard supports that are pH neutral or slightly alkaline to protect the watercolor from external acidity. A wood pulp mat, on the other hand, would damage the paper.

The backing itself should be thick, to protect against accidental puncture, while the matting (an internal frame, composed of acid-free paper or rag board with a carved-out center) should be deep enough to provide a layer of air between the work itself and the glass on the frame. Condensation on the glass may result in mold growth if the paper and glass touch (and adhere). That touching may take place if the paper buckles due to changes in humidity, even when the work is correctly matted. To prevent this from happening, conservators often suggest double matting the picture to increase the space between the paper and the glass. They also recommend that glass be an acrylic Plexiglas, which reduces harmful ultraviolet rays.

Various companies around the country produce archival, or tested acid-free, materials and will supply catalogs of what they offer. Artists should contact a local museum conservator (they don't mind being asked), who can recommend the names and addresses of companies with which he or she has worked. It is wise for artists to understand how to protect their own works and, when discussing them with current or potential buyers, to note basic points of conservation that will keep the art looking new as long as possible. Art dealers almost never bring up such matters, fearing that the mention of artwork fading or needing special attention will turn off collectors. What is more likely, however, is that collectors whose works on paper turn yellow or fade will be reluctant to purchase more works from the artist again.

Balancing Artistic Experimentation and the Market for Art

Conservators would not have their hands so filled with art requiring extensive repair if artists used archival materials to begin with. Franz Kline, for instance, painted on the Yellow Pages, and Jackson Pollock occasionally used shirt cardboard. They probably did not expect these pictures to last for the ages, but collectors, who spend large amounts of money for works by these artists, do. It behooves both the artist and the collector, therefore, to proceed with greater care.

"There are a lot of masterpieces out there that weren't created archivally," Margaret Ellis, consulting conservator at the Metropolitan Museum of Art in New York

City, said. "Think of Picasso's collages. If Picasso had called up a conservator and said, 'What do you think of sticking some cut-out newsprint on a piece of paper?' the conservator would have died."

Artists usually do not see themselves as creating works for posterity—this was certainly part of the aesthetic of graffiti art—as longevity is more a concern of the marketplace than the studio. Collectors naturally expect to have the artworks they have purchased in good condition for a long period of time. Robert Rauschenberg is one who "didn't take any particular pains with a lot of his earlier pieces. He just stuck things on with glue," said his biographer, Calvin Tomkins. "At that time, he felt that the work itself is ephemeral, and that it's the process that is important. I don't think he feels that way now. He has a lot of people working for him now who make sure things are put together right." Among the more problematic Rauschenberg pieces are a silkscreen painting called "Sky Way" (created originally for the 1964 World's Fair and currently in the Dallas Fine Arts Museum), whose screening has flaked off, and the stuffed goat in the inner tube called "Monogram"—probably his most famous piece—which has attracted (among other things) lice.

The desire to have art last a long time creates ethical questions for artists, dealers, and conservators. Should a dealer charge the same price for a work that is likely to need extensive restoration in the not-too-distant future as for another that will hold up better? To what degree should a likely buyer be informed of the potential problems? For conservators, the surface of the work is where the problems are, but in many modern and contemporary artworks, the subtle surface characteristics are part of the aesthetic statement. The conservator is compelled to re-create this, but will the end result be the same work of art?

As a practical matter, however, artists should consult with a museum conservator about the kinds of experiments that they are performing and test their works for light-fastness and basic durability before putting them into the market. Artists need to balance their desire to experiment with their materials with the interests of their collectors whose good will is required to maintain a career over years.

9

GETTING READY TO
HANDLE THE PRESSURES

The life of a visual artist is frequently one of continual pressure and tension. Like lawyers, doctors, and other highly skilled professionals, they must live solely by their wits; yet, unlike these professionals, there are no prescriptions, laws, or standard rules on which they may rely—artists must forever chart their own paths, both artistically and careerwise.

The best art tends to be a "catharsis" (to use Aristotle's definition), a spiritual renewal, and it is often a wonder that it can be created at all. Artists are pulled by many conflicting needs. On the one hand, they are creating an intense moment—the art itself—yet their intensity is disrupted by the need to do some kind of work, often unrelated to their skill as artists, in order to survive. They may receive no recognition throughout their entire careers, but they must maintain their personal identity as artists and not let bitterness interfere with their ability to work.

Artists always live with the knowledge that many are called and few chosen; they suffer the agony of self-reliance, as their subject matter, especially for those whose realm is nonobjective art, must come full-blown out of their own heads. They take chances and risk public ridicule; they often feel guilty about "selling out." Small wonder, then, that many artists seek psychological counseling. Certainly, a large segment of society already views artists as mentally defective.

Learning how to handle the pressures of creating art or of being an artist is something each creator must do for him- or herself. For example, when painter Philip Guston wanted to obliterate all the art history he had filling his mind and forget the work of other artists in order to ready himself for something new, he would take in a double feature.

"I generally clean the house a few times, go shopping," painter-sculptor Lucas Samaras said about his own method, "all sorts of stuff to wipe my consciousness clean of what everyone else is doing."

Other artists have been more self-destructive when responding to pressure, often with the view that such behavior enhanced their art. Alexander Calder overate; Pablo Picasso vented his anger on women; Jackson Pollock and Franz Kline got drunk; Jean-Michel Basquiat took drugs. Some artists, such as Arshile Gorky, Mark Rothko, and Vincent van Gogh, simply found the pressures on their lives too great to be borne.

Some ways of handling talent and artistic pressures are clearly preferable to others. Unfortunately, stories about self-destructive artists have given the world an image of what an artist is and does, and many younger artists seek to live up to the bohemian image. The likelihood, however, is that this leads to more ruined lives than good art.

In his study, *The Thirsty Muse*, literary historian Tom Dardis wrote, "what a number of . . . great talents have sought in [alcohol and] drugs: an altered state of consciousness that permits the artists a freedom they don't believe they possess in sobriety. The fact that this freedom is illusory is beside the point; many artists have convinced themselves that they obtain it in no other way."

Clearly, it is important for artists to know some of the potential pressures they will be facing in their lives and careers so that they may be prepared.

CHANGING YOUR STYLE

During the winter of 1906 and 1907, Pablo Picasso painted "Les Demoiselles d'Avignon," a work that was a breakthrough for both figurative and cubist art. Drawing on African influences and defying Western art's tradition of visual perspective, Picasso developed a style that appears to present a clumsy relationship between parts but that actually creates its own more personal order.

For thirty years after its creation, however, the "Demoiselles" was almost more legendary than real, as few people had actually seen it, although more had heard of it. Having received some initial criticism and fearing that people would not understand the painting, Picasso turned the canvas to the wall and only the few who came to his Paris studio—artists and dealers, mostly—ever saw it until its first public exhibition at the Petit Palais gallery in Paris in 1937.

Most artists won't wait 30 years before showing their developing art, but if their work is well-known and they change their style, they may easily understand Picasso's reluctance to exhibit the "Demoiselles."

Style has become all-important to an art market where investments, high prices, and the desire by dealers and collectors to "package" an artist in a particular mode or school have been paramount. Up and coming artists are given major media attention early—Frank Stella was only 34 when the Museum of Modern Art in New York City held its 1970 retrospective of his work—and less time is permitted for an artist to develop and formulate ideas.

How an artist changes his or her style and to what degree are questions as significant to buyers and sellers of art as the specific content or formal qualities of a work. Most artists see changes in style as part of an evolution and not as a radical departure, with the change reflected in the form works take but not in their basic meaning. Pressures

to change or not to change come from a variety of sources, including friends and peers, critics, collectors, dealers, and of course, from within the artists themselves.

One of the most notable examples of an artist leaving a successful style to work in a different manner is painter Philip Guston, who died in 1980 at the age of 66. Originally a social realist, heavily influenced by Mexican revolutionary painters David Siqueiros and Diego Rivera (who himself started out as an orthodox cubist painter in Paris), Guston switched to an abstract expressionist style in the 1950s. Lauded for this abstract work by critics, collectors, and peers, he shocked many when in 1970 he returned to the more figurative, albeit cartoonish social realist style of his youth.

No works sold from his 1970 show at the Marlborough Gallery in New York City and the gallery quickly dropped him from its roster. Some fellow artists were quick to register their disgust with Guston, capped by a *New York Times* review of the exhibit that concluded, "In offering us his new style of cartoon anecdotage, Mr. Guston is appealing to a taste for something funky, clumsy and demotic. We are asked to take seriously his new persona as an urban primitive, and this is asking too much."

Guston himself was "uncertain about his own works and somewhat fearful to show them," according to his dealer, David McKee. "He was worried about what people thought as no one knew what to expect." McKee noted that Guston needed "more nourishment from his own work than abstraction allowed" and looked to bridge the separation of art from social realities for his own survival as a painter and for the survival of painting as a serious activity.

Guston's two dramatic changes in style were not, however, complete breaks in the entire body of his work. There are clear similarities in the palettes for the various phases of his work, and he was always searching to revitalize painting. The differences, however, were what got pointed out, drawing the sharpest criticism.

Guston was deeply affected by the negative response of many of his peers and was quite grateful that his friend of many years, fellow painter Willem de Kooning (who himself went back and forth between total abstraction and elements of figuration), liked his work, assuring him in the midst of the storm that "this is all about freedom."

Freedom is an essential ingredient of the best work, but many artists claim that their freedom is limited by outside forces influencing how they change their style and in what direction. Artists tend to point the finger at dealers.

"When you are talking about art as a commodity, dealers are mainly selling a look," stated Sol Lewitt, whose own art has ranged from painting to minimalist sculptures to "wall drawings." "If you change your look, dealers have to resell the artist all over again. This is all about product recognition."

"Changing a style really means changing an audience," painter Alex Katz said. "If an artist has a small audience, changing a style is no problem. If he has a large audience, then many people become upset. Dealers are in the commodity business and generally are concerned with keeping the same look year after year."

The ways in which dealers may put pressure on an artist are usually quite subtle. Regular exhibitions may not materialize, for instance, or dealers may relay criticism

from "potential collectors." The result is that many artists are pushed to do the same work again and again. Sol Lewitt noted that dealers will say to him about his newer work, "'I like it, but I really like the work you were doing from 1967 to 1974' or something like that. What I usually tell them is, 'You'll get used to it.'"

For other artists, the greatest pressures come from peers. Artists often feel that the only other people who know anything about art are other artists. Philip Guston was far more hurt by the unfavorable reaction of his peers than by critics or collectors, and he responded with anger and rejection. In general, however, artists criticize each other in the form of silence.

Sculptor George Segal stated that his artist friends are his toughest audience and that they have gotten the most upset over every change he has made in his work over the years. Renowned for his white plaster cast sculptures of human figures in common outdoor urban settings, Segal said that "when I began introducing color a number of years ago, friends said, 'Don't give up white!' They complained that I was changing their idea of what my sculpture was." He added that "if you have the nerve to withstand criticism from close friends, you can stand it from anyone."

At times, collectors, dealers, and critics may react quite sharply to changes in an artist's work, as though aiming to confine that person to a single style. Guston's work from all his periods now sells quite well, and many of his paintings hang in museums around the country, but the negative *New York Times* review of the 1970 show greatly affected sales at the time.

Clement Greenberg is often cited by artists and dealers as the archetypal critic-strongman, emphatically promoting a certain style of work and scorning all others. Willem de Kooning claimed that he once threw Greenberg out of his studio after the critic pointed at various canvases, saying "You can't do that. You can't do that."

For his part, Greenberg stated that the influence of dealers and critics has been greatly overplayed in discussions of what artists do. Noting that nobody now worries about what critics said about Matisse or Courbet, he said that the pressures that "make artists do less than their best" come from within. These include being afraid of having their work look different than it has in the past because it will sell less, "or it may just be a fear of their own originality. Artists will change anyhow. I've never known an artist who works dishonestly."

Art collectors are no less a part of the equation and may also react favorably or unfavorably to changes in an artist's style. Many dealers, aware that collectors frequently lag behind artists in terms of style changes, promote prints in the styles with which these buyers are more familiar, allowing their artists time to evolve.

Most artists have made some significant changes in their art at some time in their careers, although few do so when their careers have reached a pinnacle. Of course, there are some exceptions. Picasso had half a dozen distinct "periods," and de Kooning shocked many when, for a time in the 1950s, he left behind his totally abstract pictures to do his "Women" series. The look of Frank Stella's painting also changed radically in the 1970s, losing its flat linear appearance and becoming more gestural

and three-dimensional. However, all three artists were well enough established that their careers did not suffer and, in fact, were enhanced by the changes and evolution in their work.

Unless there is some movement in an artist's career, his or her work will tend to fall into a decorative vein or just be repetitive. Even though art is usually seen as a calling for the very sensitive, it is not a profession for the thin-skinned. Artists whose work suffers because they have succumbed to the demands of market or who cringe from possible criticism and never experiment have no one to blame but themselves.

HANDLING CRITICISM

It's the cry of every scorned artist—"The critics hated the Impressionists, too!"—but the claim is only partly true. Within a decade or so of their first major exhibitions, the critical tide had turned in the Impressionists' favor, especially as unceasing stylistic developments within the School of Paris soon made the work of Monet and company look relatively tame. By the time he was in his late seventies, Monet was lionized, an acknowledged Old Master of modernism.

In his eighties, Andrew Wyeth is still scorned by almost all the major art critics, perhaps for being the Old Master of "un-Modernism." Wyeth's painting, according to critic Peter Schjeldahl, is "formulaic stuff not very effective even as illustrational 'realism'"; and Robert Storr, curator of contemporary painting and sculpture at New York's Museum of Modern Art, wrote of Wyeth as "our greatest living 'kitsch-meister.'" Hilton Kramer, editor of *The New Criterion*, has complained about Wyeth's "scatological palette," a comment echoed by critic Dave Hickey who referred to Wyeth's palette of "mud and baby poop." *Time* magazine's Robert Hughes disparagingly described Wyeth's art as suggesting "a frugal, bare-bones rectitude, glazed by nostalgia but incarnated in real objects, which millions of people look back upon as the lost marrow of American history."

Andrew Wyeth claimed that he is "not bitter" about the quantity and intensity of negative criticism he has received "because I've been so successful in my career." However, he stated that since the public attention and critical firestorm that met his "Helga" series of paintings and drawings in 1986, "there has been a real dampening of interest in me. I don't feel I'll ever get another favorable review in my lifetime."

He claims to read everything that is written about him, "which is nowadays absolutely negative," and that he has never "developed a thick skin. Negative criticism really knocks you flat, like a stiff haymaker to the midsection. So much of it is so unfair."

Wyeth is anomalous in the art world, vastly popular with the public and unanimously condemned by critics. Most successful, better-known artists have enjoyed a far more favorable balance of positive and negative reviews, but the example of Wyeth points up the degree to which critics and the public are wide apart in their appreciation of artwork. Who's right is not the issue, but a review is likely to have different meanings for readers, critics, and artists. Artists themselves have the most complicated relationship with write-ups of their artwork.

Artists, especially those who have achieved some recognition, tend to shrug off negative reviews of their work and stress how it's more important to concentrate on your own art. "That's part of the game." "It just makes me laugh." "I don't care what they say as long as they spell my name right." However, not far below the surface, anger at some art critic or critics in general lies waiting to be tapped.

"One reviewer said about my work, and I'm paraphrasing, 'Is this art? Why did someone go to the bother to make this thing?'" sculptor Donna Dennis said. "Another time, a critic with a Marxist point of view said that the scale of my work suggested the upper classes looking down on poor people. My problem with art critics is that they often have a set point of view to which they want your work to conform, and they refuse to open their minds to see where you're coming from."

For his part, painter Leon Golub noted that negative reviews "irritate and, sometimes, depress me," while Larry Rivers, another painter, stated that he "can be stung by something I've read about my work. I remember what was said, but I try not to let it weigh on me." When she has become angry or depressed by a review that seems "nasty or personal," sculptor Marisol has gone to the lengths of sending the critic "a letter insulting him, in order to get even." Clearly, success doesn't make an artist's anger or insecurities go away when a review is unfavorable.

In fact, success may seem to raise the stakes on whether or not the write-up is favorable or otherwise. Robert Longo, a painter in New York City, stated that negative reviews are "harder to deal with now than in the past" as "the quality of my work demands a certain kind of attention, which is greater than when I first started out." Donna Dennis also noted that "a poor review affects me financially now whereas, when I first started out, it only hurt my feelings."

Perhaps, commercial success should compensate for criticism's version of Bronx cheers, and it may be that the critical nay-saying is a result of the commercial success. *Newsweek's* art critic Peter Plagens noted that "critics seem to say, 'This artist already makes a lot of money and is so popular, why should I add to it?'" Perhaps, negative criticism may reflect the degree to which an artist's work is unsettling to critics. Art historian Robert Rosenblum, who claimed that he neither loves nor hates Andrew Wyeth's work, said that "Wyeth is treated as an enemy by so many critics, because he represents a challenge to modern art long after the public triumph of modern art. The fact that he is such a crowd-pleaser may suggest that this triumph isn't as complete as some may have thought."

Coping with criticism, both adverse and positive, is one of the most difficult tasks for any artist. Is there any truth in what someone else is saying? Does a negative review mean that the work is bad? Do misinterpretations by a critic suggest that the work isn't communicating clearly with the public? Should one just write off all art criticism as, in the words of painter Jules Olitski, "the lowest, most scurrilous area for writers to go into"?

To a certain degree, reviews and criticism serve different purposes for the writer (of the review) than for the artist (whose work is being reviewed). Critics generally like to establish their own presence in a review—as judge of art or the ideas conveyed in the art, as a wit (Dorothy Parker: Katharine Hepburn "runs the gamut of emotions from A

to B"), or even to make sweeping statements about trends in art—while artists first and foremost see the write-up as a public acknowledgment of their presence in the art world. Being written up in a newspaper makes one's show an event, something that readers may want to attend regardless of the content of the review, which tends to be forgotten sooner than the fact of the exhibition. A picture of one's work next to the review has a lot longer staying power in a reader's mind than the words describing the piece, which is why press photographs are deemed so essential. "I don't care what they say about me since people don't usually read it," painter James Rosenquist said, "but they may look at the picture and remember that."

That more cynical approach to criticism does not tell the whole story as artists often read and remember what is written about their work even if most readers do not. An art exhibition is a form of public exposure, revealing a variety of vulnerabilities. (Critics, on the other hand, do not indicate anywhere near as much about themselves.) More mature artists learn to keep an open mind to potentially valuable opinions and suggestions while maintaining a steely confidence in their own work and vision. The more negative the critical reception, the more one's inner resources are tested. "If what someone writes about me affects my work, if I don't have any conviction in what I'm doing, then God help me," Andrew Wyeth said.

The critic, at his or her most basic level, is a conduit of information to the public that such-and-such an artist exists and whose artwork may be seen at such-and-such a place. At a more gratifying level to the artist particularly, the review indicates that the creator is being taken seriously as a professional, which may take the edge off the sting of any negative commentary.

Artists may feel a great temptation to respond to misinformation in a review, a problem creators complain of frequently. Environmental artist Christo noted that the titles of his work are frequently mispelled, as are his and his wife's names, and facts such as his nationality (Bulgarian) are often incorrect. "Some critics wrote that I am Czechoslavakian," he said. "One person wrote that I was born in Belgium." Donna Dennis pointed out that the scale of her work doesn't reflect class differences (as the Marxist critic had written) but "the scale of my own body, which a feminist critic would have understood." Most artists, however, see reasons to check the impulse to respond.

"I've never responded to criticism, even when I thought that facts needed to be corrected," Jules Olitski stated. "Its unseemly, demeaning, and gives the critic too much importance. I compose the letter in my mind but never send it."

Beyond the questions of the critic's value in making public mention of the artist and of responding to potential misinterpretations is the deeper issue of whether criticism resonates as true. Larry Rivers suggested that criticism may prove most valuable and constructive when it parallels one's own private doubts and concerns. Criticism, whether favorable or otherwise, is often able to open up ideas and provoke discussion.

"Criticism has expanded my vision when the person has tried to make an intelligible and intelligent statement," Leon Golub said. "It's like a goad, a provocation thrown at you, and it energizes me and my work. Sometimes, I respond to criticism through my work."

Not all criticism is unfavorable, of course. Smaller circulation newspapers rarely knock artwork, and editors often try to help locals—artists and galleries. Frequently, the artist may be met with praise, which certainly makes the creator feel good but also may involve a pitfall or two. One can start believing in one's own touted "genius" too much, interfering with one's ability to work boldly.

"Artists who have been pushed around a little should know not to let praise go to their heads," Golub stated. "Sure, I'm happy when I get praise, and I get depressed when something negative comes out. If you let it go to your head, you're a schmuck; if you let it stop you from working, you're self-destructive. You can't let either praise or damnation take over."

Artists may be able to hear criticism only from critics, from friends, peers, family members, or perhaps, from no one. Some people respond to criticism in certain ways, regardless of whether they are artists or shoemakers, but the real issue is how confident the creator is his or her own work. Criticism can come too early and too hard for some artists, and James Rosenquist recommends that creators hold off displaying their art until they feel secure in what they have made—secure enough to make it public and, like a child, let it go off into the world. Once a work of art leaves the studio, it no longer belongs exclusively to the artist; rather, it belongs to the world. It is liked and under-stood according to the tastes and knowledge of the people who see it, and the creator becomes just one more person in this chain. Sometimes, criticism opens an artist's eyes to facets of the work that he or she hadn't before realized. The artist learns to step back, watch the processes of the art world, pick up what good can be gleaned, and go on to the next creation.

ART OUTSIDE THE MAINSTREAM

"Yes, but is it art?" is a question that can give people who call themselves "artists" many sleepless nights. It is a question but also a kind of judgment on artwork that veers from the already seen. It seems to become more difficult every year to clarify what is and isn't art, but still, most people tend to cling to some concept or other. To a degree, theories of art become a part of the problem for artists because the intent of these theories is to exclude.

The art world has always had some borderline media, which people are unsure how to classify, and that number is increasing as the use of computers and other new technology by artists has led to artworks that can only be described as "cross-media."

Computer Art, Holography, and Xerography

Computer-generated art has many enthusiasts but few buyers. Holography has been used by some people to represent three-dimensional moving images of human figures or abstract shapes but, outside of supermarket scanners or the reflecting area of one's credit card, few people ever have any association with it—almost no museums or art galleries represent it. Xerography may be another example. It has been deemed a legit-imate art process by the Print Council of America, but what is that? And what does that mean?

Most offbeat media that enter the mainstream art world do so either on the strength of a noted artist making it—for instance, Picasso and collage—or by a sizeable number of artists involved in it, as in the case of fiber art. Photography and graffiti art have become part of museum collections where they had in the past been viewed as, respectively, mere craft and urban blight. Rubber stamp art, however, for which there was a passing fancy among some artists in the 1970s, seems to have died out. Like party favors, anyone could do it, but that may have been its undoing.

The new borderline media is distinguished by its reliance on technology and its relative inexpensiveness. "I tried taking some of my still images to a number of galleries, but most dealers didn't want to touch the stuff," Mark Lindquist, a New Yorker who works in both the fine and applied arts, said. "It's so easily reproducible, once you've punched in all the data, and art galleries want works that are unique. They saw no real sales value."

Holography was invented as a theory in 1947 by a Hungarian physicist Dr. Denis Gabor, who stumbled upon this use of laser photography while attempting to improve the electron microscope. One used to be able to see holograms either in special multimedia exhibitions or at the Museum of Holography in New York, before that institution went out of business.

"Whether you are using holography in supermarkets or for medical research or for making art, it's all valid," said Harriet Casdin-Silver, a professor at the Center for Advanced Visual Studies at the Massachusetts Institute of Technology. Her holograms have been exhibited around the world, "and I never have heard anyone ask, 'Is it art?' The problem comes when too many people jump into making holograms after taking some six-week course somewhere, and their works strikes no one as art."

Xerography, the use of copying machines in art making, has a small group of collectors and practitioners, with prices that reflect more the cost of operating a copying machine than keeping body and soul together for an artist. As with computer art and holography, the public is hesitant about embracing xerography as a serious art form. Among the reasons, noted Louise Neaderland, director of the International Society of Copier Artists, is that most people who work in offices view copying machines in a somewhat negative way. She said that much of the public thinks of the medium in terms of the junky quality copies it is used to from the office. This is an image problem that she hopes will be changed.

Collectors of these media are probably aware that these works may never receive recognition as serious forms of art. Risk taking is as much a part of buying art as making it. In a market sense, the purchase of works raises nonfunctional, possibly decorative objects into the realm of art. An artist's say-so is no guarantee of value, for collectors vote on what is art with their money.

When it was first installed, many St. Louis residents sneered at the Golden Arch (which has since become that city's symbol), but these days, locals point to it with pride. It wasn't because a swarm of art critics and architectural historians descended on the city to explain and defend Eero Saarinen's creation that so changed many people's

minds. People just got used to it. The clock does a better job of defending art than art critics, as time has a way of opening closed minds. So it may be with experimental forms of art.

Watercolors

Most people are happy to say something nice about watercolors—at least, no one says anything bad about them—but why, then, is it so difficult for watercolorists to make any money from their work? The reason may well be the difficulty in finding somewhere to show (hence, sell) these works to the public.

"Dealers know that there's more money in oils than watercolors," said Lawrence Fleischman, partner of Kennedy Galleries in New York City, which does exhibit this medium, adding that a watercolor will generally sell for half the price of an oil even when both were painted by the same artist.

Some dealers will handle an occasional watercolor if it is done by an artist they already represent who primarily works in another medium. Few galleries have much interest in watercolors by artists whose primary medium is watercolor. Deborah Frizzell of the Connecticut Gallery in Marlborough, Connecticut, noted that collectors are "far less interested" in buying watercolors than oils, both because of the sense that works on canvas are physically longer lasting and need less care than works on paper and due to the lingering view of watercolors as preliminary sketches for more major works. Yet other dealers speak of nervous collectors who have sunny homes and are fearful of buying a watercolor that may deteriorate in the light. There is also an undercurrent in the art world that equates watercolors with amateurism. The result is watercolors that are harder to sell and that bring in fewer dollars. The same degree of talent, effort, and professionalism by a watercolor artist tends to mean less money in galleries, and the same amount of selling by a dealer nets more of a profit with an oil painting than with a watercolor.

The debate over what to do about watercolors is both old and new, as it largely concerns the attitudes of those who buy or take care of these works. Adolph Gottlieb, the New York School painter, recalled that "a dealer, when I was young, was considering giving me a show of my watercolors, and she turned me down. She said, 'Well, you know, the history of art was never made with watercolors, anyway.'"

Museums don't help the situation, as many of them have significant collections of watercolors but rarely exhibit them. Part of the reason is that they are legitimately concerned about the ability of these works to withstand long-term exposure; another reason is that few institutions have galleries set aside for works on paper of any sort (the Art Institute of Chicago, Cleveland Museum of Art, and Museum of Modern Art in New York City are rare exceptions). Curators in these departments occasionally do battle—and usually lose—to find temporary or permanent space for exhibits of watercolors, depriving the public of ever seeing many watercolors at any one time. This reinforces their invisibility.

Because of this, watercolorists have had to find other avenues for selling their work, the most common being the juried art competition. Regional juried shows do not

tend to attract as much of the country's small body of watercolor collectors as those com-
petitions sponsored by the national watercolor associations, and prices for works reflect
the differences in these shows' stature. Relatively few artists can earn a living from
these shows, especially at the regional level.

THE BENEFITS AND PITFALLS OF CENSORSHIP AND CONTROVERSY

"I've refused to become a prisoner of 'Piss Christ,'" said photographer Andres Serrano,
referring to his photograph of a crucifix submerged into a glass filled with urine, but the
fact remains that he has become a very wealthy prisoner of that work. The picture, cre-
ated while a recipient of a $15,000 grant from the Southeastern Center for
Contemporary Art in Winston-Salem, North Carolina, which itself had received a grant
from the National Endowment for the Arts in fiscal year 1987–1988, drew fiery con-
demnation from religious groups around the United States and members of Congress,
including North Carolina senator Jesse Helms. Coming at the same time as the contro-
versy over the indirectly government-sponsored exhibition of the work of photographer
Robert Mapplethorpe, the outcry came close to abolishing the federal arts agency.

The dispute over "Piss Christ" has proven to be a "double-edged sword," the
artist said. "Collectors rushed to support me. I've sold a lot of work, and I wouldn't have
sold anywhere near that much if the controversy hadn't occurred." The other side is that
the flap broke up the artist's marriage ("I was a little paranoid for about nine months")
and made Serrano a symbol, represented by this one work that colors all he has ever
done or will do. "'Piss Christ' has been over for me for a long time; for other people, it
may never be over."

Great public controversies or instances of censorship can't help but affect an artist
in a significant way. For certain artists, there is a clear upside. "I like to think that my
career would have reached this level without the help of the FBI," said photographer
Jock Sturges, whose San Francisco studio was raided in 1990 by the Federal Bureau of
Investigation, which confiscated and destroyed many of the artist's prints and negatives
of nude children before a federal grand jury failed to indict Sturges. "Certainly, the feds
pushed my career ahead by 10 years."

David Hammons gained considerable publicity and new collectors when his sculp-
ture of a blond and blue-eyed version of Jesse Jackson (entitled "How Ya Like Me Now?")
was attacked in 1989 during an outdoor exhibit in Washington, D.C., with sledgeham-
mers by a group of black men who felt the work disparaged Jackson. The artist repaired
the piece in time for a more recent retrospective, adding to the work sledgehammers and
the logo of the cigarette maker "Lucky Strike" since "it was lucky for me that those men
struck the piece with sledgehammers, because that got everyone to notice me."

However, for most artists, the sword is not double edged. The controversy elevates
an artist's name and face long enough for the individual to become the focus of death
threats and hate mail and snubs from collectors, dealers, and curators, with little but a
tarnished reputation to show for it.

"Controversy hasn't been a fast track to success for me in the art world," said Kate Millett, whose 1970 "The American Dream Goes to Pot" featuring an American flag partially stuffed into a toilet behind prison bars has been picketed by veterans groups and others whenever it has been displayed. The work was most recently exhibited as part of an "Old Glory" show at the Phoenix Art Museum in Arizona in 1996, where it was met with protests and condemnations from Senator Jesse Helms, House of Representatives speaker Newt Gingrich, and then-presidential candidate Bob Dole. "I've gotten a sort of notoriety because of that piece and some others I've done but, in another way, the controversy hasn't affected me a lot because I've never been able to sell my sculpture. All my life, collectors and curators have backed away from me. No dealer has come to me for any purpose whatsoever. I think I've sold only a couple of works to friends, for $350 apiece."

Controversy worked in her favor, after her 1971 book, *Sexual Politics*, was published, which became an instant classic among feminists and lesbians, but her artwork has never benefited. Why one artist's career is aided by controversy but another's is not may not be easily understood. Senator Helms denounced both Serrano and Millett, both of whom produced work that cause viewer discomfort; collectors, critics, curators, and dealers rallied around Serrano but avoided Millett.

The studio of photograper Marilyn Zimmerman, a tenured professor at Wayne State University in Michigan, was raided in 1993 by police who confiscated prints and negatives in a manner similar to the FBI raid on Jock Sturges. She, like Sturges, took photographs of a nude child—her own daughter, in fact—and the district attorney decided to drop all charges in the face of protests. However, "there was no great surge of interest from collectors in buying my work or from dealers who might show my work," she said. The fear that this raid created in her life "did stop me from photographing the nude. I use other, appropriated images instead. Frankly, for a long while, I lost the heart to make images." She also lost her daughter as her ex-husband used the photograph controversy to gain primary custody in court.

Instances of censorship effectively ended the art aspirations of two young artists, David Swim in Austin, Texas, and David Nelson in Chicago. Swim's figurative plaster sculpture of a nude man was removed in 1993 from a public art show. His lawsuit against the city, the mayor, and the head of the local Art in Public Places program was supported by the Art Censorship Project of the American Civil Liberties Union and the National Campaign for Freedom of Expression, but "support for me in Austin was pretty nonexistent. The Austin Visual Arts Association, which receives money from the city, tacitly supported the city's decision." In addition, the area galleries in which Swim had been showing his work became "concerned about the work I did, and no other dealers came to pick me up."

The controversy and lawsuit (eventually dropped after a trial, several appeals, and an overturned conviction) proved too distracting for him to get back to work. "I wasn't in an emotional place where I could create any art," he said, and he stopped producing art altogether, taking a job as a computer technical support representative for Apple.

David Nelson was an art student at the School of the Art Institute of Chicago in 1988 when he placed in a student show a portrait of the late Chicago Mayor Harold Washington dressed in frilly lingerie. Several black aldermen came into the museum's gallery and took the picture away, inciting an ACLU-sponsored lawsuit and several protests on both sides. According to the registrar's office at the School of the Art Institute, Nelson lives "somewhere in the Midwest and doesn't pursue art anymore, to our knowledge."

Controversy invariably requires that an artist take time away from his or her work, to speak with police, the press, lawyers, other artists, and even groups that ask the artist to give a public talk. It also takes an emotional toll. Dread Scott Tyler, whose 1989 work in an exhibition in Chicago, "What Is the Proper Way to Display the U.S. Flag?" requires viewers to walk on a flag in order to read from a book, noted that he has received death threats in the mail, his mother has received death threats at her home and office, and that other black artists have received these same threats. "People don't know what I look like," he said. "They see black artists and assume they're me."

Millett also noted that she felt frightened when Speaker Gingrich "denounced me on the floor of Congress. In another society, I would be arrested and jailed or worse that day. There is something about being the target of all this animus. It's different than just a bad review when the government is attacking you. It has the power of social force behind it."

Artists are sometimes accused of deliberately seeking publicity by courting the outrageous, then taking advantage of the notoriety in order to sell their work, but "would you trade what Sturges went through just to get your name out there?" said David Mendoza, former executive director of the Washington, D.C.–based National Campaign for Freedom of Expression. Within the first five weeks of the FBI raid on his studio, Sturges said that he had spent $80,000 on legal fees, "lost 40 pounds, I couldn't sleep; I was anxious all the time. If I had been convicted, the sentencing was ten years. I thought I was going to prison. I had read that child pornographers were usually raped and brutalized in jail, and I would get AIDS. I thought I was under a death sentence." He sought psychiatric help.

In the relatively small art world, artists have a large measure of control over the context in which their work is placed through the exhibition of that art. Public controversies bring artwork into a far larger realm—photographs of Dread Scott's piece appeared on the front pages of the *Chicago Tribune, New York Daily News,* and *Village Voice,* among others—where artists have little to no control. Serrano is the "Piss Christ" artist; Sturges, a child pornographer. Karen Finley, the performance artist for whom a grant from the National Endowment for the Arts was recommended by a peer review panel but denied by the agency's advisory council in 1990, has been labeled the "chocolate lady" for some much-debated performances years ago in which she smeared chocolate on her body. Their entire careers have been reduced to one or more images that encapsulate the public controversy generated. At other times, their work has been cited by their opponents to make points about something else.

"I saw a picture of my flag-in-the-toilet reproduced in a newspaper, accompanying an article on why the NEA should be abolished," Millett said. "I've never received a cent from the NEA, but that didn't apparently matter to this newspaper or to the person who wrote the article. I feel horrible about being used in this way."

HANDLING ART WORLD PUBLICITY

In 1949, *Life* magazine published an article whose title asked the question, "Is Jackson Pollock the Greatest Living Painter in the United States?" Although the article's tone seemed to ask readers to answer in the negative—which, based on the letters to the editor that were published, they did—it heralded a new attitude by the media toward art. Despite a portrayal of Pollock as an oddity whose work and mode of art making defied comprehension, the art was described in terms of his success in selling his works. If he sells, it is assumed, the rest is OK.

Money talks, and in the art world it publicizes. Exhibitions of the work of van Gogh in Paris, Chicago, and New York City have not done as much for the widespread acknowledgment of the artist's greatness as the sales within the past fifteen years of several of his paintings for $20 million, $40 million, $53 million, and $82 million.

Publicity has become a staple of the art world, affecting how artists see themselves and how dealers work. On its good side, this publicity has attracted increasing numbers of people to museums and galleries to see what all the hullabaloo is about and, consequently, expanded the market for works of art. More artists are able to live off their work and be socially accepted for what they are and do.

On the other hand, it has made the appreciation of art a bit shallower by seeming to equate financial success with artistic importance. At times, publicity becomes the art itself, with the public knowing that it should appreciate some work because "it's famous" rather than because it's good, distorting the entire experience of art. Seeing the touted works of art may be anticlimatic, especially when, as in the case of Georgia O'Keeffe, the poster images of an artist's paintings are occasionally larger than the actual pieces themselves.

Certain artists, artworks, and art collectors have become celebrities in the same way that the latest supermodel, the Hope Diamond, and society page figures turn ordinary occasions into notable events by their very presence. One must not forget the essential irony of Andy Warhol's comment about everyone's fifteen minutes of fame—that this type of notoriety is hollow, more to be watched in a detached manner (Warhol's art in film, painting, and prints was a documentary on celebrity) than taken to heart.

The focus of publicity in the art world has changed in the years since the *Life* magazine article. Back then, the radical look of the artwork was highlighted; later, in the 1960s, the spotlight shifted to the artist's lifestyle, and after that, to the buyers of art. Clearly, money has made itself known with art taken along as a passenger.

The artists who were most affected by the media interest in the arts were the abstract expressionists in the 1950s. Although their works and goals were almost too diverse to truly label them as a group, these artists, who had grown up during the same

period and shared many similar experiences, were united by a mood that all shared: alienation. That shared isolation was broken up by the new attention their work began to receive, as some artists who were less successful felt bitter about others who were more so. They all felt a degree of anger at the loss of their seclusion and at how their lives had suddenly gone public, as well as guilty that they had become commercial—they were all committed leftists, after all, whose decision to abandon politically conscious art for total abstraction had been difficult.

Feuds, alcoholism, and bitterness poisoned these artists' lives. Franz Kline, William Baziotes, Bradley Walker Tomlin, and Ad Reinhardt all died relatively young. Arshile Gorky and Mark Rothko committed suicide—Jackson Pollock's car crash (the last of many) can be called an "accident" only with quotations—and the male survivors (Willem de Kooning, Conrad Marca-Relli, Philip Pavia, and Jack Tworkov) complained of feeling passed over by the media for the next generation of artists.

"The art world, by which I mean critics, dealers, everyone except the artist, is interested in the new and forgets everything else," Jack Tworkov noted not long before he died. "Some artists got put on the back burner after a while. It is inevitable."

Whereas in the 1950s the art attracted the most attention—treated with curiosity, disdain, and bewilderment by a public that was unused to such stuff—the focus shifted in the 1960s to the artist's life. To many, it represented an alternative lifestyle for those disenchanted with middle-class society; to others, it became chic for the socially ambitious to rub elbows with artists and become a museum trustee. Within relatively few years, in fact, the boards of trustees at the nation's major art institutions changed from old money and old families to new wealthy businesspeople who brought a whole new set of values to the operation of museums. Openings at museums and galleries also became major social events during this time, and artists were courted by politicians and tycoons.

A growing number of artists thrived on this recognition, while others—who found that their lives had become a matter of public concern, limiting their freedom—did not.

Many aspects of the artist's lifestyle—with the exception, of course, of the general poverty of most artists—were appropriated by members of the middle class, the most obvious example being loft living. Artists found themselves priced out of the abandoned warehouse buildings into which they had settled as the glamour of living in a spacious loft (as opposed to the suburbs) gained popularity in Boston, Chicago, Los Angeles, New York City, Philadelphia, and elsewhere.

The spotlight in the 1970s shifted from the art and the artist to the buyers of art, largely because of the record-setting prices paid for works, and the focus of publicity has remained there since. To a degree, the reason for this is the lack of any consensus about aesthetics or standards of taste. With no clear conception of inherent quality, the only certainty about art becomes the amount of money paid for it. A new definition of art is the result: Art is whatever someone puts down money for and says, "This is art." The corollary of this is that quality is identifiable only in terms of the sums spent. A $200 piece is nothing special; a $2,000 piece is OK, a $20,000 work is significant; a $200,000 piece is excellent; and, at $2 million, the artwork starts to be called "priceless."

Traditionally, the art world had made a distinction between commercial success and what is called *success d'estime,* the prestige and influence of a work. More and more, the distinction has been blurred as critical and monetary values have become intertwined.

This may not necessarily be a bad thing; rather, it is a recognition that the history of art and the history of art patronage are the same history—it is a twentieth century concept that art should belong to artists. In a market sense, it is the purchase of works, or a recognition of their salability, that is the primary factor in raising nonfunctional, possibly decorative objects into the realm of art. An artist's say-so is no guarantee of value, and because of this, collectors of art are not mere dispensers of money but proponents of entirely new concepts of art.

Whether art was purchased as a hedge against inflation, a tax shelter, a form of self-flattery, or for more personal reasons, the buyers of art found themselves the celebrities over the past twenty years. The artist's success became their success in being wise or wealthy enough to acquire a work. Armand Hammer, Walter Annenberg, J. Paul Getty, Robert Lehman, Norton Simon, David Rockefeller, Alfred Sackler, Joseph Hirshhorn, Victor Kiam, Robert and Ethel Scull, Count Panza di Biumo, Daniel Terra—these were among the most notable buyers of art, and they received considerable attention for the prices they paid for works, the collections they amassed, and what they did with those collections. Various art magazines now annually devote whole sections or issues to who the top buyers are in any given year, and a number of home and architecture magazines regularly feature the houses and collections of wealthy art buyers.

In some cases, they erected monuments to their art interests. Conglomerateur Norton Simon purchased the Pasadena Museum of Modern Art in 1974, renaming it the Norton Simon Museum of Art at Pasadena, and reserved 75 percent of the museum's space for his own works. He began selling off many pieces in the museum's original collection that were not his personally. Others have set up whole museums, or had other art institutions add wings, that bear their names, and often some strings are attached to ensure that their persons are not forgotten amidst the art. Robert Lehman, for instance, whose collection went to the Metropolitan Museum of Art in New York City, which built a wing (the Lehman wing) for it, stipulated that the display be set up to exactly resemble the donor's home, with works (and furniture) placed just as Lehman liked them.

Capturing publicity becomes a means of nabbing dollars, and in many instances, artists have become as infected with the excitement as dealers, auction houses, and collectors. Small wonder, then, that so much art of the present day goes in for theatrics, exaggeration, and rhetorical stances, as the getting and keeping of public attention has become a central part of contemporary art making. Attuned to the requirements of marketing, many artists are reacting to their times.

OUT OF THE SPOTLIGHT

Most people tend to limit their memories to either what is personally important to them or what is currently being talked about. It is always with a sense of astonishment that anyone thumbs through a ten- or twenty-year-old art magazine and remembers the

artists who were being lauded right and left. The obvious question is, "Whatever happened to . . . ?"

The language used to describe these artists' then-current work is learned, partisan, and enthusiastic. This artist's work is a "significant contribution," that artist is having a "major show," while another is the "leading spokesman for his generation."

So many of them never seemed to get written up again and, years later, one wonders, what happened to them. Did they die? Did they stop working? Was their subsequent work so bad that everyone thought it best just not to mention it ever again?

They largely continued to live and do work of the same quality, but they all learned how uneven attention can be in the art world. They also learned what it is to go out of fashion. "America is a consumption society," Marisol, a folk-Pop art sculptor who was the toast of the art world during the mid-1960s, said. "They take you and they use you and then they throw you away."

Marisol was in all the art and fashion magazines and her opinions on fashion, culture, and cuisine were meticulously noted. People hungering for her pronouncements have had little sustenance since the late 1960s when she seemed to disappear—at least from the periodicals. Exhibitions of her work became fewer, and her name fell into that area of consciousness that includes the name of President Eisenhower's Secretary of Agriculture and the first movie one ever saw.

"The people who count don't forget," she said, "but you do wonder, when all the noise dies down, what all the attention was about. Was all that excitement really about your work or just excitement about being in" fashion. She added that she never stopped working—"but now I just do it more privately."

All art is created privately, anyway. An artist goes into his or her studio to commune with the Muse, not with the art magazines, to produce a work of art. But creating art is not just a form of self-therapy, and artists need some way of gauging their audience. Most artists want to project themselves and get more than an echo.

The feedback they receive is often short-lived and not without some drawbacks. Historically, since Impressionism, no single art movement has dominated the art world for as long as ten years. By the time one group of artists begins to receive recognition, a new generation has grown up and starts to express itself. The old group recedes, having made its mark on history, but no one wants to be historical in his or her lifetime—one might as well be dead.

One example of this phenomenon took place midway through this century. Abstract expressionism hit the art world like an earthquake in the late 1940s and early 1950s, and like an earthquake, it left a number of institutions in shambles. Among the ruins were American realist painters, who had dominated the galleries and museums that displayed work by contemporary artists and who found interest in their work tumbling.

The most severely hit artists, perhaps, were the social realist painters who saw all of their most cherished beliefs about art upended. To them, art had to address itself to the concerns of the masses, depicting in recognizable (although often exaggerated) imagery aspects of the lives of the poor and working classes, exhorting them to some sort of political action.

The art of the new abstract school that swept away these older artists of the 1930s and early 1940s suggested just the opposite. The new art was concerned with color and formal problems of art, implicitly rejecting mass political efforts for personal solace and expression.

Arguments over artists' intentions aside, the new art did pose a very practical problem for those social realists who still believed in their art but sought to make a living. "The big change in the art world damn near buried me," painter Jack Levine stated, adding that the market for his works shrank considerably for a number of years. Some artists—the most notable being Philip Guston—jumped ship and became abstractionists. Others slogged on and hoped for a change in the winds of the art world.

"I felt more and more that I was not painting in the popular mode," said Lee Jackson, who first gained prominence in the 1930s with his social realist images of life in the city. "It felt like the air you breathed, the ground you stood on was suddenly pulled out from under you and left you dangling. I felt deflated as people all around me who had been doing social realism suddenly began doing abstraction. For a lot of us, it was a period of self-searching and disappointment."

Some social realists attempted to combine their social concerns with the new emphasis on color as an expressive entity in itself and on the more formal concerns (flatness, the painting surface, lack of illusionism) of the abstractionists. In the 1950s, for instance, Isabel Bishop showed new interest in movement in a painting as well as spatial relations between figures in a composition, and Ethel Magafan's pictures became considerably more abstract.

"An artist has to change," Magafan, a former Works Progress Administration muralist, said. "If you don't move forward, you fall back, and you can't really be an artist of your time if all you do is disapprove of everything around you."

Ben Shahn was another painter who refused to omit politics from his work, yet, by the 1950s, he too began to focus less on specific instances of social or political injustice and more on broader allegorical themes of humanity. Some scholars have also noted a greater interest in more formal, compositional problems in Shahn's art.

Certainly, most of the social realist artists—such as Philip Evergood, William Gropper, Robert Gwathmey, and Stefan Hirsch—continued in the same vein of painting, refusing to allow changes in fashion to dictate their style or subject matter, but the price of that decision was relative or total obscurity. "I wouldn't sink so low," Jack Levine remarked when asked if he had ever tried an abstract painting. A number of the social realists refused to believe that the interest in abstraction was not a spoof, a scam that would soon pass, allowing their work to be appreciated once again. Devoted dealers continued to display the ongoing work of the social realists into the 1950s, 1960s, 1970s, and 1980s, but for most art enthusiasts, it was as though an entire school of artists had mysteriously died. Books on twentieth-century American art reinforce that impression by highlighting these painters' works of the 1930s and never what they did afterward.

The phenomenon was repeated a dozen years later. A number of artists of the New York School of abstract expressionism, most notably Mark Rothko and Franz Kline, felt

bitter when they seemed to be passed over for the Pop artists. They continued to sell well, but they were wholly unprepared for the fickleness of the art world, and bitterness was added to their sense of alienation and, in some cases, depression.

Another painter of that period, Ray Parker, claimed that he has been through the popularity-neglect mill several times now: "Taste changes very rapidly," he stated. "One day, everyone loves you, the next day no one remembers you. But the changes are fast enough and cyclical enough that, at least in my case, people come back. Then, they go away again. You learn to get used to it."

Other artists handle the seeming fall from grace in their own way. Painter Robert de Niro, father of the actor, was highly respected and touted in the 1950s but, when his works seemed to be ignored during the 1960s and 1970s, he retreated into a scornful silence. The career of Adja Yunkers, who died in the mid-1980s, went through a period of prolonged submergence in the 1970s and the artist himself grew increasingly cantankerous as a result. "I was all over the place in the 1960s," Yunkers said shortly before he died. "You couldn't open an art magazine without finding my name in it."

By now, most artists in the public eye know that some day they will be replaced, and they must prepare themselves for that eventuality, investing their money now, producing as much as possible while they're hot and attempting to change their style with the turns of the market. One of the unwritten credos of today's art world is that a young artist (like a young rock star) may well be considered through by the time he or she is 40, and one should rush to strike while the iron is hot. Isn't that what hype is all about? Commitment by an artist means persevering even when recognition is not there.

For all those artists in the old magazines about whom one hasn't heard anything since, the real issues may be whether or not they deserved the attention in the first place—were they just hot starlets of only passing interest?—and if the attention they received had less to do with their work's qualities than with then-current fads.

LOVE AND MARRIAGE

People marry or divorce for a number of reasons, and sometimes, it is because both are artists. Another artist will understand the art one is attempting to create, will accept the lifestyle and serve as an in-house supporter as well as an experienced eye. Another artist may also be in-house competition and one's fiercest critic, resentful of one's success and scornful in his or her own.

It is not infrequent that artists marry each other, as the people they tend to meet in their art studies, at gallery openings, or through their professional associations often are involved in the art world. Leon Golub and Jack Beal, for instance, met their wives (Nancy Spero and Sondra Freckelton, respectively) while attending the school of the Art Institute of Chicago.

Despite the real benefits of an artist marrying (or living with) another artist, the identical careers—regardless of how dissimilar their respective artwork may be—create tensions for them. Being an artist requires an ego of considerable size; two such peo-

ple may find themselves clashing frequently, even if their disputes have nothing to do with their art or careers. Strong, unbending wills have destroyed more marriages than anything else.

Some artists approach these issues in advance by talking out a list of potential concerns. Jack Beal proposed to Sondra Freckelton three times before she finally accepted. "At first, he had the idea that I might be Madame Matisse, but I said 'no' to that. I didn't study art in order not to have a career on my own," she said. The back of their 1953 marriage certificate includes a written "agreement of partnership" establishing that they are equal partners.

"Artists have to outline what the dangers are, could be, might have been," said Miriam Schapiro, a painter who has been married to another painter, Paul Brach, for over 40 years. "You have to discuss whether or not to have the same or separate friends, whether you want to be treated as a couple or as individuals, whether your careers allow you to have a family, where you want to live, whether you want to be in the same gallery or not. They're all difficult subjects, but married couples—especially those with the same career—have to be able to communicate."

Other artists attempt to resolve the tensions of both spouses being artists through establishing separate studios (sometimes never even visiting each other's studios), using different dealers, and generally staying out of each other's careers. One example of this was the house that Mexican muralist Diego Rivera had built for himself and his painter wife Frida Kahlo. There were two separate buildings, containing two separate living units and art studios, connected by a bridge on the second floor level.

Having two distinct studios, one for her in the garage and one for him away from the house, is "a physical manifestation of what is already going on," said Scott Prior who is married to Nanette Vonnegut, both of whom are painters. "If we are too close, we sort of step on each other's toes. We do talk about each other's work, but there are times when Nanny would just as soon that I not say anything about her work because I can be disruptive."

It is relatively seldom that both artists in a marriage receive the same degree of attention and success in selling their work. At times, one artist's career is clearly on the rise while the other's has peaked, a scenario played out in the film *A Star Is Born*. Collectors, critics, and dealers may visit one artist's studio and not the other's, which can be especially painful when the two artists share the same space. Competition and anger may enter a relationship.

"When my wife's career is doing better than mine," Leon Golub stated, "I don't feel as good about myself and may develop resentment." Golub added, however, that he directs that resentment elsewhere—at limited thinking in the art world, for instance— and not at his wife.

The tension and sense of competition may be too great for some marriages. The wives of Edward Hopper and Philip Pearlstein gave up their art careers, for instance, believing that there could only be one "genius" in the family. Sally Avery said that her "career has flourished over the past twenty years" after her husband, Milton Avery,

died. While he was alive, "I wasn't trying to promote my own work. I tried to promote his work, because I thought he was a better artist than me."

Problems are not necessarily lessened when an artist marries a nonartist. Janet Fish, a painter who first married and divorced an artist, then married and divorced a nonartist, and currently lives with another artist, noted that "problems about being an artist are really symptomatic of other problems in the relationship. Men simply have more problems than women with competition. There is something in their upbringing that requires them to be the breadwinner. The bad relationships I've had have been when the man's ego has been too tender."

She added that "I know some women artists who say their husbands never come to their openings or to see their shows, as though they are trying to deny these careers exist."

While artists marrying artists has a certain logic, the history of art reveals many examples of artists preferring a caretaker. Almost the entire abstract expressionist movement of the 1940s and 1950s, for instance, was supported by the wives of the major artists. Barnett Newman's wife, Anna Lee, for example, was a typing instructor; Mark Rothko's wife worked as a model; and Adolph Gottlieb's wife, Esther, taught school. In Europe, it was a tradition for artists to marry "working girls." Goethe married his housekeeper, as did Pierre Bonnard and Marc Chagall—when his first wife left him, Chagall married his next housekeeper. This kind of marriage (and this kind of support for male artists in general) has largely disappeared with the advent of the women's liberation movement.

Marriage, of course, isn't a professional decision but a personal one. The success rate of marriages is not necessarily improved when artists marry critics or dealers, and in many respects, the marriages of artists are no different than those of everyone else. Some artists get along well enough both personally and professionally that they, like Claes Oldenburg and Coosjie van Bruggen or Edward and Nancy Reddin Kienholz, are able to collaborate on art projects. Others, whose artistic ideas are not easily compatible, keep their marriage out of their careers as best they can.

"I think it's hard to be an artist married to an artist. I think it's generally hard to be married and be an artist," painter Lois Dodd, who was once married to sculptor William King, said. "When you're married, you have to think of another person, and art is a very selfish activity."

THE CHILDREN OF ARTISTS

Many children of artists grow up to be artists themselves. For some, it seems the obvious thing to do, but the hardest part are the comparisons and the internal need to live up to the success. "Big American stardom doesn't have a lot to do with being an artist," noted Abbie Shahn, one of Ben Shahn's three artist children, "but you sometimes feel like you have to prove something to people, make as big a statement."

Few children born to the famous can equal—or better—their parent's renown, which often gives some of them an ongoing sense that they didn't live up to something

chromosomal. Their sense of identity is somehow misplaced and the results can be trag-ic. Certainly, this is not by any means limited to artists. Daughters of Karl Marx and Winston Churchill, for instance, took their own lives as did the eldest sons of Josef Stalin, Theodor Herzl, and Bishop Pike. The lives of these great temporal and spiritual leaders took the form of a missionary single-mindedness in the service of a tangible cause. Their children felt connected to the causes but not equal to them. With artists, however, the goal is more personal and internal. One cannot really carry on an artist par-ent's work the way, for instance, that Anna Freud could follow through on her father's. The children of artists may understand what their parents are doing and share in aspects of it, but no one can truly participate in another's creative act. That they must discover within themselves. They see how an artist lives and works—the accouterments of the artistic life—and may attach themselves to it, waiting for creative impulses.

For these children, the choice of being an artist is rarely easy. A certain amount of guilt centers about not having to work as hard for name recognition as others. It can be extremely difficult to contact dealers, especially those with family connections, and ask them to come to one's studio.

Kurt Vonnegut's daughter, Edith, who is a painter, spent five years wondering whether she should change her last name. She never could make up her mind and final-ly decided that she needn't run away from the fact of her father's literary fame.

Jack Tworkov's daughter felt that her name problem was a "double whammy" since both her father and her husband, Robert Moskowitz, are well-known painters, the one of the abstract expressionist school and the latter of a minimalist orientation. She chose an in-between road, using her middle name and calling herself Hermine Ford.

No such luck for Maxfield Parrish, Jr., but, unlike Edith Vonnegut and Hermine Ford, he sought to escape his father's renown by staying away from art. He took other, industrial sorts of jobs but finally drifted back to painting and an acceptance of his name and its implications.

Some find themselves wondering whether or not there is such a thing as a "cre-ative streak" and if it exists within them or ended with their parents. Failure can seem doubly harsh—failing both oneself and one's artistic inheritance—and it raises the stakes in the decision to be an artist.

One of the saddest examples of this is Klaus Mann, son of the Nobel Prize–win-ning author Thomas Mann. Klaus wrote three novels concerned with existential root-lessness before committing suicide in 1949 at the age of 45. He chose fiction writing, although it was never easy for him, and one wonders if he ever felt he could do other-wise. He stated in a letter to his sister that literary pursuits were "a curse with us"; and in an interview toward the end of his life, he said that he felt "under an especially great obligation. When the son of a great writer writes books on his own, many people shrug their shoulders. The mixture of condescending patronage and hypercriticism with which people usually approach the son of a great writer rather hinders than helps him."

The lives of most children of artists forever revolve around their decision whether or not to enter the "approved career." Hermine Ford stated that she "grew up

painting" but felt terrified of making the decision to be an artist when she became an adult: "It wasn't such a struggle for me to make art as it was for everyone else. I thought I must be doing something wrong." She put off the decision for a time and even debated going for a teaching degree, but finally resolved at age 30 to try to make a go of being an artist.

Children of artists often appear to take a different attitude toward the artistic lifestyle than their parents; of course, they grew up in it—it was not a matter of choice for them—and it seems quite natural. Milton and Sally Avery's daughter, March, was born in the middle of the Depression when her parents (her mother, Sally Avery, is also a painter) were making very little money. Being an artist then meant no security but, to March, drawing and painting were a form of security in itself.

"My parents didn't have a separate studio and worked in the house," said March. "Artwork was all over the place. All their friends were artists. When I was young, I thought that everyone grew up to be artists. Sometimes, I think it was only because of lack of imagination that I became an artist."

In these families, the introduction to art starts quite early. They are given the best tools and materials to work with almost as soon as they show the first signs of artistic interest. Eric von Schmidt, son of Harold von Schmidt, the painter of life in the Wild West, remembers drawing his first nude (from a live model!) at age four.

Noting that "painting is taken quite seriously in my family—you could never just dabble," Jamie Wyeth said that he "literally grew up in my father's studio" and was always encouraged to paint. His brother, Nicholas, on the other hand, never showed any artistic inclination but, not to be left out, he was made the family dealer and has handled Andrew and N. C. Wyeth's (the grandfather) paintings since he was sixteen years old.

Not every family of artists is as lucky. One of the sadder footnotes to greatness was the Cornish Colony, a community of commercial and fine artists living in Cornish, New Hampshire, during the first half of this century. Painters, sculptors, and writers lived there, including Maxfield Parrish and Abbott Anderson Thayer as well as sculptor Gaston Lachaise. The legacy of this colony was over forty-five divorces and a dozen suicides among the children of these artists.

This was first-generation greatness and second-generation decline. "These artists were not used to all the attention, accolades, and wealth," Maxfield Parrish, Jr., said. "The Rockefellers had several generations of wealth and knew how to handle it and raise their children with discipline. The kids of Cornish weren't so lucky. They were handed everything and taught nothing."

His older brother, Dillyn, was one of the victims of Cornish. Dillyn Parrish began drawing animals at age eight and was considered to be the sure successor to the father, but something went wrong. Dillyn had talent but measured it in terms of the amount he could earn. When he didn't make money quickly, he gave up painting and drifted from job to job, at one point selling cars. He resented his father's success and his own lack of it, finally drinking himself to an early death. Some of his childhood friends from Cornish followed similar paths.

It should not be particularly surprising that a child of an artist grows up with a desire to make art, and historically, this has frequently been the case. The Renaissance had numerous father-and-son pairings of artists, although rarely were they of equal renown. Being the son of an artist was a tremendous advantage then as it led to instant recognition and commissions. Pieter Bruegel the Elder (1525–1569) was undoubtedly the finest Netherlandish artist of the sixteenth century, and his sons Jan (1568–1625) and Pieter the Younger (1564–1638) were also talented painters, although they largely pursued their father's style and themes. A similar sort of progression existed with the German painter Lucas Cranach the Elder (1472–1553) and his capable if less original son, Lucas the Younger (1515–1586), as well as the Florentine sculptor Luca della Robbia (1400–1482) and his son Giovanni (1469–1529) and his nephew Andrea (1435–1525) who largely carried on, mostly working from Luca's designs.

A certain progression of increasing renown through the generations, however, may be seen with Pisan sculptors Nicola Pisano (1239–1284?) and his son Giovanni (1258–1325?). While the father was a highly expressive artist, the son was far more revolutionary in outlook and is considered a precursor of the advanced Renaissance style soon to predominate Italian sculpture. Also with Hans Holbein the Elder (1465–1524) and Younger (1497–1553), the son was by far the more forward looking, employing a painstaking realism and psychological nuance that gave his paintings real forcefulness. Similar conclusions may be drawn about the sons of Jacopo Bellini, Giovanni and Gentile, although probably not about Filippino Lippi, son of Filippo Lippi—all of whom were fifteenth century Italian painters. Antonio da Sangallo the Elder and his nephew, known as the Younger, were both architects and sculptors, and historians generally take no stand on their relative merit.

Sculptors, always as much craftspeople as artists, tended to need assistants; and they brought their sons and relatives into the business. Family, as well as artistic, traditions were carried on this way.

As time passed and tastes changed, it was no longer considered adequate for an artist to continue doing the same kind of art as had been done by one's parent (or in one's parent's day) but important, rather, to strike out on one's own. In some cases, children have worked in different media than their artist parents like, for instance, Jean Renoir, filmmaker and son of impressionist painter Pierre Auguste Renoir. Norman Rockwell had three children, of whom two became artists—Thomas, a writer, and Jarvis, a sculptor. Art historian Richard G. Tansey's son, Mark, became a painter. Painters Roy Lichtenstein and Robert de Niro, Sr., both have sons who became actors, and two of Kurt Vonnegut's daughters paint.

"I wouldn't touch writing," Edith Vonnegut said. "I would feel like I'm in competition. The females of my family have always been better in the visual arts than the males, and I thought I had something over my father because I could paint and he couldn't."

The differences in media have allowed her to acknowledge her father's influence and find peace with it. "I do bizarre things in paint the way he writes," she noted. "I guess you could say I carry on a family tradition."

For those who work in the same medium as their parents, the problem of "influence" has been the largest stumbling block in establishing their own identity as artists—and possibly as individuals. The strength of their names opens some doors and closes others. Art dealers and collectors may be more willing to look at the work of the child of a noted artist than that of an unknown, but their responses, as Klaus Mann discovered, can be either patronizing or hypercritical.

"A name inflames peoples' ideas and expectations. It's a cultural defect," said Jonathan Shahn, sculptor son of Ben Shahn. "People lose objectivity, looking at things either too kindly or hostilely. It's rarely just looking at the work and, sometimes, I think that they aren't looking at all but just thinking about the name."

Both of his sisters, Judy and Abbie, have experienced similar treatment. But, even more, they have privately worried when their own work begins to resemble paintings or themes their father did. Three times in her career, Judy Shahn has stepped back to look at a canvas and said, "Oh, my God, that looks like something Dad painted," and all three times she decided never to display the work publicly. Abbie has had similar situations. In 1980, she was painting a somewhat allegorical work about El Salvador and, when she stepped back, she was struck by how similar it was to "The Passion of Sacco and Vanzetti"—one of her father's most famous paintings.

At first, Abbie was somewhat alarmed: "I felt that it came from the inside of me, but when it was right out there to see, it was obvious that there was a lot of Ben Shahn in it. I began to feel that I was carrying on a tradition, and there's nothing really wrong with that. Others try all the time to be original, but I don't think that's what art is about."

10

HOW ARTISTS PERCEIVE THEMSELVES AND HOW OTHERS SEE THEM

Age doesn't appear to be such an important factor with people who paint or sculpt. No one asks a gallery director how old the person is who painted a picture on the wall. The artist could be twenty or eighty—it really doesn't matter if you like it or even if you don't.

Historically, most visual artists (as well as writers) tend to reach their stride somewhere in the middle of their careers, and the inspiration that drives them to keep going lasts well into their later years. One looks back with a mixture of pity and admiration at Matisse who, unable to get out of a sickbed at age eighty, began to make wall-sized collages of cut paper and other materials he could handle working supine. Impressionist painter Renoir, crippled by arthritis, strapped a brush to his arm in order to keep painting. Even when he was completely unable to work, he dictated instructions to an assistant for the creation of some simple sculptures. There was no quit.

Such stories are heroic yet appear to be common for most artists who try to accommodate their creative impulses to the limitations caused by age. For instance, doctors told Alice Neel, who had a pacemaker implanted in her chest, to limit her painting to no more than two hours at a time, but she never worked less than those two hours.

It may be that they go on creating out of fear of dying, sustained by creative feelings. But some of the most productive artists have led remarkably long lives. For example, Titian lived to be ninety-nine, as did Georgia O'Keeffe; both Louis Nevelson and Michelangelo lived to be eighty-nine; Picasso, Matisse, and Monet lasted until they were ninety-two, eighty-five, and eighty-six, respectively.

Art itself is immortal, and its creators seem to try to keep up with it, for immortality confers perfection. The Japanese artist Hokusai felt this sort of ongoing self-realization through art, writing to a friend that "by the age of fifty, I had produced countless designs; yet, in all I drew prior to the age of seventy, there is truly nothing of great note. At the age of seventy-three, I have at last begun to understand the true aspect of birds, animals, insects—the vital nature of grasses and trees. Therefore, at eighty, I shall have

penetrated still further, and at ninety I shall have penetrated the deeper meaning of things. At one hundred, I shall have become truly marvelous, and at one hundred and ten each dot, each line will surely possess a life of its own." Unfortunately, he was unable to reach his hoped-for plateau, as he died at age eighty-nine in 1849, and was troubled by intermittent bouts of partial paralysis for the last twenty years of his life.

Maintaining one's creativity into old age means overcoming obstacles—some of them emotional and others physical. On the emotional side is the ever-present possibility of simply running out of gas or just losing the drive to keep producing. If they have never been able to receive the recognition or favor their peers did, some artists may become disappointed and move further and further from art into something else.

Other artists still have the interest to keep going but find themselves less physically able to do so. During the last years of Norman Rockwell's life, his work deteriorated dramatically. His technical facility diminished, with the realistic sharpness that was his trademark becoming increasingly dull, and the subjects he chose were also not as poignant. In addition, he became increasingly senile during these years and was unable to see the decline.

Many artists somehow try to adapt to their age and physical limitations, the way a veteran major league pitcher will vary speeds and pitches and stop trying to strike out every batter with fastballs. Adolph Gottlieb discontinued his large-scale works and began painting watercolors from his wheelchair. Milton Avery was slowed by a heart attack but used the time he spent recuperating to experiment with monotypes of which he did 200.

In many cases, as they get older, artists become more what they are, becoming more fully released as artists. They often cast off what is unimportant, such as social activities and looking at what other artists are doing and, instead, concentrate on their artwork.

It is often said that, as artists get older, they become more artistically conventional. In fact, it appears that the opposite is true and that they become more revolutionary. J. M. W. Turner, for example, moved further and further away from strictly identifiable forms in his later years, concentrating on atmospheric conditions and changes. This was the Turner to whom John Ruskin and many of the French impressionists felt most drawn. Goya's style became darker in his old age with, as some historians have postulated, a sense of mortality providing a nightmarish intensity to his later works. Titian is another whose style became looser, the pallette decidedly bolder; and Monet, bedeviled by cataracts and a resulting depression, devoted ten years to painting images of waterlilies that experimented with color and light.

Adja Yunkers was practically blind in his last years, bending over to look at his colors close up. His late paintings, often composed of one or two simple colors, have been highly praised. The artist frequently said during that time that "one has to be blind in order to see color." Age, of course, has nothing to do with aesthetics, although it does give an artist more time to make his or her artwork closer to the perceptions that inspire it.

BECOMING AN ARTIST AFTER ANOTHER CAREER

All kinds of people get involved in some form of artwork—often, the dabbling "Sunday painter" sort of activity—as a way to pass the time or simply because it's fun. For some, the art turns into more than a hobby. It becomes their passion. Sundays aren't long enough to say all that they have to say. Canvases accumulate, stacked neatly in the room designated "the studio," and the creator's consciousness of him- or herself as an "artist" begins to grow. Some people quit their jobs and take the plunge; others, possibly retirees, just work at it harder, taking classes, trying to get their work shown, and hoping to make some money from it.

Mary Anne Robertson, "Grandma" Moses, is probably the best known example of the late-blooming artist. A housewife, she began taking painting seriously in the late 1920s after the death of her husband, in part to overcome her sorrow, and her first one-person show took place when she was 80. A Pittsburgh housepainter, John Kane, also painted on the side—interestingly, he used housepaints on his canvases, well before Jackson Pollock startled the art world by this practice—but was not publicly shown until age 67.

Another, James Stewart of Rock Creek, West Virginia, took up sculpture after retiring from the coal mines with black lung disease in 1974, chiseling busts of current and historical figures from the pieces of coal that brought about his retirement. The executives of coal companies found out about his skill and began commissioning him to do their portraits at $3,000 and up.

"I wish I had gotten into this a bit sooner, but I never thought I could make a living at it," he said. "The fellows I used to work with find it hard to connect me with the person they see getting written up in art publications. I never thought of myself as a sculptor but as a coal miner. The people I've known all my life aren't sure if they should look at me differently. It's hard to know how to take all this."

Herbert Ferber, a well-recognized painter and sculptor born in 1906, exhibited his work for decades—during the 1960s, his room-sized environmental sculptures influenced countless artists—but he did not give up his dentistry practice until the late 1970s.

"I knew that painting and sculpture couldn't support me, so I became a dentist," he said. "I quit being a dentist when I realized that I could make more money from art." Those intervening years were quite busy for him, as he maintained a private practice, taught at Columbia University's dental school and researched and published numerous articles in a variety of dentistry journals, all the while making art and keeping his hope alive that, someday, he might not have to do anything else. When it finally came true, he noted, "it was like a holiday."

Another well-known dentist-turned-sculptor, Seymour Lipton, seemed almost embarrassed about his previous career. "You know, there's a book out about my work, just my work," he said shortly before his death. "In the whole book, there is only one paragraph about my having been a dentist. The fact that I was a dentist has nothing to do with my artwork. Dentistry was just an oddity I did for a number of years in order to make a buck. No one talks about Wallace Stevens because of his work as an investment banker in the insurance industry. The important thing is the poetry he wrote."

To a degree, he is right. No one would think to look for images of molars or gum disease in Lipton's work. However, the need to create art and the necessity of earning a living are twin concerns in every artist's life. In a society where the work ethic is central, you are what you make a living at, and lawyers, doctors, (both William Carlos Williams and Chekhov were doctors) and bankers (T. S. Eliot and Gauguin) and others have to keep their own faith. For many women, artistic pursuits may have to take a back seat to family obligations, such as childrearing. Both Louise Nevelson and Louise Bourgeois, two of the most important sculptors of the postwar era, took time off from their work to raise children, but they came back. "You have children for fifteen years, not for eighty years," said Louise Bourgeois. "It's just one episode in your life. There's a lot more to life than that."

Those whose involvement in art making is not full time are often put down as dabblers, Sunday painters, amateurs, or hobbyists. Artists have enough obstacles already without having to also prove that they are serious about their work. In a world where former president Jimmy Carter turns out to be a poet and painters David Salle and Julian Schnabel recast themselves as filmmakers (film director and country music singer with Schnabel), should there be any wonder when actors, singers, and other entertainers declare themselves fine artists?

There is currently a burgeoning supply of paintings by celebrity artists, among them Tony Bennett, Bob Dylan, Tony Curtis, Sylvester Stallone, Phyllis Diller, Whoopi Goldberg, Lily Tomlin, Morley Safer, and Scottie Pippen. Their work is sold at charity auctions or at galleries that specialize in celebrity artists, selling for thousands or tens of thousands of dollars.

"Jerry Garcia [the deceased lead singer of the rock group The Grateful Dead] is the top grossing artist at the gallery," said Maggie Houseman, one of the directors of New York City's Ambassador Galleries, which also represents the paintings of actor Tony Curtis, comedienne Phyllis Diller, Penthouse magazine publisher Bob Guccione, and Gloria Vanderbilt, to name a few. "We're talking about Dead Heads who spend their last dime on a Jerry Garcia, and some Dead Heads from twenty years ago who are VIPs now."

According to Sylvia White, an art dealer and artists' career advisor in Santa Monica, California, "any celebrity artist is guaranteed success in terms of selling works. People want to touch celebrities; they want a piece of their lives, and when they buy a celebrity artist's work, people feel they have made an association with that person."

The idea of guaranteed sales at high prices would likely make most struggling, noncelebrity artists green with envy, but there is a downside to this commercial success: None of these celebrity artists' work is taken seriously as art by the mainstream art world; that is, collectors, critics, dealers, museum curators, and other noncelebrity artists. The artwork is roundly viewed as high-priced, limited edition autographs, produced by people whose commitment to art is superficial.

That verdict is a bitter one for many celebrity artists, whose careers have afforded them considerable free time to pursue their art interests and who may have studied art

initially but found they could earn a better living as performers. Probably the three most serious of all these artists, and whose art is treated most seriously by the art world, David Byrne, Anthony James, and Martin Mull, are continually combating the image of the celebrity artist.

"It was helpful when Martin was on David Letterman at the same time that I was showing his work in my gallery," said New York City gallery owner David Beitzel, who has represented Mull since 1993. "Of course, Letterman had to pry the information out of Martin that he had a current show and where it was. He wants his art to stand on its own and not to be associated with his face and his public persona."

Since the late 1970s, Mull has appeared in more than twenty films and scores of television programs, all of which are comedies. A career like Mull's is a precarious balancing act of conflicting personas, interests, and advice. As a method of generating interest in a current exhibition, which might result in increased attendance and (likely) sales, Beitzel clearly wants Mull to talk about his art on Letterman, yet (as Mull knew very well) the Letterman show is not a forum in which to discuss art in a serious way. Guests on the show are expected to be amusing and upbeat, not dwelling on one topic for too long.

In addition, the comic actor side of Martin Mull tends to take over when describing his artwork: "I draw to touch base; to debrief myself of all but visual and sensual reality and, like a businessman checking his answering machine, to see if the muses are biting."

Mull's principal West Coast dealer, Dorothy Goldeen in Santa Monica, California, also stated that "we try to counteract interest in Martin that is based on his celebrity status," yet she noted that "Martin's exhibits generate a lot of attention, and that helps him, it helps the gallery and it helps the other artists we represent." Dealer and artist trade off his roster of ready buyers for her list of noncelebrity collectors. In time, he may make the transition into the mainstream of the art world. The comedian and actor Steve Martin, a renowned collector of contemporary art, has several of Mull's paintings, but now, so do the Metropolitan Museum of Art in New York, the Columbus Museum of Fine Art in Ohio, and the Newport Harbor Museum in California.

In the early 1990s, Mull knew that he had a problem getting his work taken seriously. Despite receiving both a bachelors and a masters of fine arts degrees in art from the Rhode Island School of Design in the mid-1960s, he found his work grouped with that of far less accomplished celebrities and little to no interest on the part of serious art dealers. "It's of interest for people who know his work that he has an MFA from RISD, but obviously that isn't a main reason anyone would buy his work," Beitzel said. Mull sought art career counseling from Sylvia White.

"My biggest goal, when Martin first came to me, was to not allow any press coverage unless it was art coverage," White said. "I would have a show of Martin's work in my gallery, and I'd get a call from a reporter at the Los Angeles Times who wanted to write about Martin's work. I'd ask that person, 'What section of the paper will it be in, and what art writing have you done in the past?' Often, the reporter had no specific art

writing experience, and the article was slated for a features section. I turned down a lot of opportunities for Martin's work to be mentioned in the newspaper, or in magazines, because it wasn't the appropriate kind of coverage."

After a few exhibitions, art reviews largely began to treat Mull as any other artist. One annoyance Sylvia White recalled was a review in *ARTnews* that, instead of including a reproduction of a painting to accompany the write-up (as is usually done), used a head shot of Martin Mull. Eventually, the celebrity art collectors were matched by a growing number of traditional art buyers who had simply read the reviews.

Although White acts as a dealer, her main activity is consulting to artists. To fully advance Mull's career, she began to promote him to more high-powered art dealers, finally placing him with Dorothy Goldeen in California and David Beitzel in New York.

"I knew we had a market for his work, because of the celebrity," White said, "but I had to position him in such a way that would be taken seriously. It took a full year of constant lobbying to get Dorothy to take Martin's work. She wanted to know if he was a fluff artist, and she was also concerned what the other artists in her gallery would think if she started to represent Martin Mull. 'Has Dorothy gone Hollywood? Is she no longer interested in serious art?' It took a full year to convince her—and, through her, the gallery's regular artists—that Martin was for real."

Dorothy Goldeen's response has been matched by other dealers, museum directors, and visitors to art shows. "We had a larger than usual attendance for Martin's show here," said Gary Sangster, director of the Cleveland Center for Contemporary Art, which showed Mull's work in early 1995, and our outgoing survey indicated that people were surprised he was so good."

Anthony James also talked briefly with Sylvia White about his career, but they did not establish a client relationship. Nevertheless, James—who appeared in more than twenty-five films, including *In the Heat of the Night, High Plains Drifter,* and *Unforgiven,* and in more than 100 television programs—was equally if not more determined to establish himself as a fine artist. In late 1994, after a 28-year film career, James withdrew his membership in the Screen Actors Guild, gave notice to his agent, and moved from California to Arlington, Massachusetts, where he began to paint full-time. "I still get residuals from the films and TV shows I've done," James said, "which helps me support myself and my mother. I don't yet know for a fact that I can support myself." For career advice, he relies on long-time Boston art dealer Portia Harcus, who is one of the dealers representing his artwork.

While still an actor, James hired an artist's representative to promote his paintings, and he himself also sent slides of his paintings to various West Coast galleries, usually meeting with various shades of rejection. Eventually, he began to exhibit his work, and these shows received favorable attention. As with Martin Mull, his collectors grew out of the initial Hollywood celebrity buyers to include those primarily interested in contemporary art.

Also like Mull, James found his acting background a hindrance in winning wider respect. "When you think of Hollywood, you think of entertainment," James said, "and

entertainment essentially distracts you from what you are. Serious art does just the opposite—it tells you more about who you are. The preconceived notion is that someone who has been an actor for twenty-eight years does art for a hobby or for relaxation and isn't really serious about it."

Unlike Mull, James has no formal art training. "I never studied acting, and I never studied art," he stated. "Everything I've ever done is all trial-and-error. I was lucky to be in *In the Heat of the Night*—a film that wins all the awards—and I've been lucky that people like my artwork."

Also unlike Mull, James's name is not as well recognized—his face, on the other hand, which Clint Eastwood said "communicated evil to an audience," is a better known commodity—and he has had less of an uphill battle dispelling stereotypes about actors who paint.

As a result, James's own promotional efforts have been to trumpet the fact that he was an actor but gave it up to pursue art full time. "Any way that an artist has to get his name and work out to people is good, and my background is a distinct advantage in that regard," he said. "People so far have liked the fact that I gave up acting to be an artist. It helps."

He added that the celebrity artist's problem of being taken serious is solved over a period of time, "not by denying your background. It doesn't make sense to go before people and say, 'Here I am, don't look at me.'"

An obvious drawback to having a long-term career in another field is that both James and Mull are having to learn things that other artists in their fifties learned twenty years earlier: How to talk about their art; how to make connections with dealers, museum officials, critics, collectors, and other artists; how to make an attractive exhibition of their work.

Both James and Mull have made some mistakes that reflect their inexperience. For example, both have had coffee table books of their paintings published by Journey Editions, a Boston-based company that specializes in art books of actors and musicians. The only essays in James's and Mull's books were written by the respective artists, which makes them look like vanity publications.

"I think it was a mistake not to have an essay written by someone else," Gary Sangster said. "It looks like no one wants to speak on Martin Mull's behalf. But, you know, a publisher comes to you and says, 'I want to do this kind of book on you,' and an artist has to know what that means. Martin wasn't experienced, and he didn't know what he was getting into."

The publisher of Journey Editions also arranged a show of James's artwork to coincide with the release of his book at Ambassador Galleries, the showplace of Tony Curtis, Jerry Garcia, Bob Guccione, and others. "I'm not particularly happy about his New York address. I've talked to Anthony about that," said Tamar Erdberg, director of Adamar Fine Arts in Miami, which exhibits James's work. "How can you be taken seriously as an artist when your work hangs next to Bob Guccione?"

James has also been unhappy with the association with Ambassador Galleries. "I was told it was a gallery in New York, in SoHo," he said. "I got into it unknowingly, because I trusted the taste and information of the publisher."

Another celebrity who found that establishing oneself as an artist is hard enough without having the extra burden of fame getting in one's way is David Byrne, the lead singer and songwriter for the rock group Talking Heads (1976–1992). Byrne, who in 1987 received an Academy Award for cowriting the score for Bernardo Bertolucci's film *The Last Emperor,* has had a difficult time achieving recognition for his photography. "Art dealers in the United States have wanted to keep me at arm's length," he said. "They seem to wonder, 'Who is this guy, and what does he think he's doing?'"

Byrne is not new to the art world; like Mull, he received a degree in fine art from the Rhode Island School of Design in 1974. "When I moved to New York City in the 1970s, I was making art and writing songs, but the songs proved to have an audience that was receptive and immediate," he said. It is personally liberating to create art rather than music, Byrne noted. "When I put out a record now, there is a sense of expectations in people's minds. They want more of what they like and less of what they don't like, and what I do now is judged on the basis of what I've done before. With my art, people don't have the foggiest notion of what I'm going to do, and that's a rare opportunity."

Although he had continued to make art during his Talking Heads career, it was only in the early 1990s that Byrne began attempting to show his work. "I brought my pictures to a number of dealers in New York, and no one was all that interested," he said. "Finally, I guess about three years ago, I got some works included in a group show in *Aperture,* the photography magazine. That was a real ego boost, because I was accept-ed in it because of my art, not because of—or in spite of—who I am as a singer."

That exposure did not make his work any more appealing to dealers, and Byrne's only solo or group exhibition in the United States in 1994 was at the art space of a rock night club, CBGB's 313 Gallery in New York City. Unlike other celebrity artists, such as Martin Mull, Morley Safer, and Tony Bennett, whose works have received publicity through a dealer or publicist, David Byrne has attempted to market himself as a fine artist largely by himself. He also avoided the galleries that regularly exhibit celebrity-artists' work, opting for respected contemporary art spaces. "I've talked with other artists," he said, "but about purely practical things, you know, 'What lab do you use to print your pictures?'" This approach to introducing dealers to his work, reflecting Byrne's primary concentration on the music career, has not met with considerable success.

However, Byrne took a portfolio of his pictures to galleries in Europe and South America, where he was performing in 1994 and 1995, generating a number of shows in such cities as Lisbon (Portugal), Berlin and Cologne (Germany), Edinburgh (Scotland), Leiden (Holland), Istanbul (Turkey), Louvain (Belgium), and Buenos Aires (Argentina). "In Europe, there is less compartmentalization, so I could be accepted as a singer and as an artist," Byrne said. "I wasn't so burdened there as I have been here."

Although these exhibitions did not result in significant buying (few of the cities have a significant art market), they did engender more interest in his work. Byrne's pho-tographs began to be included in some touring group shows and in some solo exhibits. In 1995, Chronicle Books in San Francisco published a volume of Byrne's images and text ("I had a friend who knew someone there," he said), called *Strange Ritual,* which

was selected by *The New York Times* as one of the ten top photography books of the Christmas season. Other shows have followed—solo exhibitions in London, Rome, Toronto, Stockholm, Bologna (Italy), Santorin (Greece), and Ljubljana (Slovenia) and a group show at Exit Art in New York. Then, in 1996, the San Francisco Museum of Modern Art included one of Byrne's photographs in its permanent collection. Still, David Byrne has no dealer representation in the United States, and those who seek to buy his work must contact his record label, Luaka Bop, in New York.

It should not seem surprising that creative people are creative in more than one area, but talents are quickly and decisively pigeonholed these days, and crossing boundaries is no easy feat. Vassily Kandinsky and Henri Matisse could leave off careers in the law for painting, and both Herbert Ferber and Seymour Lipton were able to give up their dentistry practices for full-time sculpting, without widespread disbelief. Certainly, few lawyers or dentists are internationally known, and these professions themselves do not carry all the associations—positive and negative—of the Hollywood actor. Anthony James portrayed evil characters for twenty-eight years because the movie-going public accepted his face as that of a bad man. Perhaps a few roles as a romantic lead might have prolonged his interest in acting. "The issue is how people react and respond to media," he said, and it is this new image as visual artist that Byrne, James, and Mull must establish with the public that will determine whether or not they are allowed to succeed.

With these and many other artists who have pursued other disciplines, the desire to create art gives one's life a shape and meaning. For a number of years, Grandma Moses submitted both homemade jellies and paintings to competitions at country fairs: The jellies won prizes but never the art. She was undaunted. Her work had moved from escapism and hobby to obsession, and her patience and talent won out.

One person who understood that victory was Sidney Janis, a former ballroom dancer and shirt manufacturer who became a professional art dealer in 1948 at the age of 52. One of the first people to show abstract expressionism and Pop Art, he had been a collector of art since 1926 and wrote books and articles about artists in his off hours. Janis is credited with, among other things, having discovered Morris Hirschfield, another clothing manufacturer who turned to painting at age 65.

"A large number of artists, Hirschfield included, retire or become ill and turn to painting," Janis said. "They've often worked in very different professions and took up art, painting in a very untutored, instinctual way. The world has always had them; the art world has not been quite so aware."

The world still has such artists. Publishers are backed up with piles of manuscripts sent in by people who believe that they have a story to tell. Art galleries are jammed with prospective artists trying to show portfolios and slides of their work in the hope of an exhibition. Meanwhile, the dentist fills a cavity, the clothier stitches a seam, the actor rehearses his lines, the house painter scrapes off one layer of paint before applying another, and a massive reservoir of art interest and talent await discovery a little below the surface.

MUST ALL ARTISTS MOVE TO NEW YORK CITY?

Once a year, Mideast Moslems make a pilgrimage to Mecca in Saudi Arabia, the spiritual center of their religion. Many Christians make an Easter trip to Calvary, and for the Jews, the Passover seder ends "Next year in Jerusalem."

For artists in the United States, too, there is a central point where they may feel whole again, where their troubles are understood and their good works appreciated. That place is New York City, the capital of the world's art market and home of most of the country's major art critics and magazines.

Most of the nation's artists, however, do not live in New York City, although many have gallery or dealer representation there. If they don't have Manhattan representation, they spend a lot of time trying to get it.

For the majority of this country's artists, New York City is more than just a place. It is where works of art are seen by people from all over the world, and where that art is taken seriously and understood by a sophisticated market. The pressure to decide whether or not to move to New York City may be the most intense that any artist will have to face. To many artists, it is synonymous with the question of whether or not they think of themselves as serious professionals or just Sunday painters.

"Anyone who goes to art school—and I got a graduate degree—constantly hears, 'New York! New York! You'll never be on the big board if you're not in New York,'" said Robin Rose, a painter who has lived in a number of different cities and is represented by a New York City gallery.

"New York is always at the back of my mind," stated Ida Kohlmeyer, a Baton Rouge, Louisiana, painter. "I thought about moving to New York back in 1963, after I had won a Ford fellowship. But I had a family, and it might have broken up my family, and so I stayed."

Pluralism has been one of the dominant features of the art market over the past two decades, and more attention is being given to "regional" arts activity. No longer is the rest of the country referred to as "the provinces." But, is it possible for an artist to establish a major reputation outside of New York City?

Yes, says Dickie Pfaelzer, assistant director of the Elaine Horwitch Galleries in Santa Fe, New Mexico, but it just takes a lot longer.

"You don't find that many 28-year-old artists here with national reputations," she said. "Generally, the gallery has to show some national names to get the serious collectors to come in. They can then see the local artists."

No, says Ivan Karp, director of the O.K. Harris Gallery in New York City, but they can support themselves and make a fair living without being in New York.

"If they have a rampant ego and a driving ambition, which is what a real artist must have, they will want to make it in New York," he stated. "Some artists will be satisfied with local fame. They have a coterie of disciples where they are and do quite well. They may redefine what it is to establish oneself as a major artist, but history won't afford them recognition in the wider culture."

Ivan Karp pointed out that he sees 150 artists a week, many of them from out of town, who are looking to be represented in his gallery. It would mean a major sacrifice for many artists to try to "make it" in New York—a sacrifice of time away from their work or of money as New York City is an expensive place to live and work.

It is also difficult for artists who are not familiar with New York City to know which galleries and dealers are right for their particular work. There are hundreds of galleries, some in for the long term while others have a short life span, and each has its own particular level of artistic quality and pricing. The wide variety does not necessarily ensure a good fit for an artist.

Still, "New York" tends to rest heavily on the minds of many artists not living there.

David Freed, a painter in Sedalia, Missouri, who is represented by a SoHo gallery in New York City, noted that, although he has been able to sell well in the Midwest, "the art world just doesn't come to the Midwest. Artists, dealers, and collectors here have a big inferiority complex: They live in a never-never land, hoping that fame can happen to them without having to go to New York."

A regional reputation, he feels, is "meaningless in terms of the national market. You enter regional competitive shows in order to build your confidence, and you try to establish a following for your own happiness. If you are serious, though, you recognize that you will have to do the New York thing."

Some artists don't just think about New York but, in fact, move there. "You can charge twice the price for your works in New York than in Cleveland," Vivian Abrams, a painter who left Ohio for the Big Apple in the late 1970s, said. "I had a show in my Cleveland gallery in 1977 where I sold two thirds of my work and still didn't make a profit. I was charging as much as a local artist could."

"There's more critical attention in New York to your work, and it makes New York more exciting than any other place," said Taro Ichikashi, a Japanese-born painter who moved to New York City from Washington, D.C.

It was not easy for either of these two artists to obtain gallery representation—that was something they left behind—although the move brought more optimism about their careers. If something was going to happen for them, they believed, it would happen in New York City. "What does it really mean," Abrams asked, "to 'make it' in Cleveland?"

Many artists in other parts of the country feel a bitterness toward New York City and a "New York Arts Establishment," which they believe ignores them. They claim that it is difficult to be reviewed in the major art magazines and by the major critics who are based in New York City.

"I like to think that it's possible to be a good artist anywhere," said Tony DeLap, a painter and sculptor in Corona del Mar, California. "It's important for artists everywhere to be seen and receive critical comment. However, it gets distorted when a well-known West Coast artist like myself is ignored and less talented artists in New York are hyped by the media."

Others take their bitterness a step further. Betty Moody, owner of the Moody Gallery in Houston, Texas, stated that she speaks for "most if not all" Houston dealers when she noted that "the coverage in the New York-based arts magazines has been inadequate. The reason for this, I believe, is due to advertising. I think that, if there were more advertising coming out of Houston, you would see more coverage of the arts in Houston. None of the arts magazines will admit to this, but I believe it's true."

The media situation is changing, if slowly. Some of the major art magazines have featured special sections of the country, such as Taos, New Mexico, or California, and their writers now include correspondents from a variety of cities. Certainly, there are more artists living in New York City than in any other single location, and the reasons are not solely the easy access to galleries where they can attempt to show their work. Many of them enjoy the atmosphere and the kind of intellectual stimulation that comes from being in the center of the art world. That stimulation, which can dramatically affect the way artists there make art, is less available for artists outside of New York or any major urban art center. Without at least visiting Manhattan from time to time, artists can glean only those developments that the art magazines report.

The question of whether to move to New York City is often more burning with younger artists than with those who are older and have settled in a particular region. The "need" to go to New York City must be weighed against other personal concerns. Sculptor Joan Grant, who lives in New Orleans and is "still married," noted that career decisions are based on "what you want to do and how you're going to make it work. For me, making art is more important than hustling to sell it. It's all dependent on your individual needs for achievement; otherwise, you lose touch with yourself and with your art."

Although Ida Kohlmeyer didn't choose to come to New York City in 1963, her years of work in establishing a regional reputation were not wasted. By the early 1970s, New York art dealer David Findlay asked to represent her work in his gallery, and her first show there was a sellout. By 1980, she was one of five women to receive an award for her work from the Women's Caucus on Art.

"I've received many accolades, and I've thought many times to myself that I had really made it on a national scale," she said. "But when I was honored by that award along with such women as Alice Neel and Louise Bourgeois—that tasted so good."

THE (UNFLATTERING) PORTRAIT OF THE ARTIST

Artists may think well of themselves, cope admirably with the vicissitudes of stylistic changes and critical praise or damnation, stay out of trouble with the Internal Revenue Service, make peace with their decision about where to live, and maintain their desire to create to the last minutes of their lives. Still, the perception of artists in the wider society tends to be negative. One finds that view most clearly stated in novels and movies (where artists are forever immoral or amoral, often unkempt, always selfish, frequently alcoholic or hooked on drugs) as well as in a growing number of psychological studies of artists and creativity in general (usually finding neurotic or psychotic disorders as essential ingredients of art making). These perceptions reflect and give weight to societal biases,

which frequently come to the fore during debates over public financing of the arts or censorship. One easily senses an anger throughout the United States over who artists are, how they undermine traditional values, and why they should not be supported in their endeavors.

Unfortunately, this negative stereotyping of artists is not a new phenomenon and, in fact, has a long history. What is more unfortunate is when young artists, insecure as to their place in the art world, attempt to look or act the part of the artist as defined by these images. It is more surprising that age-old attitudes continue to the present day, obscuring more meaningful discussions of art and the creative process. Having two strikes against you in the public's mind is one of the most severe pressures faced by artists.

What makes artists create objects and images? This is a question that has bothered essayists, philosophers and psychologists for centuries, with new epochs providing fresh theories. Scorning the apparent irrationality of the artistic process, Plato described the poet as "not in [his] right mind," possessed by the Muse with "reason . . . no longer in him" and, many centuries later, Friedrich Nietzsche wrote that "it does not seem possible to be an artist and not be sick." Certainly, others have assigned loftier attributes to artists than mental or physical disorders, but artists have tended to be seen through the years as somehow "off," removed from real-world concerns (except, of course, poverty), and the what and whys of making art have remained a mystery.

Artists Under the Clinician's Microscope

The psychoanalytic world has entered the quest for the source of creativity with a spate of psychological studies of artists that generally find manic-depression and other mood disorders as essential ingredients of art making. An example of this trend is Kay Redfield Jamison's study, *Touched with Fire: Manic-Depressive Illness and the Artistic Temperament*. A professor of psychiatry at Johns Hopkins School of Medicine and a sufferer from bipolar disorder herself (which she describes in another book, *An Unquiet Mind*), Jamison writes that "many lines of evidence point to a strong relationship between mood disorders and achievement, especially artistic achievement. Biographical studies, as well as investigations conducted on living writers and artists, show a remarkable and consistent increase in rates of suicide, depression and manic-depressive illness in these highly creative groups." She goes on to claim, "not that all writers and artists are depressed, suicidal, or manic. It is, rather, that a greatly disproportionate number of them are; that the manic-depressive and artistic temperaments are, in many ways, overlapping ones; and that the two temperaments are causally related to one another." She cites a vast number of clinical studies in this area as well as her own in order to bear out her argument.

Two questions arise: Is this relationship so strong? And What are the assumptions (or cultural biases) that led to these studies being conducted in the first place? In fact, the two questions merge, as relationship between madness and creativity only can be "found" when one has looked specifically for it and stacked the deck to ensure the results.

Take, for example, a study by J. J. Schildkraut, A. J. Hirshfield, and J. Murphy of fifteen New York School of artists that Jamison cites, in which it is noted that two committed suicide. Jamison leaps to the claim that "the suicide rate among the artists . . . is at least thirteen times the general [population] rate." It didn't occur to her to notice that this group of fifteen is rather small, specially hand picked, and is viewed outside of any context. Arshile Gorky and Mark Rothko, the two who committed suicide, for instance, were in the late stages of cancer at the time; and an accident had left Gorky unable to use his right, painting hand: Why not view their suicides more heroically as choosing their own terms for death instead of as somehow inherent in their choice of occupation?

Some in the psychotherapeutic community have never been wholly comfortable with art and artists of all media and disciplines, and studies of artistic creativity reflect this unease. Sigmund Freud, for instance, a keen observer and enjoyer of art, believed that all emotions were chemically based and that their chemistry would someday be discovered. Freud saw art as a neurotic symptom of an individual who could not face reality and was convinced that art was something of which people could be cured.

Freud's followers have sought to be more precise in their work on the subject. We now can speak of which side of one's brain controls the creative impulses, for example, as though that tells us anything. The most disconcerting efforts, however, have been when psychologists have attempted to prove the basis for making art. In the early 1970s, University of Iowa College of Medicine psychiatrist Nancy C. Andreasen found that 80 percent of the participants in the university's Writers' Workshop suffered from mood disorders, including manic-depression in some cases. Dr. Andreasen went on to publish findings on the relationship of creativity and mental illness.

Ernest Hartmann, a sleep researcher and professor of psychiatry at Tufts University School of Medicine, discovered a connection between nightmares and creative activity in 1984. Writing in *The American Journal of Psychiatry* that the subjects in his study "have a biological vulnerability to schizophrenia," he noted that "nearly all the subjects had occupations or career plans relating to arts or crafts." Not long after, Karl U. Smith, a psychologist at the University of Wisconsin, discovered that people who are more expressive on the left side of their faces are more likely to be creators than others who are "right faced." In 1999, Stanford University psychologist Robert Solso declared that artists have "different inborn brain structures" after having attached magnetic resonance imaging scanners to a portrait painter and a nonartist graduate student and asking them both to draw six faces on a notepad. A weird sideline, the psychology of artists, has now moved into the forefront.

Beyond the analysis of data is a structural problem; that is, the manner by which this data was established. Why investigate only artists and not lawyers, doctors, physicists, psychiatrists, and other professionals who are also highly trained, who often work independently, and who need to develop creative solutions to thorny problems? The fact is, artists make their work and—through their work—their lives available for public consumption in ways that few other professions do. We don't know what lawyers generally think about suicide because it is their interpretation of law, rather than the presentation of their feelings, that is the source of their income.

Clinicians could have tracked everyone who graduated from Oxford or Yale between 1880 and 1920, for instance, to learn what they did in life and how they lived and died. Oxford graduates may not be fully representative of the larger society, but at least they are closer to the society of which artists are a part and for whom their works are intended. Who in this group suffered mental illnesses? And what were their occupations? When you look *only* at artists, you predetermine the results.

If clinicians sought only to look at artists, they could track everyone who went to a particular art school to discover what percentage was subject to manic-depression or other psychological ailments. The authors of the study of the fifteen New York School artists might have looked at every artist who worked on the artists projects of the WPA during the 1930s, for instance, to obtain a fairer representation of the population or painters. Why didn't they? The answer is obvious: The results are not likely to be so dramatic and publishable.

Psychological studies fall into three general categories: The first is the individual case, such as Freud's "Little Hans" or "The Wolfman," which are presented for their particularly interesting qualities. The second type are studies of similar symptoms in a group, such as bulimia or anorexia nervosa, that are seen to come from similar or disparate causes (incest or societal expectations, for instance). The third are studies of disparate symptoms, such as alcoholism, drug addiction, or violence against family members, that stem from a similar cause (post-traumatic stress disorder, for example).

On the other hand, studies that target a particular group (in this case, artists), suggest that there is something peculiar about this group, requiring evaluation. Generalizing about a heterogeneous group—any occupational category, nationality, religion, race, or "type"—is normally thought of as bad manners or just plain discrimination. When the subject is artists, however, rules seem to change. From the start, any claim to objectivity is lost, and it is only because our society tacitly accepts the otherness of artists that these assumptions aren't more vigorously questioned.

Credible associative studies can be accomplished that involve artists. For instance, the 1981 examination of the causes of death of 1,598 artists by industrial hygienist Michael McCann and Barry A. Miller and Aaron Blair of the National Cancer Institute found higher incidences of certain types of cancer than in the general population, which may have resulted from the toxic ingredients in the art materials they used. This survey, which eventually helped convince lawmakers of the need to enact a federal art materials labeling law in 1988, was based on 1,598 obituaries in an art magazine. There was no hunting around for colorful characters or good quotes.

Associating art making and mental instability condemns art, presenting an *ad hominem* attack on art. Why should anyone care so much for the creations of crazy people? The aim here is not to understand general human psychological issues, nor is it to gain an appreciation of art or its sources; rather, the endeavor is consistently to segregate artists as a special category and diagnose them as flawed individuals whose flaws give rise to their art. Examinations of the subject of art and mental illness, such as the American Institute of Medical Educations' annual "Creativity and Madness" conference

(to name just one), only add to misconceptions rather than clarify general human problems and processes. Clinicians need to examine the biases that led them to single out artists in the first place.

The view of artists as essentially diseased has found favor with writers who are not psychiatrists. Among the first questions that Eve LaPlante asks in her study, *Seized: Temporal Lobe Epilepsy as a Medical, Historical, and Artistic Phenomenon*, is why Vincent van Gogh disrobed in an art gallery and sliced off a portion of one of his ears, among other strange behaviors? (No other subject in art history appears to be as fascinating to researchers as van Gogh's ear.) Of course, no one knows for certain the answers to these questions, but there are a number of competing theories, including alcoholism, chemical poisoning, glaucoma, manic-depression, schizophrenia, sunstroke, syphilis, and—according to Eve LaPlante—epilepsy. Did whatever ailed van Gogh affect his art? Eve LaPlante enters this discussion with her own affirmative, sorting out the symptoms in van Gogh as well as Alfred Lord Tennyson, Gustave Flaubert, Fyodor Dostoevsky, Lewis Carroll, Jonathan Swift, and others (well known and not) that correspond to recognized characteristics of epilepsy.

To her mind, epilepsy has "distinct benefits" for artists: "In addition to . . . seizures, the disorder is linked with personality change: between seizures many people with [temporal lobe disorder] are intensely emotional, deeply religious, and compelled to write or draw," she writes. "In such famous sufferers as Dostoevsky, Tennyson, and Lewis Carroll, these traits may have contributed to lasting works of art." This occurs, in the case of the poet Tennyson or the novelist Dostoevsky, by providing "material" for their art. With van Gogh, the painter's "desire to express himself artistically" intensified, and his production increased.

Like Jamison, LaPlante offers a number of after-the-fact diagnoses based on highly questionable evidence. "Jonathan Swift is now thought to have had epilepsy," LaPlante writes, finding proof in Swift's novel *Gulliver's Travels*. "The miniature and mammoth peoples, Lilliputians and Brobdingnagians, who Gulliver encounters in his travels suggest that Swift experienced micropsia and macropsia." More literal-minded readers, however, might think that Swift was weaving an allegory, using little people to point up petty minds and giants to reflect the smallness of Gulliver's own thinking. A similar discussion of Edgar Allen Poe's short story "The Fall of the House of Usher" reveals that LaPlante appears to have missed the point again.

Proof of what was wrong with van Gogh's brain might be seen in his art. LaPlante posits that "the celestial pinwheels in [van Gogh's] 'The Starry Night,' painted at Saint-Remy the year before he died, might suggest . . . hallucinatory flashes of light." Perhaps what we honor in van Gogh's art is finding a visual equivalent for an epileptic seizure.

The concept that art reflects, rather than transcends, the physical or emotional limitations of the artist has its own history. Patrick Trevor-Roper, a British ophthalmologist and author of *The World Through Blunted Sight*, stated that artists along with mathematicians and bookish people share a myopic personality, whose attributes include

not adapting "himself to the surroundings and . . . not willing to make compromises. He is often severe in his righteousness and his rightness and may become a disagreeable personage." The Romantic poet John Keats wrote frequently about auditory subjects (such as "Ode to a Nightingale," "On the Grasshopper and Cricket," and "On Hearing the Bagpipes") because of his nearsightedness. Noting that "there are occasional descriptions (as of the Ambleside waterfalls) that seem to confound this, it could be argued that his philosophical approach—of avoiding detailed description 'so that there should be more room for the imagination'—was a rationalization of his own physical defect."

Trevor-Roper is no more generous to visual artists, who apparently veer from realism only for reasons of poor sight. The increasingly abstracted atmospheric forms in J. M. W. Turner's late paintings, he claims, were not products of imagination or intense thought but "distortion" and "blurring" as a result of "secondary astigmatism that . . . a sclerosis of the lens may induce." He adds that "it is tempting to attribute this change to the progress of a senile cataract."

Elsewhere, Trevor-Roper speculates that van Gogh was nearsighted, because of "his childhood habit of walking with half-shut eyes, hunched shoulders, looking at his feet, and being a duffer at ball games." In addition, all of the French impressionists were myopic, and Paul Cezanne's myopia was compounded by retinal damage from diabetes. "It is not surprising that only in some of [Cezanne's] self-portraits are his colour values and optical proportions at all conventional."

One finds more of the same in Diane Ackerman's *A Natural History of the Senses,* in which she notes that "Cezanne painted the world his slightly askew eyes saw." Such analysis gives one pause. Does one admire Cezanne for offering a realistic vision of the world as seen through the eyes of someone who is nearsighted, or is it because of the new, purposefully unnaturalistic ways in which forms and colors are presented. The history of Modernism from Manet to well into the twentieth century involves taking art back from the faithful representation of things, offering a more subjective commentary on the world or the processes of mind. The possibility that the stylistic and conceptual shifts found in these artists' work is a result of intellect and choice, rather than physical defect, does not seem to enter these writers' thinking.

The Artist in Films and Novels

With the work of novelists and filmmakers, the same negative stereotypes are established through their characters, but the attack on artists becomes more dangerous as these novelists' and filmmakers' work is more widely disseminated.

Somewhere in the latter half of Gail Godwin's *Violet Clay,* the artist-protagonist sits down with a book that she hopes will give her the courage to stop doing commercial illustration and start painting seriously: "I set aside Hemingway's *Islands in the Stream.* The jacket copy said it was about an artist. What I really wanted was a book about an artist and how that artist went to his work every day and wrestled with his demons. I longed for a blow-by-blow account of what really happened when he was by himself, without any romanticizing, or skimming over or faking."

It's unlikely that the Ernest Hemingway story gave her much insight. Its central figure, painter Thomas Hudson, wrestles with young women and bottles of gin. He is a successful artist but only, it seems, because such a person may be the only kind Hemingway could think of who didn't have to work regularly and had money to drink and go boating all the time.

In its own way, *Violet Clay* also conveys rather little of what it is to be a visual artist, but to do so was probably not Godwin's intention. What one sees in her 1978 novel is a woman striving to become the best woman she can, and the artist bit is a metaphor for something else. This is a feminist novel—call it *Fear of Painting*—with a thin coat of art world terminology.

Let's not fault Godwin or Hemingway too severely; rather few writers who try to portray artists are able to do so with any real degree of credibility. Novelists tend to employ artist characters in order to make a point about something else, and that something else is what really is important to them.

Who, for instance, could take seriously the narrator of Evelyn Waugh's *Brideshead Revisited*, Charles Ryder, a man seeming to lack interest in his own career? Out of nowhere, the 20-year-old Ryder decides to be a painter, quitting school and moving to Paris to study art. Previously, we had only seen him partying with other Oxford students and having odd conversations about everything but art with his father and the family of his best friend. "I told her I had taken up architectural painting and that I enjoyed it," Ryder says to his friend's sister some years later, and that seems to sum up the entirety of his creative urge for Waugh, as Ryder is to say nothing more on the subject. "Great bosh" is his two-word description and dismissal of modern art. Clearly, this novel was written by one, and for others, with no particular interest in the visual arts. Rather, Waugh sought a narrator with no fixed schedule for a book that muses on the passing of Old Money and the gentry class.

Describing in words how a visual artist works in images is one of the most difficult endeavors a writer may attempt, as is evident in most novels about artists. There are certain ways to circumvent the problem, such as substituting research—Irving Stone's *Lust for Life* (about van Gogh) or his *The Agony and the Ecstasy* (about Michelangelo) come to mind—or creating roman-à-clefs (Emile Zola's Cezanne in *The Masterpiece*, Maugham's Gauguin in *The Moon and Sixpence*, even Thomas Mann's Arnold Schonberg in *Doctor Faustus*), or skipping how they work altogether and concentrating on describing artists in a social context. That latter path is the one most commonly taken. However, the tendency of most writers is to convey a vision of artists that reflects society's worst stereotypes of them as well as a troubling view of art. As soon as someone in a book is labeled a painter, distasteful characteristics are inevitably brought up.

Take, for instance, Somerset Maugham's *The Moon and Sixpence*, in which the central artist character is described as a man of no "great intelligence, and his views of painting were by no means out of the ordinary." He had an "untidy beard and long hair . . . and he sat in the studio, silent, occupied with God knows what dreams, or reading." The books he read "as a child reads, forming the words with his lips."

One quickly sees that this artist is essentially a stock character. At various points in the novel, Maugham criticizes those who pander to the public trade, although his painter suggests the dangers of defying society too literally. The writer-narrator of the book (the voice of Maugham himself) is ultimately presented as the middle-way voice of reason.

Being an artist can be a symptom of other, larger problems. In Niall Williams's *Four Letters of Love,* several characters are obsessed with finding a sign from God of what to do in life. One of them, a young woman, marries a clearly unsuitable, abusive man; another character, a young woman, quits her job and lays in bed for months listening to music. A third, William Coughlan, a longtime civil servant, also quits his job—a vision of God led him to paint full-time—leaving his wife and minor son penniless and distraught. One can't help seeing Coughlan's choice as just as bad as that of the other two. Perhaps worse, as the young man and woman find each other and fall in love, while Coughlan commits suicide.

Austin Fraser, the minimalist painter in Jane Urquhart's *The Underpainter,* is emotionally repressed, a quality his art seems to mirror. He cannot bring himself to feel love, comfort, concern, or interest for anyone else, never getting beyond the surface of relationships, as impersonal as minimalism itself: "I ask myself: What has your life been? You have used everything around you. And for what? An arrangement of colours on a flat surface." The "underpainting" in this novel are the colorful, figurative scenes that are covered over by one or more layers of paint until only the barest traces of the original image are visible. Just as Fraser is a minimalist because that appears to fit his aloof, impersonal nature (as though minimalists or conceptual artists cannot feel but only theorize), Fabian Vas in Howard Norman's *The Bird Artist* paints birds because dealing with people and managing his own life are too difficult for him. Life happens around him. Vas approaches life as he does his bird painting, from afar, simply trying to get the details right.

Probably the most clever depiction of an artist by a novelist is Joyce Cary's Gulley Jimson (in *The Horse's Mouth*), who is an Everyman of societal rebellion. Jimson truly sees the world in terms of encapsulated visual images, and he has a real, aching need to paint. However, he is paralyzed at the end of the book, and must dictate his life story to a secretary—this gives the narrative a crisp tension of the visual artist in the realm of words.

However, *The Horse's Mouth* is not truly "about" an artist: It is about freedom, presented as a satire of the strictures and conventions of contemporary British society. Gulley Jimson is everything antithetical to those conventions in a book that is an epic of individuality. He is, on the one hand, a unique and full-blown invention of Cary's mind, and on the other hand, the customary stock character—the scruffy, typical artist as con man whose schemes bring him into conflict with the law. Cary plays on the convention of the artist as outsider in order to examine the conventions of society. It works well, yet one is always aware that, once again, an artist is being used to make some other point.

The idea of the artist-as-outsider is most clearly made in James Baldwin's *If Beale Street Could Talk*. Alonzo "Fonny" Hunt never actually gets around to lifting a chisel to create the wood sculptures in the book since, by the time he decides to make art his career and finds a loft in SoHo for himself and his girlfriend, he is thrown into jail on a trumped-up rape charge. *If Beale Street Could Talk*, like the old W. C. Handy song from which it took its title, is about the sins and bad conscience of the many; and it really doesn't seem to matter what Hunt's vocation is. Being an artist doesn't really mean making art in this book; rather, it seems to refer to the idea of not having to answer to anyone else. As a profession, it is by nature "uppity."

"That same passion that saved Fonny got him into trouble, and put him in jail. For, you see, he had found his center, his own center, inside him: and it showed. He wasn't anybody's nigger. And that's a crime in this . . . free country." Baldwin may be hinting that this portrait of the artist as a black man cannot be created in a racist society, but the omission frees him from the need to envision it himself.

In Judith Krantz's *Mistral's Daughter*, there is also no strong sense of what kind of art is being created by painter Julien Mistral, but one understands what makes him an artist. He is selfish, irresponsible, needing of others—a woman or two, which is (one assumes) part of this book's underlying feminist statement—to take care of him but only truly interested in himself and his "needs."

Mistral appears more arty than artist, going on about bloodsucking dealers and naming his daughter Fauve. It's never clear what his paintings look like—they are realistic, as the general public's recognition of a certain model provides the engine for the action of the first half of the book, but somehow modern enough to have the artist compared with Picasso and Matisse—and one wonders whether or not Judith Krantz herself has any idea. At first, she tries to describe these works through rapturous, metaphoric language: "Each painting was like a step along a pathway into another world, an alternate world, a better world. Reasoning, deliberation, logic, time, and space itself all dissolved into an unqualified radiance." Lacking success in the art appreciation route, and making art criticism sound like nonsense in the process, she turns to the market, pointing out how every one of the artist's shows are sold out in a matter of hours and even listing later auction prices. If it's hard to describe these works or what's good about them, at least one knows they must be good because people spend a lot of money for them. Get the picture?

Krantz's identification of money, quality, and taste may touch a chord with readers who don't know much about art but know what costs a lot. Her aim was not to enlighten anyone about art but to establish Mistral's credentials through a shorthand equation of esteem and high prices—reflecting, rather than providing, greater insight into a capitalist society's appreciation of art—in order to justify commonly held stereotypes.

Back in 1949, South Carolina congressman George A. Dondero stood up on the floor of the House of Representatives to label contemporary American artists a "horde of germ-carrying art vermin." Presumably, we are far more enlightened today, but are we?

It is rare that one finds in literature or film an artist character who inspires anything other than Dondero-style scorn. The artist characters filling the pages of Tama Janowitz's *Slaves of New York* are all occasionally comical, generally disreputable types—drunks or strung-out on cocaine, with barely enough interest in their careers to get out of bed and work, producing gimmicky nothings that only people dumb enough to be part of the art world could appreciate. In both Shena MacKay's *The Artist's Widow* and Fernanda Eberstadt's *When the Sons of Heaven Meet the Daughters of the Earth*, one has the sense that artists, their dealers, and collectors deserve each other, but no one deserves them. In Eberstadt's novel, Issac Hooker, a homeless former academic star at Harvard turned painter, is "discovered" by Dolly Gebler, an arts patron who once "proudly forked out $50,000 for a piece that spontaneously combusted." Without her decent husband to act as buffer, the widow of MacKay's book finds herself surrounded by insincere art dealers and collectors, as well as a would-be artist nephew (described as "a pond with green scum on its surface") who steals her purse. With this young man, inspiration and passion take a back seat to finding a gimmick, something to generate some publicity. Taking stock of himself means trying a new angle: "Perhaps he should forget about the computer and

'ill Self's satiric
impanzees,
party fol-
ll this stuff
is just crap. It's not art, it's crap. Crappy crap. It's toilet art, the sort of t ig *anybody*
might think of sitting on the bog, but it takes a real idiot to get up, wipe hir elf and then
/ the simian
view of dis-
solute behavior in the art world is so well accepted that it needn't be explained, only described. Allan Gurganus's novel *Plays Well with Others* is devoted to the ravages in the art world of AIDS, which seems an almost likely conclusion since the three artist characters view sleeping their way to the top a smart career move.

Jeremy Pauling, the sculptor in Anne Tyler's *Celestial Navigation*, is a parody of the romantic concept of the artist who must isolate himself from the world in order to create—this artist is plainly agoraphobic and cannot bring himself to go beyond his front door. Jody, the fine art photographer in Ann Beattie's *Picturing Will*, is a photographer who can "look" but cannot "see." She overlooks, for instance, the fact that her minor son is raped by her dealer. The grand old man of painting, Henry Breasley, of John Fowles's novella, *The Ebony Tower*, is a drunken, dirty old man who delivers diatribes against all of modern art—a point of view largely accepted by the author. Still, that denunciation of art hardly compares with the invective Alberto Moravia presents in *The Empty Canvas*, in which, as the book's title indicates, no painting takes place while the ineffectual, dried-up, lecherous "artist" pursues opportunities for self-destruction.

Moving further into madness is David Rabe's *Recital of the Dog*, whose artistically blocked painter-narrator is a psychotic killer. Mental blocks, of course, free the artist characters for other pursuits, as there is little need to spend time in a studio. Again,

the question arises: Why is this character an artist? Would it have made a significant difference in the telling of the story had he another source of employment? Not having a regular job, an office to go to, is critical to the novel's plot, as absenteeism or behavior that devolves into madness would have been noted and judged by coworkers or an employer and some action taken. The narrator might be fired from his job or advised to seek treatment, perhaps placed under arrest. However, in *Recital of the Dog*, the self-employed artist's only "coworker" is his nonartist wife, and his behavior only embitters their marriage. She wouldn't view her husband's increasingly erratic behavior as a sign of mental disturbance, though—he is an artist, after all. His wife simply assumes that he is lazy and selfish.

In films as in so many novels, artists are almost always depicted as cautionary figures, and the impression of a pouty, self-absorbed individual lingers long after one leaves the theater. One thinks of the artists in *An Unmarried Woman* (a paint pourer), *Hannah and Her Sisters* (a pedantic snob), *New York Stories* (a psychological abuser of young, impressionable women), *Gauguin* (a lecher), *Amadeus* (a skirt-chasing, belching, and farting brat composer), *Round Midnight* and *Bird* (heroin-addicted musicians), *Barfly* (a slovenly, brawling drunk), or *Vincent and Theo* (an inarticulate slob).

Connie Fitzpatrick, the art photographer who also takes portraits and does weddings in the film *Guinevere*, rails against the bourgeoisie while owing back rent on his spacious live-in studio. "Guinevere" is what he calls his naive, live-in, confidence-lacking, and increasingly younger girlfriends, all of whom in turn support him monetarily in exchange for his educating them about art. He is to them about art what Humbert Humbert was to Lolita about sex, and his alcoholism, lechery, and the manner in which he intimidates these young women is seemingly mitigated (and even made sympathetic), because they all go on to become artists themselves in one medium or another. Artists have better parties, better sex, livelier conversations, and fewer repressions than other people, all of these young women discover, allowing all of them to forgive Fitzpatrick for using them over periods of years: He seems to be the price one pays for the life of art.

In both the film and the novel, *The Good Mother*, it is a male artist's lack of sexual boundaries that provides the engine for the plot—a mother, Anna Dunlap, loses custody of her daughter after the mother's boyfriend allows the little girl to touch his penis in a shower stall. Why did the boyfriend need to be an artist, since it is author Sue Miller's intention to describe the woman's experience with the legal system rather than with her male partners? Perhaps the answer is that the sexually liberated sculptor, Leo, who serves as a foil to Dunlap's uptight, lawyer ex-husband (who, throughout their marriage, had been unable to bring her to orgasm), is easier to accept as an artist when described as a sexual being. Sue Miller knows what her audience expects of artists.

If filmmakers and novelists were asked directly whether or not they believe artists generally are the negative things they describe in their works, probably they would strongly disagree, claiming that these are merely individual characters with no symbolic reference. However, when one puts all these images together (as they

must fit together in the minds of those who see these movies or read the books), what is clearly presented is a view of artists as people who are unprofessional, unsavory, and unworthy.

Using artists as subject matter in films or books has not reached the same genre level as detective novels, but to many writers and movie makers, they are obvious choices, in that artists need not report to a job and may choose their own hours in which to work. Obviously, novelists and screenwriters are not aware of teaching and graphic art jobs, among all the other second careers, that keep most artists quite busy during most of the day and exhausted at night—in effect, makes most artists middle-class people with the same aspirations as those of other professionals—but theirs is a misapprehension shared by many. The fact that their characters also tend to be unsavory types adds but one more element to our society's pervasive and negative mythology of artists.

Again, one finds an attack on art itself through denigration of the character of artists. Art cannot speak to all people if its makers are so unlike the majority of the audience for art: Either the popular perception of the artist is wrong or art is irrelevant.

Here and there, a writer or filmmaker will portray an artist in a positive light, indi-

other novels noted above, Goldberg structures *Heart Payments* as a collage, with vignettes, newspaper clippings, art catalog essays, and whatnot randomized in a story

a significant factor. The printed wedding announcement for Asher's 1951 marriage is on one page; next comes a description of the artist's first heart attack in 1966; next is a portion of the catalog essay to a 1976 retrospective of Asher's work at some museum; following that is a 1966 monologue by some unnamed black militant on drugs who is evidently talking to himself; next is a newspaper account of a 1967 anti–Vietnam War demonstration; and on and on. This is Asher's world, a piecemeal one of high art and low libidinal urges, of outside politics and internal emptiness, where intellectual excitement and mundanity fit side by side. At times, the result can be clumsy, more reminding readers of the author's intention of having the structure mirror Asher's collages rather than clarifying what is going on, but Goldberg deserves points for effort.

More successfully, Virginia Woolf also attempted to give a feeling of looking at an artist's work in *To The Lighthouse*. We never see Lily Briscoe at the easel for any real length of time, but it seems clear that her painting is impressionistic because that is the style of writing: "The pulse of colour flooded the bay with blue, and the heart expanded with it and the body swam, only the next instant to be checked and chilled by the prickly blackness on the ruffled waves." The writing is neither fully first nor third person but an ongoing experience of movement and color, allowing the reader to become involved in the manner of looking at a painting.

Both Woolf and Goldberg celebrate art and the process of making art, re-creating the world of their respective artists and reflecting on it. Few other writers make that much effort, although not all novelists present artists as disreputable. One finds a somewhat more New Age approach to art and artists in, for instance, Beattie's *Picturing Will*, Godwin's *Violet Clay*, or Margaret Atwood's *Cat's Eye*, novels in which art is used by artists as a personal catharsis, helping them get personal demons off their chests, overcoming male or societal oppressors. Perhaps, the image of the female artist is not as highly charged with stereotyped negative associations as that of the male artist, allowing these writers room to define a more positive role. Unfortunately, they make little of the opportunity, because it is not the life and work of an artist that interests them but, rather, the ability to use art making metaphorically as public therapy. The Aristotelian catharsis no longer belongs to the art's audience, but is a form of self-help for the art's maker—a view of art that advances the story of personal growth in these books while shortchanging the wider significance of art itself. If art serves only to solve the artist's own problems, what meaning or value does it have to other people?

The Problem of a Bad Image

The problem of how to present artists in films and novels, histories and psychological studies accurately may be unavoidable. Painting, sculpting, making collages, or other forms of visual art making is different in kind from most other activities, especially writing. Jackson Pollock created many of his drip paintings in an hour or two—he wanted the spontaneity of his feelings mirrored in the production of his works—but a writer must sit down and write or type for hours or days or months or longer. James Joyce took ten years to put down on paper the spontaneous thoughts, or "stream of consciousness," of his characters in *Ulysses*. Speed or length of production is no recipe for quality, but the way visual artists work appears to be a mystery to many of those who would describe or portray them.

Why does it matter to visual artists if clinical psychologists, novelists, and filmmakers don't understand them? It is precisely because artists do not stand outside of society, in the old Romantic conceit. Artists look to sell their work to people whose minds have not been prejudiced against them; they may seek financial assistance in creating or presenting their work from government agencies, trusting that their government sees them as hard-working taxpayers whose art benefits the larger society. All this becomes more difficult as artists are continually and increasingly portrayed in a negative light.

Not only artists but the arts are under unremitting attack these days. Since the late 1980s, the National Endowment for the Arts (NEA), one of the smallest and most productive agencies of the federal government, has been besieged by those in and out of Congress who want its abolition. One might go back even further, to 1981, when

President Reagan proposed the agency's abolition. In actual dollars, the NEA's budget was larger then than twenty years later. In most public school districts, the arts curriculum is the first item cut when there is any budgetary shortfall. All the arts, all artists, are being tarred by this campaign. Artists will be viewed as neurotic or psychotic fools, diseased, louses, abusers, and trivial—and the government agencies that support the arts will continue to be subject to periodic attack by religious groups, until we decide that this vision of an artist is not our vision and work to change it.

11

CONTESTS AND COMMISSIONS

For many artists, the first step in bringing their work to an audience is applying to an agency or show sponsor. Public art and juried art competitions are a growing area of opportunity in the art world.

COMMISSIONS FOR PERCENT-FOR-ART PROJECTS

Governments don't need reasons to support the work of artists, but they frequently enact laws to make that support easier to justify. The statute that the federal government, some states, and some municipalities have created is known as the Percent-for-Art law. This requires the appropriate federal, state, or city agency to spend between ½ percent and 1 percent of the construction or renovation costs of a government building on one or more works of art for that building.

Public art projects may be sponsored by a state or municipal arts commission, an airport or transit authority, planning and development, department of parks and recreation, department of business and economic development, department of community services, or any other number of public agencies. Almost every state has some public art program somewhere. There are various sources of information on who is commissioning public art, including *Public Art Review* ($17 for two semi-annual issues, 2324 University Avenue West, St. Paul, MN 55114-1802, 651-641-1128); *Art in Transit . . . Making it Happen* (Federal Transit Administration, 400 Seventh Street, S.W., Washington, D.C. 20590, *www.fta.dot.gov/library/program/art/index.html*); *Sculpture Magazine* (918 F Street, N.W., Suite 401, Washington, D.C. 20004, 202-393-4666, $50 for ten issues per year), which lists commissions in its "Opportunities" section as well as its quarterly *Insider Newsletter; Sculpture Review* (c/o National Sculpture Society, 1177 Avenue of the Americas, New York, NY 10036, 212-764-5645, $40 for four quarterly issues plus a bimonthly *NSS News Bulletin*), which contains information on grants, competitions, and available commissions); and Americans for the Arts' *Public Art Directory* ($21 prepaid, 800-321-4510, ext. 241), which is updated periodically. Obviously, the *Public Art*

Directory will not list new commissions, and those listed in both *Sculpture Review* and *Sculpture Magazine* are frequently out of date by the time readers receive the publications. Another source of help is the General Services Administration's Web site *(www.gsa.gov/)*. One of the most complete listings of public art commissioning agencies is *Percent for Art and Art in Public Places Programs* ($21.25 plus $2.50 for shipping and handling, Rosemary Cellini, P.O. Box 1233, Weston, CT 06883, 203-866-4822, e-mail: RMCellini@aol.com). A Web site called "Public Art on the Internet" *(www.zpub.com/public/)* lists opportunities for commissions, as well as offers essays on public art, descriptions of individual public art programs, and images of projects by artists and sponsoring organizations.

The federal government and a number of states have Percent-for-Art ordinances (see my *Artist's Resource Handbook* for a full list). On the federal level, the United States government commissions works of art through both the Veterans Administration (811 Vermont Avenue, N.W., Washington, D.C. 20402, tel. 202-233-4000) and the General Services Administration (18th and F Street, N.W., Washington, D.C. 20405, tel. 202-566-0950). In addition, the National Endowment for the Arts' Art in Public Places program provides federal dollars for commissioned art projects around the country.

Since 1962, the General Services Administration (GSA) has been the largest sponsor of commissioned artwork by contemporary American artists, installing more than 300 sculptures, murals, stained glass windows, graphic pieces, environmental works, and other permanent works at the sites of newly constructed federal buildings all over the country. On occasion, the GSA buys a finished work but, mostly, the agency prefers to commission new pieces for which the artist may evaluate the site with the building architect, creating something that forms a visually aesthetic whole.

Between fifteen and twenty-five commissions are made each year, ranging in value from $14,000 to several hundred thousand dollars, annually amounting to a little over $2 million. The GSA is always looking for new artists to commission, and the list of artists who have been hired over the past three decades includes both the well known and largely unknown. Those who wish to be considered should submit a résumé and representative 35mm slides (in a plastic slide sheet) of their work to the Art-in-Architecture Program of the General Services Administration. The slides are placed in the agency's permanent registry and continually reviewed. When deemed appropriate for a particular project, these slides are submitted to the artist nomination panelists for their consideration. It is advisable for artists to update their slides and résumés every five years as the agency is unlikely to track down those who have died or moved.

As one might expect, the sculptural works commissioned are the most expensive. As one might also expect, most of the pieces commissioned for the lobbies or courtyards of these federal buildings, 85 percent in fact, are abstract art. That often is the cause of public criticism of these pieces; however, the agency does commission other, more figurative styles and other media.

There is a multistep process for selecting an artist for a commission. It starts with the project architect who works with the National Endowment for the Arts, members of

the GSA's Art-in-Architecture program, and selected members of the local community working together to develop a proposal for where the art should go and what type it should be.

The arts endowment then appoints a panel of art experts to meet with the architect in order to review visual material from the GSA's slide registry. The panelists may have some specific artists in mind, or they may simply try to pick certain artists whose work fits a look—for instance, abstract and minimalist sculptures or colorful, figurative murals. The final selection is made by the GSA's administrator, who then negotiates a fixed-price contract with the artist. The contract award amount covers all costs associated with the design, execution, and installation of the piece.

Some of the Percent-for-Art laws (such as in Florida, Hawaii, Michigan, New Jersey, Ohio, South Carolina, and Texas) are not mandatory but permit the state to spend either 1 or ½ percent of construction costs on purchasing works of art. Some states (California, New York, Tennessee, and West Virginia) have no specific Percent-for-Art legislation but commission public works through special line-item appropriations. Some state Percent-for-Art laws require special administrative appropriations. Some states permit out-of-state artists to compete for projects. Most of these programs are administered by the state arts agency, while others are run by a department of capital planning or other state agencies, but the arts agency is the best place to look for information on how and where to apply.

The state arts agencies will be able to indicate which cities or counties within the state have their own Percent-for-Art laws as well as private groups sponsoring public art projects. Pennsylvania, for example, does not have a Percent-for-Art statute, yet the cities of Philadelphia and Pittsburgh both commission artists for public works, and thirty-five cities or counties in California have their own Percent-for-Art or other public art programs.

THIN SKINS AND STRONG STOMACHS

At the General Services Administration, efforts have been made over the years to increase the percentage of local artists doing local projects, and with smaller commissions, the chances that lesser-known artists may be considered are improving. In the midst of all this and while the chosen artist is preparing the work, the GSA attempts to involve the local community in seeing the proposed site and the design of the work as well as in meeting the artist to discuss the ideas behind the piece. In one case of a GSA-commissioned piece by Alexander Calder in Grand Rapids, Michigan, the agency conducted an adult education class to acquaint the public with the artist and his works so that what came out would not be a total shock. This isn't the norm, but it was considered helpful as many people are quite dumbfounded by contemporary art. Some of those people react negatively.

Sculptor Guy Dill was commissioned by the GSA to create a large steel work in Huron, South Dakota, where, according to Dill, "they had never heard of art and all of a sudden were getting a sophisticated piece of art. They didn't want it." A plumber in

Huron headed up a campaign to have the work removed. He was able to get several thousand signatures on a petition for this, although many of the names were found to be invalid.

Sam Gilliam, a Washington, D.C., painter, found himself blasted in the local press while he was working on a GSA project in Atlanta for which he was paid $50,000. "I heard people complain about how people were being laid off, how they wanted government help, and here was someone getting $50,000 for a work of art," he said.

Among the largest to-do's over GSA-commissioned work occurred in Baltimore in 1977 and in New York City in 1985. In Baltimore, nine federal judges decided that they wanted nothing to do with a steel sculpture by George Sugarman outside a newly built federal courthouse. The judges claimed that muggers could hide behind the work and rape secretaries who work late, that someone might place a bomb under it and people could be hurt by the flying shrapnel, or that children might play on the work and get hurt. The claims by the judges were lambasted by newspapers and arts leaders around the country who said that the charges covered up the fact that the judges simply didn't like the work.

Those with thin skins clearly should not look for GSA commissions, although the projects do raise an artist's national profile.

THE EFFORTS TO CONTAIN PUBLIC ART CONTROVERSY

In 1989, after several years of controversy, legal wrangling, and numerous public forums, Richard Serra's sculptural installation "Tilted Arc" was removed. The employees in the building had objected strenuously to the large, rusted metal work, claiming that it blocked the sun and took away the space where they ate their lunch and enjoyed occasional outdoor concerts.

No one came out of this looking good: The General Services Administration struck the employees in the building, many political leaders, and much of the public as insensitive to the public interest; Richard Serra's art reputation was blackened, and he was personally characterized as unwilling to listen or compromise; those complaining about the installation were denigrated as philistines; and Serra's apologists looked out-of-touch with the rest of the world as they described the artist's standing in the art world and defended the panel system that had selected the work in the first place.

In the intervening years, a sea change has taken place in the field of public art, as both public and private commissioning bodies have increasingly altered the way in which they select new works (and the types of pieces they select) and the way in which they are sited and installed. Studying public art controversies has itself become a growing field, represented by a flood of books and commissioned studies that aim to help agencies head off complaints before they occur and lessen the intensity of them after they arise.

"Controversy is a result of a process of commissioning and installing a work of public art that didn't work well. It's not so much because of the content of the art," said Cynthia Abramson, director of public art programs at the Project for Public Spaces in

New York City and a frequent essayist on public art. "The customary approach to public art, which was absolutely the case with Richard Serra, was to put art that's hard to take in an environment that is inhospitable to the enjoyment of art."

She noted that the public art commissioning process tends to fail in three areas: The first is that people working in the building where the art will be situated or who live in the area are not involved in the selection or placement. The second is that the panel making the selection is unaware of how the site is currently used. The people who work or live in the site are not consulted about the work, and no time or money had been directed for a site study. Finally, the way in which the art is introduced to the people working or living there is too abrupt (the term used in the field is "plop art"), as there is rarely an educational process about the work or the artist. As a result, local people take offense at the installed piece.

Chastened by the Serra controversy, the Art-in-Architecture program of the General Services Administration has taken steps to include more local residents, including those working at the sites, in deciding which works are picked and even making changes in an artist's proposed design, according to Susan Harrison, program manager for the Art-in-Architecture program. "We're trying to strike a balance between selecting work by the best artists with lessening controversy that their work sometimes excites," she said.

An example of this effort was a proposed Jenny Holzer installation of fourteen granite benches outside a federal courthouse in Allentown, Pennsylvania, in 1995. Holzer had planned to incise a series of aphorisms or "truisms" on these benches, which drew the objections of a resident federal judge who crossed out a number of the proposed sayings. Among the truisms deleted were "Men don't protect you anymore," "A man can't know what it's like to be a mother," "In some instances its better to die than to continue," "Murder has a sexual side," "Romantic love was invented to manipulate women," and "Fathers often use too much force." In place of those deletions were more benign, less provocative remarks, substituted by the artist, such as "A positive attitude makes all the difference in the world," "It's better to be a good person than a famous person," "Solitude is enriching," "Routine is a link with the past," and "Being alone with yourself is increasingly unpopular." The Allentown experience was not a novelty for Holzer, who had similarly made content changes in public pieces commissioned for court houses in Sacramento, California, and Kansas City, Missouri.

"Judges have a history of being involved in court house art, and they don't want to seemingly place an official stamp on something that is questionable," said Steven J. Tepper, a fellow at Princeton University's Center for Arts and Cultural Policy Studies and the author of a 1999 study on how the public responds to public art commissioned by the General Services Administration. "The judges didn't want some Jenny Holzer remark being used by an attorney in a trial as part of a defense."

Community editing of an artist's design for a 1994 public art piece occurred in Kansas City when muralist Richard Haas was asked by a group of Native Americans to change several American Indian figures from a kneeling position to a more dignified

stance, and another group recommended that more European settlers be included. Haas acceded to both requests for his painting, entitled "Justice and the Prairie" and, like the Holzer commissions, it was eventually installed with controversy.

Artists may find that the absence of a public outcry over their work comes with a large price. "I have to make a decision when these kinds of requests come in," Haas said. "Do I make the change or not? I have to be convinced that this is what I want, that it doesn't take away from the integrity of the piece. How can I satisfy this group or that without compromising the piece?"

In the end, Haas noted, "I had to make compromises. I was forced to do it. When criticism comes from the community, rather than from an individual sponsor or a panel of art judges, it's much more serious if not necessarily more valid. Criticism will land in the press, and the press can take it and warp it, and you've got a battle on your hands that you know you can't win. When there is an overwhelming community reaction to your work, you know you're in trouble. In the post–"Tilted Arc" world, artists have gone to safer shores; more cutting edge art is out."

Controversy may take a variety of forms, from minor complaints (a few letters to the editor) to a more serious airing (a newspaper editorial or the mayor of the city coming out against the art) and, finally, to organized and official protests (for instance, a rally or a citizen letter-writing campaign). At its most extreme, government officials demand a work's removal. In 1998, for example, the Carlsbad (California) City Council voted to remove (and, thereby, destroy) a "functional" artwork by Andrea Blum that had been commissioned in 1987 by the city's public art commission. The work, which consisted of a reflecting pool, concrete benches, some landscaping and metal barriers along a bluff overlooking the Pacific Ocean, had generated a significant outcry from residents, shop owners, and political figures. "Carlsbad is an ultraconservative town, and people are particular about their ocean views," an official of the public art commission noted. In 1992, the artist had agreed to certain changes in her piece, removing some of the metal bars, and the city authorized a five-year cooling-off period after which the city council could review and, in this case, demolish the work.

The search for less controversial artwork and commissioning process has led to new policies and practices. The majority of public art programs in the United States are based on Percent-for-Art statutes at the federal, state, and municipal levels, in which up to 1 percent of the building or renovation outlays for public facilities are legislatively mandated to be spent on one or more works of art at the site. In the past, the building is constructed or renovated and an artist is brought in to create a sculpture (mostly), mural, or hanging for some open area within or outside the facility. The more recent focus on the community has meant that the process no longer works in this vacuum, as both the commissioning agency and the artists develop greater contact with the people who live and work there, learning about the history of the community and even (in some cases) including aspects of that history or actual objects from the area into the final piece.

Making public art an important and valued part of the community may mean installing it in a place that matters to the community ("not a throwaway traffic island,"

Abramson said) and understanding how the piece will effect this as a community-gathering space ("not just plopping it down somewhere"). Public art may be used as part of neighborhood revitalization (a city making an investment in the community) or celebrating local heroes. Agencies are also seeking to conduct more outreach to members of these communities in order to bring them into the process. "The usual excuse that commissioning bodies give is, 'We held a public meeting, but no one showed up,' which may be true but it isn't good enough anymore," Abramson said. "They may seem apathetic now, but they won't be when the work is installed and they don't like it."

An example of an agency's failure to take into account local needs and interests was a New York Metropolitan Transportation Authority commissioning (through its Arts in Transit program) of an outdoor sculpture for a new commuter rail station in Croton-on-Hudson by the artist Donald Lipski in 1989. "There had been a long history of terrible relations between the town and the MTA," Lipski said. "The station didn't have benches, lighting, or bathroom facilities, and commuters had been complaining about this for years, first with the old station and now with the new station. There was a problem of PCBs dumped into the water by the MTA, which had upset a lot of people. There had been acrimonious labor relations between Metro-North [which operated the trains] and its employees in the town. There was a blind couple that had a newspaper concession in the old station but weren't given a place in the new station, and that made a lot of people angry. It was a hornet's nest of bad relations, which I had known nothing about."

Lipski designed canopies at the station on which were to be placed figures of barnyard animals, "and people responded very negatively. They thought I'm some city guy who thinks they're all farmers since they live out of the city. Some people thought I saw them as animals being herded onto the train. If there hadn't been so much antagonism between the town and the MTA, people might have seen my work in another way. But all they could see was $250,000 being spent on sculptures of barnyard animals placed on the roof and no one seeming to care about them and their needs. I was just in the middle." The final outcome was that Lipski withdrew from the project and no art was ever placed there.

Abramson noted that agencies are increasingly using public education programs and enlisting community leaders in a "user community" task force in order to increase awareness of the public art project before it is completed. Temporary installations of public art are sometimes devised to get the local community and building employees accustomed to seeing artwork in a particular site. Agencies and local art institutions have also worked together to create exhibitions of the public artist's other work, lessening the surprise factor. Other initiatives have included bringing in the artist to talk about the work at local schools and community centers, as well as with various groups; creating design changes for the site, such as adding benches, to make it more comfortable; surveying the community to elicit reactions about the proposed work or the site chosen; and promoting the upcoming work at various community events and activities, such as a farmers' market or jazz concerts.

Troubleshooting, of course, cannot completely eliminate the potential for controversy and, in some communities or with some types of art, disputes may be unavoidable. Tepper's study found that abstract art proved more controversial in smaller cities (with populations under 250,000), where the population is "more homogeneous and traditional." In larger cities, the population is more cosmopolitan and accepting of contemporary art styles; amidst all the other attractions, abstract "art just gets lost in the kudzu." Representational, and especially, figurative artwork is more controversial in large cities, he added, because of "identity politics—everyone will find something to complain about. In smaller cities, there are fewer minorities, and they are not as organized or as empowered."

Other than simply the demographics of a particular area, Tepper found that studying the recent population changes of the public art host city may also be a key in determining how to select appropriate art and what might be picked. "Population change is a larger determiner for controversy than anything else. Where there are rapid political, economic, and demographic shifts taking place—in short, social instability—art becomes a lightning rod for discontent," he said. "There may be no way to completely head off controversy and just try to use the conflict in a productive way to get the community to talk about the changes that are going on."

A last area in which many researchers have seen a need for improvement is how to have a useful dialogue about art, bridging communities rather than emphasizing the divisions. When public art controversies have arisen, Tepper said, the debate rarely focuses on the content of the work itself. Instead, "the art's defenders talk about how important the artist is and how art is good for society." The art's opponents, on the other hand, also frequently avoid discussing the art's content and coin some term to describe it, such as "the Jolly Green Giant's Urinal" (a 1980 yellow abstract sculpture by William Goodman in Las Cruces, New Mexico) or "Tinker Toys" (a 1975 abstract wood sculpture by Tom Doyle in Fairbanks, Alaska). "This country still has a long way to go before it can talk civilly about art."

DAMAGE AND NEGLECT OF PUBLIC ART

Just a few years after completing a granite public artwork for the City of Sarasota, Florida in 1991, Athena Tacha's "Memory Path" was becoming unrecognizably stained and corroded. Photographic images sandblasted into the stone were losing their clarity, and the smooth surface was increasingly pitted. Why? City maintenance workers were using recycled water to hose down the piece and water the surrounding grass, causing the damage. Recycled water is undrinkable because of its high bacteria count and acidity, but its potential effect on the public artwork was not foreseen by the parks department or by anyone else involved in commissioning the piece. Repairing the work has been a slow and not altogether satisfactory process.

"Memory Path," however, received a better fate than her "Marianthe," which was commissioned by the University of South Florida at Ft. Myers in 1986 and torn down in February, 2000. Constructed of bricks and metal supports, "Marianthe" was given no

maintenance, resulting in significant rust that weakened the structure and made it a potential hazard to students who might walk on or near it.

"A damaged work is detrimental to my reputation," a frustrated Tacha said, "and removing a work both damages and lessens my reputation, first because there is nothing left for people to see and, second, because it leaves the impression that my work isn't durable."

Art is not thought of as having a life expectancy, but the maintenance issues in the expanding field of public art raise the question of just how permanent is permanent public art. Some have become proponents of temporary public works of art, including Tom Eccles, director of the Public Art Fund in New York City, which primarily commissions temporary, or short term, installations of public works of art. "Contractually, 20 years is as far as anyone can go," he said "A private developer may commission a work and be very enthusiastic about it, but buildings change hands over time, and no one wants to be tied to a work in perpetuity."

Artists have been protected from unsought-after changes to, or the wholesale destruction of, their work by the Visual Artists Right Act (see chapter 6). The law does not cover damage to work caused by a lack of maintenance (an exception exists in the law for the "modification of a work of visual art as the result of the passing of time or inherent nature of materials"). Only one legal case filed under the act has been decided in the artist's favor, involving Indianapolis, Indiana sculptor Jan Randolph Martin, who sued the City of Indianapolis in 1996 for demolishing a public sculpture that he had created on land that the city had subsequently acquired. He was awarded $20,000 in statutory damages and $131,000 in attorney's fees and court costs. Although a useful precedent for artists, the high cost of legal and court fees as compared to the potential payment for damages reveals why some artists choose not to pursue their legal options.

Ann Garfinkle, an attorney in Washington, D.C. who has represented Tacha, stated that commissioning agreements should ideally include clauses requiring: a budget for maintenance and repairs; periodic inspections of the work (with photographs taken of the piece and a condition report written up by the inspector); regular maintenance (such as cleaning, regrouting or repainting, as needed); immediate notification of the artist in the event of damage; a requirement that the artist meet with someone to discuss the best reponse to the damage; mediation if there are disagreements over how best to conserve the work; and, monetary damages to the artist if the owner fails to live up to the maintenance agreement.

At times, the ongoing care of a public work will require more specialized attention than a regular grounds and building maintenance worker is able to provide. "A lot of maintenance people are challenged in some way, and they won't know what looks right or not," said Alicia Weber, chief of the fine arts program of the General Services Administration, which annually budgets $1 million for maintenance and conservation. Owners, Garfinkle noted, might be required to contract out inspection and maintenance to a local conservator or university.

A growing number of cities and counties with Percent-for-Art statutes have adjusted these laws—moving from a one percent-for-art to a two percent-for-art pro-

gram—to include money for maintenance. Some private nonprofit organizations have also made the preservation of public artwork a priority, using Adopt-a-Monument campaigns to raise money raised for regular care.

THE COST OF LIABILITY INSURANCE

It's ugly. It's a waste of taxpayers' money. Who are these con artists anyway? The debate over public works of art has generally centered on whether the public likes the way they look, but the rising cost of liability insurance, which artists or the agencies commissioning them must obtain while the work is being installed, is proving far more decisive in determining what (if anything) will be built. The insurance problem becomes even more critical as both the artists and the agencies may also have to maintain a high level of liability coverage for as long as the work remains in a public setting.

The cost of liability insurance and the not-infrequent difficulties that artists and their sponsors have in obtaining it may well undermine the future of the public art movement more than any public outrage over a particular work. This strong financial disincentive for both artists and agencies falls most heavily on lesser-known artists and smaller arts agencies, which are less able to afford the hefty insurance premiums.

The liability crisis is not peculiar to the arts; rather, the art world is affected just because everyone else is. Indeed, certain critical areas of insurance coverage, such as medical malpractice and liability policies for day care centers and manufacturers of potentially hazardous products, have experienced much higher rate increases than others. Claims in these areas have reached the millions of dollars, resulting in demands by insurance companies for changes in the tort system—the legal process of obtaining financial remuneration for injury or damages. Enormous claims, according to insurance companies, force them either to raise their rates or drop policies.

Artists and arts agencies have been seriously hindered in their work by this situation, finding insurance premiums increasing between two and ten times from one year to the next, if they can get insurance at all. With both performing and visual arts activities, high premiums are based on what insurers call their "high exposure"—the number of people who may see the object or event and become injured in an accident. The likelihood of suits grows with the number of public works of art and arts events.

There have been infrequent occasions of someone being hurt by an artist's work. A couple of injuries have resulted from children playing on Mark di Suvero sculptures, and lawsuits followed when workers hired to assemble a Richard Serra sculpture in Minneapolis in 1971 and a Harold Kimmelman sculpture in Philadelphia in 1977 were killed in connection with installing the pieces. However, the current liability situation appears to have more to do with the insurance industry's complaints about the willingness of people to bring suit and receive large jury awards.

Many artists who are regularly commissioned to build public artworks—such as Alice Aycock, Claes Oldenburg, Richard Serra, Mark di Suvero, and George Sugarman—maintain ongoing million-dollar liability policies, and others take out short-term insurance coverage when they are asked to create a piece. Most Percent-for-

Art programs around the country require the artists to have a liability policy (valued at up to $1 million in some cases), at least during the work's installation.

Premiums for these policies may come to more than $5,000 a year, sometimes eating up much of the value of the commission for the artist. Many artists find that they are either unable to afford this insurance or simply cannot obtain it, due to the reluctance of companies to open up areas of potential risk.

In some instances, the contract between the artist and the agency commissioning the work may require the artist to have liability insurance from beginning to end of a project. The requirement may also extend to a year after transfer of title, usually in order to ensure that the materials and workmanship are of sufficiently high quality.

"I always write into my contracts with whoever is commissioning a piece that, once the work becomes the property of whoever is commissioning it, the piece becomes their responsibility and not mine," said sculptor George Segal. "It would be unfair for an artist to have to carry a liability policy in perpetuity."

This, however, is a subject of some debate. Transfer of title, even transfer of title plus one year, may not free the artist from responsibility if someone is hurt in connection with the work, many lawyers believe. "An artist remains forever liable and cannot transfer that liability," one attorney stated, and others point out that, if someone gets hurt, the blame can always be with the artist for a poor design. Questions of which parties are actually liable in the event of an accident must be determined in court on a case-by-case basis.

Even more potentially frightening for artists is the fact that some insurance companies demand a say in which pieces they will insure. In the mid-1980s, an insurer told the Lower Manhattan Cultural Council to remove a nine-foot-high plywood sculpture, which the arts group had recently commissioned, because it looked too risky. Cityarts Workshop, also in New York City, which sponsored the creation of murals, found that a basic element in its projects—community participation—had to be dramatically altered when its insurer stopped scaffold coverage in the early 1980s. Other insurers ask for a series of detailed drawings and models of the commissioned work in order for the piece to receive and maintain a liability policy up until its installation. The difference between telling an artist what to do and not permitting him or her to create it may prove negligible, and the result could be public art that is more conservative both in form and content.

Artists who do public works, and people who commission them, face enormous obstacles—from people who hate what they do, from others who vandalize or destroy their work, and from still others who may sue after getting hurt while climbing on their work. Donna Dennis, a sculptor who has had one public work in South Dakota used as target practice by gun enthusiasts and another in Dayton, Ohio, pipe-bombed, was asked some years ago to create a piece for the New York City Board of Education and based part of her decision on whether or not she could afford the liability insurance bill. She took the risk, but when one considers the costs involved and the fear that years later an artist may be named in a liability suit, blowing up public works may turn out to be the kindest thing to do for the artists.

WHO DECIDES ARTISTIC MERIT?

Not everyone fits well into the grant awards process. Albert Einstein, who stated that "I am a horse for single harness, not cut out for tandem or team work," devised the theory of relativity while employed in a patent office; and Sinclair Lewis' bittersweet novel *Arrowsmith* was based in part on the experience of Paul de Kruif at the Rockefeller Foundation.

Coming up empty when applying for a grant or commission is an ever-present possibility, but hope should never be lost. Successful grant recipients, like most recent contenders for the United States presidency, tend to try again and again until finally getting approval somewhere. Funding priorities and the people who make the final decisions change from year to year (as do application forms and deadlines for their submission at foundations and government arts agencies), and rejection may result only from this year's crop of deciders.

Every year, thousands of artists are selected to be in exhibitions, to receive awards and stipends. The quality of their work is judged (largely) sight-unseen, based only on slides, and an industry of artwork photographers has come into being in order to help artists present their creations in the best possible light.

But who are the judges determining an artist's career based on $1'' \times 1''$ transparent slides? With more than 10,000 juried arts and crafts shows taking place annually and fellowships offered by municipal, state, and federal government arts agencies as well as private foundations, there is no one type.

There is also no single number of jurors that is generally recognized as best for making these decisions. Many private, nonprofit organizations make do with just one person—deciding which of the applicants for a juried art show are to be included—while most government agencies, which provide fellowships to resident artists in a variety of disciplines, use between three and five.

However, every organization or agency has its own rules and ways of doing things. For instance, the Pollock-Krasner Foundation in New York City, which makes grants to emerging artists, involves ten people in the process (three program staff members, the four people on the Committee of Selection, the foundation's chief operating officer, and the two members of the Board of Directors), and some other organizations—such as those run by artists—will go as high as a fifteen-member artistic committee.

Ethical considerations are paramount, regardless of the actual number of people making decisions. If it is a one-person jury, the better exhibitions will use different people for each show so that no aesthetic prejudices are established from one year to the next. Multiperson juries or panels are also often rotated on and off to maintain a flow of ideas. The Artists Foundation in Boston, according to outreach coordinator Cyrus Cassells, looks for "distinguished people in their field from out of state so as to take politics right out of judging"; that is, a local juror knowing a local artist.

Many art organizations outside major urban centers that hold juried exhibitions seek jurors from the big cities. Often, the reason is prestige, perhaps a factor in the decision of the American Association of Retired People to choose Susan Larsen, then curator

of the permanent collection of New York City's Whitney Museum of American Art and now a professor of art at the University of Southern California, to judge a show of members' artwork. Another reason is the assumption that someone from a major urban institution will maintain high standards of quality when assessing works by regional artists.

A third reason may be exemplified by Berkshire Artisans in Pittsfield, Massachusetts, which has a very conscientious policy with regard to the person selected as the annual juror. That organization chooses people who have been judges elsewhere and whom no one in the organization has ever met.

"If they know the artists whose works they are jurying, they may be swayed by personal feelings," Dan O'Connell, artistic director of Berkshire Artisans, said. "I don't think any of the people who have done jurying for us have ever seen the gallery or have ever been to Pittsfield. I can only guess whether they've ever been to Massachusetts."

One of those jurors was an official at the Texas Commission on the Arts. Another was Renato Danese, then director of New York City's prestigious Pace Gallery and now a private dealer.

A former curator at the Baltimore Museum of Art who worked in both the museum services and visual arts programs at the National Endowment for the Arts in Washington, D.C., in the 1970s, Danese said that he tries "to approach individual works of art without preconceived notions. I look for quality in whatever style or medium I'm looking at. In all candor, what you'll find in a regional juried show is a great range of work, from traditional academic painting to work by artists who have their nose in the avant-garde and are influenced by it."

Although the Pace Gallery is known for its exclusively avant-garde work, much of which is based on abstraction, he noted that "I have no prejudices against realist landscapes, for instance. A lot of the best art ever produced in America are realist landscapes, and I know to judge each work on its own merits."

Danese said that he "sought to take each artist as an individual entity," a point of view held by many people who do jurying. Susan Larsen also felt that she can evaluate art that is wholly in contrast to that which is displayed at the Whitney, stating that "I'm not prejudiced by the way something looks. I look for evidence of a personal statement. I look for a voice that I haven't heard before and, unless I hear that voice, I'm not terribly interested in the art no matter what it looks like."

She added that much of the work she sees in exhibitions outside of the major urban centers tends to look alike, which she attributes to "various factors: One is the influence of a single teacher; another is a consensus in the community of what they like and will buy; the third is how-to books that everyone reads and everyone obeys down to the letter."

On occasion, however, she will find someone whose work is truly striking. That doesn't necessarily translate into that artist finding him- or herself immediately selected to be in the next Whitney Biennial, "but it might lead to a word-of-mouth recommendation. Someone may ask me if I've seen anyone good in the Northwest, and I'll remember some artist whose work I thought was really good and mention that person's name. That can go a long way."

Judging artists' slides is not a money-making enterprise for anyone, as the payment ranges anywhere from $50 to $1,300 and often involves many hours, days, or weeks of work that has to be done quickly, considering the mountains of slides and applications to go through. The National Endowment for the Arts upped its fees from $75 to $100 a day (usually between three and five ten-hour days), not including any travel, hotel, and meal expenses—these rates are established by the federal government's General Services Administration depending on location (Washington, D.C., is worth $121 a day). The larger art competitions generally pay up to $1,000 for jurying their shows, also not including travel expenses; the Artists Foundation pays between $1,100 and $1,300 (flying in out-of-staters), while Berkshire Artisans pays $200. For its part, the Guggenheim Foundation in New York City, which awards fellowships to scores of artists every year in a variety of disciplines, uses "people who are well recognized in their field as panelists," according to a spokeswoman, adding that they all provide their expertise for free.

Jurying tends not to be something art experts do for the money; rather, it is for the exposure to different art than they might otherwise see. Especially for those jurors who are art dealers or curators, looking at art is what they do for a living anyway, and they usually like it.

Many artists look to juried shows to bring in new buyers (or new orders), and the failure to be included in a particular prestigious display may damage one's livelihood and career. Frequently, the charge of bias is raised at jurors by a particular artist who is not chosen, and that is why many groups go to such lengths to establish an impartial jury system. Rotating jurors—that is, alternating the subjective opinions that put a display together—may mean that certain artists are in one show, but not in another. No one should be rewarded for selection in last year's show by inclusion in this year's, for these shows do not exist simply to help market a specific group's work; rather, these shows are intended for the public, and different work needs to be seen for visitors to remain interested from one year to the next. Artists who put too much of their emphasis on certain shows for their livelihood, instead of diversifying their marketing strategies, will always look to the jury system with longing and dread.

Jurying Art: Descending from the Ideal

If artists must give up their paranoia about having their art judged, they must also keep their eyes open to very real problems in juried art shows. The artists must demand a prospectus for any competition they may choose to enter, studying it carefully. They may also need to look beyond what the prospectus says to what it does not say.

For instance, what are the judges actually going to do, and how will they do it? The practice of "jurying" is not limited to one specific method but means different things to different people. Although the show sponsors bank the prestige of their events on them, are the judges able to vouch for the ethics and reliability of the sponsors?

On a more basic level, what does it take to be a juror for an art competition? Renown in the art world, affiliation with a notable institution, experience as an art

judge? Perhaps some or all of those things and also, sometimes, just picking up the telephone when a show sponsor calls.

"Someone—who was that?—called me up, asking me to jury some show," stated Carl Belz, director of the Rose Art Museum of Brandeis University in Waltham, Massachusetts. "I said, 'Sure, why not?' They were going to send me a bunch of slides, and I'd jury them and get paid—I don't know—$100. They didn't tell me all that much about the show."

That show of arts and crafts objects, "Art '95," sponsored by the Saddle River Art Society in Nanuet, New York, and taking place at a rental gallery in lower Manhattan, had eleven judges (all museum curators or directors) whose knowledge and information about the event runs from practically nothing to hardly anything.

None of the judges appeared to have asked any questions. For instance, Salvatore Cilella, director of the Columbia Museum of Art in South Carolina, said that he didn't "know a thing about the Saddle River Art Society," its director, its history in putting on art competitions, or even where the actual show would take place. "My focus is on the art and not on the association that's doing the show," he said. "I'm here in the deep South, and if some organization in New York or New Jersey asks me to look at work, I consider that a privilege as it gets me away from all the purely regional work I see here."

Another juror, Jay M. Fisher, curator of prints, drawings, and photography at the Baltimore Museum of Art in Maryland, conceded that he "didn't really scrutinize the offer to jury the show very much. They said they would ship the slides to me, which meant that I didn't have to travel, so it would be pretty easy." Fisher noted that he "remembered having some questions about the show sponsors—who are they, have they ever done this before—but I never got around to asking them."

He stated that he "wouldn't like to jury a show for a commercial group, that plans to make money off artists," but never asked whether or not the Saddle River Art Society is a nonprofit organization. Similarly, Daniel Kletke, a curator of medieval art at the Metropolitan Museum of Art in New York, said that he is "opposed to the practice of charging artists entry fees" in order to be included in juried shows, but he never inquired whether or not Art '95 had entry fees.

One curator, Christopher Mount, who works in the architecture department of New York's Museum of Modern Art, didn't ask any questions when he was called about judging "Art '95": "I said, 'Sure, I'll do it, but send me some written information on the show.'" He never received any, although his name was included as a juror on the flyer for the show.

Nothing is particularly out of the ordinary about "Art '95" or the Saddle River Art Society. The extraordinary part is how standard this process of finding jurors tends to be in a great many competitions. In a world of thousands of competing juried art events, show sponsors look to enlist notable judges in order to lure artists through the prospectus. In exchange for a (usually small) jurying fee, the judges bolster their credentials as experts and rarely ask a question. The interests of participating artists may be left behind.

As noted above, the prestige of a juried art show is largely dependent on who the jurors are, since artists want their work to be seen and evaluated by recognized author-

ities, and the search for distinguished judges may become intense. The same individuals are asked time and again to jury various shows. In a worst case, as in "State of the Art '93," a juried art show sponsored by the New England Fine Art Institute and held on Memorial Day, 1993 in Woburn, Massachusetts, jurors are listed who haven't been contacted or in any way associated with the event. In the best of circumstances, the jurors travel to actually examine the objects and even attend the exhibition itself to see the installation and meet with the artists.

In many, perhaps the majority of, competitions, jurors work from slides without viewing the actual pieces and have no further contact with the show or its sponsors.

As much as notable jurors lend a competition prestige, they also provide it credibility—an artist is likely to think, if so-and-so curator will be part of this show, I can trust that it will be a well-run event. Certainly, jurors must take more responsibility for the conduct of these shows, determining the qualifications and track record of the sponsors, how the event will be operated and financed, how artists and artwork will be treated.

Until then, artists must not rely on jurors to validate a show but do their own research. Certain red flags within a prospectus should make artists wary, and artists should never spend considerable amounts of money on, and ship their artwork to, events that seem questionable or whose claims are overstated.

- *Red flag number 1: An entry fee.* The entry fee and, especially, the hanging fee are simply ways for poorly financed or profit-minded show organizers to minimize their own costs, transferring the expenses to the artists involved. (The entry fee is particularly cruel to artists who may be paying for someone to reject their work.) Artists should inquire how the event is to be financed (corporate or civic sponsors, admissions, selling a catalog, commissions, concessions, for instance), and perhaps, a confirming letter or telephone call should go to a sponsor or concessionaire, especially when the show organizers are new and have no track history.
- *Red flag number 2: Responsibility for the artwork.* The show organizers should assume curatorial and financial responsibility for the artworks in their care. For example, the loan agreement between participating artists and the National Trust for Historic Preservation for the annual "Contemporary Sculpture at Chesterwood" exhibition in Stockbridge, Massachusetts, stipulates that "Works selected for exhibition will be insured for 80 percent of their established retail value while installed on the Chesterwood grounds. Additional restrictions will also apply. A condition report will be completed upon installation."
- *Red flag number 3: Promotion.* A first-time event is unlikely to draw sizeable crowds unless there is a considerable amount of advertising and promotion. Artists should ask the show organizers what kinds of promotional efforts are being planned—such as posters, radio, television, or print media advertisements—and how they are being targeted. Anyone can buy a mailing list and send out brochures blindly.

- *Red flag number 4: Previous attendance and sales.* A standard question to ask a show organizer is how many people came to the event in years past and how many sales took place (this can be confirmed through newspaper accounts or in an organization's annual report). For a first-time event, artists would want to know whether or not the organizer has any experience in staging shows of this kind (when and where, check references). Another question might concern whether or not any outside group is assisting the organizer to put on this show, and what it has done in this area in the past (when, where and references). For first-time events, it is also helpful to know something about the show organizer's personal background and employment history (references).

Such background checks may strike many artists as a huge use of their time and energy that could be better directed toward art making. However, most art shows represent a considerable investment by artists, and the majority of artists don't earn enough (if anything) from them to cover their costs. Therefore, prospective participants should judge any show that they might enter with a critical eye, demanding answers to their questions and some sort of proof that the answers they receive are true.

When Jurors May Not Seem Fair

Is it sour grapes, or are the charges some artists make about being unfairly excluded from certain juried shows founded? Probably, it's a bit of both, although proving that an artist is rejected for who he or she is may be nearly impossible. An artist complains about a show promoter's failure to publicize the event as promised, and that artist is never accepted into the show again. The promoter's defense: The artist's work is not of high enough quality anymore; we already have too many works in that category; we're looking for something a little different this year. It's enough to drive anyone paranoid. That many artists will speak with absolute certainty about being "blackballed" by a show promoter, but few for quotation and virtually none with their real names attached to their comments, attests to a widely held belief.

If blackballing exists, it does so out of the spotlight and is unlikely to adversely affect visual artists industrywide in the same way that blacklisting alleged communist sympathizers during the 1950s in movies, television, and the performing arts destroyed the careers of many actors, directors, and writers. There are an estimated 10,000–15,000 shows that take place annually throughout the year around the United States, and show promoters are too numerous and varied to join in a campaign of shutting out specific artists.

Individual promoters are more likely to exclude certain artists than a panel of jurors. That may adversely affect that person's career if a series of shows are involved, such as a string of thirty malls, for instance. The promoter's ability to shut out the blackballed artists is also only possible where there is no independent jurying. Rightly or wrongly, some promoters may exclude an artist who has passed off another artist's work as his or her own, whose work is of poor quality, whose booth display is unprofessional, or whose business practices (late deliveries, overcharging, double billing, wrong works) are unethical.

There is a lot of sifting through paranoia and an overall problem in handling rejection when looking for instances of blackballing. Part of the problem is the diversity of methods for jurying artists for shows. Promoters who themselves select artists are the most susceptible to charges of personalizing rejections. However, even when there are independent jurors, there is no standard approach among all the thousands of shows, which leads many artists to conclude that the whole process is flawed.

The least objected-to method is an independent juror (or panel of jurors) reviewing all slides that came in with applications before a stated deadline. No limitations are place on the juror's decision-making nor any instructions other than to select the works that he or she thinks best, and the juror has no knowledge of the names, sex, ethnicity, or race of the artists and can only judge the works on their own merits.

However, "jurying" is a large rubric for a variety of practices used in picking works for art shows. For instance, in rolling jurying, slides and applications are judged as they come in rather than as part of a large group. Five realist painters may be sought for a particular show and, after they are selected, the work of an arguably better realist is rejected for the reason of having sent in an application after the given slots were already filled.

Musicians for symphony orchestras are usually chosen through what are called "blind screenings," in which the musician performs behind a screen that prevents knowing whether or not that person is a woman, Asian, African-American, or anything other than capable of playing music competently. "In the visual arts, unfortunately, blind screenings are not common," said George Koch, national president of National Artists Equity Association. "Every time you are asked to submit slides for a show, you are told to put your name on them. That, at least, raises the possibility that jurors will reject your work because they know you and don't like you, or that they want to get more men in the show so reject you because you are a woman, or that they don't want blacks, Hispanics, or Asians."

When there is jurying by medium, artists whose work is multimedia may feel themselves discriminated against. Rotating jurors from one show to the next, another standard practice, may result in an artist being selected one year and rejected the next. The increasingly common practice of preselecting, or tenuring, artists into a juried show because they have a long (or even short) track record may mean that lesser-known applicants have less opportunity to display their work before the public. Of course, there are two sides to this issue: Artists who have been regularly juried into a show complain about the potential capriciousness of jurors who may adversely affect their careers, while others who are just starting out dislike tenuring because it increases the competitiveness for them alone. In a show that has, say, 100 slots for artists, preselection may result in only 20 or 30 spaces available.

Call It "Preselecting," "Tenuring," or "Grandfathering"
Juried arts and crafts shows have their proponents and critics. The public appreciates the fact that these exhibitions are different every year in terms of artists and artisans,

styles and media represented—those differences resulting from the rotation of jurors. Younger and emerging artists and craftspeople like the opportunity to compete against top creators in their media on a level playing field—again, changing who the jurors are gives everyone a chance to eventually get in.

A number of those top creators, however, have found themselves less and less pleased with the process of getting into these shows. Juries are fickle, they feel; and those artists and artisans who rely on certain shows for their market may be devastated financially if they are not selected.

"I've had lots and lots of friends who are good designers and are good technically, who are in a fair one year and out the next because of the vagaries of a nine-person jury," Josh Simpson, a glassblower in Shelburne Falls, Massachusetts, said. "Not getting into the show means they have to find a whole new way to market their work."

Others complain that jurors reject work that isn't "glitzy enough," that making a living by the jury system is "a crapshoot," that juries are "very arbitrary."

"Juries are not always reflective of the market," said jewelry maker Kyle McKeown Mansfield of Hayward, California. "They don't generally consider price or the cost of materials when scoring work for shows. My pieces are affordably priced, averaging between $20 and $35, but they can't compete against work that is extremely expensive. Jurors don't take into account the differences between production items like mine and high-end, one-of-a-kind pieces."

Concerns such as these have led the American Crafts Council to alter some of its jurying procedures, including offering "tenured" spaces to past exhibitors in the strictly wholesale area. Tenure indicates that they are exempted from the jurying process in the future. The American Crafts Council has also moved to jurying by medium, rather than using a diverse group of craftspeople to evaluate slides, and is looking into the advisability of having just one (or, perhaps, two) juries for all of its six shows around the country, instead of having different juries for each show.

"We've felt an obligation to offer stability to craftspeople who are serious about their business practices," JoAnn Brown, director of the American Crafts Council, said. "Craftspeople suffer a tremendous anxiety about these shows, wondering 'Will I be in the show or not?' And this isn't just a few people who feel this way; we've found that there is an across-the-board feeling of 'My world will come to an end if I don't get into this show.' Those who have gone through the jurying process a number of times, and with whom we feel comfortable, deserve tenure."

Brown added that she could "foresee as many as 80 percent" of the wholesale booths in its shows becoming "tenured spots."

The American Crafts Council's policy changes are but the latest indication of an antijurying trend at arts and crafts shows. Many gift shows have taken the position that once someone is juried in, that person may be part of the show for life. In 1993, the Southern Handicraft Guild in Asheville, North Carolina, voted to offer lifetime acceptance into the organization's annual crafts fair to anyone who has been admitted by jury to one of its fairs. Rebecca Orr, administrator for the Southern Handicraft Guild,

explained that exempting certain craftspeople from jurying "saves time, because it's hard to jury all the people who want to be in our show." She added that a number of the guild's members "don't like to rejury. They feel we've questioned the integrity of their work. When people tell me that, I don't know what to say. I just keep quiet."

Also in 1993, the board of directors of the Louisville (Kentucky) Craftsman's Guild decided to automatically accept anyone into its annual Art and Craft Fair who belongs to at least two of three other Kentucky crafts organizations—the Kentucky Craft Marketing Program, the Kentucky Art and Craft Foundation, and the Kentucky Guild of Artists and Craftsmen.

Calling the jurying process "a time-consuming, expensive and very frustrating practice," in which "juries often sit for hours, even days on end, viewing from hundreds to thousands of slides, viewing each artist's work for only a few seconds," Melvin D. Row, president of the Louisville Craftsman's Guild, stated that it is "pointless to make the very people whose work you'd like to have in your show go through the hoops of jurying every year. The other three organizations have high standards of jurying; we'll go with the people they've juried in."

The Rosen Agency, which runs three annual wholesale arts and crafts shows in the United States, was the first to establish a tenure system. One earns tenure by being selected to exhibit work in these shows, and that original selection process does not include jurying. "We analyze business progress of the artist," Wendy Rosen, president of the organization, said. "We look at the volume of sales, the number of employees one has, how many galleries one is represented by, whether someone is a full-time working artist and not just a hobbyist."

Once an artist or craftsperson is in one of these shows, she added, someone from the Rosen Agency staff comes to look at how professional the booth display and any brochures look. The organization will also keep an ear out for any complaints by buyers, such as poor workmanship or late deliveries, that reflect poorly on the professionalism of the artist or craftsperson. If there are any complaints by buyers, or the brochures or booth are problematical in some way, she stated, "someone from the staff will have a chat with the craftsperson."

Earning tenure means, Rosen said, "there's no need to reevaluate an artist's work. If you're self-supporting, the jury has made its decision, and that jury is the buyer. The dollar says a lot more about someone's work than the beauty contest that is the traditional jurying system."

Ensuring that the work of tenured artists maintains a certain high level of quality can be somewhat tricky. JoAnn Brown said that "we get a lot of input about craftspeople from other craftspeople and, if someone's work deteriorates, that person will be talked to," although she added that the American Crafts Council "will have to work out ways to do this." Rebecca Orr noted that the Southern Handicraft Guild's booth evaluation committee, whose task is to go from booth to booth during shows looking for fire and safety violations, will now have the responsibility of checking that craftspeople exempted from jurying "not have anything in their booths that doesn't fit the category."

Not everyone is happy with the new tenuring system, however. Younger or newer entrants into the arts and crafts field find that allotting a certain percentage of booths to long-time exhibitors vastly increases the competition for the remaining spots. Although JoAnn Brown said that, in a good show, "jurying sets high standards for everyone," a two-tracked system of tenure for certain artists and jurying for others may mean that having to submit one's slides to a jury is a mark of not having attained success.

"I believe that American Crafts Council shows should be reflective of the very best in the field from year to year," stated Pam Hill, a quilt maker in Mokelumne, California. "Juries make a show fresh every year; juries keep artists on their toes far more than tenure does. I believe in maintaining an open system, in which everyone gets juried, because that allows access to newcomers. Free access allowed me to get in, and other people deserve the same chance."

Craig Easter, a ceramicist in Fresno, California, also labeled himself "a proponent of nobody-gets-any-special-deals, we-seek-the-best" as the correct philosophy for arts and crafts shows. To his mind, jurying for everyone is the best way to find the best.

The battle over whether to jury and who should be juried reveals a debate over the continuing importance of shows to the careers of artists and craftspeople as well as why buyers go to these shows in the first place. Many artists and craftspeople wonder whether or not annual events should be so vital to artists that their careers will fall apart if they aren't accepted in a given year. Similarly, some believe that, if getting into the shows each year becomes too important, the artist or craftsperson hasn't adequately pursued the sales and contacts made at the shows for the rest of the year.

John Winfiski, a glassblower in Charlemont, Massachusetts, who "sort of" approves of tenuring for "people who have been in a show for a number of years," noted that "buyers don't go to shows to see the same old people; they can get to those people by phone. Buyers go to shows to see what's new. Buyers aren't interested in tenure; tenure is really an antibuyer concept. Craftspeople want tenure because of all the competition they face from other craftspeople."

On the other hand, Thomas Stender, a woodworker and furniture designer in New York, who doesn't "like the idea of tenure at all," stated that getting into the same shows year after year is crucial for one's career. "It's hard to service buyers by telephone," he said. "They need to physically see your work. I've found that, if you can't write orders before the show, you might find that the buyers have spent their entire budgets by the time the show is over."

Wendy Rosen also stated that successful craftspeople change 30 percent of their line every year or two, "and shows are the only effective way to present that new work to buyers. You can't do it by telephone."

Other changes in long-standing jurying practices have their defenders and critics. Judging by medium—ceramicists looking at ceramics, woodworkers evaluating wood objects, for example—is viewed by some as solving the arbitrariness of mixed juries, while others fear that it will lead to a greater emphasis on technical qualities or

mastery over one's craft than on aesthetics. Having one or two juries select all the works for a group of shows may relieve artists from having to create numerous slides of their work and fill out a variety of application forms that must be sent to different locations at different times, but the consensus that a certain group of jurors may develop can result in certain artists being locked out of all these shows, which could hurt their careers significantly.

Jurying is inherently a subjective activity, which can be more easily complained about than fixed. Perhaps, the efforts that the American Crafts Council and other show sponsors have undertaken to limit what Josh Simpson called the "vagaries" of juries reflects a growing lack of tolerance for these groups among those who see their careers riding on subjective opinions. Traditionally, an arts and crafts show is a special event, in which it is an honor rather than a right to have one's work exhibited, as opposed to an art or crafts gallery that appears to select its artists and artisans in perpetuity. New attitudes, based in part on the tremendous competition in the arts and crafts field, however, begin to blur older distinctions, and the "sanctity" of certain older concepts, such as the importance of competitive jurying for all and the relationship of jurying to the quality of a show, come into question.

Jurors with Clear Biases
In many cases, jurying may not be independent; that is, judging is not by someone unaffiliated with the sponsoring organization but conducted by those within the organization itself. Mystic Maritime Gallery in Mystic, Connecticut, for instance, holds an annual juried Mystic International Exhibition of maritime art. The works in the show are selected by gallery director Russell Jinishian and a few other gallery employees, and outside jurors are brought in solely to pick which of the previously chosen artworks should receive particular awards. Usually, the work of between 110 and 120 artists are included in the Mystic International Exhibition. Jinishian noted that the gallery has a core group of sixty or so artists, and "the majority of them get into the show. We try to pick good things that have merit."

If tenuring helps artists gain greater financial stability, a show sponsor selecting artists he happens to represent allows him to solidify his market, not leaving commercial considerations to chance with outside jurying. "When a gallery holds a juried show," George Koch stated, "artists should have no illusions about fairness. The gallery uses the show as a way not to have to go to the artists' studios, because the artists will just send their works to the gallery."

The deck may seem stacked against certain artists in other ways as well. Independent jurors—that is, judges not associated with the sponsoring individual or organization—may be given explicit instructions by the show organizer on how to evaluate works, and certain otherwise important criteria may be excluded. Sue Viders, an artists' advisor who frequently juries art competitions, noted that "salability" is a major emphasis in judging for show sponsors who want works to sell in order to make money. At other times, marketability is pointedly not a factor at all. "A lot of artists enter works

into show, assuming that they will be judged on the basis of expression and creativity, and they may try for something new," she said. "The show sponsor, however, may be more concerned with selling a certain type of art. So, I, as a judge, rate the works in the categories the sponsor wants, using a 1–5 scale that the sponsor wants, and whoever gets a certain number of points is in the show. Whoever gets the highest number of points wins whatever award is offered. It may not be, to my mind, the best artwork. People who run these shows should make it clear to artists the criteria on which the works will be judged."

If show organizers do not include criteria for judging works on a prospectus, it is advisable for artists to ask. With probably most juried shows, the jurors make their selections without the artists present, and they aren't on hand when the artists do come. Some shows, however, want—and will pay for—the jurors to come back to see the exhibition. Opportunities for artists to discuss with jurors the basis for judging works in or out should be encouraged, as it is helpful for the artists and adds an element of good will in the relationship of artists and the show organizers.

That someone has been blackballed may be difficult to prove, but it often seems quite evident that certain artists are favored by a show sponsor. "It's not just paranoia on the part of artists," painter and national academician Everett Raymond Kinstler said. "In a number of institutions, the officers and boards don't change for twenty years. The same people get in the shows and get awards; it's all very locked in."

Rolland Golden, a painter, resigned from the American Watercolor Society in 1989 "because it was too political. I saw the same people winning awards, sitting on juries for the society's annual show, and serving as officers in the society. It just didn't seem right."

The life and career of any artist is one of more rejection than acceptance, in some cases seemingly endless rejection. Jurors or show sponsors may not want to exhibit an artist's work for far more reasons—wrong size, wrong medium, wrong subject matter, wrong style, too expensive, just don't like it—than that they will. When seething about a rejection, artists must first ask themselves, Am I personalizing this rejection? If there are valid reasons to either question the jurying or conclude that the artwork was rejected for personal reasons, artists basically have three options. The first, as in the example of Rolland Golden, is to resign from an organization whose jurying practices are questionable. The second is to rally a group of artists who will petition the show sponsor or organization to reexamine its approach to jurying. That may or may not prove effective in changing policies, but it lessens the likelihood that an individual artist will be targeted for reprisals.

The third option is to direct one's attentions elsewhere. With between 10,000 and 15,000 juried shows taking place throughout the United States, many of which are highly esteemed and attended by affluent collectors, there is no reason to focus too exclusively on any one show.

12

THE SEARCH FOR
GRANTS AND GIFTS

*A*rt is not only often expensive to buy but costs money to make, in some cases a lot of money. There are materials to purchase, studio space and machinery to buy or rent, perhaps assistants or a foundry to hire; in order to leave the studio, the artwork frequently must be crated, insured, and shipped. The world needs to be alerted to the existence of this art, which may require photographs and mailings. And, of course, let's not forget the basic overhead of the artist, who needs food, clothing, and shelter.

Affording to make art is a central concern to most artists, who generally pursue second (or related) careers until—and even after—their artwork begins to sell. A frequently hoped-for option is receiving a project grant or fellowship from some private or public entity that pays for all or a substantial part of the costs. There are certainly a variety of options in this area for artists and arts organizations, including applying to local, state, regional, and federal arts funding agencies; private and government public-art agencies; foundations, corporations, and even churches.

Fellowships are the most sought-after form of artistic support, as they permit artists to pursue and enhance their careers without requiring artists to produce something in order to be paid. Fellowships are offered by the National Endowment for the Arts, the regional arts agencies, most states, a few local arts councils, and a small number of private foundations. Fellowships are paid to individual artists, while project grants—the more popular type of arts support—go to organizations. Individuals are not eligible for project grants. Occasionally, the term "fellowship grant" is heard, but that usually refers to an artist or scholar pursuing a specific project or area of research, such as during a sabbatical leave from a college or university.

To the uninitiated, the search for arts funding is a matter of asking for money from a certain group of well-known arts patrons: The National Endowment for the Arts in Washington, D.C., fifty state arts agencies, and a variety of foundations and corporations provide either (or both) project or fellowship grants. So look up the address, submit an application, and take your chances.

In fact, the funding situation is far more intricate, with varied sources of potential financial assistance for artists—some international, some national, some regional, some local—that require a significant amount of research. Money for individuals (including artists) comes in a variety of forms: There are yearlong (sometimes renewable) scholarships and fellowships, most of which are for undergraduate or graduate study, that do not require a completed project in order to receive the entire sum of funding; next are project grants (payments for short-term projects, such as painting a mural, or services, such as teaching a workshop) and project fellowships (sabbatical money, for instance, for an academician studying a specific subject). In addition, technical assistance (donated services of lawyers, accountants, or marketing specialists, for example) and in-kind support (such as tools, machinery, and office equipment) are a noncash form of help that corporations and government agencies sometimes provide.

The amounts of money available from funding sources is wide ranging. Some fellowships are designed to support an individual (without the need for another job) for the entire year, while others are more like a clap on the back. The Arrowhead Regional Arts Council in Duluth, Minnesota, offers fellowships of $1,200; and the Massachusetts Cultural Council's artists fellowships are for $7,500. The National Endowment for the Arts has $20,000 fellowships for writers, and Pew Fellowships in the Arts in Philadelphia provides $50,000. Few people grow rich on a project grant, as the money covers the work-related costs (including the artist's own labor) of completing the project.

FISCAL MANAGEMENT

Most financial support for the arts comes in the way of project grants, which are predominantly made not to individual artists but to private nonprofit "umbrella" organizations that sponsor the artist and provide financial management for the grant allotment. Most foundations are prohibited by their charters from making grants to individuals, and corporations only receive a tax write-off for their monetary gifts to not-for-profit organizations. These organizations, acting as middlemen, take responsibility for ensuring the project's success and absorb responsibility in the event of failure, relieving the funding source of the need to defend itself as vigorously (a government agency and angry constituents or a corporation and its stockholders).

Research is the key element, finding the most appropriate umbrella organization, locating the most likely funders. There is no typical umbrella organization, nor is there any list of such organizations. An umbrella can be any nonprofit group that agrees to sponsor an artist's project for the purpose of attaining funding from a third party source. An umbrella organization need not be specifically arts oriented; a chamber of commerce, church, civic or community organization, historical society, hospital, museum, school, self-help group, United Way, YMCA, or any other group may sponsor an artist. Some organizations regularly sponsor artists, while others may only do so once. These umbrellas may or may not charge fees, usually a flat percentage of the grant (no more than 10 percent), and the services they offer to artists range widely. As when hunting for a dealer or gallery to represent you, look for an umbrella group that most closely fits your ideas and working style and doesn't charge too much.

In general, these organizations help artists, whose projects they have agreed to sponsor, focus their ideas into a proposal that is clearly stated and fundable. They also help locate the most appropriate funding sources. Artists usually must fill out their own grant applications, but the umbrella organization will submit a letter of support, which lets the funder know that the project has been prescreened and found acceptable—in effect, the organization puts its imprimatur on the artist. Then, when the project is funded, the organization will receive the money, and administer it, distribute it to the artist (usually on a reimbursement basis), and take care of all other bookkeeping. The organization submits a final report to the funding source at the completion of the project.

The best places to find out information about potential umbrella organizations for an artist's project are the funding sources themselves. Any of them may direct artists to organizations with which they have worked in the past as well as indicate which groups are not thought of as reliable. "An organization may be in trouble with a funding agency for not living up to its end of a bargain on a past project," said Gary Schiro, director of the individual artist program at the New York State Council on the Arts. "The organization may not have submitted a final report or handled its bookkeeping properly, and it will be ruled ineligible for future funding."

Another useful source of information is the Washington, D.C.–based National Association of Artists' Organizations, which has over 330 members, many of which have acted as umbrellas for artists at one time or another. Groups that agree to act as an umbrella organization tend to work locally—a Pittsburgh nonprofit organization is unlikely to sponsor a project in Arizona—and artists are well advised to investigate local artist-run groups as potential sponsors.

Beyond this, artists should contact other artists who have used the organization as an umbrella to find out exactly how much and what kind of assistance was offered, whether or not the group's administrator seems trustworthy, and what (if any) fees were charged. Another point to ask: If there were disputes along the way, how were they resolved?

With organizations that regularly sponsor artists in this way, a formal agreement probably already exists. Groups that have not acted as umbrellas in the past are unlikely to have a standard contract, and artists should establish in writing the respective roles and responsibilities. Among the points that would be included in this agreement are how the artist is to be paid (in a lump sum or installments, throughout the project or after its completion), how the work is to be installed and maintained (and who pays for installation and maintenance), how the artwork will be promoted and insured (and who pays for promotion and insurance), what services the organization will provide the artist (including the use of support staff, office equipment, and studio space; not-for-profit mailing privileges; and assistance in finding suitable funding sources), and what the organization charges for these services. Some groups act as an umbrella organization for free, believing this kind of work to be a service to the field. However, most others charge a percentage of the money raised for the project, ranging from 3 to 10 percent.

The New York State Council on the Arts refuses to provide funding for any umbrella organization that charges an artist more than 10 percent. The New York Foundation for the Arts, which holds a free seminar the third Friday of every month on how to choose an umbrella organization, takes 8 percent of the money raised by individual artists, although the group also charges a $100 initiation fee "in order to start the paperwork," according to Penelope Dannenberg, director of Artists' Services and Programs. On the other hand, colleges and universities regularly take 50 percent of the research grants that their professors and scientists are given. Of course, they provide the facilities in which the actual work can be done.

Auditing and bookkeeping, monitoring the artist's progress, helping to locate potential funding sources, writing letters of support or a final report to a private or government agency, and assisting the artist in shaping his or her artistic idea into something workable takes time; and many organizations may chose to forego the opportunity to act as an umbrella if the total project cost is too small, for instance, under $2,000.

So who will provide the funding? There are basically five categories of funders: private, nonprofit foundations; government on the federal, state, and local levels; corporations; individuals during their lives or through wills; and a more miscellaneous grouping of associations, clubs, local organizations, unions, and societies. If they all operated with the same procedures and goals, one could submit the same proposal to any number of them. However, they are all different and none should be sent a proposal or application without first learning a particular funder's procedures and history of giving. (It is wise, for instance, to submit a proposal to a specific individual rather than to a "Dear Sir" or "To Whom It May Concern.")

Grant-seekers need to maintain a wide perspective when approaching the issue of fundraising. The project may be an arts event or the creation of a specific artwork, but the realm of potential funding sources need not be limited to those agencies that support the arts. Most art presents a vision of the world and its inhabitants, and there are funding sources available for almost every global and human concern. Artists should ask themselves: Does the project have an educational component (agencies that provide funding for education might be interested, for example)? Does the project involve the environment or science, history (cultural, economic, political, or social) or specific groups (African-Americans, Asians, the elderly, the handicapped, labor, Latinos, Native Americans, religious denominations, and the young, among others)? Who will benefit from the project (a target audience or a general population within geographical boundaries)? It might be beneficial for artists to create a chart of the subject areas involved in the project and its potential interest to constituency groups: This chart will prove helpful when it is time to prepare an application.

In general, one may say that all granting agencies and organizations are more likely to provide money for the types of projects and programs they have funded in the past than something completely new. What should be fresh is the manner in which the artist tackles a familiar problem.

Foundations

Foundations are probably the best-tracked group of funders because of the Foundation Center, which collects information about foundations from the Internal Revenue Service as well as conducts regular surveys of foundations. According to Rayburn Chan, coordinator of grant-maker services at the Foundation Center's New York branch, 14.2 percent of all foundation grants (or 12.4 percent of all foundation grant dollars, totaling $899 million) in 1999 were directed to the arts, culture, and humanities. Of that pot of money, the visual arts and architecture received 3 percent, with the lion's share going to museums (32 percent) and the performing arts (33 percent).

The Foundation Center publishes books and a CD-ROM, many of which are quite expensive, such as *National Guide to Funding in Arts and Culture* ($145), *Guide to U.S. Foundations* ($215), *The Foundation Directory* ($215), *Foundation Grants to Individuals* ($65), and FC Search ($1,195). The information in these books is invaluable, providing an alphabetized (by state and within states) listing of foundations, contact names, current addresses, and telephone numbers; the size of typical grants; the types of projects funded and where (for instance, limited to New Jersey or Newark, New Jersey); the names of officers and trustees of the foundation; and when and how to apply for grants. However, one may look at these publications for free at its two main locations, in New York City (79 Fifth Avenue, New York, NY 10003-3076, 212-620-4230) and Washington, D.C. (1001 Connecticut Avenue, N.W., Washington, D.C. 20036, 202-331-1400), as well as field offices in Atlanta (Suite 150, Hurt Building, 50 Hurt Plaza, Atlanta, GA 30303-2914, 404-880-0094), Cleveland (1356 Hanna Building, 1422 Euclid Avenue, Cleveland, OH, 216-861-1934), San Francisco (312 Sutter Street, San Francisco, CA 94108, 415-397-0902), and a network of 213 cooperating libraries in all fifty states. A small amount of the same information is available on the Foundation Center's Web site *(www.fdncenter.org)*, which also lists all 213 libraries. The only costs for library visitors is for photocopying or printing from the CD-ROM.

Some foundations also publish annual reports, which may be examined for its list of grants given, future commitments of funding, officers and staff, application procedures, and deadlines. One might also ask to get on a foundation's mailing list, where much of the same information can be found. While the Foundation Center collects information from the returns that foundations file with the Internal Revenue Service, one may view the entire returns at the Foundation Center offices or their cooperating libraries. Those full returns contain basic financial data, names and addresses of officers (although not necessarily staff), and a complete list of grants (recipients' names and amounts but usually no descriptive information).

Making a detailed search of exactly to whom or for what a foundation provided money is an essential element in the process of fundraising, because it saves time and clarifies what the organization is truly interested in supporting. The listings in the Foundation Center's books consist of what each foundation writes about itself, and the funding areas are noted in generic terms—"arts," "education," and "health care," for instance. A particular foundation, for example, may indeed provide money for educa-

tion, but those funds only go to support a particular school or for scholarships for a specific ethnic group. An arts project with an education component is unlikely to receive an award from this foundation, regardless of its merits.

Some foundations provide grant money on a national or international basis, but most direct their philanthrophy locally. A search of community foundations, which provide grants to address problems and areas of interest (primarily, health care, social welfare, education, and arts and culture) within a defined geographic area, is the best place to start. The Council on Foundations (1828 L Street, N.W., Washington, D.C. 20036, 202-466-6512, *www.cof.org/*) is one good source of information on community foundations. Another source of information on foundation's in your own area is the Regional Association of Grantmakers *(www.rag.org)*, which is composed of twenty-nine organizations around the United States. Clicking on the Web site map, one can quickly obtain the membership list of each organization, which are divided into categories. At the Connecticut Council for Philanthropy, for instance, there are corporate members (Aetna Foundation, The Hartford Foundation, and Lincoln Financial Group's Community Partnership Program, among others), family and independent foundations, community foundations (including Community Foundation of New Haven, Hartford Foundation for Public Giving, Middlesex County Community Foundation, and Waterbury Foundation), and other grant makers (such as Combined Health Appeal, Junior League of Hartford, and United Way of Connecticut). The United Way is known as a federated giving program and the Junior League is simply a nonprofit organization. If a nonprofit organization dispenses grant money and is not set up as a private foundation, they fall under the classification of a grant-making public charity. Many of these may not have a track record of giving to the arts, but a proposal that fits into other areas of their past funding may generate interest.

An additional source of information and potential money is The Funding Exchange (666 Broadway, New York, NY 10012, tel. 212-529-5300, *www.fex.org*), a group of fifteen politically active, left-of-center private foundations around the country that occasionally provide funds for art projects related to community organizing or current social issues.

Corporations

Under current law, businesses are permitted to take charitable deductions of up to 10 percent of their pretax net income, although it is quite rare indeed to see corporations granting away that much of their money. Company executives must answer to stockholders, who sometimes are not excited about charitable giving programs in the first place, and this also explains why corporate grants are usually small and for nonadventurous projects. Ninety percent of all corporate support is spent on the local level, where a company has its headquarters and in the cities in which it has operations, according to Judith Jedlicka, executive director of the New York City–based Business Committee for the Arts. Because of this, she recommended contacting the local chamber of commerce for the names and contact people in businesses that have contributed money to the arts

and culture in the past. One may also contact the local Better Business Bureau (their locations may be found through the Council of Better Business Bureaus, 4200 Wilson Boulevard, Arlington, VA 22203, 703-276-0100, *www.bbb.org*).

Companies make charitable grants for a number of different reasons: to create a positive public image, to influence legislators and opinion makers, to build community relations, to keep up with the competition, to please special interest groups, to support employee services, to increase productivity, to entice prospective employees, and to associate with quality. However, most corporations tend to be rather secretive about their giving programs, publishing no brochures on how to apply or what they give money to; the annual report rarely mentions giving in anything but vague terms. In many cases, companies prefer to treat their support for the arts not as charitable gifts but as standard business expenses, such as commissioning artists to decorate a lobby or offices, hiring musicians or dancers to perform for employees, using a portion of the public relations budget for a fair or festival, even lending out their employees or equipment to assist an arts event or project.

Without the myriad of publications available at the Foundation Center available for corporations, grant seekers must do their own sleuthwork. Grant seekers must ask themselves what the company would gain by supporting their projects (Is the idea potentially profitable to the company? Will it serve the employees? Will the proposal help the company realize its corporate giving goals?) and tailor their proposals accordingly.

Additionally, grant seekers must know what the company produces and what its future plans are. (Trade associations and articles in the business press are apt to reveal that information.) They must also know the organizational structure of the company. (It is not enough to have ideas—one must know how new projects are proposed, accepted, and implemented within the company.) A number of books reveal significant information about a company and its top management, including *Standard & Poor's Register* (updated annually), *Ward's Business Directory of U.S. Private and Public Companies* (updated periodically), *Dun & Bradstreet Million Dollar Directory* (updated periodically), *Thomas Register* (updated periodically), *Macrae's State Industrial Directories* (updated periodically), *Directory of Corporate Affiliations* (updated periodically), and *The National Directory of Addresses and Telephone Numbers* (updated periodically). Many businesses also have annual reports and a Web site. Some corporations and most graduate business schools at universities have their own libraries, where specific information about its history of giving may be found (one may need to make an appointment). R.R. Bowker's *American Library Directory* and Gale Research's *Directory of Special Libraries and Information Centers* may additionally lead grant seekers to libraries bearing pertinent information about businesses with giving programs.

One may have to simply inquire by telephone, asking whether the company supports programs in the community. Does the company provide financial support for arts and culture (and what has been sponsored in the past)? What are the guidelines for support and how should a proposal or application be submitted (and to whom)? There is no standard method for how businesses donate money or even if they will make charitable

gifts from one year to the next (that usually depends upon profits). The individual in charge of giving may be the president or chief executive officer or the public relations or marketing person. A telephone inquiry about whether the company ever supports arts projects might result in the call being transferred to the very person making decisions about giving, who starts asking about the specifics of the caller's proposal—so be prepared.

Corporate Foundations

Perhaps 2,000 corporate foundations in the United States are designed to separate charitable giving from the regular activities of a company but often such giving is still tied to the business. Take, for instance, the Herman Goldman Foundation, which was created in the 1940s by the New York City law firm Brauner, Baron, Rosenzweig & Klein and has a $32 million endowment. The foundation gives approximately 150 grants per year, totalling $1.7 million (the average grant is $6,000–$7,000). Of those 150 grants, only about 20 are to organizations to which no one on the foundation's board has a personal interest, according to Rich Baron, director of the foundation and the son of a board member and law firm partner. All of the board members are involved with the law firm in some way (each board member is paid $1,000 per month to attend the monthly meetings), and "the vast majority of grants are made where board members have some personal involvement," he said. That involvement includes a friend's or business associate's strong connection to a nonprofit organization (for example, a college that a board member's child is attending), a board member who is also a board member of another nonprofit organization, clients who are involved with an organization (for instance, a hospital where a family member was treated), or organizations in the town where a board member lives (spreading money around adds to one's personal prestige in a community). One of the board members of the Herman Goldman Foundation directed a number of grants to various synagogues, all of which then gave the law firm their business. In general, there is a strong relationship between the grantees and the firm, and most of the board members' individual grant recommendations need not be voted on individually.

The twenty grants not pertaining to board members' personal and professional interests generally are made from Rich Baron's small discretionary funds. "I've been told by board members here not to network," Baron said. "They don't want a high profile—they don't want any profile. They don't want the phone to ring off the hook." Those looking for a grant from a corporate foundation should probably make it their business to meet and become friendly with a higher-up at the company.

Government

As these are public entities (and not involved in national secrets), government support for arts and culture on the local, state, and federal levels should be the easiest to identify. Unfortunately, nothing government does or how it does it is ever easy to understand. The reason for the difficulty in tracking arts funding is that a number of different agencies may have some involvement, marginal or significant. For instance, states may have an arts funding agency (locate through the Web site of the National Endowment for the

Arts—*www.arts.endow.gov/*—clicking on NEA partnerships, then on state and region-
al arts agencies), but they may also make awards to arts organizations. Among the sources of
these funds may be a state department of education (for arts education curricula or a Very
Special Arts program, and Kansas has an accessible arts program for the blind), travel and
tourism or department of parks and recreation (for a festival or to develop cultural tourism),
department of social or rehabilitation services (Massachusetts has an arts therapy initiative),
or department of public safety or correction (Hawaii has a dance program for prison
inmates). A state budget may also have arts-related line items, such as funding to a museum
or other cultural institution outside of the state arts agency budget or capital improvements
for a performing arts center or a literacy program in the state libraries.

Information on state government programs and agencies may be found on the Web
site of the National Association for State Information Resource Executives
(*www.nasire.org/ss/index.html)*, and one might also try the official state library (locat-
ed in the state capital; look in R.R. Bowker's *American Library Directory* or Gale
Research's *Directory of Special Libraries and Information Centers* for locations and tele-
phone numbers).

For information on how and where the federal government spends its money, one
might consult the *Catalog of Federal Domestic Assistance* ($72, send check to the
Government Printing Office, Superintendant of Documents, P.O. Box 371954,
Pittsburgh, PA 15250-7954, or order by Discover, MasterCard or Visa through calling
202-512-1800). Some of the information from the catalog is available online
(*www.gsa.gov/fdac/queryfdac.htm)* or through a library (a college or university library
will be more likely to have an up-to-date copy). The *Federal Register* is the federal gov-
ernment's newspaper, and it lists new programs, funding guidelines, and deadlines and
public meetings. The cost of a subscription is $550 per year, available through the
Government Printing Office, but they may be viewed for free at government depository
libraries—to find the closest one, search *www.pueblo.gsa.gov/*. One may also search the
Federal Register online (*www.access.gpo.gov/su_docs/aces/aces140.html*—check the
most recent year, click on "notices," and search ART* AND GRANTS, all caps), where
federal grants and notices of funding are listed. Another source is the Federal
Information Center (P.O. Box 600, Cumberland, MD 21501-0600, 800-688-9889,
www.gsa.gov/et/fic-firs/fic.htm) through which different agency programs and their
budgets may be tracked. A final source of information is the Web site of the National
Endowment for the Arts (*www.arts.gov/Federal.html)*.

Public support of the arts is available on the local, state, regional, and national
levels, although each has its own styles and criteria for awarding grants and fellow-
ships. Even on the same level—for instance, different agencies of a state government—
there may be wide variability in the awards process.

LOCAL ARTS AGENCIES There are an estimated 3,800 local arts agencies around the
United States, two thirds of which have discretionary funds with which to make grants.
According to Randy Cohen, director of research for the National Assembly of Local Arts

Agencies, "'benefit to the community' tends to be the top priority. Local arts agencies are about all of the arts for all of the people, and artistic excellence is not necessarily the single most important concern." Benefit to the community often results in an emphasis on social issues—using art, or art making, to bring diverse groups together—or it may mean using agency money for an arts festival or to enhance art-in-the-schools programs. It is otherwise difficult to predict funding priorities and patterns: Some local arts agencies give most of their money to a few local major arts institutions, with little remaining for other organizations (which may work to the detriment of emerging artists), while others have no qualms about making grants to organizations that do not have 501(c)(3) non-profit incorporation. As public agencies go, local arts councils have the least money to give, with average grants of $1,200 for communities with populations under 30,000, and $23,000 for cities of more than 1 million people. Most local arts agencies are completely run by volunteers, who make all decisions about funding. For information on local arts councils near you, contact Americans for the Arts, 927 15th Street, N.W., Washington, D.C. 20005, tel. 202-371-2830.

STATE ARTS AGENCIES Each state in the union and all six American territories have government arts agencies. Like the local arts councils, an important criterion for funding is making the arts accessible to people, ensuring that public tax dollars are spent in the interests of the public. However, artistic excellence is a higher priority than at the local level, and applicants are usually judged by peer-review panels. These panels change from one year to the next, maintaining diversity in the process of artistic selection. The conventional wisdom about state arts funding is that agencies give smaller grants to more organizations. According to Kelly Barsdate, director of research at the National Assembly of State Arts Agencies, approximately 32 percent of all individuals applying for fellowships and 55 percent of all organizations seeking grants from state arts agencies receive some award, the average amount being $6,700. That average varies widely from state to state. In Virginia, the average was $2,000, whereas in Minnesota the amount was $15,000. New Jersey's average was $42,000; and Hawaii's, an even more generous $62,000, which reflects the fact that most of these states' arts money is assigned to general operating support for major institutions, leaving relatively little for project support and other artist initiatives. For more information about the states, contact the National Assembly of State Arts Agencies, 1010 Vermont Avenue, N.W., Washington, D.C. 20005, tel. 202-347-6352.

REGIONAL ARTS AGENCIES There are seven agencies around the United States, set up and supported by both the National Endowment for the Arts and the state arts agencies (with additional fundraising from corporations and individuals), in order to provide assistance to individual artists and arts organizations on a regional level. They are:

ARTS MIDWEST
Hennepin Center for the Arts
528 Hennepin Avenue, Suite 310
Minneapolis, MN 55403
tel. 612-341-0755
Serves Illinois, Indiana, Iowa, Michigan, Minnesota, North Dakota, Ohio,
South Dakota, and Wisconsin

CONSORTIUM FOR PACIFIC ARTS AND CULTURE
2141C Atherton Road
Honolulu, HI 96822
tel. 808-946-7381
Serves American Samoa, Guam and Northern Marianas

MID-AMERICA ARTS ALLIANCE
20 West 9th Street, Suite 550
Kansas City, MO 64105
tel. 816-421-1388
Serves Arkansas, Kansas, Missouri, Nebraska, Oklahoma, and Texas

MID-ATLANTIC ARTS FOUNDATION
11 East Chase Street, Suite 1-A
Baltimore, MD 21202
tel. 410-539-6656
Serves Delaware, the District of Columbia, Maryland, New Jersey, New York,
Pennsylvania, Virginia, and West Virginia

NEW ENGLAND FOUNDATION FOR THE ARTS
330 Congress Street
Boston, MA 02210-1216
tel. 617-951-0010
Serves Connecticut, Maine, Massachusetts, New Hampshire, Rhode Island,
and Vermont

SOUTHERN ARTS FOUNDATION
1401 Peachtree Street, N.E., Suite 122
Atlanta, GA 30309
tel. 404-874-7244
Serves Alabama, Florida, Georgia, Kentucky, Louisiana, Mississippi, North Carolina,
South Carolina, and Tennessee

WESTERN STATES ARTS FOUNDATION
207 Shelby Street, Suite 200
Santa Fe, NM 87501
tel. (505) 988-1166
Serves Alaska, Arizona, California, Colorado, Hawaii, Idaho, Montana, Nevada, New
Mexico, Oregon, Utah, Washington, and Wyoming

The stated intent of the seven arts agencies is to promote the arts of their respective regions. "We allow more artists and arts organizations in the Midwest to get grants than they would if they only had the National Endowment for the Arts to apply to," said Susan Chandler, development director at Arts Midwest. "It always seems in the NEA's panel system that the East Coast and the West Coast get a lot higher percentage of grants. The Midwest just doesn't get enough attention financially or stylistically from the NEA." As at the state level, funding decisions are made by peer review panels whose members change annually. The other main emphasis of the regional arts agencies is promoting interstate cultural activities, such as providing financial support for a theater company's regional tour, arranging collaborative efforts between arts organizations within the region or holding a conference. Each regional arts agency works differently, but they all tend to make awards to between 60 and 80 percent of their organizational applicants and to 5 percent of their individual fellowship applicants.

NATIONAL ENDOWMENT FOR THE ARTS As one moves from local and state to regional and federal arts agencies, there is more and more prestige attached to grant recipients, but there is also stiffer competition for awards and more paperwork involved in the application process. The prestige results from the increasing emphasis on artistic excellence as the central factor in receiving a grant, especially at the federal level. The degree of competitiveness is heightened because applicants from throughout the United States, rather than simply your own region, state, or town, vie for funds. Only between 2 and 3 percent of the applicants in the literature fellowship category receive awards, which range from $5,000 to $20,000.

According to A. B. Spellman, associate deputy chairman for program coordination at the arts endowment, competition is also greater at the federal level because "it's less likely that [peer review] panelists will be familiar with the applicants. It's also easier to recognize regional styles on the more local level." Grants and fellowships are decided in all institutional, literary, performing, and visual arts categories by peer review panels, which consist of seven people. For fellowships, a panel is made up of five practicing writers, one critic or academician, and one "layperson," such as a publishing executive. Different panel members are appointed every year, so there is no possibility of characterizing what the arts endowment supports or doesn't support. Artists may have to apply again and again until the right mix of panelists chooses to provide financial assistance to their particular style or type of work. The NEA attempts to find pan-

elists with a stylistic, ethnic, and geographic diversity as well as a gender balance. The agency also tries to bring in people who reflect the applicant pool; that is, living in the same states or regions as the bulk of the applicants. Panelists in any of the media are not given a number of how many artists they may select for a fellowship.

Arts endowment guidelines also require projects and applicants to have "national significance," vague language that means the art has broad implications for its medium, advancing the discipline, and speaking beyond the merely local. For that reason, Spellman said, the arts endowment is often seen as more amenable to avant-garde art styles, whereas there is more interest in traditional realists at the state level. For more information, contact the National Endowment for the Arts, 1100 Pennsylvania Avenue, N.W., Washington, D.C. 20506, tel. 202-682-5400.

One is permitted to apply to the National Endowment for the Arts and the regional arts agencies at the same time. In fact, one Maryland sculptor received fellowships in 1993 from both the arts endowment and the Mid-Atlantic Arts Foundation, although such coincidences are rare (the regional agencies tend to look to support artists who are unlikely to receive fellowships on the national level). After receiving an NEA fellowship, however, an artist is prohibited from applying to a regional agency for ten years.

ASKING FOR MONEY

The search for project grants and fellowships is a two-part process: On the one hand, there is a hunt for appropriate and likely funders, and the process of winnowing down that field is long and difficult; on the other side is the process of developing an idea for a proposal and tailoring it to a particular funder (in terms of the objective, budget, how and when money is spent, the statement of need, and the type of endorsements included). Obviously, there is more to requesting funding than remembering to say "please." An elaborate process is involved for both locating financial sponsors and making an application for that money.

The nature of the application often differs from one granting agency to the next. Corporations rarely have formal applications, while government agencies always do; the largest foundations often have application forms, and the smaller ones sometimes do. Contacting the funding source in advance allows you to gather information about which types of projects are most likely to receive an award—enabling grant seekers to tailor their proposals—and how the organization wants to be approached. Both the Adolph and Esther Gottlieb Foundation and the Pollock-Krasner Foundation, for instance, require applicants for their emergency assistance funds to submit letters requesting an application, while many state arts agencies permit grant seekers to download application forms from their Web sites.

In all cases, it is valuable to establish a personal relationship with the specific individual making the funding decisions by means of a telephone call or a letter requesting an appointment. This type of letter is straightforward, describing an idea in general terms (not so specific that it cannot be modified according to the interests of the funding source) that would interest the individual receiving the letter.

<div style="text-align: right">

Melissa Painter
1827 Dempster Avenue
Evanston, IL 60207
(847) 741-1445

[date]

</div>

Name [executive director, for example]
Title
[organization, agency, company, society]
Address

Dear _____,
 I am interested in meeting with you to discuss an important project that deals with
_____.

 In researching this field, I have observed serious, active interest on the part of [*name of the funding source*] in projects of this type.
 As I continue to develop this idea, your input would be most valuable in advance of making a formal proposal. A few minutes of your time would enable me to meet your needs more closely.
 I will call you to request a brief meeting at your convenience.

<div style="text-align: right">

Sincerely,

Name

</div>

When application guidelines state "no telephone calls" or "no appointments," one may attempt to make contact with other staff or board members of the granting agency through networking and advocates. When looking for funding, artists cannot think of themselves as alone and unknown: They need to draw upon all of their (and their spouses' and friends' and relatives') relevant contacts. A board member or officer of the umbrella organization sponsoring one's project, for instance, might know someone—or know someone who knows someone—who may write a letter on your behalf or set up a telephone appointment or actual meeting. A member of an association to which you belong, a religious leader, or even a member of Congress might be approached to lend support for a proposal by letter or arranging a meeting with someone at the funding source.

 If a meeting is arranged, dress according to your information about the funding source (some are more formal and straitlaced than others) and bring one or more visual images that offer a reasonable sense of what the completed project might look like, as well as background information (curriculum vitae, news clippings of one's past work, and lists of previous awards and grants received) and a rough budget. As they may not be used to being questioned about their work, artists might rehearse or role play their presentation and answering general questions with friends, a spouse, or family members until they feel comfortable. It is useful to have questions to ask, among which might

be, How do you review the proposal and who actually does it (outside experts, staff, board members)? Are your funding deadlines the same as last year? Would you look over my proposal if I finished it early? Is the budget estimate realistic? Is the amount I am requesting realistic? May I see a proposal you have funded that you feel is well written? Could you suggest other funders who would be appropriate for this project?

The value of a personal connection cannot be minimized. By speaking with you over the telephone or, better, in person, the individual involved in grant giving makes an investment in time and interest, which he or she will not want to view as wasted. That same individual will also take very seriously endorsements by staff, board members, and other noted figures—in short, grant seekers want to make it hard to be turned down.

Eventually, a request for funds will need to be put on paper and submitted by a certain date. In certain instances, a one-page letter may suffice. However, even in the most informal of proposals, four main points need to be made:

- First, clearly define the nature of the art project and its importance as well as indicate that it is doable. Documentary material, such as a drawing of the project or a maquette, helps reveal what the artwork will actually look like.
- Second, note the experience and qualifications of the person, team, or organization planning to accomplish the project. Reviews or other notices of past work of this type are useful.
- Third, note that other factors (such as facilities in which to site the art project; the support of colleagues, an institution, or town body; the availability of materials; and other sources of financial support), which ensure the project will be successfully realized, are in place.
- Finally, the project should be of the sort that the foundation or arts agency to which you are applying has shown a decided preference. That final point needs to be discovered through research in the various publications. Potential sponsors who have clearly indicated an interest in projects that assist the educational process in public schools, for instance, may be more interested in an arts-in-the-schools idea than a community poetry reading.

One should also keep in mind that funding agencies receive a great many proposals, some of which are likely to be similar. An artist's project needs to stand out from the competition, which requires the proposal to stress the unique qualities of both the project and the artist. Perhaps on a worksheet, the artist should note what makes the project unique (such as, experience and training of the artist, new design, project will be undertaken at an especially public and visible site, or a very large population will be served), and those distinct advantages should have a prominent place in the description and discussion of the project in the application.

The Proposal Package
When submitting an application or project proposal, remember that the "visuals" are the main focus of concern, so the presentation of the artwork must be excellent. Objects

should be well-photographed (proper lighting, unobtrusive background, no distorting angles) and the slides good (correct colors, no scratches).

There should be more than a slide of just one exquisite object for panelists to view, and the works chosen should be varied, to show one's range and not bore the panelists, but stylistically coherent; that is, not such a wide range of styles and materials that panelists are unsure what kind of work the applicant actually prefers to create.

Some work is not easily understood, and an artist statement may be of value. This statement tells panelists what the work is about. A rule of thumb about artist statements is this: The clearer you are, the happier everyone will be (see "The Artist Statement" in chapter 5). Try to avoid "artspeak." No one wants statements that go on and on and, at the end of it, no one knows what the person is saying. Artists may want to try out their statements on people not in the art world, in order to find out if they are understandable.

A more formal proposal would include the following:

- *Cover letter.* This letter generally begins "Please find enclosed," listing the package contents, and it should be addressed to a specific person rather than "Dear Sir" or "To whom it may concern" (find out that name through a telephone call, an annual report or other printed material, application guidelines).
- *Title page.* The title page makes the proposal look well-organized, neat, and professional. Used only for proposals over three pages, it should include the basic information—applicant's full name, address, and telephone number; name of the sponsoring organization; name of the funding organization; amount requested; purpose of the grant (short, descriptive title); and time frame of project.
- *Abstract.* At 250 words or less, the abstract is the summation of the project and will help the individual reviewing the proposal develop a quick understanding. (Without an abstract, the funding staff member often will create one anyway for the benefit of others examining the proposal, and that write-up may contain misconceptions or factual errors.)
- *Introduction.* The introduction serves two purposes: First, it describes the artist's own credentials (background, previously funded projects), how the artist is uniquely qualified to carry the project through to completion and success, and the relationship to the sponsoring organization; second, it notes how this project fits into the grant-making goals of the funder.
- *Statement of need.* This indicates why the idea needs to be realized and funded. Kept short and factual, the statement identifies a problem for which the idea is a solution (for instance, the park would be used by more people if there were a sculpture at the center). There are many ways to prepare a "needs assessment" for potential funders: Solicit testimony from important members of the community, such as elected officials, community and religious leaders, agency heads, or school administrators; organize a community forum to elicit opinions and responses, notes from which can be submitted with the proposal; create a "case study" involving a select group of individuals from the target community to show the problem they face and their need for the project in question; marshall

available statistics, or develop one's own study, to present a "statistical analysis" to demonstrate the need; and survey the population to gather information on needs. Each method has benefits and drawbacks, and some are considerably more time consuming than others, but they all show a reasonable effort on the part of the applicant to make a case that the project is needed.

- *Objectives.* This describes precisely what you expect to accomplish (the senior citizen art class will improve technical skills in painting and instill an appreciation of contemporary art).
- *Procedures.* If the introduction answers the question "who," the statement of need, "why" and the objectives, "what," the section on procedures looks at the issue of "how." Usually, the longest component of a proposal package, the procedures area describes how the objectives will be accomplished, establishing a chain of events that follow in a logical sequence. It includes design (the approach to be used and why), who (if anyone) else will participate in the creation of the project, how long the project will take (starting and ending dates), and how the finances will be handled.
- *Budget.* The budget is a picture of what the project looks like in dollars and cents. The total cost of the project, and the amount requested of the funder, should be based on actual expenses rather than dreamy wishes. The general range of expenses are salaries (for the artist and any assistants), insurance (liability or workers' compensation, for instance), consultants and contract services (such as movers or landscapers), space (including studio rental), equipment (to be rented or purchased), food, travel, accommodations, telephone, and miscellaneous (postage, printing, fees and licenses, dues, etc.).
- *Future funding.* As projects don't always begin and end neatly within funding cycles, the overall budget may include expenses that will need to be paid for by subsequent grants. Funding sources are not opposed to renewing a grant and, once they have invested money into it, they are likely to want to see the project completed and successful. LEF Foundation, for example, which provides funding for public art projects, notes in its application guidelines that past grantees may reapply "for two additional years, provided all final reports have been filled. After a third year of funding, the Foundation requests that grantees allow a two-year hiatus prior to reapplication."
- *Appendix.* The appendix to a proposal is frequently several times larger than the proposal itself. A grab bag that adds heft to a proposal, it may include an artist's complete résumé, endorsement letters from knowledgeable people in and out of the arts, newspaper or magazine clippings of articles about the artist's work, list of past support from other funders, a list of awards and prizes won, permits or certificates from local or state agencies, information about the artist or his or her project by the organization sponsoring the project, statistical charts or graphs, and photographs of the artist's work.

A proposal package is the ideal method of presenting one's ideas and projects, as artists lay out all the information in a manner that affords them maximum control. Often, however, you are given a standardized application to fill out, answering the funder's questions in very small spaces. Applicants may still try to be more expansive, writing in those small spaces "See Document A" and attaching a separate sheet; few funders will reject a proposal because the grant seeker needed more space. However, you still must answer the funder's questions, rather than reformulating the questions more to your liking. The same information contained in a proposal package (introduction, abstract, statement of need, objectives, procedures, and budget) should be included somewhere.

Individuals

"People spend a lot of time courting foundations and corporations for charitable gifts, but it is really individuals who do the bulk of all giving," said Ann Kaplan, director of research at the New York City–based American Association of Fund-Raising Council. Annually, individuals provide approximately 85 percent of all charitable gifts—well ahead of foundations (9.3 percent) and corporations (5.7 percent)—and the bulk of that giving (between 60 and 70 percent) comes from people whose household income is under $200,000. Almost half of all charitable contributions by individuals goes to religious institutions, and most gifts are made locally.

As with corporations and foundations, one needs to understand why a particular individual is making a gift (individuals, by the way, make "gifts" while corporations and foundations provide "funds"). The potential reasons are varied: to add to a personal sense of self-esteem or to one's reputation within the community as a supporter of the arts, to appear to other people as a generous person, to share vicariously in an artist's success (the person may be a frustrated artist), to receive a much sought-after publicity, to create a sense of indebtedness in the recipient, to elicit some form of allegiance or gratitude from the recipient. (There may be times when a gift has "strings attached" that are unacceptable to a recipient and reluctantly must be rejected by the would-be recipient.) Once the donor's motives are determined, a solicitation can be properly targeted.

"Giving is a form of exchange," said Andrea Kihlstedt, a fundraising consultant in Lancaster, Pennsylvania. "You need to become familiar with what the donor needs to get back." The process of obtaining personal information about potential contributors is not "brain surgery," she noted, adding that "people are happy to talk about themselves, their lives, their families and their interests even with relative strangers. You want to know how they live, how much money they earn above what they need to live, how much traveling they do and where they go. You want to know if they collect things, and what they collect. What you need to do is find among this personal information what leads them to support the arts, where your interests and their interests dovetail."

Although they are the largest group of charitable gift givers, individual donors remain the least documented, in part because there are so many of them. No books are published on who donates how much money and for what causes; the Internal Revenue Service receives much of this information, because of declared deductions for charitable

gifts, but the federal agency does not make individual taxpayer's returns publicly available. (Also, even if the IRS did release information, the full extent of individual giving would not be told, since many nonitemizers do not declare their charitable gifts.) Tax deductions generally are not a primary reason that individuals make a charitable gift to a nonprofit organization. For example, there has been no decrease in giving by individuals since the top marginal tax rates were reduced from 88 percent to 35 percent in the early 1980s. According to Kaplan, changes in the federal tax code changes the timing of gifts but not giving itself, and even the timing isn't changed all that significantly for most people. "A deduction is useful for individuals who are giving to organizations," said Halsey North, a New York City fundraising consultant, "but it is far less important when there is a personal relationship. A deduction is a way to give patrons a tax benefit for something they probably would have done anyway."

There are methods to identify likely contributors, starting from one's own circle of family, friends, colleagues, acquaintances, and past collectors and expanding from there. The connection to the donor may be someone who graduated from the same school in the same year or who has children in the same schools or on the same soccer league or is a board member of another organization with this person. "You want to determine with whom you or the organization sponsoring your project have a linkage," Kihlstedt said. "From there, you look to see who has the interest in giving and who has the ability to give." She recommended circulating a list of names of wealthy individuals and known donors to members of the board of directors of the umbrella organization in order to determine who knows these people (or know people who know them). This may provide information about the potential donors and a means of meeting them.

Some information, especially for individuals with whom an artist or an artist's network does not have a personal relationship, is available in business, university, or public libraries. Biographies and even newspaper or magazine articles about well- or lesser-known figures would reveal considerable information about their tastes, interests, and spending habits. Club rosters and social registers (or a *Who's Who* directory) would note the professional accomplishments, club or association membership, and philanthropic interests of potential donors. The newsletters or annual report to members of nonprofit organizations and institutions (such as artists' clubs, historical societies, hospitals, libraries, museums, nature conservancies, public radio or television stations, and schools) often list their individual and institutional donors. Playbills and programs for performing arts groups are also quite valuable as a resource in that they not only indicate who has made a donation but at what amount (listing categories of contributions, such as donor, sponsor, benefactor, producer, patron, angel, or other terms). Business publications, such as *Dun & Bradstreet's Million Dollar Directory,* Standard and Poor's *The Corporation Records,* and Moody's *Manuals,* will offer information on the individuals who are members of the board of directors or senior officers of publicly traded companies, for these are likely to be wealthy individuals. Besides being a publisher, Dun & Bradstreet is also a credit-rating service for businesses and sells financial analysis reports on both private and public companies, which reveal the names of executives and

board members. One may obtain Securities and Exchange Commission records on public corporations, as well as information on executive salaries and the major stockholders, online from Lexis-Nexis *(www.lexis-nexis.com)* through subscription; often, universities and business schools are subscribers and make the service available to students and other users for free or at a reduced rate.

Once a list of potential donors is assembled, collect information about them: their addresses, telephone numbers, financial worth, educational background, military service, religious and political affiliation, business affiliation (name, address, and telephone number of the company; what the company produces; the individual's title), other business affiliations (board members of a corporation, perhaps), membership in clubs and organizations, awards received, publications, previous gifts made (and to whom), and personal data on spouse, children, interests, and hobbies.

"Individual giving happens between individuals," said Ann Butterfield, a fundraising consultant in Harvard, Massachusetts. "It happens when people meet face-to-face and after a personal relationship has been established." The wrong approach, she noted, was just calling up, or sending a letter, to someone you don't know asking for a contribution. A better method, she suggested, is asking a mutual friend to set up a lunch date in which the potential donor's interests in the arts are noted and the artist's projects (past, current, and future) may be discussed.

In general, asking for money ought not to come up at the first meeting of a potential donor. The courtship should be slow, first discussing the mutual connection that put artist and possible benefactor in touch, then describing the artist's past and current work and inviting the individual to visit in order to see what's going on. The individual could be invited to events—openings, performances, receptions, lectures, demonstrations, to view the work in progress. "Involvement begets investment," Kihlstedt said, "so you want to figure out ways to involve potential donors." It may take as many as five or ten visits in order to build the relationship to the point that you may request a contribution. To a degree, this courtship is a game that both are playing, but experienced donors expect their counsel and interest to be solicited and not just their money.

There are various approaches to fundraising, the most common being either direct mail and telephone solicitations, which tend to elicit smaller donations (in the $10–$50 range) or personally cultivating a small group of larger contributors. Mailers and phone calls are certainly a more labor intensive activity, with lower potential returns, and you'll have to do the same work the next year or next time a project needs financial support. The benefit of cultivating larger donors is that you actually may come to understand what the donors want from their gifts and be able to personally give it to them.

According to Kihlstedt, the hard part may seem actually asking for money, but it is only hard "if you haven't figured out why they'd like to give. If you have figured that out, the only question is negotiating the terms of the gift." The terms, or the most appropriate means of making the gift, may be an immediate payment of cash, donations on a schedule (for instance, regular contributions of $1,000 per month), a gift of stock (usable as dividend income or in a sale), a gift in the form of a trust or a bequest. Fundraising is

not an exact science but its own type of art, and those looking for contributions will have to feel their way through the relationship they are cultivating with potential donors. Individual artists need to express themselves clearly in stating their ideas—outlining what they hope to do—and sense whether or not the person listening to them shows any excitement: If not, the likelihood of a donation is small; if so, an artist may invite the individual to be part of the next step in the process of designing or creating the project. The other hard part may be how artists feel about asking people for money, viewing themselves as supplicants or hucksters. North noted that artists should "look at it as fundraising but as developing a cadre of people who like and support your work. You are actually sharing your creativity with people."

Government agencies, corporations, and foundations all want to have their contributions noted in some visible way, such as a mention on a brochure, banner, or press release, but individual contributors frequently need to be appreciated in a more personal manner. Larger institutions sometimes name a building or hall after a contributor but, even on a smaller level, donors should receive a personal letter of thanks, invitations to current and future openings, or even a pot-luck dinner. "A thank-you letter is crucial," North said. "You can't say thank you enough." He added that one might send large donors a "gift of some kind, not a regular work necessarily, but something smaller or something humorous. That kind of token will mean a great deal." In general, one should maintain the level of involvement that was developed prior to asking for money. An appreciation for a past gift is the first step toward the next gift.

Miscellaneous Funders

A variety of groups and organizations make awards and scholarships or offer prizes, usually for very specific areas of endeavor and to particular individuals. A sports club, for instance, may provide a scholarship for a promising athlete or sponsor the athlete in competitive events, such as a track meet or Olympic tryout. It is not outside of reason, however, to believe that the club might pay for a sports-related mural or sculpture or even pay a dancer to teach members of a football team about movement. Artists need to be as imaginative in their search for financial sponsorship as in their artwork. Among the groups that might be considered are these:

- Business groups, such as Elks, Lions, or Rotary clubs, frequently make awards; and Rotary International regularly sends students and young professionals to foreign countries for study.
- Fraternal organizations, such as the Knights of Columbus, provide scholarships.
- Labor unions, guilds, and leagues offer medical and emergency funds for members, and some also pay for training.
- Sports groups make awards, provide scholarships, and sponsor athletes.
- Veteran, hereditary, and patriotic organizations offer loans, grants, prizes, and scholarships.
- Greek letter societies provide scholarships and occasional fellowships.

- Trade, business, and commercial associations usually offer medals and plaques but sometimes make research grants.
- Scientific and technical organizations offer fellowships, internships, and residencies.
- Hobby groups may make awards and provide research grants.

REPORTING REQUIREMENTS FOR GRANT RECIPIENTS

Like most stories, the fundraising process has a beginning, middle, and an end: The first part is the request (usually filling out an application) to some private or public agency for money; the middle sequence is actually performing the work or service for which the funding was requested; the final part usually is letting the agency know what was done with its money.

The last area is probably the least structured and least consistent in the fundraising process, as the requirements for a final summation differ from one agency to the next. Some allow artists to tell in narrative (perhaps even handwritten) form what went on during their project or fellowship period, while others send out questionnaires of one to four pages that must be filled out. Some agencies require fellowship recipients to detail how the money was spent, while others show little interest in the subject. Other funders hold back a certain percentage of the award until the final report is in, while still others put no strings on the disbursement of funds.

It is not possible to generalize about the reporting requirements for any particular class of funders—for instance, that public arts agencies call for more documentation than private philanthropies or that smaller or local agencies require less paperwork than their larger or federal counterparts—and they must all be viewed individually.

The Adolph and Esther Gottlieb Foundation and Artists Fellowships, Inc., both of which are private, nonprofit organizations that provide emergency assistance to artists in financial need, have very different ideas about reporting. The Gottlieb Foundation demands that recipients describe by letter how money was used within six months of receiving their grants. The letter accompanying the foundation's check states, "You should be advised that the Foundation may request copies of receipts, which document your expenditures." Artists Fellowships, Inc., on the other hand, requires no reporting whatsoever, believing that the essential documentation took place as part of the application process.

At times, a private or public funding agency's application guidelines indicate how money will be released to an individual artist or organization and under what terms. Even when that information is provided, many applicants will overlook it as they are concentrating so intently on describing their projects and monetary needs in a way that is most likely to appeal to the granting agency. As a result, agency reporting requirements may come as a surprise, pleasant or otherwise. Artists and organizations may not decide to forego applying to a particular funding agency because of its reporting or other requirements, but they would want to know what they are getting in to.

Among the issues that artists should be aware of early in the process are:

Interim Reports

Not only do agencies ask for final reports, some ask for progress or interim reports during the period of the project or fellowship. Bush Artist Fellowships, which offers fellowships of $36,000 to artists in seven counties of Minnesota and the Dakotas, requires quarterly reports of approximately 100 words that describe the recipient's activities during the preceding three-month period. The money is paid over a twelve- or eighteen-month period and, "we can withhold payments if quarterly reports aren't submitted," said Kathy Polley, a grants officer. The Philadelphia-based Pew Fellowships in the Arts, on the other hand, which provides grants of $50,000 for fellowship periods lasting up to two years, asks for brief reports or "updates" every six months, and most of these are the length of a paragraph.

The National Endowment for the Arts requires fellowship and project grant recipients to submit a progress report after they have received two thirds of their allocation in order to receive the remainder of the money. In a very different approach, the Elizabeth Foundation for the Arts in New York City contacts grants-in-aid recipients three times during the grant period by telephone, in March, July, and October, in order to discuss their work. "We don't just forget them but try to see what else they need, what else we can do for them," said Jane Stevenson, director of the Elizabeth Foundation. She added that recipients are also asked to complete a two-page questionnaire at the end of their grant year, detailing how the money was spent and the effect that the funding had on their work.

Grant Disbursement

Every agency has its own ideas about how money should be paid out. Pew Fellowships provides a monthly stipend (the same amount each month during the fellowship period), while the Kentucky Arts Council and the Massachusetts Cultural Council award the entirety of their fellowships and project grants up front. Bush Artist Fellowships spread out payments evenly over the fellowship period, although it will make an initial payout of up to $10,000 when asked. Such a request may be the result of the costs of purchasing materials or equipment, without which the project could not be accomplished smoothly.

The Ohio Arts Council pays half of the fellowship amount in one calendar year and the remainder in the next calendar year in order to not burden artists with a large tax liability in one given year, while The Elizabeth Foundation allows artists to receive half of their grant in July and the rest in January or to take the entire amount all at once. The Guggenheim Foundation and the National Endowment for the Arts have the most artist-friendly approach, distributing fellowship awards in whatever manner the artists want them.

Public Service Requirements

Fellowships essentially mean monetary awards with no strings attached. Artists can use the money to create a new work or simply to pay their rent and buy groceries. It is

unclear why an agency would require a final report for a fellowship recipient when it makes no demands on how its money is used, and some artists may feel obliged to claim that the award helped to complete a new work when it actually was part of the down payment on a house.

At times, a fellowship comes with a specific public service requirement, such as a demonstration, lecture, visit to a school, or something else. Both the New York Foundation for the Arts and the Seattle Artists Trust pay artists 90 percent of the total amount of the fellowship, holding back the final 10 percent until a community service function has been performed. The New York Foundation for the Arts allows an artist up to 18 months following the completion of the fellowship to fulfill the public service requirement, and "we suggest to the artists specific organizations or people who could help them in setting up a public service opportunity," said Jennifer Feil, assistant director of artists programs at the agency. "We write to the artists, we may call them once or twice, to remind them that they will forfeit the final 10 percent if they don't perform their public service."

Final Reports

Whereas an application for a grant or fellowship is often read by a number of people (a program director, peer review panel, agency director, board of directors), it is never quite clear who reads an interim or final report and what is done with that information. It may be just one person at the agency checking to see that a certain amount of information has been included. Those funders who send out questionnaires usually have something specific they want to know, such as the attendance at a certain event, the demographic breakdown of an audience, how their money was spent, or what artistic achievements their grants helped to create. This information may be used solely for statistical purposes or to show an agency's accomplishments to legislators or the public.

At other times, final reports are examined by one or more agency personnel in order to determine the effectiveness of a program and whether or not changes should be made. "I read the final reports," said Julyen Norman, program officer for creative arts and technology at the Mid-Atlantic Arts Foundation in Baltimore. "They don't just get filed." Norman, who oversees the agency's artist-in-residence program, noted that both artists and their sponsoring organizations are asked to fill out separate forms; in effect, evaluate each other. "We ask the artists, Were they paid on time? Were they treated well by the organization? Would they do it again? This is really the only way we have of knowing how organizations treat artists. If we receive criticism of an organization, we may not penalize it by taking away a contract, but we will try to work with it to solve some of the problems the next time we provide funding for a residency."

Information gleaned from these forms in the past has led him and other staff members of the agency to make more site visits during a residency and to offer additional technical assistance (nonfinancial help) to the sponsoring organization.

For the questionnaire to the organization, the Mid-Atlantic Arts Foundation wants to learn about the artist's temperament and ability to work with people (in the

event that the same artist is eligible for another residency elsewhere) and to "measure the activity generated by the residency," Norman noted. "We want to know how many people attended events and what kinds of people." Also asked is what kinds of matching grants were raised for the residency by the sponsoring organization.

The two-page final report form of Bush Artist Fellowships is, in many ways, typical of most agencies' questionnaires. On the first page are asked three questions—to describe the activity for which the artist needed funding, to describe what the artist had hoped to achieve during the fellowship year, and to note what actually the artist accomplished. The second asks the artist to provide a "best estimate" of how the fellowship money was spent, listing seven categories (materials and production costs, transportation costs, food and lodging, insurance costs, utilities, taxes, and miscellaneous).

Prodding artists and organizations to complete their questionnaires is a major activity at most arts agencies. "We send out a reminder a couple of months before the final report is due, and then we generally have to call the artists once or twice to remind them again," said Jeff Swain, grants director at the Arts Council of Winston-Salem/Forsyth County in North Carolina, which runs an individual fellowship program. The Arrowhead Regional Arts Council in Minnesota, which also offers fellowships, sends its one-page final report questionnaire along with the check ($1,200), and "artists frequently say that they have forgotten about it or just lost it by the time the year is over," said Robert DeArmond, executive director of the council. "Considering the fact that the amount of money is so small, we try to make the questionnaire as simple as possible to answer, and we don't get too angry if the artists just don't bother."

Julyen Norman also stated that he has to "keep chasing his artists to get them to fill out their forms. However, once the money has been spent, there is no money in it for them to do the final report." As a result, the Mid-Atlantic Arts Foundation decided to withhold the last $500 (10 percent of the grant) until the final report has been submitted in order to provide artists and organizations with an incentive to complete this part of the job. The National Endowment for the Arts has taken an even stricter line with regard to final reports, declaring those artists and organizations who fail to submit the completed four-page questionnaire on time ineligible to receive funding from the federal agency for five years.

Some individual artists may worry about incurring disapproval from an agency over what they actually accomplished during a grant or fellowship period and do not submit a final report (would they ask for the money back?). Robert Bush, a consultant to nonprofit organizations, noted that, in fact, "agencies tend to bend over backwards to make things easier for artists. They know artists need help filling out a final report, and they generally provide support in many ways."

There is a hierarchy of difficulty in final reports. Fellowships tend to require the least paperwork and take the most relaxed attitude about what the report says, while project grant recipients (typically organizations) have to provide more documentation about what was done and how as well as provide an accounting of expenditures. In some instances, organizations receive a certain percentage of the project grant award (say, 75

percent) up front and the rest at the conclusion of the project after the report and budget have been submitted; at other times, payment is only available on a reimbursement basis, submitting specific receipts to the agency for which a check will be issued. The most onerous reports are those by recipients of operating support grants, who must usually provide the agency with quarterly financial statements and pay for an audit.

KEEPING PERSPECTIVE

The first and last thing artists need to keep in mind about applying for a grant is that they may not get it. Rejection leads some artists to bitterness and dejection, an I-won't-get-burned-twice attitude that cuts off future options and attempts. The failure of a grant application to be approved may be taken personally as a negative judgment about the artist and his or her work or talent. Meanings are read into form letters and into the psyches of those who approve or disapprove applications—many of whom serve as jurors on selection panels for only one grant cycle—are examined to discern prejudices and favoritism. Hell hath no fury like an artist scorned.

It is wiser to realize that all funding sources these days are besieged by applicants—that's the reason for the form rejection letters—and that grant givers need to look for reasons not to allocate money. Applicants who don't fill out the grant form completely or neatly, who are not residents of the right area (for instance, a German applying for a National Endowment for the Arts fellowship or a Maine resident seeking project funding from the Oregon Arts Commission), who are not professional artists but art students, who are applying for money from the wrong organization (such as seeking a fellowship from the New York State Council for the Arts, which makes no individual grants), whose projects are not described succinctly, or whose budget sounds inflated (or too low)—these are the easiest to dismiss and are eliminated eagerly as the decision makers look to whittle down the stack.

Artists should seek information about the granting process before they apply and after the decisions are made. Public agencies especially are obligated to provide information on why a particular proposal was rejected (written notes are taken and filed) and that feedback is welcome. Problems in an application or an overstated budget or a lack of documentation or something else may have been the reason, and they can be corrected for the next round of funding or when applying to another granting agency.

* * *

There is a reason why the subject of grants and fellowships comes in the last chapter in this book. When I entered the arts service field, in the mid-1970s, the most commonly asked question was how and where to apply for grants, and most of the career books for artists at that time and into the 1980s devoted the majority of their pages to this topic. Perhaps the reason was that public arts agencies were being created on the national and state levels during the 1960s and 1970s, and their budgets increased every year. Career seminars for artists during this time also focused almost exclusively on the

grant application process and, still today, the most common form of "technical assistance" that state arts agencies provide to artists and arts organizations is information on how to fill out their grant application forms. (In fact, state arts agency Web sites primarily exist to allow applicants to download applications: The Internet is a labor-saving tool, rather than an interactive one, for these agencies.) At the dawn of a new millenium, the question of how and where to apply for a grant seems less central to the careers of most serious artists. Ongoing and increasing public financing of the arts seems less assured than it did just twenty years ago. The budgets of many public arts agencies and some private foundations have been reduced or just not kept up with even modest inflation, and the competition for every available dollar is ferocious. Artists who tie their career hopes to grants and awards are likely to meet with repeated frustration. Instead, artists must see themselves as entrepreneurs, learning how to earn rather than simply apply for money.

BIBLIOGRAPHY

There has been a growing quantity of information that has been compiled in various sources that may be of great help to artists. No one book can tell artists everything they need to know anymore; artists whose long-term goal is to support themselves solely through the sale of their art probably should begin to assemble a library of career-oriented books and other publications.

SOURCES OF PUBLIC AND PRIVATE GRANTS

American Art Directory. New Providence, NJ: R.R. Bowker, 1992.

American Council for the Arts. *Money for Film and Video Artists.* New York: American Council for the Arts, 1991.

American Council for the Arts. *Money for Performing Artists.* New York: American Council for the Arts, 1991.

American Council for the Arts. *Money for Visual Artists.* New York: American Council for the Arts and Allworth Press, 1991.

Annual Register of Grant Support. New Providence, NJ: R.R. Bowker, 1994.

Art Resources International. *Money to Work,* 1992.

Fandel, Nancy A., ed. *A National Directory of Arts and Education Support by Business and Corporations.* Washington International Arts Letters, 1989.

Fandel, Nancy A., ed. *A National Directory of Grants and Aid to Individuals in the Arts.* Washington International Arts Letters, 1987.

Gullong, Jane, Noreen Tomassi, and Anna Rubin. *Money for International Exchange in the Arts.* New York: American Council for the Arts and Arts International, 1992.

Hale, Suzanne, ed. *Foundation Grants to Individuals.* New York: The Foundation Center, 1991.

Roosevelt, Rita K., Anita M. Granoff, and Karen P. K. Kennedy. *Money Business: Grants and Awards for Creative Artists.* The Artists Foundation, 1985.

White, Virginia P. *Grants for the Arts.* New York: Plenum Press, 1980.

OTHER SOURCES OF FINANCIAL SUPPORT FOR ARTISTS

ARTnews' International Directory of Corporate Art Collections. ARTnews, 1992.

Christensen, Warren, ed. *National Directory of Arts Internships.* National Network for Artist Placement, 1989.

Jeffri, Joan. *ArtsMoney: Raising It, Saving It, and Earning It.* St. Paul: University of Minnesota Press, 1983.

Jeffri, Joan, ed. *Artisthelp: The Artist's Guide to Human and Social Services.* New York: Neal-Schuman,1990.

Kartes, Cheryl. *Creating Space: A Guide to Real Estate Development for Artists.* New York: American Council for the Arts and Allworth Press, 1993.

Kruikshank, Jeffrey L., and Pam Korza. *Going Public: A Field Guide to the Developments of Art.* Amherst: Arts Extension Service, University of Massachusetts, 1989.

Porter, Robert, ed. *Guide to Corporate Giving in the Arts.* New York: American Council for the Arts, 1987.

CAREER SKILLS FOR ARTISTS

Abbott, Robert J. *Art & Reality: The New Standard Reference Guide and Business Plan for Actively Developing Your Career as an Artist.* Philadelphia: Steven Locks Press, 1997.

Abbott, Susan. *Corporate Art Consulting.* New York: Allworth Press, 1999.

Abbott, Susan, and Barbara Webb. *Fine Art Publicity: The Complete Guide for Galleries and Artists.* New York: Allworth Press, 1996.

ArtCalendar. *Making a Living as an Artist.* ArtCalendar, 1993.

Alliance of Artists' Communities. *Artists Communities: A Directory of Residencies in the United States That Offer Time and Space for Creativity.* New York: Allworth Press, 2000.

Brabec, Barbara. *Handmade for Profit: Hundreds of Secrets to Success in Selling Arts & Crafts.* New York: M. Evans & Co., 1996.

Brabec, Barbara. *The Crafts Business Answer Book & Resource Guide.* New York: M. Evans & Co., 1998.

Caplan, Evan, Tom Power, and Livingston Biddle, eds. *The Business of Art.* Englewood Cliffs, NJ: Prentice-Hall, 1998.

Caputo, Kathryn. *How to Start Making Money with Your Crafts.* Crozet, VA: Betterway Publications, 1995.

Cochrane, Diana. *This Business of Art.* New York: Watson-Guptill, 1988.

Cummings, Paul. *Fine Arts Market Place.* New Providence, NJ: R.R. Bowker, 1977.

Davis, Sally Prince. *The Fine Artist's Guide to Showing and Selling Your Work.* Cincinnati: North Light Books, 1990.

Davis, Sally Prince. *Graphic Artists Guide to Marketing and Self-Promotion*. Cincinnati: North Light Books, 1987.

Egan, Dorothy. *How to Start Making Money with Your Decorative Painting*. Cincinnati: North Light Books, 1998.

Frascogna, Xavier M., and J. Lee Hetherington. *This Business of Artist Management*. New York: Watson-Guptill, 1997.

Gerhard, Paul. *How to Sell What You Make: The Business of Marketing Crafts*. Mechanicsburg, PA: Stackpole Books, 1996.

Goldfarb, Roz. *Careers by Design: A Headhunter's Secrets for Success and Survival in Graphic Design*. New York: Allworth Press, 1997.

Goodman, Calvin J. *Art Marketing Handbook*. GeePeeBee, 1985.

Gordon, Elliott, and Barbara Gordon. *How to Sell Your Photographs and Illustrations*. New York: Allworth Press, 1990.

Grant, Daniel. *The Artist's Resource Handbook*. New York: Allworth Press, 1997.

Grant, Daniel. *The Fine Artist's Career Guide*. New York: Allworth Press, 1998.

Grant, Daniel. *How to Start and Succeed as an Artist*. New York: Allworth Press, 1997.

Graphic Artists Guild Handbook: Pricing and Ethical Guidelines. Graphic Artists Guild, 1984.

Hadden, Peggy. *The Artist's Guide to New Markets*. New York: Allworth Press, 1998.

Hill, Elizabeth, Catherine O'Sullivan, and Terry O'Sullivan. *Creative Arts Marketing*. Newton, MA: Butterworth-Heinemann, 1996.

Holden, Donald. *Art Career Guide*. New York: Watson-Guptill, 1983.

Hoover, Deborah A. *Supporting Yourself as an Artist*. New York: Oxford University Press, 1989.

Indian Arts and Crafts Board. *Potential Marketing Outlets for Native American Artists and Craftspeople*. Washington, DC: U.S. Department of the Interior (1849 C Street, N.W., MS-4004, Washington, D.C. 20240-0001), 1993.

Janecek, Lenore. *Health Insurance: A Guide for Artists, Consultants, Entrepreneurs & Other Self-Employed*. New York: American Council for the Arts, 1993.

Katchen, Carole. *How to Get Started Selling Your Art*. Cincinnati: North Light Books, 1996.

Klayman, Toby, and Cobbett Steinberg. *The Artist's Survival Manual*. New York: Charles Scribner's Sons, 1987.

Landman, Sylvia. *Crafting for Dollars: Turn Your Hobby into Serious Cash*. Rocklin, CA: Prima Publishing, 1996.

Langley, Stephen, and James Abruzzo. *Jobs in Arts and Media Management*. New York: American Council for the Arts, 1992.

Manolis, Argie, ed. *Crafts Market Place: Where and How to Sell Your Crafts*. Crozet, VA: Betterway Publications, 1997.

MFA Programs in the Visual Arts: A Directory. College Art Association of America, 1987.

Michels, Caroll. *How to Survive & Prosper as an Artist.* New York: Henry Holt and Company, 1998.

Muth, Marcia. *How to Paint and Sell Your Work.* Santa Fe, NM: Sunstone Press, 1984.

National Association of Artists Organizations. *NAAO Directory.* National Association of Artists Organizations, 1989.

Oberrecht, Kenn. *How to Start a Home-Based Crafts Business.* Old Saybrook, CT: Globe Pequot Press, 1997.

Pratt, Nina. *How to Find Art Buyers.* Succotash Press, 1994.

Pratt, Nina. *How to Sell Art.* Succotash Press, 1992.

Ramsey, Dan. *The Crafter's Guide to Pricing Your Work.* Crozet, VA: Betterway Publications, 1997.

Rosen, Wendy. *Crafting as a Business.* New York: Sterling Publishing, 1998.

Sager, Susan Joy. *Selling Your Crafts.* New York: Allworth Press, 1998.

Shaw Associates. *The Guide to Arts & Crafts Workshops.* Shaw Associates, 1991.

Shaw Associates. *The Guide to Photography Workshops & Schools.* Shaw Associates, 1992.

Shaw Associates. *The Guide to Writers Conferences.* Shaw Associates, 1992.

Shipley, Lloyd W. *Information Resources in the Arts.* Washington, DC: Library of Congress, 1986.

Shiva, V. A. *Arts and the Internet: A Guide to the Revolution.* New York: Allworth Press, 1996.

Shiva, V. A. *The Internet Publicity Guide: How to Maximize Your Marketing and Promotion in Cyberspace.* New York: Allworth Press, 1997.

Stolper, Carolyn L., and Karen Brooks Hopkins. *Successful Fundraising for Arts and Cultural Organizations.* Phoenix: Oryx Press, 1989.

Viders, Sue. *Producing and Marketing Prints.* Color Q, Inc., 1992.

West, Janice. *Marketing Your Arts & Crafts: Creative Ways to Profit from Your Work.* Arlington, TX: Summit Publishing Group, 1994.

ART AND THE LAW

Conner, Floyd, et al. *The Artist's Friendly Legal Guide.* Cincinnati: North Light Books, 1988.

Crawford, Tad, and Susan Mellon. *The Artist-Gallery Partnership: A Practical Guide to Consigning Art.* New York: Allworth Press, 1998.

Crawford, Tad. *Business and Legal Forms for Crafts.* New York: Allworth Press, 1998.

Crawford, Tad. *Business and Legal Forms for Fine Artists.* New York: Allworth Press, 1999.

Crawford, Tad. *Business and Legal Forms for Graphic Designers*. New York: Allworth Press, 1999.

Crawford, Tad. *Business and Legal Forms for Illustrators*. New York: Allworth Press, 1998.

Crawford, Tad. *Business and Legal Forms for Authors and Self-Publishers*. New York: Allworth Press, 1996.

Crawford, Tad. *Legal Guide for the Visual Artist*. New York: Allworth Press, 1999.

Crawford, Tad, and Eva Doman Bruck. *Business and Legal Forms for Graphic Designers*. New York: Allworth Press, 1990.

Duboff, Leonard D. *The Law (in Plain English) for Crafts*. New York: Allworth Press, 1998.

Leland, Caryn. *Licensing Art and Design*. New York: Allworth Press, 1995.

Messman, Carla. *The Artist's Tax Workbook*. New York: Lyons & Burford, 1992.

Norwick, Kenneth P., and Jerry Simon Chasen. *The Rights of Authors, Artists, and Other Creative People*. Carbondale: Southern Illinois University Press, 1992.

Wilson, Lee. *Make It Legal*. New York: Allworth Press, 1990.

HEALTH AND SAFETY IN THE ARTS AND CRAFTS

Mayer, Ralph. *The Artist's Handbook*. New York: Viking Press, 1982.

Mayer, Ralph. *The Painter's Craft*. New York: Penguin Books, 1977.

McCann, Michael. *Artist Beware*. New York: Lyons & Burford, 1992.

Rossol, Monona. *The Artist's Complete Health and Safety Guide*. New York: Allworth Press, 1994.

Shaw, Susan D., and Monona Rossol. *Overexposure: Health Hazards in Photography*. New York: American Council for the Arts and Allworth Press, 1991.

OF RELATED INTEREST

Baumol, William J., and William G. Bowen. *Performing Arts: The Economic Dilemma*. Cambridge, MA: M.I.T. Press, 1966.

Benedict, Stephen, ed. *Public Money and the Muse: Essays on Government Funding for the Arts*. New York: W.W. Norton, 1991.

Cockcroft, Eva, John Weber, and James Cockcroft. *Toward a People's Art: The Contemporary Mural Movement*. New York: E.P. Dutton, 1977.

Conrad, Barnaby III. *Absinthe: History in a Bottle*. San Francisco: Chronicle Books, 1988.

Dardis, Tom. *The Thirsty Muse: Alcohol and the American Writer*. New York: Ticknor & Fields, 1989.

Feld, Alan L., Michael O'Hare, and J. Mark Davidson Schuster. *Patrons Despite Themselves: Taxpayers and Arts Policy*. New York: New York University Press, 1983.

Jeffri, Joan. *The Emerging Arts: Management, Survival and Growth.* New York: Praeger, 1980.

Misey, Johanna L., ed. *National Directory of Multi-Cultural Arts Organizations.* National Assembly of State Arts Agencies, 1990.

Mitchell, W. J. T., ed. *Art and the Public Sphere.* Chicago: University of Chicago Press, 1992.

Naude, Virginia, and Glenn Wharton. *Guide to the Maintenance of Outdoor Sculpture.* American Institute for Conservation of Historic and Artistic Works, 1992.

Netzer, Dick. *The Subsidized Muse: Public Support for the Arts in the United States.* Cambridge, MA: Cambridge University Press, 1978.

Shore, Irma, and Beatrice Jacinto. *Access to Art: A Museum Directory for Blind and Visually Impaired People.* New York: American Foundation for the Blind, 1989.

Snyder, Jill. *Caring for Your Art: A Guide for Artists, Collectors, Galleries, and Art Institutions.* New York: Allworth Press,1990.

Whitaker, Ben. *The Philanthropoids: Foundations and Society.* New York: William Morrow, 1974.

ART PUBLICATIONS

A number of magazines and journals are published for artists that include news in the field, trends and opinions, listings of upcoming juried art shows, art workshops, and other opportunities, technical information, and career advice as well as feature articles. Among these are the following:

ACTS FACTS
Arts, Crafts and Theater Safety
181 Thompson Street
Room 23
New York, NY 10012
tel. 212-777-0062
$10 a year

AMERICAN ARTIST
1 Color Court
Marion, OH 43305
tel. 800-347-6969
$24.95 a year

ART CALENDAR
P.O. Box 199
Upper Fairmount, MD 21867-0199
tel. 410-651-9150
$32 a year

THE ARTIST'S MAGAZINE
P.O. Box 2120
Harlan, IA 51593
tel. 800-333-0444
$30 a year

ARTJOB
236 Montezuma Avenue
Santa Fe, NM 87501
tel. 505-988-1166
$24 a year

ARTNEWS
P.O. 2083
Knoxville, IA 50197-2083
tel. 800-284-4625
$32.95 a year

ART NOW GALLERY GUIDE
Art Now, Inc.
P.O. Box 888
Vineland, NJ 08360
(201) 322-8333
$35 a year

THE CHRONICLE OF PHILANTHROPY
1225 23rd Street, N.W.
Washington, D.C. 20037
tel. 202-466-1200
$67.50 a year

FAIRS AND FESTIVALS IN THE NORTHEAST
FAIRS AND FESTIVALS IN THE SOUTHEAST
Arts Extension Service
Division of Continuing Education
604 Goodell
University of Massachusetts
Amherst, MA 01003
tel. 413-545-2360
$7.50 apiece; $13 for both

INSTITUTE ITEMS
Art & Creative Materials Institute
100 Boylston Street
Suite 1050
Boston, MA 02116
tel. 617-426-6400
$20 a year (for individual artists)
$50 a year (for companies)

NEW ART EXAMINER
1255 South Wabash
Fourth floor
Chicago, IL 60605
tel. 312-786-0200
$35 a year

PEN, PENCIL & PAINT
National Artists Equity Association
P.O. Box 28068
Washington, D.C. 20038
tel. 800-727-6232
$12 a year

SUNSHINE ARTISTS USA
2600 Temple Drive
Winter Park, FL 32789
tel. 407-539-1399
$22.50 a year

Throughout the book, a number of specific periodicals, organizations, Web sites and sources of information were noted. For easy access, many of them are reprised here.

Public Art

Art in Transit . . . Making it Happen, Federal Transit Administration, 400 Seventh Street, S.W., Washington, D.C. 20590, www.fta.dot.gov/library/program/art/index.html.

General Services Administration, 18th and F Street, N.W., Washington, D.C. 20405, tel. 202-566-0950, www.gsa.gov/.

National Endowment for the Arts' Art in Public Places program, 1100 Pennsylvania Avenue, N.W., Washington, D.c. 20506, tel. 202-682-5400, www.arts.endow.gov/.

Percent for Art and Art in Public Places Programs, Rosemary Cellini, P.O. Box 1233, Weston, CT 06883, 203-866-4822, e-mail: RMCellini@aol.com ($21.25 plus $2.50 for shipping and handling).

Public Art Directory (Americans for the Arts, 927 15th Street, N.W., Washington, D.C. 20005, 202-371-2830, $21 prepaid, 800-321-4510, ext. 241).

"Public Art on the Internet" (www.zpub.com/public/) lists opportunities for commissions.

Public Art Review, 2324 University Avenue West, St. Paul, MN 55114-1802, 651-641-1128 ($17 for two semi-annual issues).

Save Outdoor Sculpture and Heritage Preservation, 1730 K Street, N.W., Washington, D.C. 20006-3836, 202-634-1422 or 888-SOS-SCULP. www.heritagepreservation.org.

Sculpture Magazine, 918 F Street, N.W., Suite 401, Washington, D.C. 20004, 202-393-4666 ($50 for 10 issues per year).

Sculpture Review, c/o National Sculpture Society, 1177 Avenue of the Americas, New York, NY 10036, 212-764-5645 ($40 for four quarterly issues plus a bimonthly *NSS News Bulletin*).

Veterans Administration, 811 Vermont Avenue, N.W., Washington, D.C. 20402, tel. 202-233-4000.

Fundraising

Americans for the Arts, 927 15th Street, N.W., Washington, D.C. 20005, 202-371-2830, or One East 53rd Street, New York, NY 10022, 212-223-2787, www.artsusa.org/.

Catalog of Federal Domestic Assistance, c/o Government Printing Office, Superintendant of Documents, P.O. Box 371954, Pittsburgh, PA 15250-7954, www.gsa.gov/fdac/queryfdac.htm ($72); order by Discover, Mastercard or Visa through calling 202-512-1800).

Council of Better Business Bureaus, 4200 Wilson Boulevard, Arlington, VA 22203, 703-276-0100, www.bbb.org/.

The Council on Foundations, 1828 L Street, N.W., Washington, D.C. 20036, 202-466-6512, www.cof.org/.

Federal Information Center, P.O. Box 600, Cumberland, MD 21501-0600, 800-688-9889, www.gsa.gov/et/fic-firs/fic.htm.

The *Federal Register,* www.pueblo.gsa.gov/ and (www.access.gpo.gov/su_docs/aces/ aces140.html, ($550 per year for a subscription).

Foundation Center (www.fdncenter.org)—four locations: New York City (79 Fifth Avenue, New York, NY 10003-3076, 212-620-4230) and Washington, D.C. (1001 Connecticut Avenue, N.W., Washington, D.C. 20036, 202-331-1400), as well as field offices in Atlanta (Suite 150, Hurt Building, 50 Hurt Plaza, Atlanta, GA 30303-2914, 404-880-0094), Cleveland (1356 Hanna Building, 1422 Euclid Avenue, Cleveland, OH, 216-861-1934), San Francisco (312 Sutter Street, San Francisco, Ca 94108, 415-397-0902) and a network of 213 cooperating libraries in all 50 states (see Web site for complete list).

The Funding Exchange, 666 Broadway, New York, NY 10012, 212-529-5300, www.fex.org.

National Assembly of State Arts Agencies, 1010 Vermont Avenue, N.W., Washington, D.C. 20005, 202-347-6352.

National Association for State Information Resource Executives (www.nasire.org/ss/index.html).

National Endowment for the Arts, www.arts.gov/federal.html.

National Endowment for the Humanities, www.neh.gov/.

Regional Association of Grantmakers, www.rag.org/.

Regional Arts Agencies

Arts Midwest, Hennepin Center for the Arts, 528 Hennepin Avenue, Suite 310, Minneapolis, MN 55403, 612-341-0755 (Illinois, Indiana, Iowa, Michigan, Minnesota, North Dakota, Ohio, South Dakota and Wisconsin).

Consortium for Pacific Arts and Culture, 2141C Atherton Road, Honolulu, HI 96822, 808-946-7381 (American Samoa, Guam and Northern Marianas).

Mid-America Arts Alliance, 20 West 9th Street, Suite 550, Kansas City, MO 64105, 816-421-1388 (Arkansas, Kansas, Missouri, Nebraska, Oklahoma and Texas).

Mid-Atlantic Arts Foundation, 11 East Chase Street, Suite 1-A, Baltimore, MD 21202, 410-539-6656 (Delaware, the District of Columbia, Maryland, New Jersey, New York, Pennsylvania, Virginia and West Virginia).

New England Foundation for the Arts, 330 Congress Street, Boston, MA 02210-1216, 617-951-0010 (Connecticut, Maine, Massachusetts, New Hampshire, Rhode Island and Vermont).

Southern Arts Foundation, 1401 Peachtree Street, N.E., Suite 122, Atlanta, GA 30309, 404-874-7244 (Alabama, Florida, Georgia, Kentucky, Louisiana, Mississippi, North Carolina, South Carolina and Tennessee).

Western States Arts Foundation, 207 Shelby Street, Suite 200, Santa Fe, NM 87501, 505-988-1166 (Alaska, Arizona, California, Colorado, Hawaii, Idaho, Montana, Nevada, New Mexico, Oregon, Utah, Washington and Wyoming).

Finding Buyers

American Collection Association, 4040 West 70th Street, Minneapolis, MN 55435, tel. 612-925-0760.

ARTnews' International Directory of Corporate Art Collections, 48 West 38th Street, New York, NY 10018, 212-398-1690 ($110).

Art Now Gallery Guide, P.O. Box 888, Vineland, NJ 08360, 201-322-8333.

Art Deadline (www.artdeadline.com).

Art Job (www.artjob.org/).

The Audit Book ($49), Sunshine Artists, 2600 Temple Drive, Winter Park, FL 32789, 800-597-2573.

Corporate Giving to the Arts, Americans for the Arts, One East 53 Street, New York, NY 10022, 212-223-2787 ($30, plus $4 for shipping and handling).

Decor: The Magazine of Fine Interior Accessories, Commerce Publishing Company, 330 North Fourth Street, St. Louis, MO 63102-2036 ($20 per year for 12 monthly issues).

Directory of Artists Slide Registries, Americans for the Arts, One East 53rd Street, New York, NY 10022, 212-223-2787 ($15).

Licensing Industry Merchandisers' Association, 350 Fifth Avenue, New York, NY 10118, 212-244-1944, www.lima.org/.

Selling Your Art Online by Chris Maher, http://1xcom/advisor/index.html.

Sourcebook to the U.S. Art World, Brant Art Publications, Inc. 575 Broadway, New York, NY 10012, 212-941-2800 ($15).

WorldWide Art Resources, http://wwar.com/employment.

MASSACHUSETTS
Department of Revenue, Executive Office for Administration & Finance, 100 Cambridge Street, Room 806, Boston, MA 02202, 617-727-4201

MICHIGAN
Bureau of Revenue, Department of Treasury, Treasury Building, Lansing, MI 48909, 517-373-3196

MINNESOTA
Department of Revenue, 10 River Park Plaza, St. Paul, MN 55146, 612-296-3403

MISSISSIPPI
State Tax Commission, 102 Woolfolk Building, Jackson, MS 39201, 601-359-1098

MISSOURI
Department of Revenue, 301 West High Street, P.O. Box 311, Jefferson City, MO 65105, 314-751-4450

MONTANA
Department of Revenue, Sam Mitchell Building, Room 455, Helena, MT 59620, 406-444-2460

NEBRASKA
Department of Revenue, P.O. Box 94818, Lincoln, NE 68509, 402-471-5604

NEVADA
Department of Taxation, 1340 South Curry Street, Carson City, NV 89701, 702-687-4892

NEW HAMPSHIRE
Department of Revenue Administration, 61 South Spring Street, Concord, NH 03302, 603-271-2191

NEW JERSEY
Division of Taxation, Department of Treasury, 50 Barrack Street, CN240, Trenton, NJ 08625, 609-292-7191

NEW MEXICO
Department of Taxation & Revenue, Joseph Montoya Building, Santa Fe, NM 87503, 505-827-0341

NEW YORK
Department of Taxation & Finance, State Campus, Building 9, Room 205, Albany, NY 12227, 518-457-2244

NORTH CAROLINA
Department of Revenue, 2 South Salisbury Street, Raleigh, NC 27602, 919-733-7211

NORTH DAKOTA
Tax Department, State Capitol, Eighth Floor, 600 East Boulevard Avenue, Bismarck, ND 58505, 701-224-2770

OHIO
Department of Taxation, 30 East Broad Street, 22nd Floor, Columbus, OH 43266, 614-466-2166

OKLAHOMA
Tax Commission, 2501 North Lincoln Boulevard, Oklahoma City, OK 93194, 405-521-3115

OREGON
Department of Revenue, 955 Center Street, N.E., Salem, OR 97310, 503-378-3363

PENNSYLVANIA
Department of Revenue, Strawberry Square, 11th Floor, Harrisburg, PA 17127, 717-783-3680

RHODE ISLAND
Division of Taxation, Department of Administration, One Capitol Hill, Providence, RI 02908, 401-277-3050

SOUTH CAROLINA
Tax Commission, 301 Gervais Street, Columbia, SC 29201, 803-737-9830

SOUTH DAKOTA
Department of Revenue, 700 Governors Drive, Pierre, SD 57501, 605-773-3311

TENNESSEE
Department of Revenue, 927 Andrew Jackson Building, Nashville, TN 37219, 615-741-2461

TEXAS
Public Accounts, P.O. Box 13528, Capitol Station, Austin, TX 78711, 512-463-4000

UTAH
Tax Commission, 160 East 300 Street, Salt Lake City, UT 84134, 801-530-6088

VERMONT
Department of Taxes, Agency of Administration, 109 State Street, Montpelier, VT 05602, 802-828-2523

VIRGINIA
Department of Taxation, P.O. Box 6-L, Richmond, VA 23282, 804-367-8005

WASHINGTON
Department of Revenue, General Administration Building, P.O. Box 47450, Olympia, WA 98504, 206-753-5540

WEST VIRGINIA
Department of Tax & Revenue, State Capitol Complex, Building 1, Room WW-300, P.O. Box 963, Charleston, WV 25305, 304-558-0211

WISCONSIN
Department of Revenue, 125 South Webster, Madison, WI 53702, 608-266-6466

WYOMING
Department of Revenue, Herschler Building, Cheyenne, WY 82002, 307-777-5287

AMERICAN SAMOA
Revenue Division, Department of Treasury, Pago Pago, AS 96799, 684-633-5166

GUAM
Department of Revenue & Taxation, 855 West Marine Drive, Agana, GU 96910, 671-477-5144

NORTHERN MARIANA ISLANDS
Revenue & Taxation Division, Department of Finance & Accounting, P.O. Box 234, CHRB, Saipan, MP 96950, 670-664-1000

PUERTO RICO
Income Tax Bureau, Department of Treasury, P.O. Box S-4515, San Juan, PR 00904, 809-721-2020

U.S. VIRGIN ISLANDS
Bureau of Internal Revenue, P.O. Box 3186, St. Thomas, VI 00801, 809-774-4572

For additional contact information on state departments of revenue, log on www.aicpa.org/yellow/yptsgus.htm.

Artists and the Law
Artists Rights Society, 65 Bleecker Street, New York, NY 10012, 212-420-9160.

Business Volunteers for the Arts, http:artsandbusiness.org/.

Copyright Office, Library of Congress, Washington, D.C. 20559, 202-287-9100.

Graphic Artists Guild, 90 John Street, Suite 403, New York, NY 10038, 212-791-3400.

Visual Artists and Galleries Association, Empire State Building, 350 Fifth Avenue, Suite 6305, New York, NY 10118, 212-736-6666.

Volunteer Lawyers for the Arts, www.stus.com/ncs/vla.htm.

Commissions and Employment
American Society of Interior Designers, 608 Massachusetts Avenue, N.E., Washington, D.C. 20002-6006, 202-546-3480, www.asid.org/.

Artists and Graphic Designers Marketplace ($24.99), *Poetry Marketplace* ($23.99), both published by F&W Publications (1507 Dana Avenue, Cincinnati, OH 45207, 800-289-0963).

Arts in Healthcare, 3867 Tennyson Street, Denver, CO 80212-2107, 303-433-4446 or 800-243-1233, www.societyartshealthcare.org/.

Artlinks, P.O. Box 223, Berkeley, CA 94701, 510-528-2668.

Artjob, c/o WESTAF, 236 Montezuma Avenue, Santa Fe, NM 87501, 505-988-1166 ($30 for six monthly issues).

Artsearch, 355 Lexington Avenue, New York, NY 10017, 212-697-5230 ($54 for 24 issues).

Artswire, www.artswire.org/current/jobs.html. In addition.

College Art Association, 275 Seventh Avenue, New York, NY 10001, 212-691-1051, www.collegeart.org/.

Communication Arts, P.O. Box 51785, Boulder, CO 80322, 800-258-9111 ($53 for eight issues).

Current Jobs in the Arts, P.O. Box 40550, Washington, D.C. 20016, 703-506-4400 ($19 for three monthly issues).

DC Art/Works, 410 Eighth Street, N.W., Washington, D.C. 20004, 202-727-3412.

The Greeting Card Association, 1030 15th Street, N.W., Washington, D.C. 20005, 202-393-1778, www.greetingcard.org/.

Greetings, Etc., 4 Middlebury Boulevard, Randolph, NJ 07869, 800-948-6189, $36 for four issues).

Hospital Audiences, Inc.,220 West 42nd Street, New York, NY 10036, 212-575-7696, www.hospitalaudiences.org/.

International Arts Medicine Association, 714 Old Lancaster Road, Bryn Mawr, PA 19010, 610-523-3784, http://members.aol.com/iama.org/.

The National Network for Artist Placement, 935 West Avenue 37, Los Angeles, CA 90065, 213-222-4035.

Health and Safety

American Association of Textile Chemists and Colorists in the United States, One Davis Drive, P.O. Box 1215 Research Triangle Park, NC 27709-2215.

American Society of Testing and Materials, 100 Barr Harbor Drive, West Conshohocken, PA 19428, tel. 610-832-9500

The Arts and Creative Materials Institute, 100 Boylston Street, Boston, MA 02116, 617-426-6400, www.creative-industries.com/acmi/.

Arts, Crafts and Theater Safety, 181 Thompson Street, New York, NY 10012, 212-777-0062, www.caseweb.com/acts/.

Center for Safety in the Arts, 2124 Broadway, New York, NY 10023 or c/o New York Foundation for the Arts, 155 Avenue of the Americas, New York, NY 10013-1507, 212-366-6900, ext. 333, www.artswire/1/Artswire/csa/.

Society of Dyers and Colourists, P.O. Box 244 Perkin House, 82 Grattan Road, Bradford West Yorkshire, Great Britian BD1 2JB.

INDEX

BOOKS FROM ALLWORTH PRESS

Artists Communities: A Directory of Residencies in the United States That Offer Time and Space for Creativity, Second Edition by the Alliance of Artists' Communities (softcover, 6¾ × 10, 240 pages, $18.95)

The Artist's Quest for Inspiration by Peggy Hadden (softcover, 6 × 9, 256 pages, $15.95)

Business and Legal Forms for Fine Artists, Revised Edition with CD-ROM by Tad Crawford (softcover, 8½ × 11, 144 pages, $19.95)

Legal Guide for the Visual Artist, Fourth Edition by Tad Crawford (softcover, 8½ × 11, 272 pages, $19.95)

The Copyright Guide: A Friendly Guide to Protecting and Profiting from Copyrights by Lee Wilson (softcover, 6 × 9, 192 pages, $18.95)

Corporate Art Consulting by Susan Abbott (softcover, 11 × 8½, 256 pages, $34.95)

How to Start and Succeed as an Artist by Daniel Grant (softcover, 6 × 9, 240 pages, $18.95)

The Fine Artist's Career Guide by Daniel Grant (softcover, 6 × 9, 224 pages, $18.95)

The Artist's Guide to New Markets: Opportunities to Show and Sell Art Beyond Galleries by Peggy Hadden (softcover, 5½ × 8½, 252 pages, $18.95)

Redeeming Art: Critical Reveries by Donald Kuspit (softcover with flaps, 6 × 9, 352 pages, $21.95)

Beauty and the Contemporary Sublime by Jeremy Gilbert-Rolfe (softcover with flaps, 6 × 9, 208 pages, $18.95)

Please write to request our free catalog. To order by credit card, call 1-800-491-2808 or send a check or money order to Allworth Press, 10 East 23rd Street, Suite 510, New York, NY 10010. Include $5 for shipping and handling for the first book ordered and $1 for each additional book. Ten dollars plus $1 for each additional book if ordering from Canada. New York State residents must add sales tax.

To see our complete catalog on the World Wide Web, or to order online, you can find us at *www.allworth.com*.